TODAY'S MOVIES ARE MADE IN DIFFERENT PLACES, IN DIFFERENT WAYS

Movies are being made indoors and outdoors . . . on big budgets and small . . . with the most elaborate equipment and with the latest, surprisingly inexpensive and accessible hand-held cameras and video machines . . . with a variety of lenses, editing techniques, sound recording methods . . . with bright lights and soft focus, close-ups and jump-cuts, montage and staged scenes . . . behind the camera and in the lab . . .

Whatever kind of movie you want to make . . . whatever money you want to spend, time you want to take, and style you want to use . . . whatever equipment, skills and terminology you want to master . . . you'll find the most up-to-date information—in language you can understand— in this indispensable book . . .

THE FILMMAKER'S HANDBOOK

EDWARD PINCUS has taught film at both Harvard University and the Massachusetts Institute of Technology. He is author of the widely used *Guide to Filmmaking* (available in a Signet edition).

STEVEN ASCHER has also taught film at the Massachusetts Institute of Technology. Both have made numerous films and collaborated on *Life and Other Anxieties.*

THE FILMMAKER'S HANDBOOK

Edward Pincus and Steven Ascher

DRAWINGS BY CAROL KELLER

ORIGINAL PHOTOGRAPHS BY TED SPAGNA

Ⓟ

A PLUME BOOK

PLUME
Published by the Penguin Group
Penguin Books USA Inc., 375 Hudson Street, New York, New York 10014, U.S.A.
Penguin Books Ltd, 27 Wrights Lane, London W8 5TZ, England
Penguin Books Australia Ltd, Ringwood, Victoria, Australia
Penguin Books Canada Ltd, 10 Alcorn Avenue, Toronto, Ontario, Canada M4V 3B2
Penguin Books (N.Z.) Ltd, 182–190 Wairau Road, Auckland 10, New Zealand

Penguin Books Ltd, Registered Offices: Harmondsworth, Middlesex, England

Published by Plume, an imprint of Dutton Signet,
a division of Penguin Books USA Inc.

First Printing, June, 1984

13 15 17 19 20 18 16 14

Copyright © 1984 by Edward Pincus and Steven Ascher

Original photographs copyright © 1983 by Ted Spagna

All rights reserved

Library of Congress Cataloging in Publication Data

Pincus, Edward.
 The filmmaker's handbook.

 Bibliography: p.
 Includes index.
 1. Cinematography. I. Ascher, Steven. II. Title.
 TR850.P54 1984 778.5′3 83-25121
 ISBN 0-452-25526-0

 REGISTERED TRADEMARK—MARCA REGISTRADA

PRINTED IN THE UNITED STATES OF AMERICA

To
Anne and Jules Pincus
and
Anne Mackin

Contents

Foreword

These are exciting times for film. Almost every technical aspect of film-making—camera, lens, sound equipment, lighting—has radically improved over the last ten years. With new lenses and film stocks, you can film in low-light situations that were formerly inaccessible. Color stocks have improved to the point where casual snapshots have better color rendition than the high-budget feature films of the 1950s. Today, an entire generation of filmmakers has been able to explore the beauty of filming with available light on color film.

In the past twenty years, there have been two major technological innovations that have revolutionized motion picture production. The first is the development of truly portable, high-quality cameras and synchronous sound recording equipment that have brought about entirely new approaches to both fiction and documentary. Second is the introduction and growth of video. Video itself has been slow in producing interesting work, and that raises the question of whether to think of video as a new art form or as an extension of film. Film and video are becoming increasingly intertwined as video technology is often used in the shooting and editing of film. Some think of video as the inevitable successor of film. Such a transition may happen, but that time is a long way off. In our book, we discuss the applications of video in film and techniques for shooting film for television and video tape distribution. Much of the information in the book is also relevant to video makers. The contemporary filmmaker should not be ignorant of the possibilities of video.

There have always been two worlds filmed by the filmmakers: the fictional and the nonfictional. The theatrical feature film creates a world before the camera. A story is written and characters act out the events to make the film. In the documentary, filmmakers attempt to show the world as it is. The French contrast the films of Lumière, who filmed his baby eating breakfast and a train arriving at the station, with those of his contemporary Méliès, the magician, who created stories, costumes and special effects for his films. On the one hand, there is the difference

between documentary and fiction; on the other, the difference between finding magic in the world and creating it for the camera.

We wrote this book for a wide variety of filmmakers; those interested in fiction, documentary, industrial and experimental films will find it useful. We discuss techniques for filmmakers experimenting with the camera and editing bench, as well as for those working in the feature film industry. Outlined are the standard techniques in super 8, 16mm and 35mm. Whatever the format in which you chose to work, you can learn about its possibilities and limitations by comparing it with the other formats. We see sound as a major part of the film tradition and thus discuss techniques and applications in detail. Synchronous sound is emphasized and is considered in conjunction with both handheld and tripod- or dolly-mounted camera techniques. The book stresses new technologies that permit the independent filmmaker to make low-cost films with high production values.

In a sense, all filmmakers start out as independents. More often than not, the novice must become versed in all aspects of film production—shooting, sound recording, editing, raising money and distribution—simply because there is no one else to perform these tasks. Learning these facets of filmmaking has its advantages no matter what your future career is in film. The best cameraman or woman is one familiar with the needs of the sound recordist and editor, and vice versa. In the book, when we use the industry's terms for craft division—editor, director of photography, camera operator, recordist and the like—it is for convenience and not to encourage the division of these roles.

The book presents technical information of practical value, introducing key terms and concepts without overwhelming the reader with technical jargon. You may want to read the book straight through or use it as a reference to answer particular questions as they arise. Most of the chapters can be read independently with a minimal amount of cross referencing. If you wish to dip in and sample, make liberal use of the Table of Contents and the Index.

We want to thank Mark Abbate, David Brown, Benjamin Bergery, Michael Callahan, Elvin Carini, Claude Chelli, Alfred Guzzetti, Ned Johnston, Rudolph Kingslake, Dennis Kitsz, Steve Kuettel, David Leitner, Mark Lipman, Ross McElwee, Robb Moss, Sami Pincus, Moe Shore and those people, too numerous to mention, who graciously supplied information or photographs.

1

Introduction to Film and Video Systems

This chapter is intended as an overview of the filmmaking process, an outline of techniques and equipment. Most of the material here is discussed in greater detail later in the book.

Making a Film

Film production ranges from multimillion dollar Hollywood epics to individuals drawing film "sketches" with a super 8 camera. Although films vary widely in terms of budgets allotted, personnel involved and intended uses, many of the processes required to create film are similar for all productions. Filmmaking tasks can be divided chronologically into *preproduction, production and postproduction periods*.

Preproduction is the time for planning and preparation. Fiction films usually begin with a script, while unscripted documentaries may start as a written proposal outlining what is to be filmed. The filmmaker (or film producer) draws up a budget of the movie's estimated cost and arranges for financing. For higher-budget films, this usually involves soliciting investors, film distributors, grants or a television contract. Lower-budget films are often financed out of pocket, sometimes with the hope of recouping costs after the film is finished. During the preproduction period, *locations* (the sites where the film will be shot) are scouted, casting is done (for a fiction project) and the film crew is put together.

The production period essentially begins when the camera rolls. Since film equipment is extremely expensive, it is usually rented for the duration of the film's production, or only on the days it is needed. Fiction film production may take place in a studio or "on location," while documentaries are rarely filmed in studios. During production, film footage is sent to the laboratory for processing. The footage that comes back from the lab is called *rushes* or *dailies* (because on large productions it is rushed back and viewed every day; small films rarely get such good service).

1

Rushes are usually *workprint,* that is, a protection copy of the *original* film (the film which actually went through the camera).

The postproduction period begins once the principal photography is completed. Editing is done to condense what are often hours of rushes into a watchable film. It is usually on the editing table that the movie can be seen in its entirety for the first time. Films are often substantially rearranged and reworked during editing. A *rough cut* is honed to a *fine cut,* and, when a satisfactory version is complete, the original film is cut identically to the workprint and then duplicated. Several *prints,* or copies, are made. Finally, the completed prints are *distributed*—sent out into the world to find their audience.

The Moving Image

The impression of continuous movement in a motion picture is an illusion. The film camera records a series of still photographs in rapid succession (usually 24 frames per second, written 24 fps). After the film is developed, these images, separated from each other by an instant of darkness, are projected on a screen. Since the eye retains images slightly longer than it is actually exposed to them, it tends to meld two successive images into one, creating a smooth transition between them. This phenomenon is called *persistence of vision* and is responsible for the illusion of motion in movies, flip books and television.

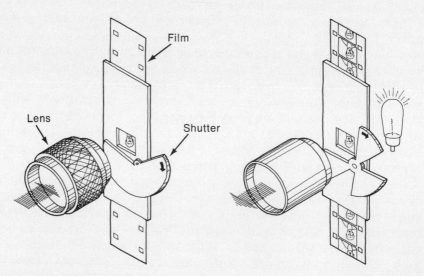

FIG. 1-1. The camera and the projector. The camera (left) draws in light to create an image of the world; the projector (right) throws the image back into the world.

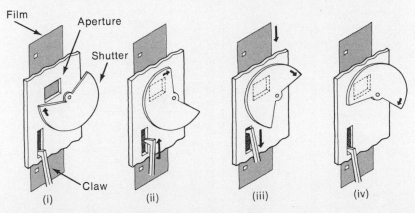

FIG. 1-2. The shutter and intermittent movement. (i) The claw holds the film in place during exposure. (ii, iii) The shutter rotates to block light from the film while the claw moves up to pull down the next frame. (iv) The claw freezes in position to hold the next frame steady for exposure.

The camera works by focusing light from the scene to be photographed onto a small rectangular area of the film. After each rectangle *(frame)* is exposed to light, the *shutter* blocks off the light. The *claw* then pulls more film into position and holds it in place. When the film is at rest, the shutter opens again, allowing light to strike the film. This stop-start process is called the *intermittent movement*.

The film projector operates on the same principle, but rather than focusing light from the surroundings onto the film, it projects the filmed image onto a screen using a bright light behind the film path. As long as the projector runs at the same speed as the camera, motion will appear normal. Sometimes cameras are run at a higher speed so that motion will appear slowed down.

The Format

While all movie cameras expose film images in basically the same way, the size and shape of the image produced vary with the camera type. The first movies, made in the 1890s by Thomas Edison, were shot on *cellulose nitrate* base film that was 35 millimeters (mm) wide. Nitrate film is highly flammable (much of the first version of Robert Flaherty's *Nanook of the North* was destroyed by a cigarette ash) and becomes explosive as it deteriorates with age. Nitrate has since been replaced by the more stable *cellulose acetate* base. The 35mm gauge remains the most commonly used in theatrical filmmaking.

In the 1920s, 16mm film was introduced as a cheaper, lower-quality

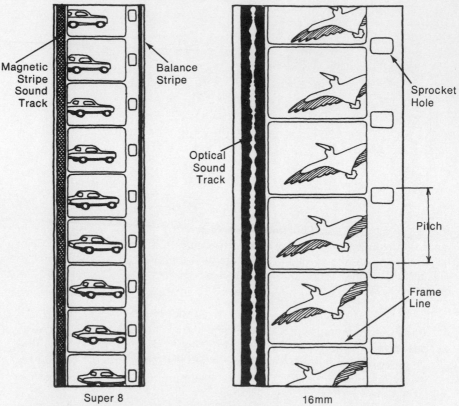

FIG. 1-3. The moving image is composed of a series of still images called frames. Successive frames are divided by the *frame line*. The claw advances the film by engaging a sprocket hole, or perforation. The 16mm film here has an optical sound track and the super 8 film a magnetic stripe sound track. Note the different sprocket hole positions in super 8 and 16mm.

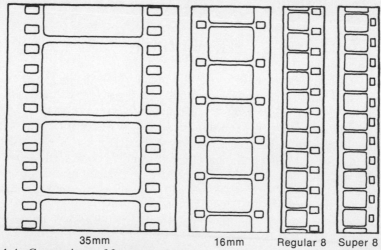

FIG. 1-4. Comparison of formats.

alternative to 35mm for amateur filmmakers. At the time, it was looked upon as "spaghetti" by professionals, much as super 8 film is today. The area of the 16mm frame is only one quarter of that of the 35mm frame and, when projected side-by-side, the 16mm film looks noticeably grainier, less sharp and usually dimmer. However, with the technological improvements made in lenses, cameras and film emulsions, 16mm is now used extensively in professional filmmaking.

In 1932, regular 8mm (actually double 8mm) was introduced. Double 8mm cameras use 16mm film that has twice the normal number of perforations. The film is run through the camera in one direction, exposing, say, the right side of the film. The film is then rethreaded in the camera running in the opposite direction, this time exposing the left side. After the film is processed, the roll is split in half lengthwise, producing two rolls of regular 8mm film. Other cameras were designed to accept pre-split regular 8mm film that is run in one direction only. Regular 8mm cameras are no longer manufactured, but many are still in use.

In 1965 Kodak brought out super 8 film. Super 8 is 8mm wide but has smaller, repositioned sprocket holes, so that it can record an image 50 percent larger than regular 8mm. The super 8 frame is still only one third the area of the 16mm frame. Super 8 is very convenient because it comes in cartridges that, unlike 16mm and 35mm film rolls, can be inserted in the camera in daylight without threading. Fujica packages super 8 film in special cartridges that fit "single 8" Fuji-made cameras only, but the film can be edited and projected with normal super 8 equipment. Although single 8 cameras allow more flexibility for dissolves and multiple exposures than some super 8 equipment (see below), the use of single 8 is decreasing in the U.S.

The term *format* refers to the width of a film stock, as well as the size and shape of the image that is recorded on it. The super 8 and regular 8mm formats use film of the same width or gauge (8mm), but the sizes of their frames are different. The shape of the frame is described by the proportions of its rectangle: the width of the frame divided by the height is the *aspect ratio* (see Fig. 1-5). The aspect ratio of 1.33:1 (read one thirty-three to one) is the standard for several formats—regular 8mm, super 8, 16mm, as well as video tape. In 35mm the full frame for sound film has an aspect ratio of about 1.33:1 and is called *Academy aperture*. Most movies viewed in American commercial theaters are shown at 1.85:1, which is a "wide-screen" aspect ratio. European theatrical films are made for projection at 1.66:1, which, for the same height, is not quite as wide as the 1.85:1 image. Theatrical films are usually shot on 35mm (or, in some cases, 65mm) film. Often, *anamorphic lenses* are used to "squeeze" the width of the image being shot so that it will fit on the film frame. The image is then "unsqueezed" in projection to restore it to its original aspect ratio. Anamorphic systems are often called "scope" (from the trade name CinemaScope), and prints using conventional lens sys-

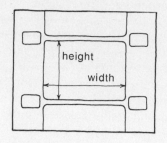

1.33:1 1.85:1 2.35:1

FIG. 1-5. The aspect ratio is the width of the frame divided by its height. Wide-screen formats require a different approach to image composition.

tems are called *flat*. The most common aspect ratios for anamorphic systems are as wide as 2.35:1.

Comparing the Formats

In general, the larger the format, the better the quality of the recorded image. When a large area of film emulsion is used for each exposure, the grain and imperfections of the film detract less from the image. In the 35mm camera, about 13 square inches of film are exposed each second; in 16mm only about 3 square inches are used. This principle applies to sound recording as well; recordings made on wide tape running at high speeds are usually of better quality than those made with narrower, slower-moving formats.

One of the key disadvantages of small formats is the amount of magnification required to project the image on a screen. When a 16mm frame is projected on a modest 8' × 10' screen, it must be enlarged about 100,000 times. To fill a screen of the same size a super 8 frame must be magnified more than 300,000 times. Small format films are rarely shown on big screens in large theaters in part because the more the film is magnified, the more the sharpness and steadiness of the image decrease; the image begins to "fall apart."

The quality of the projected image is affected not only by the format but by the quality of the camera lens and the film (called *film stock* or *raw*

stock) as well. Most professional filmmaking is done with *negative* film stocks. After the film is developed, negative stocks render a scene with reversed tonalities, that is, what was light in reality is dark on the negative (see Fig. 4-2). Any negative must be printed on *positive* film stock to correct the image. Sometimes films are made on *reversal* film stocks, which are like slides in still photography, that is, they show a normal image as soon as they are developed. Usually, copies made from color reversal camera films show noticeably more grain and contrast than prints made from negative stocks; in some situations, however, reversal stocks may be more economical because no print is needed to view the positive image. Not all stocks are available in all formats.

The filmmaker's choice of format affects not only the cost and complexity of producing the film but its possibilities for distribution as well.

Super 8

Manufacturers produce super 8 film and equipment primarily for the amateur market. They make inexpensive, portable equipment for the home movie maker who rarely does much editing or makes multiple copies of his films. These cameras are extremely light and are compact enough to fit in a small shoulder bag; they are often highly automated to minimize technical errors. Super 8 cameras are extremely noisy by 16mm and 35mm standards, and their clatter can usually be heard on the film's soundtrack. Most cameras accept 50′ film cartridges which run for 2½ minutes at normal *sound speed* (24 fps) or about 3½ minutes at the slower *silent speed* (18 fps). A few cameras accept 200′ cartridges as well. A

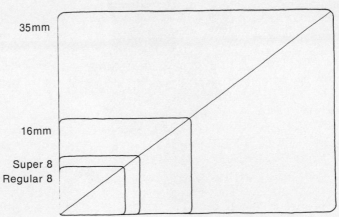

FIG. 1-6. Relative frame sizes of 35mm, 16mm, super 8 and regular 8mm. All of the frames shown here have the same aspect ratio.

variety of color and black-and-white reversal film stocks are available in super 8, but there are no readily available negative camera stocks.

Super 8 cameras often have features not usually found on 16mm cameras, such as the ability to fade the image in or out, run at several different speeds and automatically expose single frames for time-lapse and animation effects. Many super 8 cameras will also make *dissolves*, where one image melts into another. In many cameras, a 50′ super 8 cartridge allows up to 90 frame dissolves; the 200′ cartridge and the single 8 camera both allow the film to be wound farther backward for making long dissolves. In 16mm and 35mm, time-lapse work must usually be done with a special camera, and the other effects created when the film is printed. Unlike in 16mm filmmaking, it is typical in super 8 to record sound in *single system*, that is, within the camera and without an additional tape recorder.

Despite the use of super 8 by serious amateurs and professionals, film manufacturers and processing laboratories do not usually provide the same materials, services and standards of quality for super 8 as they do for 16mm. Thus, it may be very difficult to force develop some super 8 film stocks (see Chapter 4), to make a copy for editing *(workprint)* that can be matched to the original or to make prints with full color correction. Unlike in 16mm, prints in Super 8 usually look substantially worse than the original. In addition, there are many techniques, film stocks, lenses and other items that are not available in super 8 at all.

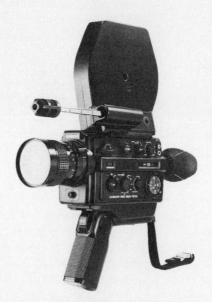

FIG. 1-7. A Chinon super 8, single system sound (sound-on-film) camera with telescoping boom microphone. This camera is shown with a 200′ magazine. (Chinon, USA)

For these reasons, many filmmakers do not regard super 8 as a less expensive substitute for 16mm. However, it does have distinct advantages. Super 8 cameras are extremely convenient and unobtrusive; they can be used in many places where larger-format equipment would attract attention. Shooting and sound recording can easily be done by one person with minimal training, and simple editing of a sound film can be done with a low-cost viewer. Super 8 original, when shown on a relatively small screen, can provide a beautiful color image and good quality sound.

Commercial film distribution of super 8 is mostly limited to short, cartridge-loaded films for educational use and to home showings of theatrical shorts. Films for both these markets are usually shot in larger formats and then reduced to super 8; video cassettes will probably replace super 8 entirely in these fields. Super 8 films can be blown up to 16mm for distribution, but the quality is lower than if the film were originally shot in 16mm. This may save money on the initial outlay for the film, but the blowup is expensive.

The ability to transfer super 8 film to video tape has revolutionized the use of super 8. As anyone who has edited super 8 knows, manipulating this small-gauge film can be a trying process. Super 8 film lacks the *edge numbers* (see Fig. 12-4) that the manufacturer prints along the edge of 16mm and 35mm film, without which matching a workprint to the original film after editing can be a nightmare. For these and other reasons, video editing (and/or distribution) of material that was filmed on super 8 has made the serious use of super 8 far more viable.

16mm

Like super 8, 16mm was originally introduced as an amateur film but has since developed into a fully professional format. Because 16mm equipment is easily portable, its principal use for years was newsreels, with which the grainy, handheld 16mm image is still associated. Now 16mm is used for documentaries, animation, experimental or avant-garde films and low-budget features.

16mm cameras are heavier than super 8 cameras (ranging from about 5 to about 20 lbs), and their cost usually runs in the thousands, not the hundreds, of dollars. The smallest, least expensive 16mm cameras are quite noisy and are intended for making silent films or films whose sound tracks are recorded after shooting. These cameras are sometimes called "silent cameras," although the term is also used for cameras that are quiet enough to be used for sound filmmaking. Audible camera noise on the sound track can be disastrous, especially in fiction film applications.

16mm film comes on spools, which can be threaded into the camera in daylight, and in rolls, which must be loaded in the dark. Most cameras accept 100', 2¾ minute daylight spools. 16mm film runs 36 feet/minute at sound speed (24 frames per second). Larger cameras also accept both

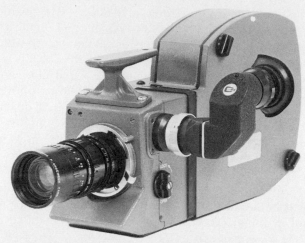

FIG. 1-8. Cinema Products GSMO (pronounced "gizmo") 16mm camera. A light-weight reflex camera that accepts quick-change magazines. (Cinema Products)

200' spools and the standard 16mm roll, which is 400' and runs 11 minutes at sound speed. For cameras that accept 400' rolls, the film is usually loaded into a *magazine* inside a light-tight *changing bag* (see Fig. 4-11) prior to shooting, and each magazine is then attached and threaded into the camera as needed. A full range of negative and reversal film stocks is manufactured in 16mm.

Because of available film stocks, lenses and shutters, 16mm filming can be done with significantly less light than can super 8. There is also a greater selection of film stocks, equipment and accessories in 16mm. It is possible to shoot and edit the same piece of 16mm film (that is, to edit the original) to save money and time, or a workprint can be made to which the original can be easily matched in order to maintain high quality. A full range of optical effects and printing techniques is available in 16mm. To protect the original, multiple prints of 16mm films are usually made from an *intermediate*, which is a copy of the original film.

Films can be easily made in 16mm by a two- or three-person crew and even by an adroit, lone filmmaker, but somewhat larger crews are the norm. To shoot ten minutes of color film and then edit the original (without sound track) costs about two or three times as much in 16mm as in super 8.

Films in 16mm are distributed to schools, institutions and industry, and are broadcast over television. A few commercial theaters show films in 16mm, but more commonly 16mm films are blown up to 35mm for theatrical distribution. When this is anticipated, films may be shot in super 16, which, like super 8, records on a larger image area than the standard format (see Fig. 14-6). The super 16 image extends to the edge of the film,

which is normally reserved for the sound track on a 16mm print. For this reason, films shot in super 16 cannot be distributed in 16mm without cropping out some of the image.

35mm

The standard format of feature films, as well as television commercials and TV movies not shot on video tape, is 35mm. Films made to be shown in the large, first-run theaters are often shot in 65mm and are later reduced to 35mm for subsequent distribution. Conventional 35mm cameras are extremely heavy, cumbersome and expensive, costing in the tens of thousands. These cameras are usually supported on tripods because of

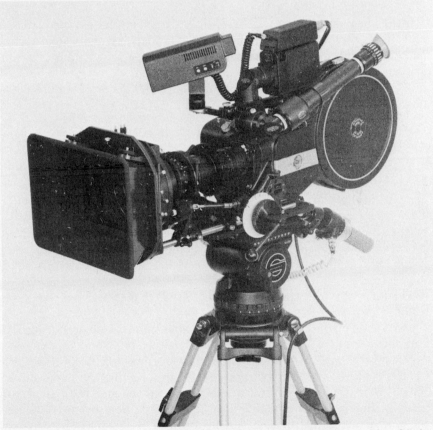

FIG. 1-9. 35mm Arriflex BL with a 400′ magazine. Although capable of being handheld, it is shown here set up for studio work with matte box, follow focus device and long viewfinder. The box directly on top of the camera next to the viewfinder is a video tap. (Arriflex Corp. of America)

both their bulk and the importance of having a steady image on a large theater screen. The newer generation of lighter, handheld 35mm cameras and stabilization devices, such as Steadicam and Panaglide (which enable the operator to carry the camera smoothly, see Fig. 6-10), provide greater mobility and allow 16mm filming techniques to be used in feature films. Steadicams are also used in 16mm and video production.

In general, the highest-quality equipment, techniques and lab services are available for 35mm production, for which film budgets usually run in the millions. Due to the sheer bulk of the equipment and the complexity of films undertaken in 35mm, crews of about eight to more than 100 persons are employed.

Motion Picture Sound

Most films have sound tracks; even in the silent film era at the beginning of this century, films were intended to be shown with musical accompaniment. Today, sound films can easily be made by amateurs working at home with super 8 equipment. The choice of sound recording techniques affects both the method of making the film and the nature of the finished product.

Single System Sound

The simplest type of film sound recording is *single system*, which involves recording sound directly on the film in the camera. Single system cameras accept film that has a magnetic stripe running along one edge. The camera exposes the image in the normal way while simultaneously a magnetic head records sound on the film's magnetic stripe. The recording process is much the same as that in a home tape recorder. This method of filming is called single system because the same strand of material is used to record both sound and image; in *double system*, a separate tape recorder is used to record sound. Single system cameras are sometimes called *sound-on-film* cameras.

Most people who shoot with single system cameras do so because the equipment is quick and easy to handle. Single system sound is extremely popular with super 8 filmmakers, and, before portable color video was developed, it was used extensively in 16mm for gathering news stories. Single system equipment can be handled conveniently by one person. The microphone can be mounted on the camera, held by the filmmaker or, with minimal instructions, given to an interviewer or film subject. Single system is a simple and inexpensive way to film scenes that have dialogue or other sounds that must be precisely aligned with their corresponding picture.

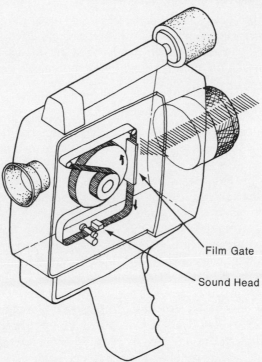

Film Gate

Sound Head

FIG. 1-10. Cutaway view of single system super 8 camera. The sound head is separated by eighteen frames from the film gate where the image is recorded.

The greatest difficulties with single system occur during editing. First, because sound and picture are on the same strand, the sound must be cut whenever the picture is. Second, all single system cameras have a separation between the area behind the lens where the image is exposed and the sound head where the sound is recorded. This separation is 18 frames in super 8, 28 frames in 16mm. Thus, the sound for anything filmed on super 8 film is found 18 frames ahead of the picture, creating several editing problems (see Chapter 12).

Another drawback to single system is that it is impractical for recording sound independently of picture (to record background sound, for example). It is also difficult in editing to combine picture on one piece of film with sound track taken from another. For these reasons, it is helpful to have a separate tape recorder on hand even when working primarily in single system.

Despite these inconveniences, single system filming is quite practical for films that do not require much editing or complicated sound work. Most of the editing difficulties can be avoided by transferring the sound to double system for editing; alternately, both picture and sound can be transferred to video tape.

Many super 8 projectors are capable of recording sound on more than one channel, which allows music, narration or sound effects to be added to an existing sound track. The projector often plays an integral role in the creation of the sound track for single system films.

Double System Sound

Some super 8 films and most 16mm and 35mm films are made in *double system*, that is, with the use of a separate tape recorder. Working in double system requires more gear but it allows a great deal of versatility and control over the filmmaking process.

Before easily portable recording equipment became available, most sound films were made in the studio under controlled conditions. The *sound stage* was acoustically isolated from distracting noises, and the bulky recording equipment was permanently mounted in place. When it was necessary to film on location, no attempt was usually made to record a quality sound track. Instead, the film would be *looped* afterward in the sound studio. This involves cutting the scenes into short, endless loops that the actors watch while respeaking their lines. This technique, also called *postsynchronized dubbing* or, simply, *dubbing*, is still used today, usually as a remedy for sound that was badly recorded on location or when the dialogue is to be redone in another language.

In the 1950s, advances in magnetic tape recorders made it practical to record the film sound track on location. Today, lightweight reel-to-reel recorders with ¼" wide tape are the most commonly used for film work, although audio cassette recorders are being used increasingly by amateurs and some professionals.

Synchronous or *sync* (pronounced "sink") sound, also known as *lip sync*, matches the picture in the way you are used to hearing it: when the actor's lips move on the screen, the words are heard simultaneously. Nonsynchronous or *wild sound* is not *in sync*, or matched to the picture, in this way. Many films use wild sound exclusively, such as travelogue films that have only narration and a musical background. Wild sound can be recorded with any tape recorder and then transferred to the proper material for editing (see below).

Because synchronous sound requires the precise alignment of sound and picture, only cameras and recorders equipped for sync-sound work can be used. No matter how high its quality, non-sync equipment only approximates its proper speed; a typical non-sync camera rated for 24 fps may vary between 23 and 25 fps. If the speed of the camera were to vary from that of the tape recorder, even if the projector and the tape playback machine are started together, the picture of the lips moving on screen might come before or after the sound of the words. The sound is then *out of sync* with the picture.

Sync sound is easy to achieve in single system recording because both sound and picture are recorded on the same piece of material and are thus always in sync. With double system equipment, special techniques must be used to maintain synchronization. One method, *crystal sync*, employs crystal oscillators within the camera and recorder to control their speeds accurately. An older, less expensive method called *cable sync* uses a wire that runs between camera and recorder.

Double system recording has a number of advantages over single system. First, the sound recorders used are generally of better quality than the sound systems found in single system cameras. The sound recordist has much more freedom to place the microphone in an optional position with crystal sync since there is no cable between microphone and camera; with single system cameras, the attached microphone is often too far from the sound source to make good recordings.

DOUBLE SYSTEM EDITING. Another important advantage of double system is the flexibility it provides the film editor. Double system editing allows the sound and picture to be cut and positioned independently; this freedom is essential for exploiting the film medium to its fullest.

Before editing, double system sound is re-recorded, or *transferred*, from the original ¼" tape or cassette tape to magnetic film. Magnetic film has the same dimensions and sprocket holes of super 8, 16mm or 35mm picture film, but it is brown or black in color and has the magnetic oxide like that used in sound recording tape. Double system editing is then done with two strands of material (picture and sound) that are both sprocketed and can be placed in frame-for-frame correspondence. The original sound tapes can be stored safely and can remain undamaged during editing. Additional transfers can be made as needed.

During the editing of double system material, sound and picture can be freely combined. Many films made in double system are edited with several sound tracks to accompany the picture. The use of multiple tracks allows music, narration and sound effects to be added to the sync sound. Sometimes these tracks are built up one at a time after the picture is cut, and sometimes editors use multitrack editing machines that can play two or three tracks in sync with the picture; this permits the editor to use multiple strands of sync sound as an integral element in the cutting of the film.

After the editing is complete, a *sound mix* is done to re-record all the various sound tracks onto one final track. Sometimes filmmakers edit films with ¼" tape instead of magnetic film, but this does not permit synchronous positioning of the picture with sound. Some ¼" tape recorders can record several tracks on a single piece of tape, which can then be played back together without a complicated sound mix.

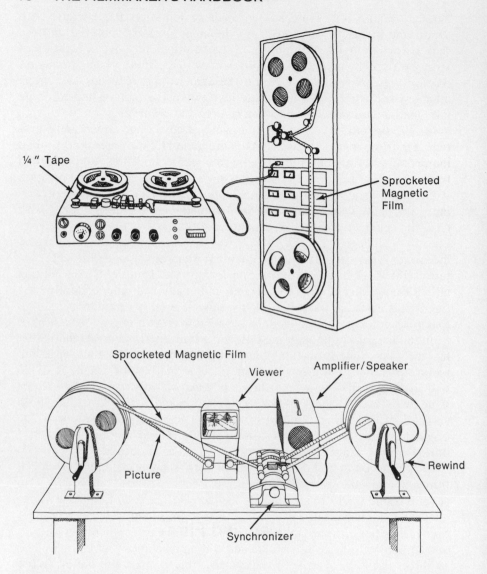

FIG. 1-11. (i) Sound is usually recorded with a ¼″ tape recorder and then transferred to sprocketed magnetic film. (ii) It can then be edited with the picture in frame-for-frame correspondence.

Film Prints and Sound Tracks

Films shot in single system are often projected in the original with no print (copy) made. These films may be shown on any sound projector equipped to handle the magnetic stripe along the edge of the film. Mag-

netic sound projectors are much more commonly found in super 8 than they are in 16mm.

Double system films have separate sound tracks that must be played in sync with the picture. This may be done with a double system projector that accommodates the super 8 or 16mm picture on one side and the appropriate magnetic film on the other (see Fig. 15-1). Alternately, the film can be shown in a studio equipped to *interlock* the projector with a *dubber* that plays the magnetic film sound track. Double system projection provides excellent sound reproduction but is awkward and often impractical, and it is more convenient to make a print that has a sound track on it.

There are many other advantages to making prints rather than to showing a film in the original. One is that projectors are famous for scratching and damaging film, a heartbreaking prospect when the original is involved. If a film is to be shown a great deal or sent via mail to various locations, it is far too risky not to have an insurance copy. Also, when a print is made, the lab can correct the brightness and color rendition of individual shots and groups of shots can be balanced together. In 16mm, one common method of printing makes the splices that join pieces of film together invisible.

Super 8 and 16mm prints can be made with a magnetic sound track that is essentially the same as the magnetic stripe used for single system camera films. In 16mm and 35mm, it is far more common to print a film with an *optical track,* a band of wavy lines that is reproduced as sound by a photocell within the projector (see Fig. 12-9). Magnetic stripe prints produce better-quality sound but are harder to show in 16mm due to the scarcity of magnetic sound projectors. Optical tracks are cheaper if several prints are to be made but produce a noisier and lower-fidelity sound track. Prints made with sound tracks are known as *composite* or *married* prints.

Video and Film

Much of what has traditionally been the domain of the filmmaker is rapidly being taken over by the video maker. Video is playing an increasingly important role in all facets of movie making, and it is conceivable that it will eventually make film obsolete, at least in many of its current applications. The main difference between video and film cameras is that video uses no photographic emulsions. Inside the video camera, the lens focuses the image on a tube that converts the image into an electrical signal. This signal is then recorded on tape similar to that used by a typical audio tape recorder.

The image of the video camera can be seen "live," and it can be recorded and played back on the video tape recorder (VTR) immediately

without the developing needed with film. Furthermore, as the signal passes from camera to recorder, or from one VTR to another, it can be altered and manipulated in many ways: the color and contrast of the image can be changed, a special effects generator can combine several images or distort the size and shape of the picture, the image can be frozen or replayed at varying speeds. Television viewers are familiar with the dazzling array of computer-generated effects that can be done with the video image.

Video has almost entirely replaced film in areas like television news reporting (where it is called *electronic news gathering* or *ENG*). It is perfectly suited to recording fast-breaking events and replaying them immediately on television, via satellite if necessary. Similarly, events and performances that need to be covered with several cameras simultaneously are often best served by video tape.

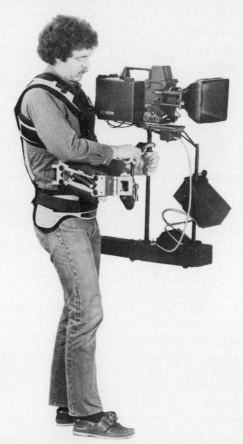

FIG. 1-12. Ikegami EC-35 video camera mounted on a Steadicam camera support. (Cinema Products)

FIG. 1-13. Videola film-to-tape transfer machine. This double system model is shown with 35mm picture (rear) and magnetic film (front). (MagnaSync/Moviola)

Another advantage of video over film is that tape is much cheaper than film and is reuseable. Like film, video tape comes in several gauges that differ in the quality of the image they reproduce: ½", ¾", 1" and 2" are the standards. A crude equivalence would parallel slow-speed ½" (used in home video cassette machines) with super 8 film; ¾" with 16mm; and high-speed ½", 1" and 2" with 35mm. Minute for minute, ¾" tape is about one-tenth the cost of processed 16mm color film.

As with computers, video technology is evolving so quickly that much of the equipment available today is likely to be significantly outdated in five years. To illustrate this point, the quality of color video recording that in 1975 could only be produced in studios with bulky, nonportable equipment could in 1982 be attained with handheld cameras that have built-in VTRs. High quality in video equipment is getting cheaper yearly, and flexibility is increasing equally fast. Computer editing, low-light cameras, user-recordable video discs and big-screen projection are changing the face of the video process.

Aside from video's applications as a production medium, it also offers useful techniques for making films. Many film cameras are equipped for *video taps*, which allow video recording and instant playback of the scene being filmed. This can save time in production and give the filmmakers a

much more precise idea of what they are getting on film. Transferring film footage to tape for editing purposes can often save time and trouble, especially in super 8 where making a workprint is not practical. Francis Coppola has said that video editing was invaluable in *Apocalypse Now* because it allowed him to preview all fade-ins, fade-outs and double-exposed images. Such effects in film are normally only viewable after the lab has printed the edited film.

As film costs rise, video distribution may be the only practical route for many films. The cost of materials for a 60-minute film print is a few hundred dollars; the same length of tape costs about $60. Many expect that video discs will make movies as consumable as LP records; an edition of 2000 disc copies of a 20-minute film can be produced for a few dollars each. And, in addition, video discs, unlike film prints, do not fade with age.

At the present time, film often serves as the original medium for video tapes and television. 35mm is often used for television movies and commercials because it offers sharpness and color reproduction, as well as certain production methods, not currently available in video. At the other end of the scale, super 8 can be an excellent means of producing low-cost color video. This exploits the greatest advantages of super 8—its light-weight and easy-to-use cameras and wide range of film stocks—to supply a picture that is sharper and can be taken in less light than that made by inexpensive video cameras. Video editing and distribution of super 8 films avoid many of the limitations of this format.

Video in its current state has disadvantages with respect to film. Portable film equipment is lighter, works in less light and produces much sharper images than comparable, portable video gear. Sophisticated video equipment is more expensive, takes more training to maintain in the field and is more prone to breakdown than the relatively tried-and-true film technology. Video is not well suited to the great brightness range found outdoors on a sunny day. On some television shows, the interiors (indoor scenes) are shot on tape and the exteriors on film. Many people do not like the hard-edged look of the video picture and prefer the subtle shading of the film image. These drawbacks of video are improving with time.

In addition to technical considerations are the aesthetic ones. The cultural associations we have with video are radically different from those of film. For years, the majority of material seen on television has been television programming that is usually very different from the features, documentaries and other films seen in theaters. In the future, big-screen video projection may make video more suitable for presentation in theaters, but currently it cannot approach film's sharpness and tonal range. By the time high-definition video approaches film quality, it is likely that the convenience of cable television and cassettes and discs will significantly diminish the importance of theatrical distribution.

2
The Motion Picture Camera

Components of the Camera

An Overview of the Camera

The motion picture camera has the following components:

1. The film chamber: a light-tight compartment which holds the film before and after exposure.
2. The drive mechanism: supplies the power to run the film past the lens for exposure.
3. The film gate and claw: The claw pulls down the film for exposure and holds it steady in the film gate during exposure.
4. The shutter: blocks light from the film when it is moving between successive exposures.
5. The viewfinder: allows the filmmaker to know what image is being recorded on the film.
6. The lens mount: allows lenses to be attached to the camera.

The unexposed raw stock is loaded into the camera from the *supply* or *feed reel*. The film passes behind the lens for exposure and is spooled on the *take-up reel*. Cartridge-loaded film (super 8 and some older 16mm systems) have the supply and take-up reels inside the cartridge.

The Film Gate

In the *film gate*, the raw stock is exposed to light passing through the lens. The gate is composed of two plates that sandwich the film. The plate between the lens and the film is the *aperture plate*. The *aperture* itself is a rectangle cut out of the aperture plate through which light from the lens shines. The aperture's edges define the border of the image on the film. The base of the film rests on the other half of the gate, the *pressure plate*, which holds the film flat during exposure. Super 8 cartridges and some

21

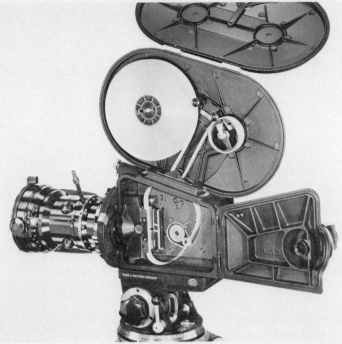

FIG. 2-1. Arriflex 16mm BL. The film chamber door and magazine lid are open to reveal the film path. The feed roll is 400′ of core-loaded film. The pressure plate is open to show the film gate. The camera has a mirror shutter for reflex viewing. (Arriflex Corp. of America)

FIG. 2-2. Simplified camera.

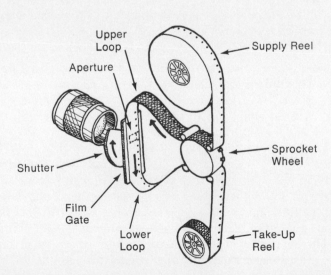

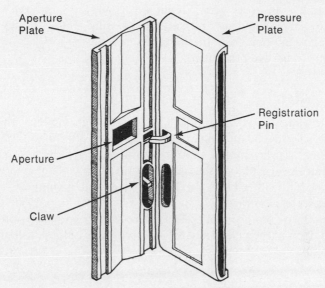

Aperture
Plate

Pressure
Plate

Registration
Pin

Aperture

Claw

FIG. 2-3. Film gate with open pressure plate. Only some of the more expensive cameras have registration pins.

quick-change magazines (see p. 44) have a built-in pressure plate that is not part of the camera's body.

THE CLAW. Most cameras and projectors have a *claw* or *shuttle* that advances the film frame by frame in the gate. The claw engages a perforation near the aperture and pulls the film forward one frame *(the pulldown)*. It also holds the frame steady while it is exposed. After exposure, the claw engages the next frame and pulls it down (see Fig. 1-2).

Some of the more expensive cameras, like the Arriflex SR, have a *registration pin* that increases steadiness of the image during exposure. The pin enters a perforation while the film is stopped in the gate and holds it steady for exposure.

THE INTERMITTENT. The film is fed and taken up continuously, but it must be stationary in the gate during exposure. The claw is on an *intermittent* (that is, a noncontinuous stop-start) movement that allows the film alternately to stop in front of the camera aperture and then to move on. Since some of the film is moving continuously (the supply and take-up reels) and some intermittently (the film in the gate), slack must be provided to prevent the film from tearing. On most cameras and projectors, *loops* are formed between the sprocket wheel, which drives the film, and the film gate to supply the needed slack.

Loops must be accurately formed. If they are too small, they will not provide adequate slack and the film may tear or chatter. When a camera

jams, it usually "loses its loop." If the loops are too large, they may rub against the camera housing and scratch the film. Some 16mm Bolexes and the Canon Scoopic form their own loops automatically. The loops in a super 8 cartridge are preformed.

The Shutter

After the film is exposed to light coming through the lens, the shutter must close to prevent the light from hitting the film. The film must be completely at rest before the shutter opens again for the next exposure. If the shutter does not block the light from the film when it is moving, the image on the film will be blurred. The simplest kind of shutter is a rotating disc with a section removed.

A circle may be represented by 360°. The *shutter opening* is the number of degrees open in the disc. The 180° shutter, a half-moon in shape, is the most common.

SHUTTER SPEED AND EXPOSURE. Exposure is determined by the intensity of the light that passes through the lens and the time or duration of exposure. The *reciprocity law* simply says: Exposure = intensity × time. Doubling exposure time is equivalent to doubling intensity. The halving and doubling of light intensity are measured in *stops* (see Chapter 3). Stopping down the lens one stop requires the doubling of the time of exposure to keep exposure constant.

Standard film speed is 24 frames per second (fps). A camera with a 180° shutter admits light to the film half the time (the disc is half open) so the exposure time (the *shutter speed*) is 1/24 × 1/2 = 1/48 second (rounded off to 1/50 second). At 24 fps, shutters with about 180° openings can be assumed to have a shutter speed of 1/50 second. The general formula for any shutter opening and camera speed is:

$$\frac{\text{Exposure time}}{\text{(shutter speed)}} = \frac{1}{\text{speed in fps}} \times \frac{\text{angle of shutter opening}}{360}$$

For shutter openings less than 180°, the shutter speed is faster than 1/50 second. For example, a 135° shutter at 24 fps yields a shutter speed of 1/24 × 135/360 = 1/64 (approximately 1/65 second).

In general, the longer the time of exposure, the better. Short exposures increase the possibility of strobing (see p. 25). The longer the time of exposure, the less light needed for proper exposure. Shutter speeds shorter than 1/60 second under fluorescent light may result in a pulsing or flickering of the image.

A shutter with precisely a 144° opening is sometimes used for filming a television image (see Chapter 15).

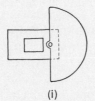

(i) (ii) (iii)

FIG. 2-4. Variable shutter. (i) A 180-degree shutter shown fully open. The small rectangle represents the aperture. (ii) An adjustable disc (shaded) swings out to form a 90-degree opening. (iii) The shutter is almost completely closed.

THE VARIABLE SHUTTER. On cameras equipped with a *variable shutter*, the shutter angle can be narrowed to change shutter speed. Some variable shutters may be shut down continuously, while others can only be shut down to certain angles.

Narrowing the angle reduces shutter speed. A 90° shutter, for example, gives a shutter speed of about 1/100 at 24 fps (using the above formula for shutter speed). Closing the shutter reduces the exposure, allowing high-speed film to be used outdoors or allowing the lens to be opened to decrease depth of field or shooting at a selected *f*-stop (see Chapter 3).

A variable shutter that can be closed down while the camera is running allows exposure changes in the middle of a shot. For example, when the camera moves from a sunlit to a shaded area within a shot, it is often necessary to change exposure. The iris diaphragm of the lens can be changed, but this would change the depth of field and may be more noticeable than shutting down the variable shutter. If the variable shutter can be shut down continuously to 0 degree with the camera running, in-camera fades and dissolves can be created (see p. 46).

STROBING OR SKIPPING. Decreasing the shutter angle makes the exposure for each frame shorter and freezes motion more effectively. The increased sharpness of each frame is advantageous for making still enlargements from movie frames and for motion analysis but often causes unwanted effects in the moving image. *Strobing* or *skipping* may occur when there is any camera or subject movement. If the movement is too fast, the eye is not able to integrate successive frames and the image seems to skip rather than move continuously, causing the viewer eye strain. Skipping most often appears in pans (see Chapter 6), especially pans across strong vertical lines. The higher the image contrast or greater the image sharpness, the more likely that strobing will occur. Fast shutter speeds also increase the likelihood of strobing. In general, it is safer not

to close down the shutter for exposure control if there is any camera or subject movement (see Chapter 6).

A phenomenon related to strobing, and frequently referred to by the same term, is often noticed when the wheels of a moving vehicle on the screen seem to be stopped or to be traveling in reverse. This occurs when the intermittent exposures happen to catch spokes at the same position in consecutive frames (thus, the wheels seem stopped) or catch them in a position that causes the wheels to appear to be spinning in reverse.

On cameras with a variable shutter, always check that the shutter is open before every day's shooting. If someone else has used the camera, the shutter opening may have been narrowed. Some cameras have devices to warn you that the shutter has been closed. On others, like the Eclair NPR, you must rotate the turret to check the position of the shutter.

The Lens Mount

Lenses are discussed fully in Chapter 3; it is the lens mount on the camera that defines the range of lenses that can be accepted. Most super 8 cameras (the Beaulieu is an exception) and a few 16mm cameras (for example, the Canon Scoopic) have permanently mounted zoom lenses. Although this prohibits the use of other lenses, it allows for an accurate and sturdy mount.

The *C mount* was at one time the most common 16mm lens mount. It is a simple screw mount that is not particularly strong nor designed for very close tolerances, and it is not desirable for zoom lenses, heavy lenses or very wide angle lenses (see Chapter 3). The Bolex Rx mount is a variant of the C mount that is specially designed to accommodate the change in back focus on the Bolex camera equipped with a behind-the-lens viewfinder prism. Prime lenses of less than 50mm and zoom lenses in Rx mount should only be used on these Bolexes and not on other cameras. The Arriflex standard mount is stronger, and the Arriflex steel bayonet mount is a further improvement. Lenses with the standard mount may be fitted on cameras with provisions for the bayonet mount, but not vice versa.

Many of the more recently designed 16mm cameras have their own mounts (for example, CP, Eclair and Aaton) as do many 35mm cameras (for example, Mitchell, Panavision).

LENS ADAPTORS. Most cameras will accept only one type of mount. Adaptors often fit incompatible mounts, but they make the lens' seating potentially less accurate. Lenses that require very accurate seating are liable to produce out-of-focus footage with a lens adaptor. Lenses of medium to long focal length generally may be used with adaptors with little worry. Adaptors allow most mounts to be fitted onto a camera that

accepts C mounts, but you cannot adapt a C mount to a camera that takes, for example, an Arri or Aaton mount. The Eclair NPR accepts lenses of two different mounts in its turret, usually the Eclair CA-1 and the C mount. The Eclair ACL accepts C mount lenses as well as almost any mount through a series of adaptors that are very sturdy since they screw into a large thread on the body of the camera. Adaptors allow 35mm still photography lenses to be mounted on some motion picture cameras.

THE LENS TURRET. Before the advent of high-quality zoom lenses, 16mm cameras often had turrets that would accept two or three lenses. The lens tube used for shooting, the *taking lens*, is rotated in front of the aperture, and a click or detent assures proper seating. You should take care that a wide-angle lens does not include in its field of view a long focal length lens mounted on the same turret. A divergent turret, like the one on the Arriflex S (see Fig. 2-5), permits you to mount a slightly greater range of lenses. When you rotate the turret, grasp the turret grips and never the lens. Although turrets are never as stable as single-lens mounts, the Arriflex S and Eclair NPR have very stable turrets.

FIG. 2-5. Arriflex 16S with three prime lenses on a divergent turret. The camera has reflex viewing with a mirror shutter, a registration pin and high-quality optics, but it is very noisy. This camera accepts 100′ internal loads (pictured) or an external magazine. (Arriflex Corp. of America)

Camera Weight and Noise

Weight and Balance

All super 8 cameras and some 16mm and 35mm cameras are light enough for handholding, but it is difficult to hold a camera steady unless part of its weight is supported by your body. A well-designed handle makes handheld shooting easier. Forehead braces and body braces can remove part of the strain from the arms. Heavier cameras—those that weigh 7 pounds or more—should either rest on your shoulder or on a body brace (see Fig. 6-9). Some of the newer designs, like the Aaton, are so well balanced that they need little leverage from the hands to keep them in proper position. The better-balanced cameras are much easier to hold steady for long periods. Shoulder-mounted cameras are sometimes held with both hands on the lens, letting one hand zoom and the other focus.

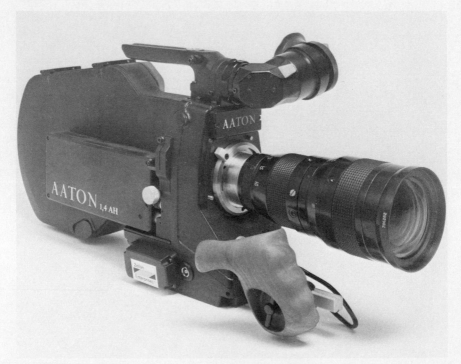

FIG. 2-6. Aaton 7 LTR 16mm camera with mirror shutter. It is exceptionally well balanced for handheld synchronous sound shooting, and easily converts to super 16. Shown here with zoom lens, "on-board" battery and pistol grip. (Zellan Enterprises)

If you plan to do handheld shooting, first try holding the camera for an hour or more to discover if the camera is comfortable for you. Since you may end up holding the camera on your shoulder for the better part of a day's shoot, slight differences in its weight and balance will make a great difference in steadiness. (See Chapter 6 for further discussion on hand-held shooting.)

Camera Noise

Cameras not designed for synchronous sound are often quite noisy. Sometimes a blimp or barney (see below) is used to make them quieter. Camera noise can cause problems, even when you are filming without sound. Noise calls attention to the operation of the camera and can disrupt subjects: sometimes actors lose their concentration; *candid shooting* (that is, when the subject is unaware of being filmed) becomes difficult and animals' behavior may be altered when doing nature cinematography.

SELF-BLIMPED CAMERAS. Super 8 cameras, though they may be intended for sound, are generally fairly noisy, but there are significant differences between models. Cameras quiet enough not to cause an appreciable amount of camera noise on a sound track are called *self-blimped*.

Camera manufacturers often rate cameras intended for sync-sound shooting according to a measure expressed in decibels (dB) (see Chapter 7). Cameras in the low 30 dB range are usually considered adequate in 16mm for sync-sound. Some 16mm cameras are rated as low as 26 dB. But noise ratings have to be taken with a grain of salt. Some cameras over time become noisier while others become quieter; on some cameras most of the noise comes from the magazine, and a magazine barney (see below) may make an appreciable difference; slightly shrunk film chatters in some cameras more than in others; also, high frequency sounds may be more bothersome than low rumbly sounds.

Shooting outdoors or in noisier locations allows the use of a noisier camera. Since much of 35mm cinematography is done on a sound stage where there is virtually no background noise, standards for a quiet camera are more stringent; some are as quiet as 19 dB.

Camera Motors

The first cameras were cranked by hand. The camera operator would often hum a popular song of an appropriate tempo to approximate the filming speed. On modern cameras, either a spring-wound or electric motor drives the film through the camera and controls the rate at which the film moves.

Camera Speed or Frame Rate

Standard projection speed is 24 fps (frames per second). There are three principal exceptions: European TV is filmed at 25 fps for compatibility with the 50 Hz video signal; an old silent film standard in 16mm is 16 fps, and some super 8 work is done at 18 fps to conserve film. Except in those cases when 25 fps is called for, we would recommend filming at the standard sound speed of 24 fps if at all possible since it is the standard for sound and projection equipment.

When the camera speed (or frame rate) matches the projection speed, movement on the screen looks natural. When the camera speed increases, more frames are filmed each second. When this film is projected at the normal speed, action is slowed down (slow motion). Conversely, if you film at a slower speed, say 8 fps, and then project at normal speed, movement is sped up—in this case, three times as fast.

When you change camera speed, make an exposure compensation since the exposure time is different. Use the formula for shutter speed (see p. 24) for different camera speeds. In general, if you double the frame rate, you lose a stop of exposure.

SLOW MOTION. Slow motion is often used to analyze motion or even to call attention to motion itself. In Leni Riefenstahl's *Olympiad*, a film of the 1936 Olympics in Berlin, the movements of the athletes are broken down and extended in time with slow motion, letting the viewer's eye see things unobservable in real time. Televised sports events often show replays in slow motion to analyze plays or the athletes' movements.

Slow motion extends real time, sometimes giving an event more psychological weight. A character's death may occur in an instant, yet be the most important moment in a film. In countless films the protagonist's death is shown in slow motion, extending the time of death to give it greater emotional emphasis.

Speeds faster than 24 fps are used to minimize the effect of unwanted camera jiggle and vibration. When the camera is handheld or on a moving vehicle, faster camera speeds lengthen the distance between jerky or uneven movements and make the image seem steadier. Of course, any subject movement will also be in slow motion.

Standard cameras rarely go faster than 64 fps; for significantly faster speeds, use a high-speed camera (see p. 48).

UNDERCRANKING. When the film is shot at slower than normal speed, each frame is exposed for a greater length of time. For example, filming at 12 fps gives one stop more exposure than filming at 24 fps. Consequently, if the light level is too low for exposure at normal speed and

there is no movement in the scene, the camera can be *undercranked*, that is, run at a slower speed to get proper exposure. This technique is often used when filming cityscapes or large exteriors at night. Sometimes actors are asked to walk slower in such a shot so their movement will appear normal during projection. If there is camera movement during the shot, you should compensate for the slower camera speed and the consequent speeding up of motion. For example, if filming at 12 fps, execute a pan at half speed.

The sped-up motion of silent film comedy was, supposedly, the result of an unintentionally undercranked camera on a Max Sennett set. If you will project at 24 fps, film at about 16 to 20 fps for this effect. Also, chase sequences can be undercranked to make motion appear faster and more dangerous.

TIME-LAPSE. With significantly slower speeds, time is proportionally sped up. In *time-lapse*, a flower can grow and blossom or a building can be demolished and another constructed in a few seconds (sometimes called *pixilation*). For very condensed time, use a camera that can make single-frame exposures. Many super 8 cameras have this option, but most 16mm cameras need an *animation motor*. When you expose single frames, check the instruction manual to find the shutter speed for calculating exposure.

An *intervalometer* allows the frame rate to be preset when you do time-lapse. Intervalometers vary from relatively simple devices built into various super 8 cameras that set a frame rate for a given time period to highly sophisticated devices that vary camera speed at set times, switch on lights, change exposure, activate a motor, turn on the coffee and signal a malfunction. Exposures may be programmed for a single frame or several frames at a given time interval or at varying intervals.

Spring-Wound Motors

Spring-wound motors are manually wound. Their chief disadvantage is the limited amount of film that can be shot on a take—about 30 seconds. Wind the spring after each shot. Usually these motors allow filming speeds from 8 to 64 fps. They may be operated at very low temperatures (sometimes lubrication must be changed) and are often used on Arctic expeditions. Since they are much less likely to produce a spark than an electric motor, they are safer in explosive environments.

Electric Motors

Electric motors can be used for takes the length of the film capacity; some may be used for sync-sound. Electric motors require a power supply, either batteries or some other source of electric power. There are

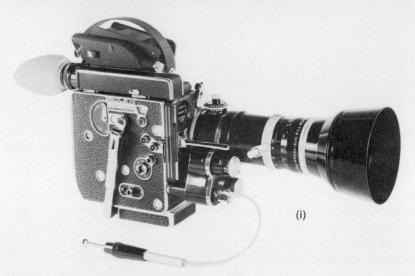

(i)

Fɪɢ. 2-7. (i) Bolex H16 Reflex 16mm camera. Beam-splitter reflex with nondi-vergent lens turret. Shown here with zoom lens and automatic exposure system. Spring-wound motor with 16½' run; capable of single-frame operation. This camera accepts 100' internal loads or an external magazine. It has a 135-degree variable shutter. (ii) Bolex H16 EBM 16mm camera. An electric motor runs the camera. Pictured here with accessory pistol grip and 400' detachable magazine, it also will take 100' internal loads. 170-degree fixed shutter. (Bolex)

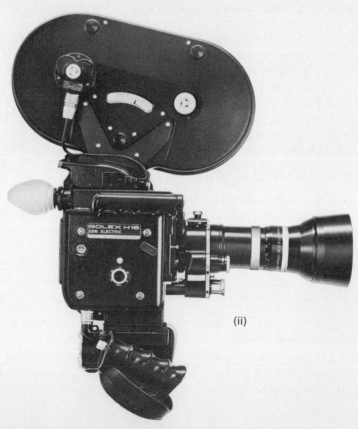

(ii)

four basic types of electric motors: animation motors, wild motors, governor motors and synchronous motors.

WILD MOTORS. *Wild motors* offer a selection of camera speeds, ranging from a few frames per second to as many as 64 fps or occasionally more. A rheostat controls voltage from the power supply, which in turn determines the approximate speed of the camera. Although speed is not accurate enough for sync-sound, it is adequate for filming without sound. Some wild motors can be run in reverse for reverse motion shots, for example, when spilled water appears to be sucked back into its container. This effect can also be achieved by shooting double perf film with the camera upside down. In the latter case, to reverse the motion, project the film tails out (that is, the last frame first).

GOVERNOR MOTORS. *Governor motors* are generally set at one speed, usually 24 fps, and keep to the rated speed in much the same way as a thermostat regulates temperature, slowing down when the speed is too fast, and speeding up when too slow. Most have a speed accuracy better than 1.5 percent (one and a half frames in a hundred). This allows sync-sound with an umbilical cord from camera to recorder, or single system sync. Motors designed for sync-sound are often quite silent.

SYNCHRONOUS MOTORS. This section should be read in conjunction with Chapter 7.

To shoot double-system synchronous sound without a cable, the motor must run at sound speed with an accuracy ideally better than one frame within a shot. A 10-minute shot has 14,000 frames, requiring an accuracy greater than one part in 14,000. A synchronous motor needs a signal to regulate its speed. An *AC synchronous motor* gets its signal from the 60 Hz (50 Hz in some countries) frequency generated by the power company and tapped off a typical wall outlet (called *the mains*). AC sync motors tend to be fairly large and heavy, and, if operated off house current, are not very mobile.

In the 1960s, small tuning forks like those used in some wrist watches were used to regulate sync motors. The more recently designed *crystal sync motors* are DC (direct current) motors controlled by a crystal oscillator. They are accurate to one part in 30,000 or better—about one frame accuracy in the longest possible take, that is, 1,200′ of 16mm film.

Crystal motors sometimes have a choice of 24 or 25 fps. In Europe where the AC frequency is 50 Hz and film is scanned for television at 25 fps, shoot footage for television at 25 fps. The tape recorder must also be set for the 50 Hz standard.

Some crystal motors allow for a variety of camera speeds, usually a range of about 8 to 64 fps. When these speeds are controlled by the crystal, they are accurate enough for various types of scientific work.

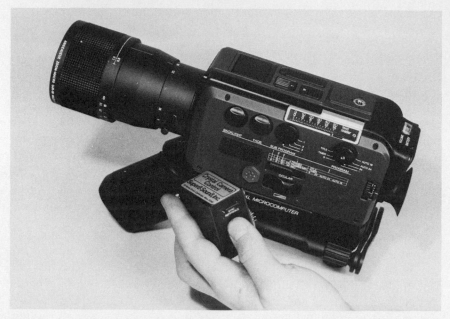

Fig. 2-8. A detachable crystal sync module shown with Bauer super 8 camera. (Super 8 Sound)

Speed Indicators

On some cameras a tachometer measures camera speed. This is fine for governor and wild motors, but is not accurate enough for synchronous motors. Crystal sync cameras often have a warning light to indicate when the camera is running out of sync.

On non-sync cameras that have dial settings for selecting speed, the dial may become miscalibrated and the camera speed may not be close enough even for silent filming. Check the speed with a stop watch and a measured amount of waste film. Sometimes intermediate adjustments between markings can be made for miscalibrated speed settings. Check sync speed accuracy with a strobe light designed for checking camera speed or use an oscilloscope.

Power Supplies

As previously stated, electric motors require a power supply, and synchronous motors may be run off the mains. When you use an electric outlet, it is essential to check the label on the motor for its power requirements. Different countries have different types of electric power. The mains may supply alternating or direct current, voltage may be 120 or

240 volts and the line frequency may be 50 or 60 Hz. Incompatibility of motor and electric supply may result in motor damage, uneven camera speed or loss of sync (see Electric Power, Chapter 9).

Most super 8 cameras and some 16mm cameras have a battery compartment in their handle or body. The batteries are either rechargeable or disposable dry cells. On some cameras, the battery pack attaches with a cable, while others have "on-board" batteries that attach directly to the camera. Find out how much film the batteries can run and always have spares. Rechargeable nickel-cadmium (Ni-Cad), on-board batteries usually run four to five 400' 16mm magazines. Some chargers take as long as 16 hours to recharge a battery, while quick-chargers take about an hour.

Sometimes the rated output from a battery is not obtained because the battery is old or because the camera jams and uses additional power. Cold weather reduces battery capacity significantly. Keep the battery warm by storing it in a pocket until ready for shooting. Some cameras with built-in battery compartments have dummy batteries with a cable that allows the battery itself to be kept in a pocket while filming.

Nickel-cadmium batteries are the most popular portable, rechargeable batteries. They are fairly light, compact and reliable over their 5-year life-expectancy. Check the charger for proper line voltage. Some chargers allow overcharging without serious harm to the battery while others must be turned off when the battery is fully charged. To preserve battery life, avoid excessive charging and over-discharging.

Battery belts with significantly larger capacity are available in voltages appropriate to most cameras. Expedition belts will run as much as 13,000' of 16mm footage on one charge, or solar chargers with conventional battery packs can be used on expeditions. Car batteries can be used to power a camera's motor, but, although they supply a great deal of power, are too heavy to use with a mobile camera. Maintenance-free, sealed batteries are preferable to batteries that have caps on top, for these may leak acid when tipped and need constant attention to the electrolyte level. Batteries may be wired *in series* (the positive terminal of one battery wired to the negative terminal of the next battery) to increase voltage. Batteries wired in series produce voltage equal to the sum of the individual batteries. Ten 12 volt batteries wired in series produce the voltage needed to power a 120 volt DC motor. Batteries wired *in parallel* (positive to positive terminals and negative to negative terminals) keep the same voltage as the individual batteries but increase capacity so that equipment can be run for a longer period.

Check batteries often to determine reserve capacity. However, Ni-cad batteries maintain a fairly constant voltage during discharge and then drop off sharply, so battery checks generally do not give much prior warning of low charge. As voltage drops, wild motors run progressively slower, whereas most governor and sync motors stay at the rated speed until an unsatisfactorily low voltage is reached and then run erratically.

Reflex Viewing Systems

Reflex cameras have through-the-lens viewing; *nonreflex* cameras employ other methods for composing and focusing.

The Reflex Viewfinder

The oldest style of reflex system was found in 35mm where the camera operator, his head covered by a dark cloth, viewed a dim image through the back of the film. The introduction of anti-halation backing (see Chapter 4) made the film opaque and this system obsolete. Modern reflex cameras divert light coming through the lens to a viewfinder. An image is formed on a viewfinder screen usually made of *ground glass* (that is, glass ground on one side) so that a focusable image can be projected onto it and viewed from the other side by the camera operator.

A plain glass screen in place of a ground glass screen provides an *aerial image* which is brighter but, except in some circumstances, is only used for composing and *not* for focusing. Aerial image systems generally have a focusing ground glass disc or a *range finder* in the center of the viewfinder screen. Super 8 cameras are often equipped with range finder focusing. Range finders are usually *split image* or *microprism:* in the former, you can focus by aligning the two parts of the image; in the latter, focus by making the texture of the microprism disappear. Center focusing on a disc has its drawbacks. Unlike a full ground glass screen, the viewfinder gives no impression of the depth of field (see Chapter 3). Also, your point of focus may not be in the center of the frame, which is especially awkward when pulling focus in the middle of the shot.

Newer camera models often have a *fiber optics screen* instead of a ground glass one. Fiber optics are bundles of glass fibers that transmit light from one end to the other. Fiber optics viewfinders are brighter than ground glass viewfinders, especially noticeable when the lens is stopped down; whereas the ground glass tends to blacken out, the fiber optics image remains relatively bright. Fiber optics viewfinders on a flexible cable allow remote viewing, even around corners. If possible, use such a viewfinder when the camera is inaccessibly placed (for example, on the hood of a car) or use a video tap.

Most viewfinders are marked for the standard *projector aperture,* which is a slightly smaller frame than the *camera aperture,* the frame that is actually recorded on film. The difference between the two is significant only in very detailed work. Some viewfinders display a *safe viewing area* that is larger than the projector aperture and provides advance warning when objects, such as the microphone boom, are about to enter the frame. Many finders are etched for a few different formats. For example,

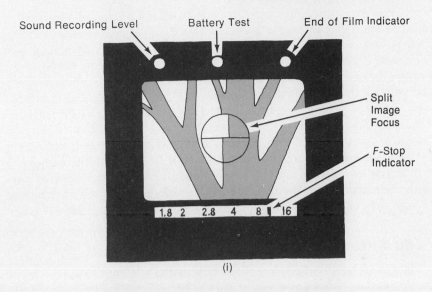

Sound Recording Level Battery Test End of Film Indicator

Split
Image
Focus

F-Stop
Indicator

1.8 2 2.8 4 8 | 16

(i)

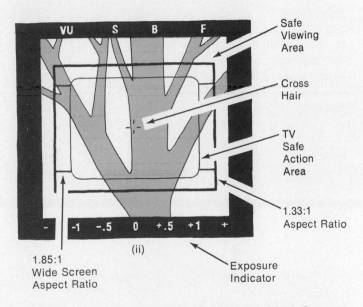

VU S B F

Safe
Viewing
Area

Cross
Hair

TV
Safe
Action
Area

1.33:1
Aspect Ratio

− −1 −.5 0 +.5 +1 +

(ii)

1.85:1
Wide Screen
Aspect Ratio

Exposure
Indicator

FIG. 2-9. Viewfinder screens. (i) An aerial image typical of super 8 reflex cameras. The split image range finder here shows that the image is out of focus. (ii) A ground glass typical of 16mm cameras. Note the safe viewing area. Viewfinders sometimes have indicators for lens aperture, overexposure or underexposure, sound recording level, out-of-sync warning and end-of-film warning. On some 35mm cameras, the viewfinder includes a magnification system to enlarge the center of the frame for critical focusing, contrast viewing filters and a lens to "unsqueeze" an anamorphic image.

since television transmission usually cuts off the edges of the original image, some viewfinders are etched with a *TV safe action area* (see Fig. 2-9). If you plan to blow up 16mm footage to 35mm wide screen (see Chapter 14), use a viewfinder marked with wide-screen proportions. Frames for different formats are often nested within each other, so shots can be composed from the center out, thus guaranteeing that important information is visible in each format. However, placing essential information in the center of the screen often leads to dull composition; you may want to compose from the edges in and scan the image (see Chapter 14) when changing from one aspect ratio to another. On some cameras it is relatively easy to change the viewfinder screen. This is especially convenient when different productions call for different formats, since having several lines on the viewfinder makes composing more difficult.

The Mirror Shutter

Light may be diverted from the lens to the viewfinder screen by a *mirror shutter*. The mirror, either part of the shutter itself or rotating in synchronization with it, alternately allows all the light to hit the film, and then, when the shutter is closed, all the light to go to the viewfinder (see Fig. 2-10). When the camera is stopped, all the light is always available for the viewfinder; when it is running, the light goes to the viewfinder only half the time. During filming, the viewfinder image is thus only half as bright (and, on some designs, less than half). The viewfinder image also flickers. On better designed systems, the finder is brighter and the flicker less annoying.

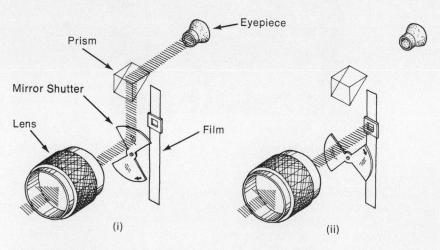

Fig. 2-10. Mirror shutter. (i) With the shutter closed, all the light is diverted to the viewfinder. (ii) With the shutter open, all the light strikes the film and exposes it. Compare with Figure 2-11.

One paradox of the mirror shutter is that you see an image in the viewfinder during nonexposure, but the viewfinder image blackens during exposure. In some situations this can be misleading. For example, if you are filming a TV receiver, a bar may not be visible in the viewfinder but may appear on the film (see Chapter 15). Similarly, if you are filming under strobe lights, for example, at a dance, the flashes you see in the viewfinder are exactly the ones that will not be photographed. Some strobing rates read well on film (for example, those around 10 to 15 flashes per second). If the rate is too slow, there may not be enough frames exposed; if the rate is too fast, too many frames will be exposed and the strobing effect may be lost.

Beam-Splitter Reflex

In an alternate design for reflex viewing, a partially reflecting mirror (*pellicule*) or a prism with a partially reflecting mirror (*beam-splitter*) in the light path diverts some of the light to the viewfinder, letting the balance hit the film (see Fig. 2-11). This system is used in most super 8 cameras. From one third of a stop to a full stop of light (depending on the camera) goes to the finder and does not contribute to exposing the film. This avoids flicker, but the exposure loss can be serious for low-light filming. If the prism is in the camera body, an exposure compensation for the light loss is usually made by altering the shutter speed used for exposure calculation. For example, some 16mm Bolex cameras have 135° shutters (1/65 second at 24 fps), but the Bolex manual suggests that an exposure compensation be made by using an "effective" shutter speed

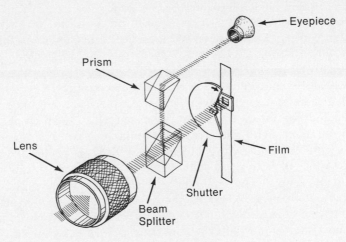

Fig. 2-11. Beam-splitter reflex. Some light is always diverted to the viewfinder, making it unavailable for exposing the film. The beam-splitter prism may be internal to a zoom lens or may be part of the camera.

of 1/80 second with your light meter. In super 8 cameras with built-in light meters, the exposure compensation is made automatically (see Chapter 5).

This same kind of split beam with an integral viewfinder is sometimes incorporated into a zoom lens to convert a nonreflex camera to one that has many of the focusing and framing capabilities of a reflex (see Fig. 7-15). In such lenses, the exposure compensation for light lost to the viewfinder is made by T-stop calibrations engraved on the iris diaphragm ring of the lens (see Chapter 3).

The viewfinder on beam-splitter systems tends to be darker than that on mirror reflex systems, making the use of a full ground glass difficult. Consequently, most beam-splitter systems use an aerial image with center focusing, as discussed above.

The advantage of the brighter focusing image of a mirror-reflex system so outweighs that system's disadvantages that, for the most part, the beam-splitter reflex is rarely found in new 16mm equipment. The price of used beam-splitter reflex zoom lenses and nonreflex cameras has subsequently dropped very low and good buys are available.

Reflex Viewfinder Placement

For tripod- or dolly-mounted cameras, you should use a viewfinder that extends to the back of the camera (see Fig. 3-10). For shoulder-mounted camera rigs, the ideal position of the viewfinder is close to the film plane (*zero finder*), since this generally allows the camera to be optimally balanced. Cameras used in both tripod and handheld work should ideally have interchangeable finders.

Some viewfinders swivel for viewing in awkward positions—for example, if you are kneeling on one knee with the camera on the other or if the camera is pointed backward over your shoulder. *Orientable finders* (also called *dovetail, erect image* or *periscope finders*) maintain an upright image even when the finder is rotated (see Figs. 2-6, 2-17).

Most camera designs favor right-eyed viewing, but some finders can extend out for left-eyed viewing. Test yourself to see if you favor one eye over the other. With both eyes open, point at an object. Then alternately close your left and right eye. The favored eye's vision will correspond best to that of both eyes. Although most people are "right-eyed," this group does not seem to comprise as large a majority as right-handed people do. Some left-eyed people have no difficulty viewing with their right eye. Try to cultivate viewing with your right eye since many viewfinding systems will only accommodate right-eyed viewing. Also, right-eyed viewing on most cameras permits a less restricted view of the surroundings. Documentary filmmakers often develop the ability to look through the viewfinder with the right eye, keeping the left eye open to see what is happening outside the frame.

The Diopter Adjustment

The viewfinder eyepiece on reflex cameras can correct for the camera-person's near or far sightedness. Make sure the *diopter adjustment* on the eyepiece is adjusted every time someone new uses the camera.

If your system has a ground glass, partial ground glass or fiber optics screen (most 16mm cameras), adjust the diopter as follows: Remove the lens or open the iris diaphragm on the lens. Point the camera at a bright area, like the sky or a bright wall. (If viewing through a lens, throw the image out of focus as much as possible.) Rotate the eyepiece diopter adjustment ring (on some finders it is a push–pull) until the grains of the ground glass (on fiber optics screens use the etched frame line) are as sharp as possible. If there is a locking device, lock the setting in place. The eyepiece is now adjusted.

On reflex cameras that have an aerial image in place of a ground glass (many Super 8 cameras), the diopter adjustment is more critical since you are calibrating the focusing system. To adjust this system: Zoom the lens out to the longest focal length, open the lens aperture wide and focus the lens at infinity. Find a distant object that you can focus on (like a building far away) and focus the eyepiece until the object is as sharp as possible. Lock the adjustment and the eyepiece is adjusted.

If you wear eyeglasses while shooting, adjust the diopter with your glasses on. Wearing eyeglasses during shooting makes it difficult, if not impossible, to see the whole viewfinder image. Adjusting the diopter for your eyes without glasses and then wearing the glasses when you are not viewing through the finder is preferable. If the camera's diopter adjustment is not strong enough to correct your eyesight, a correction lens can be mounted in the eyepiece.

THE EYEPIECE ON REFLEX VIEWFINDERS. The eyepiece often fogs up in very cold or humid weather. An anticondensation coating for the eyepiece can be purchased at sporting goods stores. Never apply it to the lens, because it will harm the lens coating.

To prevent stray light from entering the eyepiece, traveling through the reflex system in reverse and fogging the film, viewfinders have light traps that shut light off from the finder. During filming, your eye usually seals off stray light. When you are filming without looking through the viewfinder, close the light trap or place something against the eyepiece. This problem is most serious on beam-splitter systems, especially if there is a light source behind the camera. On some cameras, the light trap can be set so that it opens when you press your eye up against the eyepiece and closes when there is no pressure on the eyepiece.

The eyepiece is usually fitted with an eyecup that cushions the eye (or

eyeglasses) and helps seal out stray light. Eyepieces frequently get lost so you should have a spare. Foam eyepieces are generally more comfortable than rubber ones.

Nonreflex Viewing Systems

Some cameras have side viewfinders which have a separate lens from the one which records the image on film (see Fig. 2-12) and permit an inexpensive, sturdy design. Such viewfinders have some advantages over reflex systems since they are always bright, allow for easy tracking of fast movement and, unlike beam-splitters, do not divert light from the film. A major disadvantage, however, is that the side viewfinder does not display the same view as that seen by the camera lens since it is viewing the scene from a slightly different angle. To illustrate this: close one eye and point your finger toward an object (think of this eye as the camera lens). Now close that eye and open the other (think of this eye as the side viewfinder). Your finger is no longer pointing to the selected object. This difference in viewing is called *parallax error* (see Fig. 2-13); the closer the object, the greater the error. Side finders are often adjusted to swivel horizontally to approximate the lens' view when it is focused at a particular point. The viewfinder is still, however, looking at the scene from a slightly different angle, which could cause difficulties; for example, an object in the finder may appear to be directly behind something else but will not photograph that way.

Fig. 2-12. EMP 16mm. A tiny, nonreflex 16mm camera, weighing about 3 pounds. (Richter Cine Equipment)

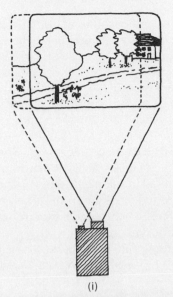
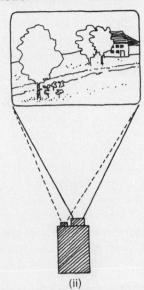

(i) (ii)

FIG. 2-13. Parallax. (i) The viewfinder and the lens "see" the scene differently, creating the parallax error. (ii) Parallax correction in the viewfinder adjusts the finder image so that it sees more or less what the lens does at the plane of focus. However, it does not allow close framing or lining up objects exactly. [Note how the trees cover more windows in (ii).]

Side viewfinders employ masks, engraved markings or small lenses to outline the dimensions of the frame. Use only corresponding focal length lenses with these finders. In general, it is not practical to use nonreflex zoom lenses or long focal length lenses with nonreflex finders.

Focusing is generally done by estimating the distance or using a tape measure, and setting the lens distance scale accordingly. Some cameras, like the Mitchell NC and BNC, have a *rackover mechanism* that allows a ground glass to occupy the camera aperture position when setting up a shot. On most cameras, a prism accessory can be placed in the gate for precise framing, but this is so unwieldy that it is normally only used for titles.

Camera Film Capacity

Magazines

Some cameras have an internal film capacity of 50 to 100′ while some cameras accept *magazines (mags)*, which are detachable film chambers (see Figs. 1-7 and 2-6). Super 8 magazines take 200′ cartridges (10 min-

utes of film at 24 fps). Magazines for 16mm come in 200′ and 1200′ sizes but are most often 400′ (runs almost 11 minutes). Magazines generally have core adaptors that attach to a spindle and allow the use of darkroom loads (see Fig. 2-1). Though most magazines will accept daylight spools of up to 400′, spools are heavier than darkroom loads and may scrape against the side of the magazine, creating an annoying noise. Have on hand spare cores or spools, and cans and black bags for *short ends* (the unshot portion of a partially filmed roll).

Nearly all raw stocks are supplied emulsion-in (see Fig. 4-12). Some magazines take up emulsion-in and others, emulsion-out. When film is taken up on a core (as it can be even if the feed is a daylight spool), attach it to the core, as shown in Figure 2-14. Wind the film around the core several times in the direction it takes up. Run several feet of film through the camera with the take-up cover off (only on magazines with separate supply and take-up compartments) to check that the film is taking up properly and not being scratched (see p. 52 for scratch test). See Chapter 4 for further discussion on loading film.

Mitchell mags have screw-in discs for covers. When the cover is difficult to unscrew, apply light but steady pressure with your palm to the middle of the cover to loosen it. If film scrapes against the cover, try unscrewing the cover one fourth to one half of a turn.

Quick-Change Magazines

Quick-change magazines have a built-in sprocket wheel and pressure plate so that most of the film threading takes place in the magazine.

FIG. 2-14. Attaching the film to take-up core. Fold the film over itself and insert it in the slot. Position the slot as illustrated—angled against the direction of the take-up to keep the film from slipping out. Rotate the core to wind up several turns of film. Some magazines take up emulsion face in and others face out.

Quick-change mags are bulkier, heavier and more expensive than the magazines that function merely as film chambers. These disadvantages may outweigh the ability to change magazines in a few seconds. On some shoots, however, fast mag changing can be invaluable—for example, in unscripted filming, where action is often unpredictable. The crew feels tense toward the end of a roll, concerned with whether to change film and discard the end of the roll or to wait to the end and possibly miss a key moment. When film can be changed in seconds, continuous shooting becomes possible, reducing concern and the need to measure. Even in scripted situations, actors must sometimes wait until film is loaded, losing perhaps their momentum or mood.

Care of Magazines

The magazine cover and the point where the magazine attaches to the camera are often sources of light leaks that may fog film. Taping the magazine with camera tape along the length of the lid insures against light leaks (see below for a light leak test).

Identify magazines by the type of stock loaded and, when mounted on the camera, the camera roll number. You can place the tape from the raw stock can on the magazine, both to keep track of it and to identify the raw stock. Write the film speed on the side of the magazine and whether it is to be force processed. At the end of the day's shooting, empty all the magazines and repack, tape and label all exposed and unexposed stock (see Chapter 4).

Keep the magazine clean to cut down on dirt in the gate and scratches on the film. If magazines are cleaned with compressed air, be careful not to blow dirt into cavities or delicate mechanisms. Keep the felt rollers clean. Clean felt linings with tape, sticky side out, wrapped around the finger.

Spare Magazines

Have at least one extra magazine. This lets you change magazines if one starts to squeak or has other problems. It also allows the next roll of film to be loaded beforehand, saving time at what might be a crucial moment. When you use two different raw stocks (for example, a high-speed film for interiors and a slow speed for exteriors) or two different exposure indexes for the same stock (for example, "normal" and "push one"), the extra magazine makes both immediately available.

Some documentary crews load up a lot of film at the beginning of a day's shoot so that they are able to do without a magazine changer and keep the crew size to a minimum. In two-person documentary film crews some spare magazines are carried by the sound recordist—usually two quick-change mags or three or four regular mags.

FIG. 2-15. EWA super 8 backwinder allows rewinding up to 270 frames for making dissolves and multiple exposures.(EWA)

In-Camera Effects

Some cameras, usually nonprofessional ones, can make in-camera effects, such as fades and dissolves. Few 16mm cameras (some Bolexes are an exception) have provisions for these effects since, in 16mm and 35mm, effects are generally created in the laboratory during the printing stage. Super 8 cartridges are somewhat difficult to rewind for dissolves or multiple images. Fuji's single 8 is packaged differently and allows for backwinding. Some super 8 cameras do have backwinding capabilities for dissolves and multiple images but are limited to certain lengths. Backwinders for super 8 cartridges may backwind the cartridge to greater lengths (see Fig. 2-15). Super 8 cartridges in 200′ lengths allow for unlimited backwinding.

You create multiple images by exposing the same section of film two *(double exposure)* or more times. Make sure you compensate for double exposure to avoid overexposure. The rule of thumb for this is to underexpose each image one stop. Be thoughtful, however, in applying this rule. If a light scene is to be double-exposed, it may have to be further underexposed (since it will bleach out a darker scene), whereas a dark scene is often exposed normally without any underexposure.

Do in-camera fades by closing down a variable shutter to 0 degrees. Merely stopping the lens iris down will generally not produce a totally black image, and the changing depth of field may be noticeable. Make dissolves by overlapping a fade-out with a fade-in. A frame counter in addition to a footage counter (see p. 47) is needed for dissolves, or for making any precise in-camera effect. Several super 8 cameras will do

fades and dissolves automatically at the touch of a button. The matte box is also used for some in-camera effects (see Chapter 3).

Other Features

Footage Counters

Some cameras give precise footage counts while others approximate footage. Sometimes a zero footage reset button is pushed when loading a new roll or a dial may have to be set to indicate the length of the loaded roll. On many super 8 cameras, the footage counter automatically resets to zero when the film compartment door is opened. On these cameras, write the footage numbers down before opening the door when checking the gate or changing film in the middle of a cartridge. Some magazines have indicators to signal the approximate amount of film left on the feed side. On Mitchell mags, you can judge the length of the remaining film by rotating the supply side pulley to feel its weight.

Camera Release Control

A cable release lets you start a tripod-mounted camera with minimum disturbance to the camera position or allows starting the camera from a remote spot. This can also be done with a toggle switch in the power supply cable.

It is most convenient to have the camera release switch on the back of the camera when you film from a tripod or dolly and on the camera handgrip when you shoot handheld. Some cameras have both options. Silent switches make the beginning of filming less obvious. A light flashes on the front of some cameras to signal to the subject that the camera is running (this is particularly useful for newscasters). You can put black tape over the light if you do not want your subjects to know when you are shooting.

Video Taps

A video system can tap into many cameras to give an immediate video image of what the camera is shooting. Cameras with *video taps* (*video assists*) divert some light from a reflex viewfinder to a video recorder or monitor. The video image is essentially the same image as the one that is exposed on the film, although the color, contrast and sharpness can be quite different. This system is extremely helpful in various filming situations. The director and actors can check takes immediately, deciding on which to print and which to retake. Viewing a monitor during a take can cue actors or technicians when to perform certain tasks. One frame can

be held in place while you set up the next shot that may relate to it. The monitor is also used to check camera movement and, to a certain extent, focus, lighting, and other technical concerns. It allows monitoring when the camera must be placed in an inaccessible or dangerous location.

High-Speed Cameras

As discussed earlier, to achieve a slow motion effect, the camera must run at a faster speed than normal. Some standard cameras run at speeds up to three times that of sound speed (that is, 72 fps), and, when equipped with a special high-speed motor, can run at 128 fps or faster. *High-speed cameras* with intermittent type movements can run up to around 400 fps. You must make an exposure compensation, when changing camera speed, if the camera does not do so automatically. Since the shutter speed is so fast, a fast stock and a lot of light are generally required.

Some high-speed cameras require specially ordered film: those with double pulldown claws require double-perf stock; some need high-speed pitch perfs (see Chapter 4); some require spool-wound film.

High-speed cameras are available in super 8, 16mm and 35mm; some cameras have a selection of speeds while others have two speeds (for example, 24 and 250 fps). Speeds higher than 250 fps are rarely needed in nonscientific filming. A camera speed of 250 fps stretches 1 second of real time into more than 10 seconds of film time.

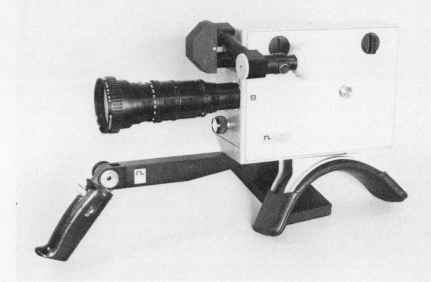

FIG. 2-16. Locam II high-speed reflex camera. Allows speeds up to 500 fps. Shown with a shoulder brace for handholding. (Redlake Corp.)

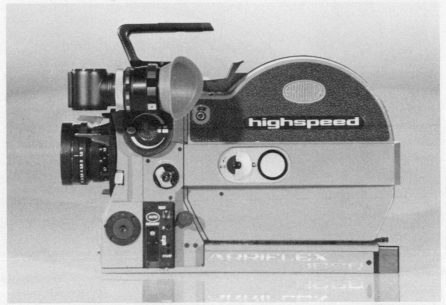

FIG. 2-17. Arriflex 16SR Highspeed. A similar SR is available for standard-speed operation. This camera is reflex, with quick-change magazines and on-board battery (not shown). (Arriflex Corp. of America)

Very high speed cameras do not use an intermittent movement. For speeds up to 10,000 fps, the film runs continuously and a rotating prism forms the individual frames. At 10,000 fps, 1 second of real time is stretched into 6½ minutes. Other methods permit speeds in the hundreds of thousands of frames per second. Very high speed cameras use quite a bit of film before reaching rated speed and the usable footage is only part of the load.

The Blimp and the Barney

Until the advent of sound, camera noise was not considered much of a problem. In the first sound pictures, the camera and the operator were in a soundproof room with a glass port. It was hot inside and the camera was immobile. The *blimp*—a soundproof camera housing that allows the camera operator access to all the controls from outside the housing (see Fig. 2-18)—was a major improvement. The Mitchell BNC ("B" for blimp), one of Hollywood's standard cameras, is a blimped version of the Mitchell NC. Although blimps are quite heavy, they are so effective that they can be used on a sound stage very close to the microphones without picking up camera noise.

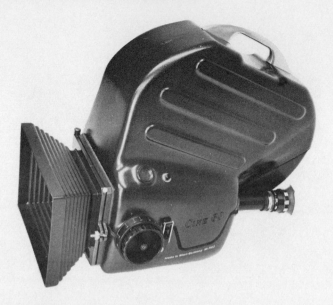

FIG. 2-18. Blimp. (Cine 60)

Originally the *barney* was a blanket draped over the camera to dampen the camera noise. Barneys are soft covers that now come in models customized for various cameras; many are made with lead foam. Some fit over the camera, allowing access to lens and camera controls from below, others only cover the magazine. A camera may be quiet enough to film in most environments but be too noisy in interiors that have little background noise. A barney may quiet it down sufficiently. Although barneys do not provide nearly as much sound isolation as a blimp, they do not impair camera mobility.

The *heater barney* (see Fig. 2-19) is a battery-operated camera cover that keeps the camera warm when filming in very cold weather. White barneys are sometimes used to reflect the heat of the sun and thus keep the film cooler in very hot weather. Underwater housings are available for cameras in all gauges for filming underwater or in very wet locations.

Camera Tests and Maintenance

Camera Tests

CHECKING THE GATE. Dirt or bits of emulsion often lodge in the camera aperture and are exposed as a shadow on the edge of the picture (''hairs in the gate''). Standard procedure on a set is to check the gate for hairs before every take. In many situations this is not possible, in which case

Fig. 2-19. Heater barney. (Birns & Sawyer)

you should check the gate often, at least once a roll. Remove quick-change mags with integral pressure plates and check the aperture at close range. Camera assistants often use a magnifying glass with a built-in light to get a better view of the aperture. Some cameras, mostly 35mm ones, have an easy-to-check, removable aperture. Removing the lens is often the best way to check the gate, especially if the camera is on a tripod.

Clean the aperture's edges with an orangewood stick, a flat wooden toothpick or a plastic toothpick. Never use metal. Blowing compressed air may damage parts of the shutter. Use cotton swabs only if the cotton is removed before cleaning.

Some camera gates are designed to minimize hairs in the gate, while other designs seem to encourage the problem. Obviously, these cameras need to be checked more often. Keep the changing bag and camera clean to prevent the problem at its source.

SCRATCH TEST. If possible, make a scratch test every time a new roll is loaded in the camera. Run a few feet of film through the camera, and remove the film from the take-up reel. Examine the footage for surface scratches by holding the film obliquely toward a light source. To locate the cause of a scratch, mark the frame in the aperture; unload the film; mark where the scratch begins; thread the film with the first marked frame in the aperture and note the location where the scratch begins.

TESTING VIEWFINDER ACCURACY. To check the accuracy of the view-finder, mount the camera on a tripod. Make a chart of numbered rectangles with the proper aspect ratio (usually 4:3 or 1.33:1) nested within one another. Carefully align the viewfinder with one of the rectangles, photograph and check for accuracy. The only discrepancy on a reflex finder should be between camera aperture and projector aperture.

TESTING RETICULE POSITION. Viewfinders like those on zoom lenses with auxiliary finders (see Fig. 7-15) have a mask or *reticule* that defines the outlines of the frame. To check for proper orientation, place the camera on a flat surface (like a solid table) and align the frame edge with the table edge. The two should be parallel. If they are not, adjust the reticule. On some zooms, it is a simple adjustment.

FRAME LINE TEST. The frame line in 16mm should bisect the perforations (see Fig. 1-3). To test a camera, fold a strip of exposed and developed film over itself, place pins through the perfs and check that the frame lines are perfectly in line with each other. The projector frame line adjustment can correct for a consistently misplaced frame line. Problems arise, however, when you use two different cameras (or purchase stock footage) with a dissimilar frame line.

REGISTRATION TEST. *Registration* refers to the steadiness of the image —the camera's ability to expose each frame in the same place relative to the sprocket holes. Bad registration causes image jiggle and the viewer eye strain. To check registration, mount the camera on a steady tripod and tape a lens' zoom ring so it does not move. With negative film, photograph a black cross or grid on a white wall; with reversal, shoot a

white cross on a black field. Wind the film back to the beginning; move the camera *slightly* and photograph the cross again. Moving the camera has put a small amount of space between the two images of the cross. On projection, the greater the movement of the crosses with respect to each other, the worse the registration.

Another test of registration is done by shifting the frame line adjustment during projection so the frame line can be seen. If the frame line seems to get thicker and thinner (to breathe), registration is poor. Any jiggle between the frame line and the edge of the screen is probably a measure of the registration of the projector.

LIGHT LEAK TEST. Light leaks show up on developed camera original as uneven fogging extending *outside* the picture area. Locate a light leak by loading the camera with unexposed raw stock and marking or exposing the frame in the aperture. Move a bright light source (held a few inches from the camera) around from every angle, develop the film and check for edge fogging. If edge fog is found, reload the footage, placing the marked frame in the aperture. Edge fog at any point locates the source of the light leak. Sometimes light leaks occur when film is improperly loaded or unloaded from the mag or camera.

OTHER TESTS. See Chapter 3 for lens focusing tests that may discover faults in the camera viewfinder or the adjustment of the lens mounting. Always check rushes for any defects (see Chapter 10) and immediately troubleshoot (search for the fault). An image with total vertical blurring is a sign of a lost loop in the camera. Partial vertical blurring is a sign of a shutter timing error; the frame has been exposed while moving. The whole image moving in and out of focus *(breathing in the gate)* usually calls for pressure plate adjustment. These last three problems can also be caused by a malfunctioning projector, which should also be checked. Investigate any image flicker or unevenness in exposure.

DEVELOPING SLOP TESTS. On location it is often helpful to do a quick test for focus, framing or light leak by exposing and developing a short length of stock and performing a *slop* or *dip test*. Use black-and-white developer with a small developing tank (or even a sink). Color stock can be used, but it is difficult to remove the anti-halation backing, making projection unsatisfactory. If you bring black-and-white stock for tests, use a one-bath developer. Although the quality is not adequate to test exposure, it will be adequate for many other tests.

Camera Quality

Accurate registration in a camera is a sign of good mechanical design, but it does not measure its sturdiness nor how well it will keep to its

original specifications. The quality of workmanship often determines whether a camera will become noisier with age or break down often, but reliability is also a question of design. Seek advice on specific cameras from filmmakers who have field tested the equipment and from camera rental houses.

Some cameras are easier to repair than others. Modular designs (with replaceable units) permit easy field repair.

Camera Care

Keep the camera clean. Do not blow compressed air into the aperture or places where dirt can become lodged. Never use metal to scrape emulsion from the gate. You can use alcohol on a cotton swab to remove emulsion deposits, but take care not to leave any cotton fibers. Acetone damages some plastics. Use magazine covers, lens socket caps, and body caps to keep dust out of camera openings.

Do not run a camera without film at speeds higher than 24 fps.

Hand carry a camera on a plane rather than checking it as baggage. When shipping, use special shipping cases, which are more rugged than camera carrying cases, and detach the lens before shipping. Place all delicate equipment in foam-lined and fitted cases. Secure the camera on a car seat rather than leave it loose on the car floor or in the trunk where it will be subject to more vibration.

When you use a battery belt connected to the camera by a cable, be careful not to rest the camera on a surface and walk away, pulling the camera along behind you. Use a coiled cable to minimize the risk. When you rest the camera on a table, do not let the lens extend over the edge where it may be hit by an unwary passerby.

Obtain the manufacturer's operation and maintenance manual for special information on oiling and overhaul instructions for your camera. Check whether any special lubrication is required for cold weather filming. Try to assemble a group of tools and spare parts for field repairs.

Typical Items in a Cinematographer's Ditty Bag

50′ measuring tape	Camera tape
Camel's hair brush	Tweezers
Compressed air in a can	Scissors
Lens tissue	6″ needlenose pliers
Lens cleaning fluid	6″ adjustable wrench
Orangewood sticks	Screwdrivers
Crocus cloth for removing burrs	Marking pen
Jeweler's screwdrivers	Grease pencil
Camera oil (only needed for some cameras)	Chalk
Set of Allen wrenches	Magnifying lens with light
Spare cores	Contrast viewing glass

3
The Lens

Characteristics of Lenses

The lens is the eye of the camera system. To choose lenses wisely and get the most out of them, it is important to understand the basic characteristics of lenses and the tradeoffs involved in lens construction.

Photographic lenses are generally made of several pieces of glass, called *elements*. Some of these elements are cemented together *(compound elements)* and then mounted in the lens *barrel*. The lens gathers light rays from the subject and bends the rays to form an image behind the lens.

Focal Length

If we take a light source at infinity—a star will work fine, but anything at a great distance may serve as "infinity"—the lens will focus the rays at a point behind the lens. This point falls on the *focal plane*, and the lens is said to bring the star into *focus* in the focal plane (see Fig. 3-1). The film normally rests in the focal plane when it is exposed.

The *focal length* measures the power of a lens to bend light rays coming from the subject. The shorter the focal length, the greater the bending power and the closer the focal plane is to the rear of the lens. The focal length of a lens is defined as the distance from the lens (actually, the *nodal point* of the lens) to the focal plane when the lens is focused on an object at infinity. Lenses are identified by their focal length (or, in the case of zoom lenses, by their range of focal lengths). Focal length is usually expressed in millimeters or, more rarely, in inches (1 inch is approximately 25mm).

For each shot, the cinematographer decides how large the subject should be in the frame. For example, should the shot include the whole body or should the face fill the frame? There are two ways to increase the size of an object in the frame: you can either move the camera closer to the object or select a lens of a longer focal length (see Fig. 3-2). If we

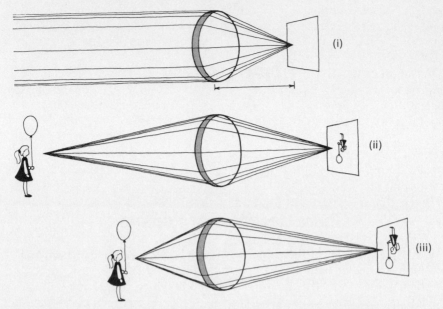

FIG. 3-1. Focal length. (i) The rays from a point light source at infinity are parallel when they strike the lens. The distance from the lens to the focal plane (where the rays are brought back to a point) is the *focal length*. (ii, iii) The closer an object is to the lens, the farther from the lens the rays converge and the larger the object appears on the film. The photographic lens forms an upside-down image flipped from left to right.

view a scene with two lenses, the lens with the longer focal length will reveal less of the scene and will make any object in its field of view appear larger. This lens "sees" the scene through a narrower angle—the longer the focal length, the narrower this angle.

Focal length is directly proportional to the size any object will appear on film. If we double the focal length (keeping the distance to the subject constant), the subject will appear twice as large on film. The size of the object is inversely proportional to its distance from the camera—that is, if we double the distance, we halve the size of the subject on film (see Fig. 3-3). At 10 feet, a 50mm lens yields the same size subject as a 25mm lens does at 5 feet.

Focal Length and Perspective

As discussed above, there are two ways to control the size of an object in the frame: change the distance of camera to subject or alter the focal length. Does it make a difference if you move the camera closer to the subject rather than use a lens of a longer focal length? Figure 3-3 illustrates that it does. When you change focal lengths to enlarge part of a

scene, it is like enlarging a detail from the image. Both foreground and background objects become larger to the same relative degree. In other words, if the focal length is doubled, all the objects in the frame double in size on film.

On the other hand, as the camera is moved closer, the relative size of foreground and background objects increase at different rates. Objects closer to the camera become larger faster than objects farther from the camera. In the first set of photographs in Figure 3-3, the camera is moved closer to the subject. The building in the background does not increase in size nearly as much as the man in the foreground. If you move twice as close to an object, the object doubles in size on film, but objects in the background increase less than half in size.

Perspective may be thought of as the rate at which objects become smaller the farther they are from the camera. In Figure 3-3, as the camera moves in toward the subject, the man increases in size at a rate faster than that of the building, increasing the feeling of depth and making the man appear relatively far from the building. However, the perspective does not change if you alter focal lengths only. Although the image is

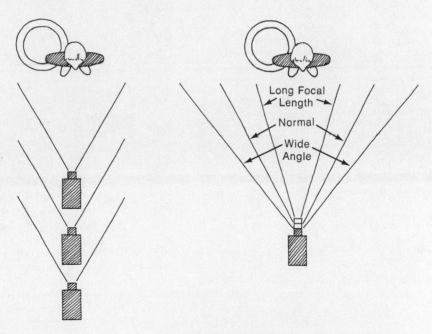

FIG. 3-2. Angle of view and focal length. (left) Keeping the angle of view constant, moving closer to the man (dollying in), makes him appear larger. (right) Keeping the camera in the same position while using increasingly longer focal lengths also makes the man larger but decreases the angle of view. (See the results in Figure 3-3.)

FIG. 3-3. Zooming compared to dollying. When you start at the same position (top), you can move the camera closer (the two photos at left) or zoom in (the two photos at right). In the zoom, everything gets proportionally larger—the man and the building double in size. In the dolly shot, at left, the man doubles in size but the building stays about the same size. (Compare how many windows are visible in the bottom pair of photographs.) (Ted Spagna)

magnified, the relationship between the man and the building does not change. By cropping out closer objects, the space appears flatter and the foreground and background seem compressed.

By altering both focal length and camera-to-subject distance, the cinematographer can control perspective. Coming in closer and using a wide-angle lens exaggerate distances, while moving back and using a lens with a long focal length compress distances. An image is said to have *natural perspective* when the perspective appears similar to what one would see if standing at the camera position. Lenses of "normal" or medium focal length generally yield images of natural perspective.

MEDIUM FOCAL LENGTH LENSES. In still photography, a normal focal length is considered to be roughly equal to the diagonal of the film format. By this standard, a lens of about 12mm would be normal in the 16mm format and 7mm in super 8. In film, however, lenses of 25mm are considered normal for the 16mm format and 12mm for super 8.

Lenses of appreciably shorter focal lengths than normal are called *wide-angle* or *short focal length lenses*. For example, lenses of 16mm or shorter are considered wide angle in 16mm. Lenses with a focal length appreciably longer than normal are called *long focal length* or *telephoto lenses*. Lenses longer than 35mm would be considered long focal length in 16mm. Until recently, most designs of lenses tended to cluster around the normal focal length for each format. For example, a 16mm, 25mm and 50mm (or 75mm) set of lenses was standard in 16mm. There were few options in extremely wide-angle lenses. This is still true in super 8, but not in 16mm and 35mm.

Perspective Effects

As discussed above, the farther the camera is from the subject, the flatter or more compressed the perspective; that is, objects of different distances from the camera do not appear greatly different in size on film. With a long focal length lens, the distant objects do not appear as small as you might expect (see Fig. 3-4). This effect is easily observed when a race is filmed head-on with a long focal length lens. The runners seem to be closer to one another than they in fact are, and although they seem to be running hard, they do not appear to be making much progress. This illusion occurs because of the great distance to the subject and the use of a long focal length lens.

Wide-angle lenses are apt to exaggerate depth; the distance between foreground and background seems greater than you would expect, objects distant from the camera seeming too small in relation to the objects close up. This phenomenon is sometimes called *wide-angle lens distortion* or *perspective distortion*. Although you may not find exaggerated perspective pleasing, it is, in fact, not "distorted," and, when the film is

FIG. 3-4. Compression and exaggeration of depth. (top) The long focal length lens makes the foreground and background appear close together. The cars look flat, packed together and close to the distant sign. (bottom) In this still from *Citizen Kane*, a feeling of deep space is created, in part, by using a short focal length lens. (Ted Spagna, RKO General)

viewed from up close, the perspective seems natural. As you get even closer to the screen, the perspective flattens. If you usually sit close to the screen (and do not suffer from myopia), you probably prefer compressed perspective; if you sit far from the screen, it may be because you prefer more depth in the image.

You can use a wide-angle lens to make a room seem larger. However, if someone is near the camera and moves toward it, he will appear to move unnaturally fast. In general, use a wide-angle lens to exaggerate the speed of any movement toward or away from the camera. A wide-angle lens on a moving vehicle pointed in the direction of the movement strongly suggests speed and sweep. Use the wide-angle lens to emphasize heights; for example, shoot down from the top of a building or shoot a person from below.

PERSPECTIVE IN THE CLOSE-UP. When you shoot a head-and-shoulder close-up with a wide-angle lens, the camera must be fairly close, which exaggerates depth. The nose will seem too large, and the ears too small and too far from the front of the face. Such close-ups are usually used for comic or eerie effect (see Fig. 3-5). If the subject moves toward the camera, the nose grows in size. A hand movement in the direction of the camera seems too fast, the hand itself too large. Faces in profile and motion perpendicular to the lens' axis show this exaggeration of perspective less.

If you film at the most common filming distances—about 5 feet or more from the subject—you do not have to worry about exaggerating facial features. For close-ups of faces, it is better to err on the side of flatter perspective (a longer focal length lens at a greater distance). However, when perspective is too flat, intimacy is lost and the viewer may feel distant from the subject (see Fig. 3-5). Although perspective varies every time the subject-to-camera distance changes, unless the change in distance and focal length is great, the change in perspective will go unnoticed by the audience.

PERSPECTIVE IN DOCUMENTARY. In unscripted documentaries, there is usually little flexibility in controlling perspective. Subject-to-camera distance is determined by what the crew and subject feel is comfortable. The cinematographer chooses the focal lengths that will allow him or her the range of desired shots from the normal filming distance. For example, working at a distance of 7 feet with focal lengths from 10 to 50mm in 16mm (6 to 30mm in super 8) will allow everything from a facial close-up to a medium shot.

The Light-Gathering Power of the Lens

F-STOPS. The lens gathers light from the subject and projects its image on the film. The light-gathering power of the lens is called the *speed of*

FIG. 3-5. Close-ups with different focal length lenses. If a head-and-shoulder close-up is made with a wide-angle lens (top), facial features are distorted—the nose appears too large and too far from the ears. (middle) A medium length lens gives a feeling of depth without looking unflattering. (bottom) A long focal length lens compresses the features, flattening the face. Although this lens sometimes creates a feeling of distance or remoteness, it is not unflattering. (Ted Spagna)

the lens. It is expressed as an *f*-number (*f*-stop, or *relative aperture*) which is the ratio between the focal length of the lens and its diameter (the *aperture*):

$$f\text{-number} = \frac{\text{focal length}}{\text{lens diameter}}$$

The *f*-number essentially tells us the light-passing power of a lens. As the lens diameter increases, so does the amount of light that passes through the lens. As the focal length increases, the light is dispersed over a greater area and the amount of light available to the film for exposure decreases. The *faster* a lens, the more light it lets through; the *slower* a lens, the less light. Lenses of about *f*/2 (that is, the diameter of the lens is one half the focal length) are considered fast.

Inside the lens is the *iris diaphragm*, which can close down to control the amount of light that the lens lets pass. The iris is a mechanical device, usually made of overlapping blades (see Fig. 3-6), which can be set to form a large or small hole or aperture *(lens aperture)*. It functions similarly to the iris in the eye. In dim light, the eye's iris opens to admit more light, and, in bright light, it closes down to let less light pass through.

A similar formula for the speed of the lens is used to express the light-gathering power of the lens at any iris diaphragm opening. The *f*-number, or *f*-stop, is the focal length of the lens divided by the diameter of the aperture.

The standard series of *f*-stops, or *f*-numbers, is:

$$1, 1.4, 2, 2.8, 4, 5.6, 8, 11, 16, 22, 32$$

The distance between consecutive numbers is called a *stop*. On most lenses, the *f*-stops are engraved on a ring on the lens barrel. Each stop represents the halving (or doubling) of the amount of light that the lens passes. At low *f*-numbers, the diaphragm is more open and more light passes through. As the ring is turned toward the lower numbers *(opening up)*, the iris opens; conversely, as the ring is turned to the higher numbers *(stopping down* or *closing down)*, the iris closes. For a lens set at *f*/4, for instance, opening up a stop would mean setting the lens at *f*/2.8 (which doubles the amount of light for exposure), and closing down two stops would mean setting the lens at *f*/8. Remember, opening the lens three stops lets *eight*, not six times more light in (each stop doubles the previous amount).

One way to remember the *f*-stop series is that each number is 1.4 (that is, $\sqrt{2}$) multiplied by the previous number. The series doubles every other number. Therefore, opening up two *f*-stops doubles the diameter of the aperture, increasing its *area* by four. Four times the light is equivalent to two stops.

Lens manufacturers generally engrave the focal length, serial number

f/11 f/4 f/2.8

FIG. 3-6. Iris diaphragm. As the blades of the iris open, more light passes through the lens.

and speed of the lens (widest relative aperture) near the front element. The speed is sometimes written as a ratio; 1:1.4 would be an f/1.4 lens.

Depending on the design of the lens, the lens' speed may not be a number included in the above f-stop series. For example, the widest aperture on one lens is f/1.9. This is approximately f/2 (see Fig. 5-6 for intermediate f-stops). In this case, the next number on the f-stop ring is f/2.8.

The standard technique for setting the f-stop is to open the lens to its widest opening and then stop down to the selected opening without passing it. This avoids any play in the iris that, in some lenses, can cause a full stop error at the smaller apertures.

T-STOPS. When you are calculating exposure, you need to know how much light passes through the lens to the film. The f-stop is a geometric relationship between focal length and aperture and does not take into account how much light is lost within a lens. Each air-to-glass surface within the lens reflects some light. A zoom lens can have more than 15 elements and lose a significant amount of light to internal reflections. A *perfect lens,* a lens of 100 percent transmission, transmits all the light it gathers with no internal losses. The *T-stop* is defined as the equivalent to an f-stop of a perfect lens. Thus, on a perfect lens, the f-stop and T-stop are identical. On a lens that lost a full stop in transmission (that is, a 50-percent loss), f/8 would result in the same exposure as T11. Note that the T-stop is always a higher number than the f-stop. Most *cine* (movie) *lenses* are calibrated in both f-stops and T-stops—the f-stop in white on one side of the iris diaphragm ring and the T-stop in red on the other side. If the lens is marked with T-stops, use them to calculate exposure *even though the light meter is marked in f-numbers* (see Chapter 5).

T-stops are especially important in zoom lenses. The widest aperture on a zoom lens may be f/2, but the T-stop may be T2.5, which means this lens loses two thirds of a stop in transmission. Most *prime lenses* (lenses of fixed focal length) do not lose enough light to upset exposure calculation. However, when you are using more than one prime lens in a scene, use T-stops for consistent exposure.

Depth of Field

As you can see in Figure 3-7, some of the subject matter is sharp while some is out of focus. In an ideal (theoretical) lens, there is only one subject plane in focus—everything in front of or behind this plane is out of focus. Fortunately, this is not true of lenses and photographic systems in the real world. A zone (called the *depth of field*), which extends from in front of the subject to behind the subject, delineates the area of acceptable sharpness. In other words, the depth of field is the zone, measured in terms of near distance and far distance from the camera, where the image appears acceptably sharp. The concept of depth of field is important, but complicated. A simple theoretical discussion is presented below with complications discussed later.

FIG. 3-7. Depth of field. The lens is focused on the man in both photographs. (left) The depth of field is not adequate to make the foreground and background appear sharp. (right) The lens has been stopped down, and the entire picture now appears sharp. (Ted Spagna)

CIRCLE OF CONFUSION. A *point* in the subject is considered in focus when it is registered as a *point* on film (see Fig. 3-1). This point in the subject is said to be in *critical focus*. All of the points in the subject that are in critical focus make up the *plane of critical focus*. Any point that is nearer or farther from the camera than the plane of critical focus registers as a circle on the film (see Fig. 3-8) called the *circle of confusion*. When a circle is sufficiently small or far enough away, the eye reads it as a point. Consequently, there is a region on either side of the plane of critical focus where points in the subject photograph as circles so small that they appear as points to the eye and thus appear to be in sharp focus. This

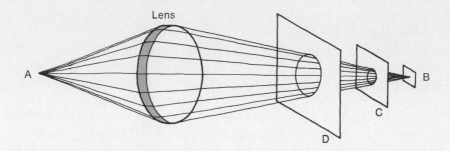

FIG. 3-8. Depth of field. The rays of light from a point in the subject (A) converge to a point in a plane behind the lens (B). The rays of light form a cone. If the film were positioned at plane C or D, it would intersect the cone to form a circle (the circles of confusion at C and D). The film positioned at C is closer to the plane where the rays converge, and thus produces a smaller circle of confusion. If the circle is sufficiently small, it appears as a point to the viewer and the image (A) seems in focus.

region where objects in the scene appear acceptably sharp on the screen is the depth of field. For example, when the lens is focused at 15', we might find the depth of field extends from 12' (near distance) to 20' (far distance). The total depth of field is the near distance subtracted from the far distance. Thus, the total depth of field in this case would be 8' (20' − 12').

Depth of field is not an absolute. There is no clear demarcation between subjects that are sharp and in focus and those that are blurry and out of focus.

To decide what determines "acceptable sharpness," a permissible circle of confusion is chosen—the *circle of least confusion*—and charts or formulas are used to calculate the subject zone where points will be rendered as discs of light smaller than this circle. For example, in 16mm a permissible circle of confusion of 1/1000″ is often chosen (see below for further discussion).

CONTROLLING DEPTH OF FIELD. There are two ways to control depth of field: change the size an object appears on film *(image reproduction ratio)* or change the *f*-stop. The larger an object is reproduced, the less the depth of field. An object photographs larger by moving closer or using a longer focal length lens. To increase depth of field, you can either use a wide-angle lens or move the camera farther away from the subject. To throw a background out of focus, use a long focal length lens or move closer to the subject.

Stopping down the *f*-stop (using a smaller aperture) increases depth of field (see Fig. 3-9). The iris can be stopped down if you add light to the subject or use a faster film (see Chapter 4). You can open the iris when

there is less light on the subject, when you use a slower film or a neutral density filter or when you narrow down a variable shutter.

In summary, to minimize depth of field, open the iris, move closer or use a longer focal length lens. To increase depth of field, stop down, move farther away or use a wide-angle lens (see split field diopters, below). Long focal length lenses at close focusing distances and with wide apertures (for example, at $f/2$) yield the least depth of field, whereas wide-angle lenses at far distances and stopped down (for example, at $f/16$) give maximum depth of field. A 25mm lens set at $f/2$ (with a 1/1000″ circle of least confusion) when focused at 4′ has a total depth of field of 7″ (about ½ foot). At $f/11$, total depth is 6′. If the same lens were set at $f/2$ but focused at 10′, total depth of field would be over 5′. In other words, moving farther back, stopping down or doing both increases depth of field dramatically.

It is commonly thought that wide-angle lenses have more depth of field than longer focal length lenses. They do, but not as much as cinematographers tend to think. Subject matter is generally reproduced smaller with a wide-angle lens, which contributes most to the increased depth of field. The question arises: if you keep a subject in the plane of critical focus the same size, do you get additional depth of field with a wider-angle

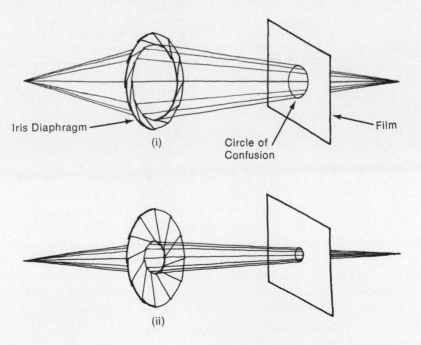

FIG. 3-9. Stopping down the lens increases depth of field. (i) Circle of confusion at wide aperture. (ii) As the iris diaphragm closes, the diameter of the cone of light gets smaller and consequently the circle of confusion is smaller.

lens? For example, does a 25mm lens at 5' have more depth of field than a 50mm at 10'? Yes, it has a bit more. But when focus extends to infinity (as in the case of hyperfocal distance, see below), wide-angle lenses have significantly more depth of field. For close distances, however, the difference is minimal. On the other hand, in the zone *outside* the depth of field, long focal length lenses make the image blurrier than short focal length lenses. For this reason, when cinematographers want to throw a background out of focus, they reach for their long focal length lenses.

Although depth of field increases as the iris is closed down, the sharpest images are not obtained with small iris openings (see Lens Sharpness, below).

SPLIT FOCUS. If you are focused on a subject, the rule of thumb is that you will have roughly twice as much depth of field behind the subject as in front of it. Thus, if two objects are at different distances from the camera, focusing at a point halfway between them will not render the two objects equally sharp. You should instead focus on a point one third the distance from the closer to the farther object. If one object is at 10' and the other at 40', the *split focus distance* is 20' (that is, 10' in front and 20' behind).[1] Only use this rule if there is sufficient depth of field to render both objects sharply.

DEPTH OF FIELD CHARTS. Depth of field charts (see appendix E) approximate the depth of field but have serious limitations. If possible, you should obtain a chart from the lens manufacturer for the lens you use, since the design of a lens affects its depth of field (in particular, the aberrations and location of the front nodal point, see below). Depth of field charts often do not include the widest apertures where depth of field is most critical, but the manufacturer's charts will. Also, lens charts assume a particular circle of least confusion that may be too liberal or too conservative for your needs. Usually charts specify 1/500″ for 35mm and 1/1000″ in super 8 and 16mm (although a smaller number is sometimes used for super 8). If your work is critical or you want the image to be projected very large, use a smaller circle of confusion. Soft (unsharp) lenses have *more* depth of field since the eye lacks a sharp standard against which to judge out of focus subject matter. As film stocks and lenses have improved, the need for a stricter circle of confusion has increased. Some charts now use a 1/2000″ circle of confusion for 16mm. Although focus is measured from the focal plane (see Focusing the Image,

[1] A more accurate (although complicated) formula for split focus is:

$$\text{Split focus distance} = \frac{2 \times \text{nearest distance} \times \text{farthest distance}}{\text{nearest distance} + \text{farthest distance}}.$$

This formula gives 16' for the above example.

below), depth of field calculations are properly made from the front nodal point, which varies with the design of the lens. On some sophisticated designs (for example, telephoto and zoom lenses at wide angle), the front nodal point is in front of the lens and there is less depth of field at *close* focusing distances. The lens manufacturer's charts should compensate for this.

There are subjective factors that increase depth of field—for example, background as opposed to foreground blurriness, low contrast, soft grain, muted color and reducing the size of the projected image. One rule of thumb calculates a 15- to 20-percent error in depth of field figures derived from a chart.

Some lenses have rough depth of field guides engraved opposite the *f*-stop ring. Depth of field calculators are generally less accurate than charts. Use only *f*-stops, and not T-stops, in depth of field calculations.

DEPTH OF FIELD IN THE VIEWFINDER. A ground glass or fiber optics reflex viewfinder screen gives a rough idea of the depth of field. Aerial image viewfinders and finders that pick up light before it passes through the iris diaphragm give almost no depth of field information. The reflex ground glass image tends to exaggerate the available depth of field since the viewfinder image is far smaller than the projected image. The grains of the ground glass also obscure fine detail, which increases the difficulty of judging depth of field. If something looks out of focus in the viewfinder, it will be out of focus on the film. But the sharpness of an image on the ground glass is no guarantee that it will be sharp on film.

THE HYPERFOCAL DISTANCE. For any lens at a particular *f*-stop, the closest distance setting such that the far limit of depth of field extends to infinity (infinity may be written ∞ on lenses and field charts) is called the *hyperfocal distance* (see Appendix F). Thus, when the distance scale is set on the hyperfocal distance, you have maximum depth of field. When the lens is set at the hyperfocal distance, the near limit of depth of field is one half the hyperfocal distance. For example, a 25mm lens at *f*/8 has a hyperfocal distance of 10' (based on a 1/1000" circle of confusion). When the lens is focused 10', the depth of field extends from 5' to infinity. The hyperfocal distance is also the near limit of depth of field when the lens is focused at infinity.

The hyperfocal distance setting is quite handy when focusing is difficult or particularly onerous. If you set the lens at the hyperfocal distance, you need not worry about focus unless the subject comes closer than one half the hyperfocal distance. Of course, the remarks about depth of field not being an absolute apply here as well, and you may find that the hyperfocal

distance based on a 1/1000″ on depth of field charts is not strict enough for your work.[2]

You can find the hyperfocal distance for any *f*-stop by dividing the *f*-number into the hyperfocal distance at *f*/1. For example, a 25mm lens has a hyperfocal distance of 80′ at *f*/1 (assuming a 1/1000″ circle of confusion). At *f*/8, the hyperfocal distance is 80′ divided by 8, or 10′. Short focal length lenses have dramatically more depth of field when using hyperfocal distance. A 25mm lens has a hyperfocal distance one fourth as great as a 50mm lens.

When you work with hyperfocal distance, it is often helpful to mark the distances on the side of the camera. If your lens has a depth of field scale on it, the hyperfocal distance can be approximated by setting the selected *f*-stop on the scale opposite the infinity setting.

Some very wide angle lenses (and some inexpensive lenses) have no provisions for focusing (*fixed focus lenses.*) These lenses are usually prefocused at the hyperfocal distance of the widest aperture. Consult the manufacturer's data sheet to find the closest focusing distances at the various *f*-stops.

Focusing the Image

Nearly all lenses have provisions for focusing the image. As the lens is brought farther from the film plane, objects closer to the camera are brought into focus (see Fig. 3-8).

The distance mark on the lens barrel opposite the distance scale indicates the plane of critical focus. The lowest number on the distance scale is the closest the lens may focus to the subject without the use of auxiliary devices.

A properly constructed lens focuses on a plane perpendicular to the direction of the lens. For example, suppose you want to focus on a group of people for a snapshot and want them as sharp as possible at 10′ from the camera. Should they be lined up along the arc of a circle, so that they are all 10′ from the lens? No, only the person directly on line with the lens should be 10′ away. All the others should be in the same plane, perpendicular to the axis of the lens.

To focus, you may measure the camera-to-subject distance and then set the lens. Typically, on a large production with setup shots, an assis-

[2] A formula for hyperfocal distance in inches is:

$$\text{Hyperfocal distance (in.)} = \frac{\text{focal length (in.)}^2}{f\text{-stop} \times \text{circle of confusion}}.$$

A formula for focal length in mm and circle of confusion in inches is:

$$\text{Hyperfocal distance (ft.)} = \frac{0.000129 \times (\text{focal length in mm})^2}{f\text{-stop} \times \text{circle of confusion}}.$$

tant measures distances with a 50′ tape. The distance is measured from the film plane (marked on many cameras by an engraved ⌀ on the camera housing) to the chosen plane of critical focus. Measurements can also be made to the near and far points that must be in focus; then, if there is adequate depth of field, calculate the split focus distance (see p. 68) and set the focus accordingly. The lens must be properly collimated for the focusing scale to be accurate (see Depth of Focus, p. 72).

On reflex systems, focusing may be done by eye. Some super 8 and 16mm cameras incorporate a split image or microprism range finder for focusing. To focus a reflex ground glass image, rotate the focus ring until the subject is brought into sharpest focus. If the camera is not running (if you are not *pulling focus*—that is changing it—during a take), ''go through'' focus once or twice, that is, rotate the focus ring past the point where the image is sharpest *(going through focus)*, stop and then rotate back to the point of sharpest focus. Whenever possible, focus a reflex finder with the lens at the widest aperture to keep the viewfinder bright, to minimize depth of field and to see the image pop in and out of focus better (see Focusing a Zoom Lens, p. 79).

In a shot in which cameras and actor movements are planned (blocked out), you should rehearse focus changes *(follow focus)*. A camera assistant or focus puller often changes *(pulls)* focus during the shot. Follow focus devices (sometimes remotely controlled) are available for studio rigs (see Fig. 3-10) to make focus pulls easier. Place tape on the floor to cue the actors or the focus puller. Put tape on the lens distance scale and mark settings for a home-made follow focus device.

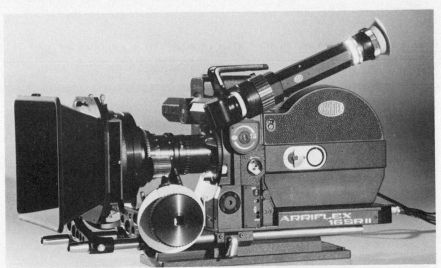

Fig. 3-10. Arriflex 16SR II outfitted as a studio camera with matte box, extended viewfinder and follow focus knob on the side of the lens. (Arriflex Corp. of America)

Depth of Focus

Never confuse depth of focus with depth of field. *Depth of focus* is the tolerance in the accuracy of the mounting or seating of the lens on the camera. It is the very small distance behind the lens on either side of the focal plane where the film can be situated and still record an acceptably sharp image. This tolerance is measured in thousandths of an inch and is usually adjusted by a lens technician. The camera lens mount (see Chapter 2) has a standard *flange focal distance*—the distance from the focal plane to the lens mount flange.

Depth of focus increases as the iris is stopped down. However, unlike depth of field, it is least in wide-angle lenses. This means that a fast wide-angle lens needs to be very accurately mounted.

The seating of the lens may be checked with an optical device called a *collimator*. The camera is loaded with fresh raw stock and the film is run during the test. A test target is projected through the front of the lens, bounced off the film and viewed through a reflex finder on the collimator. The light rays are collimated (made parallel) to simulate a light source at infinity. When the lens focus ring is set at infinity, the test target should be in sharp focus. The test checks the accuracy of the infinity setting on the lens focus ring. A poor test result is a sign of improper lens seating (or some malfunction in the lens).

If a prime lens is not properly seated, its focus scale will not be accurate and a tape-measured focus setting will be inaccurate. Although reflex focusing will correct this error, an improperly seated lens might not be able to focus to infinity. Super 8 and 16mm lenses have a stop at infinity, but some 35mm lenses will focus "through" infinity, allowing for proper focus at infinity even if the lens is improperly seated. An improperly collimated zoom lens has more serious consequences (see Seating of a Zoom Lens, below).

Lens Quality

Lens design is a complex affair, requiring the balancing of an amazing number of variables. Recent advances in lens design have mostly resulted from computer-assisted ray tracing.

LENS ABERRATIONS. Centuries before the invention of lenses, painters used a *camera obscura* (literally, dark room), which is a dark room with a small hole in one wall that looks out onto an exterior landscape. The landscape is projected upside down and reversed on the opposite wall. Reduced in size, this concept is the pinhole (lensless) camera. The image is dim and slightly fuzzy. A lens increases brightness and sharpness, but it must first be focused *and* it introduces aberrations in the image. *Lens*

aberrations are distortions in the formation of the two-dimensional image by the lens. To correct for various aberrations, a lens is made up of many elements. The most common aberrations are:

1. *Chromatic aberration*—light rays of different colors bend at different angles as they pass through the lens. A green ray and a red ray from the same point in the subject focus in different planes. This aberration decreases image sharpness and sometimes creates a rainbow-like fringing on objects.
2. *Spherical aberration*—the inability of the lens to render a point source in the subject as a point in the image, because off-axis rays are bent more than rays that go through the center of the lens. This results in fuzziness of the image.
3. *Astigmatism*—vertical lines focus in a different plane than horizontal lines do. It is different from astigmatism of the eye. Lens astigmatism shows up on a lens resolution chart when the horizontal and vertical bars resolve different amounts.
4. *Curvature of field*—the lens focuses on a curved surface rather than a plane. If the lens is perpendicular to a wall, it will not be able to focus simultaneously on the edges and center.
5. *Coma*—off-axis light sources photograph with a comet-like tail. Although this is usually corrected in expensive lenses, there are very fast, high-quality, wide-angle lenses that show coma in light sources at the edge of the frame.
6. *Geometric distortions*—if a grid is photographed with the film plane parallel to the grid, you would expect a similar grid on the film. Two geometric distortions account for the differences: If the grid lines bow away from the center, it is *barrel distortion;* if they bow toward the center, a *pincushion distortion.* Distortion, in the strict sense of the term, refers to these geometric distortions and not to perspective exaggeration as discussed above. Extremely wide-angle lenses often show geometric distortion as well as exaggerated perspective.

Nearly all aberrations, except distortion, are most apparent when the lens is wide open or nearly so. As the iris is stopped down, the effect of the aberrations becomes less pronounced. If cinematographers had no need for fast lenses, aberrations would be much less of a problem. Keep in mind that generally when the lens is completely or fairly wide open, the aberrations limit lens sharpness (see Lens Sharpness, below).

VIGNETTING. *Vignetting* is not an aberration but an optical phenomenon where less light reaches the edge of the image than the center. The closer the lens is to the film (this distance is called the *back focus*), the more pronounced is this effect. Conventionally designed wide-angle lens often show vignetting. The problem becomes even more noticeable when

a vignetted shot is cut next to a shot with little vignetting. Wide-angle lenses of an inverted telephoto design *(retrofocus)* increase the back focus distance to avoid considerable loss of exposure at the image edge.

Vignetting, in the loose sense, refers to any loss of light toward the edges of the frame. Since the lens forms a circular image, the amount of light at its boundaries falls off rapidly. If the lens does not adequately *cover* the film area, there will be a noticeable loss of light, especially at the film's corners. This often occurs when lenses from a smaller format are used in a larger format (for example, 16mm lenses for work in super 16 or 35mm). Vignetting is most apparent when the lens is wide open and the distance scale is set at infinity (and, in the case of zoom lenses, at the widest angle). If a lens shade or matte box cuts off picture area, it too is said "to vignette" (see p. 88).

LENS SHARPNESS. Defining lens sharpness has the same problems as defining film sharpness, which is discussed fully in Chapter 4. Resolution, contrast, acutance and modulation transfer function (MTF) are all used in lens evaluation. Resolution charts do have a special use in lens testing; although they have all the limitations discussed in Chapter 4, they are useful for judging if a particular lens has been badly constructed or damaged. For example, improperly centered lenses show more resolution on one side of the image than they do on the other.

Diffraction, an optical phenomenon, occurs when light passing through a small hole scatters and renders the image unsharp. Iris openings of $f/16$ or smaller may cause noticeable loss of sharpness in the image. Diffraction is a function of the absolute size of the aperture (the f-stop is a relative aperture—the ratio between aperture and focal length); thus wide-angle lenses especially become less sharp when stopped down. While long focal length lenses often stop down to $f/32$ without problems, some wide-angle lenses only stop down to $f/11$ to prevent loss of sharpness at the smallest openings.

A lens is said to be *diffraction limited* when its sharpness is limited (at particular f-stops) only by diffraction, thus showing no aberrations at those f/stops. Most lenses are sharpest when stopped down two to three stops from the widest aperture. For example, an $f/2$ lens would be sharpest around $f/4$ to $f/5.6$.

Resolution is limited at the wide apertures by aberrations and at the very smallest apertures by diffraction. You should avoid shooting at the smallest apertures; use slower film or a neutral density filter to allow shooting at a wider aperture. Some people think the notion that sharpness decreases at small f-stops while depth of field increases is contradictory. "Sharpness," however, refers to how clear the image can be, whereas "depth of field" tells us the relative sharpness of objects at different distances from the camera.

The modulation transfer function (MTF—see Chapter 4 for definition)

may be used to judge the sharpness of a combination of lens and film. If the response of one falls off at a given frequency, it no longer matters how the other responds. To get the most out of the combination, the MTF for each should roughly match. Some lens manufacturers supply MTF curves for their lenses at various f-stops.

Some lenses are sharp in the center but not in the corners. This shows up in resolution tests as less resolution at the edges. Some lenses have good contrast but do not resolve well. As you can imagine, much of lens evaluation is subjective. The cinematographer may just like the look of a particular lens or favor a lens and film combination. In super 8 and 16mm, the tendency is to maximize image sharpness, but in 35mm, which can achieve great sharpness, many cinematographers prefer a softer, more diffuse image.

LENS CONSTRUCTION. Aberrations can be introduced into a lens by poor centering of the elements. Much of the expense in lens construction results from the need to line up the center of each element so that it lies on the optical axis of the lens. Even expensive lenses vary in quality, which becomes apparent in use and can be seen on a collimator. When you purchase a lens, if possible, take a few of the same model lens to a lens technician since significant differences in sharpness and aberrations may exist from sample to sample.

Small bubbles, which are often visible in a lens element, usually do not affect quality. Small surface scratches on used lenses do not affect performance, unless they are fairly numerous, in which case they lower image contrast. A chip in an element severely impairs the image by scattering light. Contrast is lost if the internal parts of a lens are not properly blackened; you can check this by looking through the lens as it is pointed toward a light. All the controls on a lens should move smoothly, and nothing should rattle when you shake the lens. There should be no play in the iris diaphragm. A lens that has been hit hard should be tested by a technician.

FLARE. The elements of the lens are separated by air spaces. These air-to-glass surfaces reflect some of the light from the subject, which bounces around in the interior of the lens and adds an overall exposure to the image, thus lowering contrast. This *flare* is particularly noticeable when a light source is photographed; for example, when someone is standing in front of a bright window. Flare diffuses the image, lightens the blacks, increases the appearance of grain, decreases sharpness and often softens the edges of backlit figures. On color film, it often gives a romantic haze to the image. In black-and-white, the result is sometimes romantic, sometimes realistic in a gritty way.

Generally, the greater the number of elements in the lens, the more flare. Zoom lenses are particularly vulnerable. Nearly all modern lenses

have antireflective coatings on their elements to minimize flare. Coated lenses have better contrast and reduce light loss, increasing the effective lens speed (that is, a faster T-stop). Multiple, *high-efficiency* coatings increase light transmission even more. Some older lenses may not have high-efficiency coatings, while most newer versions do. One rule of thumb for checking coatings is that the more colors seen in the coating, the more efficient the coating will be.

Different lens designs display radically different amounts of flare; where a subject against the sky may appear sharp and well-defined with one lens, it may appear soft and hazy with another.

The front element of the lens often picks up stray light from bright objects or other light sources even when the light source is not in the frame. This may cause flare and internal reflections of the iris diaphragm to appear on the film as bright spots in the shape of the iris opening. If the front element of the lens is viewed from in front of the camera and an image of a light source can be seen reflected in the front element, there will be some flare in the image. The solution is to use a deeper lens shade or matte box (see below) or to flag the light source (see Chapter 9). Since flare adds exposure to the film, it sometimes affects the exposure calculation (see Chapter 5).

Flare is generally considered a phenomenon that deteriorates the quality of the image, a form of system noise. On the other hand, you may like the effects of flare. It was considered an artistic breakthrough when Jean-Luc Godard's cameraman, Raoul Coutard, in the early 1960s, pointed the camera lens into large café windows in interior shots and "degraded the image with flare" (see Fig. 3-11).

The Zoom Lens

The zoom lens offers various focal lengths in one lens. Focal lengths may be changed during a shot *(zooming)* or between shots. Changing focal lengths between shots is like changing from one focal length prime lens to another, but it takes less time with a zoom. Framing can be changed, without moving the camera, saving a great deal of time when the camera is on a tripod.

Zoom lenses are larger, heavier, more delicate and more prone to flare and distortion than primes. The more expensive, recent designs approach prime lenses in sharpness; some claim to be diffraction limited at openings such as $f/4$. The seating of zooms is critical (see below), and there are advantages in permanent mounting, common in super 8 but rare in 16mm.

FIG. 3-11. *Vivre sa vie (My Life to Live)*, Godard's 1962 film. Anna Karina is backlit with window light. Note how the extensive flare obscures the border between her hair and the window. (Corinth)

Zoom Range and Aperture

Zoom lenses are available in virtually every focal length from 5.5 to 1000mm or more. Some have apertures approaching $f/1$. Zooms are designated by their zoom range (for example, 10-100mm) or the widest focal length times a magnification factor (for example, 10×9.5 is the same as 9.5–95mm). Angénieux makes a 25×25 (25–625mm) for 35mm, one of the longest zoom ranges available.

The widest aperture f-stop and T-stop are an important part of zoom lens designations. The Angénieux $f/1.1$, 16–44mm T1.3 designation tells us this lens is $f/1.1$ at its widest aperture. Its equivalent T-stop is T1.3 (it loses about one third of a stop); thus, it is a very fast lens with a limited zoom range of 16–44mm (2.8×16 tells us its magnification factor is only 2.8).

Zoom lenses, for the most part, do not shift f-stop over the zoom range. There are exceptions. In order to achieve high speeds, some designs maintain their widest aperture only at wide angle. For example, the Angénieux 9.5–57mm is a very fast $f/1.6$ (T1.9) from 9.5mm to about 12mm. But at 45–57mm it is $f/2.2$ (T2.5). This means that if you were to shoot wide open at $f/1.6$ at 9.5mm and then zoom to 57mm, there would be a noticeable loss of exposure at the long focal length. It is undesirable to

Fig. 3-12. Angénieux 9.5-57mm zoom lens. (Angénieux Corp. of America)

zoom across a range that loses more than one third of a stop. When this lens is stopped down to $f/2.2$, the f-stop is constant across the zoom range and there are no problems. Some lenses have detents that prevent zooming at focal lengths that will change the f-stop.

Focusing a Zoom Lens

You can use a zoom on a reflex camera or else you need a zoom with an integral reflex viewfinder (see Chapter 2). To focus a zoom between shots (assuming the diopter is adjusted for your eye; see Chapter 2), zoom out to the longest focal length, open up to the widest aperture and focus. Depth of field is minimized at the longest focal length and widest aperture, so it is easy to distinguish focus. If an unrehearsed focus pull must be done during the shot, some documentary filmmakers zoom in quickly, refocus and zoom back to the selected focal length. This "focusing zoom" is generally edited out.

Focus is supposed to hold constant across the zoom range. If focusing is done at wide angle, the plane of critical focus is not as easy to distinguish. Zooming closer decreases depth of field, and any focusing error will show up. Thus, when an image is sharp at wide angle but goes out of focus when zoomed in, it means focusing was not done at long focal length as it should have been. If the image becomes seriously out of focus when zooming from long focal length to wide angle, it probably means the lens is not properly seated.

Seating of a Zoom Lens

An improperly seated zoom lens (said to be "out of collimation") will go out of focus as it is zoomed out to wide angle. As discussed above (see Depth of Focus), depth of focus decreases at short focal lengths. The lens may focus well at long focal lengths where depth of focus is considerable (although there is little depth of field), but, as the lens is zoomed to wide angle, tolerances become more critical and the picture may go out of focus. With prime lenses, proper seating is necessary for the accuracy of the distance scale (and in particular, the infinity setting), but, with zooms, it is also necessary for holding focus across the zoom range.

In an emergency, an improperly seated zoom can still be used as a variable focal length lens (that is, for changing focal lengths *between* shots), especially at the longer focal lengths. In this case, you can focus the zoom as though it were a prime.

In summary, if the projected image goes out of focus going from a short to long focal length, it means you did not focus at the long focal length. On the other hand, if it goes out of focus when zooming from long to short (just when we would expect the greatest depth of field), the lens is probably incorrectly seated (see Checking Focus and Collimation, p.91).

Zooming

Zooming changes an image significantly and, unless it is handled smoothly, it can be quite disruptive. Graceful zooming starts up slowly, reaches the desired speed and gradually slows to a stop. Many super 8 cameras are equipped with motorized zooms with a choice of zoom speeds. External zoom drives weighing a few ounces are available for 16mm and 35mm. Motorized zooms are sometimes limited in their zoom speeds, and some filmmakers feel they have a mechanical look. A joystick control for varying the speed gives more flexibility. For a very long, slow, smooth zoom, use a motorized zoom.

Manual zooming puts you in direct contact with the "feel" of the zoom, which some filmmakers prefer. Zoom lenses with cranks or zoom rods (see Fig. 3-13) produce smooth, relatively slow zooms on a tripod but are awkward when used with a handheld camera. A zoom lever extends perpendicularly from the zoom ring. The longer the lever, the smoother the zoom can be. For tripod work, you can tape a foot-long rod

FIG. 3-13. A 12-120mm zoom with rod (top) and crank (bottom). A crank or lever helps make smoother zooms when the camera is mounted on a tripod. (Angénieux Corp. of America)

onto the lever for smoother zooms. For handheld work, we prefer a fairly short lever because it is more responsive to the touch. Some filmmakers grasp the zoom ring itself. Detachable drag mechanisms are available which adjust the resistance of the zoom. Manual zooming requires practice to do smoothly. Jerkiness in the zoom shows up more in the projected image than it does in the viewfinder. Novices tend to zoom too often, and excessive zooming ("zoom-happy" or "tromboning") can be quite annoying.

ZOOM VERSUS DOLLY. Some people object to the zoom effect because the viewer is brought closer (or farther) to the filmed subject without changing perspective. In zooming, the entire image is magnified equally (see Fig. 3-3), similar to when you approach a still photograph. In a dolly shot, the camera moves in toward the subject and the perspective changes; objects also pass by the side of the frame, suggesting to the viewer that he is physically moving into the space.

The moving camera creates a feeling of depth in the space. The zoom tends to flatten space and can call attention to the act of filming itself. Some filmmakers like this feature and will use the zoom to pick out a significant detail in the subject.

ZOOM TECHNIQUES. Zooming in the opposite direction of subject or camera movement results in a treadmill effect. If an actor runs toward the camera but the lens zooms back, the viewer feels as though the actor has made no progress. Similarly, if you shoot out of a car's front window and zoom wider, the viewer will feel as though the forward movement is disrupted. In *Vertigo*, Alfred Hitchcock combined zooming and moving in reverse to simulate the feeling of vertigo. The camera is lowered down a staircase and the lens simultaneously zoomed back to keep the size of the field constant. Although the viewer sees the same subject matter, the perspective is exaggerated (since the camera moves closer), evoking the sensation of dizziness due to height.

Zooming to change focal lengths in a shot is often hidden by combining the zoom with a camera movement—for example, a pan. A zoom combined with a dolly shot increases the effect of the dolly movement.

Before you use a zoom lens, zoom back and forth several times to distribute the lubrication in the mechanism. Some lenses have a *zoom creep*—the lens zooms by itself. In this case, bring the lens to a technician for repair, but a temporary solution is to fit a wide rubber band, not too loose or too tight, around the zoom ring and barrel to create a little friction.

Sometimes, a subject in the center of the frame at wide angle may not be at the center when zoomed in, which may be due to a flaw in the lens design called *side-drift*. You can compensate for this while zooming by using the cross hair in the viewfinder (see Fig. 2-9) as a centering aid. A

similar effect also can occur due to the geometry of the zoom effect. In this case, a point looks centered at wide angle but is actually slightly off-center. Zooming in magnifies the difference, and the object becomes very off-center by the end of the zoom. Make sure you rehearse the zoom and center the object at long focal length to solve this problem. Side-drift is not often noticeable in handheld work, since the camera operator unconsciously adjusts for it. Some zoom lenses change their focal length slightly when focus is changed. If so, check framing when you change focus.

Data rings can be attached to a zoom to help you see the aperture, focus and zoom settings when you are handholding the camera or standing behind a tripod-mounted camera where it is otherwise difficult to see the markings on the lens.

Check zoom lenses for vignetting with the lens wide open, at the shortest focal length and the distance scale at infinity. The lens shade or matte box should also be checked with the lens set at the closest focusing distance (see p. 88).

You should calculate exposure with T-stops since some zooms lose almost a full stop in transmission. Zoom lenses often have less depth of field than primes of equivalent focal length. This is only important at close focusing distances, and you should use the manufacturer's depth of field charts in such instances.

Changing the Zoom Range

Some zoom lenses can be fitted with a retrofocus wide-angle attachment to convert them to a zoom range of shorter focal lengths—for example, a 17–68mm range to a 12–50mm. As a rule, these attachments do not affect aperture or focus settings and may not significantly impair the image.

Rear-mounted lens attachments, such as range extenders, change the relative aperture and reduce the lens' speed. For example, a $2\times$ range extender converts a 12–120mm zoom range to a 24–240mm and changes an $f/2.2$ aperture to an $f/4.4$. Aberrations are also magnified and may make the image unacceptable. Stopping down does minimize most of the aberrations, but stopping down to $f/8$ is the equivalent of $f/16$ when using a $2\times$ extender. Front-mounted range extenders do not change relative aperture, but sometimes they vignette at the shorter focal lengths. Range extenders are also used with prime lenses.

Choosing a Zoom Lens

The zoom is sometimes the only lens used on a production, thus placing great demands on its capabilities. A high-quality, fast zoom lens with a

10× zoom range is bound to be expensive and heavy. Often the use of a slower, lighter zoom and a fast prime or a fast zoom with a limited zoom range with a wide-angle prime will be less expensive and more versatile.

The closest focusing distance may be important to you. Some zooms focus down to 2′, some even down to their front element. Others focus only to 5′ and need close-up diopters (see below) for close focusing.

Some zooms are so large that they unbalance a handheld camera or prove intimidating in some documentary settings. Unfortunately, the lighter and smaller the lens, the slower its speed or the more deficient it is in the long focal lengths.

Short focal lengths make it easier to keep a steady image while hand-holding a camera. An extreme example may help to clarify this point. If a lens with a 90° angle of view is jiggled 1°, the jiggle is hardly noticeable. But if a very long focal length lens with a 1° angle is jiggled 1°, the previous subject is lost entirely. For handheld cameras, the longest focal length used should be around 50mm for 16mm (30mm in super 8), although some camera operators can hold longer focal lengths steady. Novices, however, may not be able to hold even a 16mm lens sufficiently steady. A head and shoulder close-up with an out of focus background often looks acceptable with long focal lengths, since any camera jiggle tends to look like subject movement. On the other hand, it is difficult to hold a shot of a building steady even with a wide-angle lens. In this instance, use a tripod.

Some of the newer lenses represent major advances in lens speed, sharpness and zoom range. The old prejudice that zoom lenses are inferior to primes no longer holds. These new lenses include the Angénieux 16–44mm T1.3 and 10–120mm T2 (claimed to be diffraction limited at $f/4$) in the 16mm format. The Angénieux $f/1.4$ 6–90mm (a 15 × zoom range) is made for super 8. Taylor-Cooke-Hobson offers two zooms in the 9–50mm range that they claim can resolve 100 lines/mm. The Zeiss Vario Sonnar 10–100mm T2 focuses down to a 1:4 image ratio and is quite compact.

Mention should be made of three workhorse Angénieux zooms: the 12–120mm, 9.5–95mm and 9.5–57mm. The 12–120mm was the first reasonably high-quality zoom and was, at one time, the standard zoom in the 16mm format. The 9.5–57mm is T1.9 at wide angle and is compact. Newer versions of these lenses are available with improved optics. Integral reflex finders (see Chapter 2) for zooms are generally only available in older designs.

Prime Lenses for Special Uses

Fast Lenses

The industry underwent a major change in low-light filming at the end of the 1970s with the introduction of high-speed, wide-angle lenses by Zeiss and Cinema Products. The Zeiss-Distagon Super-Speed lenses are T1.3 (less than one fourth of a stop faster than $f/1.4$) and come in focal lengths of 9.5, 12, 16, and 25mm. They use aspherical elements, which are quite expensive but reduce spherical aberration dramatically, making these lenses sharp even when shooting wide open. Zeiss offers a supplementary lens that converts the 12mm to 6.6mm and the 9.5mm to 5.6mm with no significant loss of light. Cinema Products' Ultra T lenses are available in focal lengths from 9mm to 25mm (mostly T1.25). They are not quite as sharp as the Zeiss lenses when wide open, especially at the edges, but they are considerably less expensive.

The Angénieux 25mm $f/.95$ (a bit faster than $f/1$) has been the standby for a very fast lens in the 16mm format for a long time. When the lens is wide open at common camera-to-subject distances, there is so little depth of field that focusing in documentary settings becomes extremely difficult. The new generation of high-speed, wide-angle lenses makes night shooting far easier because of the great depth of field of wide-angle lenses at common filming distances.

Telephoto Lenses

Telephoto lenses or *tele-lenses* are, loosely speaking, about 50 percent longer than normal lenses for the format; for example, lenses greater than 35mm in the 16mm and greater than 18mm in super 8 would be considered telephotos. True telephotos are of a sophisticated design that allows them to be physically shorter than their focal length would imply. A similar principle is used in inverted telephoto or *retrofocus* lenses, which are wide-angle lenses with increased back focus distance.

Telephoto lenses render the subject large even at great distances, allowing for camera unobtrusiveness, safe distance from dangerous events and extreme compression of perspective. Since they have little depth of field, they are useful for throwing a distracting background out of focus. When you want a dramatic focus pull, use a long focal length lens.

Tracking a subject moving laterally to the lens with a telephoto simulates a moving camera shot. The tracking pan keeps the subject's size constant in the frame and makes it appear that the camera is dollying.

Akira Kurosawa often uses these tracking pans in his samurai movies to simulate the free movement through space usually achieved with the dolly shot—the longer the focal length, the more sustained the effect.

Telephotos longer than 150mm tend to be fairly slow, although Canon has recently introduced an $f/2.8$, 300mm and 400mm lens. *Cadiotropic* lenses use reflecting mirrors for their long focal length but very compact design. They are usually in the $f/8$ range and employ neutral density filters in the place of an iris diaphragm for exposure control.

Telephotos are extremely vulnerable to camera vibration. A camera may function perfectly well with shorter focal lengths but reveal vibrations with a 300mm lens. You should use a lens support or cradle with long telephotos to minimize vibration and to avoid straining the lens mount; use a very steady tripod and do not handhold the camera (but see Chapter 6, Image Stabilization). Heat waves often show up in landscape telephoto shots, which can be avoided by shooting in the morning before the ground has heated up. Distant scenes may be overexposed due to atmospheric haze. In such instances, use a haze filter and stop the lens down one half to one full stop (see Chapter 5). Tele-extenders may be used to increase focal length, but keep in mind the limitations discussed above in Changing the Zoom Range. Inexpensive telephotos are like tele-extenders, often using optics that are not much more sophisticated than a magnifying glass. Spherical and chromatic aberrations are serious on these lenses, but stopping down minimizes their effects.

Since parallax errors are more pronounced, telephotos should be used only with reflex finder systems. Distances are often too great to be measured with a tape measure, so focus with a reflex finder. The reflex image will also allow you to gauge the flattening of perspective better.

Close Focusing

Zoom lenses often focus down no closer than 3 feet from the subject. Prime lenses often focus closer. The closer the subject is to the lens, the farther the lens must be from the film plane to focus. *Macro lenses* extend far enough to bring very close objects into focus. Often macro lenses can yield an image reproduction ratio of 1:1, that is, the image size is the same as the subject size; a thumbtack would fill a 16mm frame.

Any lens may be extended farther from the film plane by the use of *extension bellows* or *extension tubes*. Bellows permit a wider range of focusing distances and greater magnification and are faster to adjust. Extension tubes and bellows work best with normal or slightly long focal length lenses. If they are used with a zoom lens, the zoom will not remain in focus across its range, and the results are often not sharp.

When the lens is far from the focal plane, less light strikes the film and

an exposure compensation must be made (the engraved *f*-stops assume the lens is about its focal length distance from the film plane). Generally, no exposure compensation need be made until the subject is closer than ten times the focal length of the lens—for example, closer than 250mm (10″) with a 25mm (1″) lens.[3] Cameras with behind-the-lens meters (like most super 8 cameras) will make the exposure compensation automatically.

Close-up Diopters

Close-up diopters or *plus diopters* are supplementary lenses mounted in front of the lens like a filter. They permit closer focusing with all lenses, including zooms, and require no exposure compensation. The higher the number of a plus diopter, the closer you can focus. As power increases, however, the quality of the image deteriorates. It is better to use a longer focal length lens with a less powerful diopter than a shorter focal length with a more powerful diopter. For best results, close down the lens a few stops.

Diopters may be combined to increase power. Place the higher-power diopter closer to the lens. A +2 diopter combined with a +3 diopter has the same power as a +5 diopter. The convex side of the diopter should face the subject. If an arrow is marked on the diopter mount, face it toward the subject.

Split Field Diopters

Split field diopters are usually half clear glass and half close-up diopter. These diopters allow half the frame to be focused on far distances and half to be focused at close distances. Frame the distant objects through the clear glass, the close ones through the plus diopter. The area between the two parts of the diopter will be out of focus and, for the shot to be successful, should be an indeterminate field (see Fig. 3-14). Carefully compose the shot on a tripod and use a reflex finder. If the diopter is used in a matte box (see p. 88), it may be positioned so that an area greater or less than half the frame is covered by the plus diopter.

3. To calculate the exposure compensation for an object at a distance of S times the focal length, the effective *f*-stop is equal to the *f*-stop engraved on the lens multiplied by $S/(S - 1)$. If the object is three times the focal length away, then $S = 3$ and *f*/8 would have an effective aperture of $8 \times 3/2$, or *f*/12. Some macro lenses have the exposure compensation engraved on the lens barrel. When the image reproduction ratio is 1:1 or greater, many lenses will improve their optical performance if reversed (rear element facing the subject). Adaptors are sometimes available. Special lenses corrected for close-up work yield superior images.

FIG. 3-14. Extreme depth of field is possible in carefully set-up shots with a split field diopter mounted on the lens. The nondescript field between the two billiard balls obscures the border between the two halves of the diopter. (Tiffen)

Matte Boxes, Lens Shades and Filters

The Matte Box and Lens Shade

Use a *lens shade* (see Fig. 2-7) or *matte box* (see Figs. 2-5 and 3-10) to prevent stray light from hitting the front element and causing flare. A deeper matte box or shade gives better stray light protection. Matte boxes are often adjustable and should be adjusted as deep as possible without vignetting the image. Similarly, use a lens shade as deep and narrow as possible. Long focal lengths allow for a narrow shade. The shades for extreme wide angle are often so wide that they offer little protection from stray light.

CHECKING FOR VIGNETTING. To check for vignetting, make sure you can see into each corner of the frame. Place a pointed object—a pencil or finger—parallel to the front surface of the lens, and move it toward each corner of the image. If you cannot see the end of the object through a reflex finder because the corners are dark, there is vignetting. Try this test at close focusing distances and, with a zoom lens, at its widest angle. This test can also be made at the focusing distance and focal length for each particular shot.

MATTE BOXES. Matte boxes have slots that accommodate one or more filters. Often one of the slots rotates for filters like polarizers, split field diopters and special effect filters. Glass filters are expensive; with a matte box, one set of filters can be used for different lenses. Gelatin filters can be mounted in frames that fit into the slots.

Use mattes in the matte box for special effects; for example, a key hole matte simulates looking through a keyhole. A mask that blocks half the frame in one shot and the other half when the film is exposed again lets an actor play two roles in one shot. Matte boxes are sometimes used for superimposing titles on live action, especially in Super 8.

Matte boxes are fairly large, cumbersome and too intimidating in most documentary settings. If the front element of the lens does not rotate during focusing, a lightweight matte box can be attached to the lens itself although most are attached to the camera body. With a thick *optical flat* (clear glass) they help suppress camera noise.

LENS SHADES. A glass filter can usually be mounted between the lens and the lens shade. On some shades a filter can be dropped in place. Some shades have provisions for rotating a filter. Lens shades are avail-

able in metal, hard plastic and soft rubber. Rubber shades are collapsible and cause less shock if inadvertently hit. Lens shades often act like a megaphone, increasing camera noise in the direction of the subject. Rubber shades minimize this effect.

Rectangular lens shades work more efficiently for their size but can only be used on those lenses with nonrotating focusing mounts.

Mounting Filters

Most special effect filters—star, multi-image, diffusion and fog filters, as well as polarizers—are used in front of the lens. (See Chapter 4 for more on filters.) Colored and neutral density filters may be placed either in front of or behind the lens. If the orientation of the filter matters, as it does with star filters, polarizers, graduated neutral densities and split field diopters, a matte box or a lens with a nonrotating front element will make things simpler.

Filters are manufactured in glass or in gelatin *(gels)*, or as gelatin sandwiched between glass. Colored filters fade over time. Gels fade the fastest and should be fairly fresh. Store them in a cool place to increase shelf life.

GELS. Gelatins—sheets of dyed plastic—are the least expensive filters. Gelatins can be used behind the lens or mounted in a frame and placed in a matte box. Some cameras have a behind-the-lens slot for them, and there are adaptors for mounting gels on the rear of the lens. Gels are extremely vulnerable to scratching and crimping. Dust can sometimes be blown off them but cannot be wiped off. Cut the gel carefully to size, so that it fills the gel holder completely and will not shift while filming. Handle gels in paper or only by their edges, preferably with tweezers.

When a gel is mounted behind the lens, it refracts light and moves the focal plane back about one third the thickness of the gel. If the lens is wide angle (about 12mm or wider in the 16mm format) and the aperture wide, depth of focus is so narrow that the image may be thrown out of focus. If you plan to use behind-the-lens filters, have the flange focal distance adjusted by a competent technician to compensate for the change. You must then always use a clear gel when not using another filter.

There can be serious problems when you use gels behind the lens. The closer the gel is to the film, the more likely it is that physical imperfections and dust will show up on the film. The longer the focal length of the lens or the more a lens is stopped down, the greater the chance of gel defects showing up on the image. On some cameras the gel is placed behind the reflex mirror shutter, so that the viewfinder does not show whether the gel has shifted out of place or not. Check cameras with behind-the-lens slots often to make sure that no one has inserted an

unwanted gel, that a gel has not shifted position or that the gel is not damaged. When you mount a gel in a matte box, it should lie reasonably flat.

GLASS FILTERS. Glass filters are the most durable (they are also the most expensive) and can be cleaned of fingerprints, dust and the like. The filter should be of an optical quality comparable to the lens. Gels sandwiched between glass are generally of lower quality. Dyed glass filters should have an antireflective coating (coated filters). Glass filters, unless of the highest quality, may impair the image. It is not sensible nor economic to use an expensive lens and a poor-quality filter. You can check the quality of the filter with a collimator; if there is a noticeable loss of resolution, use a higher quality filter. To avoid an unwanted optical phenomenon known as Newton's rings, do not mount two or more glass filters so that their surfaces touch.

Sometimes cinematographers place a glass filter over the front element of the lens to protect it from scratches or from poor environmental conditions, such as sand or salt spray. In these instances, use a high-quality coated filter. Clear, 1A or haze filters will not alter image color or tonal rendition to any serious extent (see Chapter 4).

Glass filters come in a variety of sizes, sometimes designated in millimeters and sometimes by series size in Roman or Arabic numerals. Different lenses may take different size filters.

ADAPTOR RINGS. Most lenses accept an adaptor ring that screws into the area around the front element or slips over the barrel for mounting glass filters in front of the lens. The filter of appropriate size is then secured with the lens shade or another adaptor ring. A retainer ring lets you mount two filters. Use step-up rings to mount a large filter on a smaller lens.

To remove tightly screwed retainer rings, extension rings and the like, use light pressure. Too much pressure distorts thin rings from the round, making removal more difficult. A solvent such as carbon tetrachloride may have to be used for a particularly stubborn ring. In general, whenever you screw threaded rings, be careful to screw them properly (cross threading damages the threads). The need to force a threaded ring is a sign of misthreading.

Care of the Lens

Keep the lens mount clean. Both camera and lens mating parts must be free of dirt and dust to ensure proper seating of the lens, especially zoom and wide angle lenses. If necessary, clean the mount with a soft cloth. Shocks, prolonged vibration and extreme heat can loosen an ele-

ment. In temperatures above 100° F, the mounting cement loosens and vibrations are particularly dangerous. Remove lenses from the camera when shipping, and pack them in fitted, foam-lined cases.

When a lens is not in use, cover the front element with a lens cap to protect it from dust and fingerprints. Use a rear element cap when the lens is not on the camera.

Dust on the Lens

Dust on the lens lowers contrast. It may be blown off with a rubber syringe of the kind that can be purchased at a pharmacy or with small containers of compressed air (like Dust-Off or Omit). Avoid compressed air that may have oil droplets in the spray. Tip the lens down when blowing dust off. Some cinematographers blow softly on the lens to remove dust, but take care not to blow saliva on the element since it is harder to remove than dust.

If air does remove all the dust, use a *clean* camel hair brush, reserved for the sole purpose of lens cleaning. Avoid touching the bristles since oil from the hand will stay on the hairs. An alternate method is to fold *photographic lens tissue* over itself several times, tear off an edge and lightly brush the element with the torn edge. Do not *rub* a dry element with the lens tissue for you may damage the lens coating.

Fingerprints on the Lens

Oil and fingerprints are more difficult to remove and, if left on the lens, can etch themselves into the coating; remove them as soon as possible. First, remove dust from the lens as described above. Use photographic tissue—*not* eyeglass or silicone-coated tissue, which may damage the coating. Never rub tissue on a dry lens. Breathe on the lens to cause condensation. Rub the tissue as gently as possible, using a circular motion combined with a rolling motion to lift any dirt off the element. To avoid grinding grit into the coating, continually use a clean portion of the tissue. Whenever the condensation evaporates, breathe on the lens again.

For particularly stubborn fingerprints, apply lens cleaning solution *to the tissue*. Take care the solution does not come into contact with the area where the element meets the barrel, since it may loosen the element. After moistening the element, use a dry tissue as described above (only rubbing a moistened lens).

Checking Focus and Collimation

In addition to various tests discussed in this chapter and viewfinder tests discussed in Chapter 2, there is a simple test to check the accuracy of a reflex focusing system and the seating of a zoom lens. Tape an

opened newspaper on a wall and draw a heavy black vertical line down the center. The newsprint makes it easier to judge focus. Point the tripod-mounted camera toward the newspaper at a 45° angle, filling the frame with the newspaper (in the case of a zoom lens, at the widest angle). Focus the lens carefully on the black line with the lens wide open and run the film. With a zoom lens, focus at the longest focal length, hold for a few seconds, and then zoom to wide angle stopping for a few seconds at different focal lengths. Examine the developed film to make sure that the black line is in focus and that a region on either side is in focus. If they are not, the camera's focusing system needs to be checked by a technician. If focus shifts during the zoom, the lens may need to be seated properly, may need internal repair or this may be due to the use of a behind-the-lens filter (see Gels, p. 89).

4

The Film Image

Unexposed film is called *raw stock*. After you choose the film gauge—super 8, 16mm or 35mm—the raw stock determines much of the look of the film. Consult the laboratory for advice on obtaining the look you want.

Properties of the Film Stock

Developing the Image

The top layer of the raw stock, the *emulsion,* consists of the light sensitive material, *silver halide crystals* suspended in gelatin. The crystals vary in size, the larger ones being more sensitive to light. Exposure to light forms a *latent image* in the emulsion. The latent image becomes visible when the film goes through the *developer,* a solution that reacts chemically with those silver halide crystals that have been exposed and reduces them to *metallic silver,* which is opaque to light. At a later stage in the development process, crystals that have not been exposed to light are removed from the emulsion by another solution, the *hypo* or *fixer*.

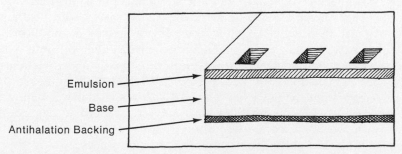

FIG. 4-1. A cross section of film. The antihalation backing, which on some stocks is between the emulsion and base, is removed during processing.

The areas of the emulsion most exposed to light end up with the greatest concentration of metallic silver. These are the densest, most opaque areas; they appear dark when you project light through them. Conversely, areas that receive little light end up with less metallic silver and are relatively transparent. This is a *negative film*. On the negative, all the brightness values in the original scene are reversed: what was dark in the scene becomes light (transparent), and what was light becomes dark (dense).

FIG. 4-2. The negative. Figure 4-7 shows the positive image. (Ted Spagna)

The emulsion rests on a binder that allows it to adhere to a firm, flexible support material, the *base*. All currently manufactured stocks have a *safety base*, usually of cellulose or acetate, that is not flammable. Stocks are also available on a synthetic base, such as polyester, which is thinner and stronger than cellulose. Standard cement splices do not work on polyester base. In such cases, splicing is done with either tape or a special fusion splicer. Polyester base film is used for single 8 and sometimes in high-speed cinematography because of its strength and thinness. Similarly, release prints on polyester base can withstand rougher handling and take up less storage space. Film on a polyester base may damage machinery, however, since the film often does not break during an equipment malfunction, putting pressure on the machine parts.

Bright light can pass through the emulsion, scatter in the base, reflect off the back of the film and re-expose the emulsion; this is known as

halation. Most camera stocks incorporate an *antihalation backing* in the emulsion to absorb these unwanted light rays. Even so, a bright light source in the subject will often show a halo in the image due to halation.

The Negative-Positive Process

In the process discussed above, the exposed raw stock became a negative image of the photographed scene after development. If you make a print of the negative, using essentially the same process to reverse the tonalities again, you end up with a *positive* of the original scene. In the positive, bright areas of the scene end up light (transparent) and dark areas end up dense. Thus you reverse the tonalities of the original scene twice to produce an image that looks normal. The negative-positive process is, at this time, the standard for film development in 16mm and 35mm filmmaking.

The Reversal Process

Reversal film uses a different development process from negative and yields a positive image that can be directly projected without the need of a print. A reversal print can be made of the reversal original to yield a print in one step.

The key to the reversal process lies in the development of the image.

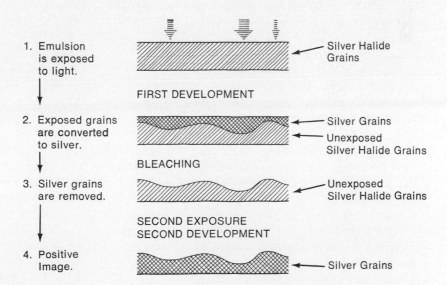

FIG. 4-3. Reversal development. A cross section of the emulsion shows the various steps in processing. The arrows at top represent varying degrees of exposure.

The film is exposed to light in the camera to form a latent image. As in the negative process, the developer reduces the silver halide of the latent image into metallic silver. Whereas in the negative process, the remaining (unexposed) silver halide crystals are washed away in the hypo, in reversal development the *metallic* silver is removed by immersing the film in a *bleach,* leaving the unexposed silver halide crystals, which are still light sensitive, in the emulsion. The film is then uniformly exposed to light (or immersed in a chemical fogging agent), exposing the remaining silver halide. It is then redeveloped in a second developer, and fixed again in the hypo. Thus, light areas in the subject build up heavier densities that get bleached away, leaving relatively little silver halide behind. These are then exposed to light and developed, leaving a transparent region on the film. Light areas of the subject end up transparent on the film, and, similarly, dark subject areas build up greater densities on the film and are more opaque (see Fig. 4-3). Thus, the reversal process maintains the relative brightness values of the original scene.

Reversal film is the standard super 8 process. It was also the standard process in 16mm until the early 1970s, when Eastman Kodak introduced an improved color negative film.

The Characteristic Curve

A rudimentary knowledge of characteristic curves will help in understanding the practical aspects of exposure, which are discussed in detail in Chapter 5. The *characteristic curve* for an emulsion is a graph that shows the relation between the amount of light that exposes the film and the corresponding density built up in the film. To plot the curve, the film is exposed to progressively greater quantities of light in constant increments. The film is then developed, and the densities are measured. For negative stocks, the greater the exposure, the greater the density, whereas for reversal the greater the exposure, the *less* the density. Exposure is plotted along the horizontal axis and density along the vertical axis (see Fig. 4-4).

Even when the film receives no exposure, some density is built up. The base itself has some density (it absorbs some of the projected light), and the development process adds an overall light *fog* to the film (some unexposed silver halide gets converted to metallic silver). This is the minimum density of the film. For black-and-white film, it is called *base-plus-fog* and for color film *D-min* (for minimum density).

In the negative process, increases in exposure do not increase the density above base-plus-fog until the *threshold* of the emulsion, the point where the curve starts to rise, is reached (point B in Fig. 4-4). Even though a dark area in the subject emits some light, if it falls below the threshold of the film, it will not produce any change in the density. That

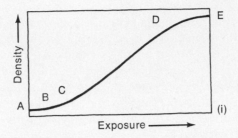

FIG. 4-4. Characteristic curves. (i) A simplified black-and-white negative characteristic curve: Point A is the base-plus-fog density; B to C is the toe; C to D is the straight line portion; D to E is the shoulder. (ii) A reversal characteristic curve. The greater steepness of the curve shows the higher contrast of reversal stock. (iii) A very high contrast black-and-white negative stock used for titles.

area produces minimum density, will show no detail and will appear in a positive print as undifferentiated black.

The *straight line section* of the curve (C to D in Fig. 4-4) is the portion where a given change in exposure produces a constant change in the density. The *toe* of the curve (B to C) is the area of lowest densities—usually the darkest shadows that show some detail—where constant increases in the exposure do not lead to proportional increases in density. The densities here increase more gradually than they do in the straight line section; the slope in the toe is thus less steep (slower rising) than in the straight line section. The *shoulder* (D to E), like the toe, is a flatter curve than the straight line section. Again, constant increases in exposure do not lead to constant increases in density. At point E, increases in

exposure do not cause any increase in density. This is the maximum density *(D-max)* possible in this film.

If an area of the subject gets exposed high on the shoulder, differences in brightness will not be recorded as significant differences in density. For example, a white wall may be three times as bright as a face, but if both expose high on the shoulder, the difference in their densities will be insignificant. In a positivè print (or the reversal original), this area will appear as an undifferentiated white *(blocking of the highlights)*.

Shadows will show no detail if they fall near the film's threshold, and highlights will show no detail if they fall too high on the shoulder. Generally, for correct exposure, the important parts of the subject that should show good tonal separation must fall on the straight line section. Shadow and highlight values may fall on the toe and shoulder, respectively, but, if you want some detail, they should not be too close to the outer limits.

Characteristic Curves for Color Film

Modern color film stocks are composed of three emulsion layers; each layer is similar to a black-and-white film emulsion. The top layer is only sensitive to blue light (and records the blue *record,* or blue part, of the scene). The second layer records the green record; the bottom, the red record. All the colors rendered by the film are created from a combination of the record of these three primaries (see Color and Filters, below, for further discussion on primaries).

Incorporated into each of the three emulsion layers of a color stock is

Fig. 4-5. Color negative before (i) and after processing (ii). Yellow and red couplers are found in the green- and red-sensitive emulsions to compensate for deficiencies in color absorption of the magenta and cyan dyes.

FIG. 4-6. Characteristic curve for color negative. The three curves represent the three layers of a color emulsion.

a distinct group of *dye couplers* that release dyes of the appropriate color during development (see Fig. 4-5). The more exposure a particular emulsion layer receives, the greater the density of the metallic silver in that layer and the more color dye that remains after development. Most of the metallic silver, along with the unused dye, is bleached away during developing. The three color layers will be recorded with the dye color of each layer's complementary color (see Color and Filters, p. 121). The blue, green and red record will be recorded with dyes colored yellow, magenta and cyan, respectively.

Because of imperfections in the absorption of color dyes, additional colored dye couplers are incorporated into the emulsion of color negative films. They form a *color masking* to compensate for unwanted dye absorption. The masking gives color negative its characteristic overall orange appearance. Reversal films have dyes that absorb their complementaries more accurately and thus have no need for color masking.

A color emulsion is represented by three curves, one for each emulsion layer (see Fig. 4-6). The curve closest to the horizontal axis (the red curve in Fig. 4-6) represents the color most susceptible to underexposure, and the highest curve (the blue), the color the most susceptible to overexposure. Underexposure or overexposure of only one of the layers can cause a color cast in underexposed shadow or overexposed highlight areas.

Contrast of the Image

Contrast measures the separation of tones (lights and darks) in an image. The higher the contrast, the greater the separation between tones (see Fig. 4-7). The steepness of the characteristic curve (mathematically, the *slope*) indicates the amount of contrast at any point on the curve. The steeper the curve, the higher the contrast and, thus, the greater the separation of tones. The straight line section is steeper than either the toe or the shoulder portions, so areas of the subject that are exposed on the

FIG. 4-7. Increasing the contrast of an image. (left) The image is flat and dull. (middle) The image has normal contrast. (right) The image has high contrast. (Ted Spagna)

straight line section will show more tonal separation (contrast) than areas that fall on the toe or shoulder.

Low-contrast images, images without good tonal separation, are called *flat* or *soft* ("soft" is also used to mean not sharp). High-contrast images are called *contrasty* or *hard*. An image with good contrast range is sometimes called *snappy*.

GAMMA AND FORCE PROCESSING. *Gamma* (γ, defined as the slope) is a measure of the steepness of the straight line section of the characteristic curve. Increasing gamma entails increasing the separation of tonalities that fall on the straight line section of the characteristic curve, that is, increasing contrast. Gamma depends on both the nature of the emulsion and the manner of development. Laboratories often talk about developing to a particular gamma. A higher gamma results from increasing the time or temperature of development. Increasing gamma also increases the sensitivity of the film to light (raises the ASA number, see p. 104), and, when done for this purpose, is called *force processing* or *pushing*. A film may be intentionally underexposed when there is insufficient light (for example, a film rated ASA 100 is exposed as though it were rated ASA 200 to push one stop), and the lab will compensate for the underexposure in development. Some stocks are pushed one to three stops, but force development increases graininess, sometimes to a degree that makes the image unacceptable (see the discussion on specific raw stocks, p. 110).

Pushing increases contrast because areas in the scene that fall on the straight line section and the shoulder increase in density more than those

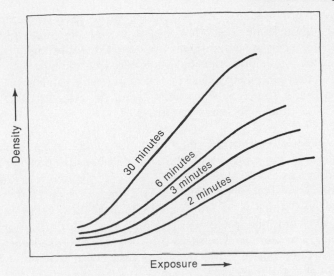

FIG. 4-8. Characteristic curves and time of development (force processing). As the development time increases, the curve becomes steeper (contrast increases) because the brighter parts of the scene (right side of graph) respond more to increased development than the darker parts. Fog level also increases with development time.

on the toe (see Fig. 4-8). Shadow values that fall on the toe will not significantly increase their densities, so pushing will not result in much more detail in the shadows. Middle tones and highlights, on the other hand, will show significant increases in density.

When reversal stocks are pushed, the blacks often become muddy and look grayish (a lower D-max). This is because pushing increases the fog level in the first developer, and the increased density due to that fog is bleached away, lowering density at the end of the processing procedure. Pushing does not generally raise the threshold of the film, that is, if shadow values fall below the threshold, pushing will not render any more detail. When we are concerned with "seeing into the shadows," stocks with long flat curves do best; pushing helps little. Some alternate processing methods, like Chemtone for color negative, will change the film stock's response to shadow value (see also Flashing, p. 103).

TWO ASPECTS OF CONTRAST. To get a general idea of the effect of altering contrast, try playing with the contrast control on a television set. An example of very high gamma can be found in a Xerox copy of a photograph. A characteristic curve of a Xerox copy would have a very steep straight line section—almost vertical (the reversal equivalent of Fig. 4-4 iii). Dark areas in the original are rendered black, and slightly

lighter areas are rendered white; nothing prints gray (no mid-tones). However, although the Xerox has a high gamma, if it does not have a rich black and a bright white, the overall contrast will probably seem low to the viewer. To demonstrate this, try Xeroxing the same photograph onto white and then blue paper. Thus, it is not only gamma but also the range from black to white, sometimes called the *contrast range* of the image, that determines its overall contrast.

CONTRAST AND EXPOSURE. Even though the gamma of force-processed reversal film is high, it often looks flat and dull because pushing fogs the blacks and makes them lighter, thereby reducing the contrast range. Underexposed film usually looks dull because important parts of the scene fall on the toe, which is of low contrast, and shadow areas fall below threshold and show no detail. On reversal film, the darkest areas will print black. However, on a positive print of underexposed negative the darkest areas are usually gray, since less printing light must be used to preserve what detail there is in the image (see Chapter 10).

When film is overexposed, highlights bleach out, faces look pasty, and deep blacks are lost. "Printing down" when the lab makes a print from overexposed negative *may* yield a bright white and a rich black, but will usually not restore much detail in the highlights. Printing overexposed reversal usually requires sacrificing a bright white. In general, correct exposure uses the full range of densities and results in an image of good contrast (see Chapter 5).

CONTRAST AND FILM STOCKS. Negative films usually have longer, more gently sloped characteristic curves than reversal films, which means they can handle a greater range of brightness in the scene (they have a greater *exposure range;* see p. 103). When you film an interior scene that includes bright windows, reversal film, unlike negative, will usually not be able to show detail in both the dark interior and the bright window (see Chapter 5).

Most reversal stocks (Ektachrome Commercial is a notable exception) are made for *direct projection* without making a print first. These stocks have a high overall contrast so that average scenes look correct when the original is projected. However, when printed, they often show too much contrast. If one of the higher contrast reversal camera stocks has been used, it is often necessary to go through an internegative to get a print of proper contrast (see Chapter 14).

OTHER FACTORS. A low-contrast lens or flare in the lens (see Chapter 3), either in the camera or projector, can make the image look flat. During projection, any stray light in the room will also cause loss of overall contrast. For example, suppose the darkest part of the screen reflects 1 unit of light and the lightest 100 units, making the overall ratio 100:1. If

someone opens a door and lets 2 units of light cover the screen, the darkest area now reflects 3 units (2 + 1) and the lightest 103 (100 + 3), a ratio of about 34:1, which is a significant drop in overall contrast.

Flashing

Gamma can be increased via force processing, which affects the rendering of bright areas in the scene more than it does the dark areas. Gamma can be lowered by underdevelopment and also by *flashing*, a process in which the film is uniformly exposed to a dim light either before *(preflashing)* or after *(postflashing)* the scene is photographed. This exposure raises base-plus-fog density (or, in reversal, it lowers D Max) and increases the exposure of shadow areas, but it has little effect on the bright areas. It thus lowers the contrast between shadow and highlight values.

The effect of flashing is similar to the screening room example given above. On negative film, two units of exposure from the flashing may double a shadow density while having almost no effect on higher densities. The contrast range of the image is thus reduced.

When two stocks of different contrast are used on the same film (especially when they are used for the same scene), the contrastier stock is sometimes flashed to better match the lower contrast film. Flashing also provides detail in some shadow areas that would otherwise be rendered as black, since it may give them enough exposure to be boosted over the threshold. Flashing can thus be used like pushing to increase the sensitivity of film to light. Unlike pushing, however, it does not increase contrast and it affects the darker, rather than the lighter, areas of the scene. When used for this purpose, flashing is sometimes called *latensification* (from intensifying the latent image). Do not expect much increase in film speed —depending on the stock, at most a half-stop or so. Printing stocks may also be flashed.

You may not like the way flashing increases graininess, desaturates colors and imparts a milkiness to the image, especially in the shadow areas. Be sure to consult your laboratory and make tests before flashing important footage.

Latitude

Latitude is a measure of the margin of acceptable exposure error with a film stock in a particular lighting situation. A film with the largest useful *exposure range* (which is usually represented by a characteristic curve with the longest straight line portion) will provide the most latitude (see Chapter 5). If underexposure or overexposure exceeds the latitude of the film, important shadow areas or highlights will be rendered without detail. A typical color negative stock has an exposure range of about seven

stops, while most reversal films can handle five or six stops. With an average subject, the color negative might allow one to one and a half stops of underexposure or two or more stops of overexposure. A color reversal film might have only a stop or less latitude at either end, although Kodak's Ektachrome Commercial might allow almost two stops error. As discussed above, some exposure error can be corrected when the film is printed, but this will affect the contrast or graininess of the image.

Film Speed and ASA

The *speed* of a stock is a measure of its sensitivity to light. The *exposure index* expresses the speed as a number that can be used with exposure meters to help determine proper exposure. The film manufacturer recommends an exposure index for each stock that is usually given in the form of an *ASA number* (American Standards Association, now American Standards Institute or ANSI). It is printed on the data sheet and often on the film's packaging. The metric equivalent is a DIN number marked with a degree sign. An *ISO number* (International Standards Organization) gives the ASA number first, then the DIN number (for example, ISO 64/19° means ASA 64, DIN 19).

A medium-speed emulsion will be rated around ASA 100. ASA speeds below 40 are usually considered *slow*. *Fast* or *high-speed* emulsions are rated ASA 200 or higher. Doubling the ASA number means that the film will be twice as sensitive to light. A film rated at ASA 100 needs only half the exposure (that is, one stop less) than a film rated ASA 50. The faster film can be used in conditions with less light or to allow a smaller iris opening on the lens.

Black-and-white emulsions are sometimes rated by two exposure indexes, one for tungsten illumination and the other for daylight. The tungsten rating is generally about one third of a stop slower than the daylight rating, representing the emulsion's lower sensitivity to the red end of the spectrum.

The manufacturer's recommended exposure index is intended as a starting point. It is not unusual for cinematographers working with a lab they know well to rate the film at a slightly different ASA. Sometimes the latitude of a stock will allow you to change the ASA. Color negative stocks are sometimes underexposed one full stop (the equivalent of doubling the ASA number) to gain more speed without force processing. When you are force processing, change ASA speed on the light meter for exposure calculations. When pushing one stop, double the ASA number; when pushing two stops, multiply it by 4.

Sharpness

Definition, or *sharpness,* expresses the degree of clarity in an image. There are several physical measurements that more or less correspond to the viewer's evaluation of sharpness.

Resolution

Resolution, or *resolving power,* is the ability to record fine detail in the image. Resolution is measured by photographing a test chart with sets of parallel lines in which the space between the lines is equal to the thickness of the lines, the thickness progressively diminishing. The image is then examined under a microscope to determine the greatest number of lines per millimeter that can be distinguished by the eye.

Resolving power is of limited use for predicting the viewer's evaluations of sharpness since those evaluations are highly dependent on the contrast in the image—the higher the contrast, the sharper the image appears. An image may have a very high resolution, say, 100 lines/mm, but will not appear to be sharp if the contrast is excessively low. Bear in mind that resolution measures small details that may not be as important to the eye as larger areas in the image.

Acutance

Acutance was introduced to remedy the limitations of resolving power as a measure of sharpness. It measures the ability to reproduce clean boundaries in the image. To measure acutance, a portion of the film is shielded from exposure by a straight edge. In an ideal situation, the line between exposure and no exposure would be reproduced as a knife edge with a sharp change in density. Actual stocks, however, change density gradually. The more rapid the change, the higher the acutance and the sharper the emulsion. To the eye, the sharp boundaries between the larger areas of the image (measured by acutance) are usually more important than the very fine detail (measured by resolution).

Modulation Transfer Function (MTF)

Acutance has largely been replaced by *MTF* as a measure of sharpness. MTF measures the "noise" in the photographic system. If you were to examine a small area of the image, you would see that some of the variations in light and dark are caused by differences in brightness in the scene. However, some of the variations are due to lens or film imperfec-

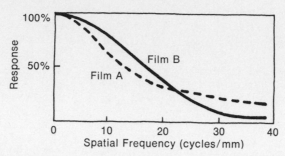

FIG. 4-9. The MTF of two stocks. Although film A (resolving power—100 lines/mm) resolves better than film B (46 lines/mm), film B may appear sharper, since it renders the larger details better.

tions that result in light spilling from a lighter to a darker area. MTF measures the loss of image quality due to graininess, light scatter in the film emulsion, and aberrations in the camera or projector lens. MTF encompasses the aspects of both resolution and acutance that contribute to evaluations of sharpness.

To measure the MTF, a test pattern of alternating light and dark strips, with distance between the strips decreasing, is photographed on film. As the light and dark areas become closer, the emulsion tends to average out the light and dark and the contrast range of the original pattern is decreased. MTF compares the spatial frequency (the distance between light and dark areas, measured in cycles per millimeter) with the accuracy of the response of the emulsion (expressed as a percentage—100% being perfect accuracy). The response at the lower spatial frequencies, around 10 to 20 cycles/mm, closely corresponds to measurements of acutance, while the response at higher spatial frequencies closely corresponds to resolving power (see Fig. 4-9). The data sheet for a raw stock generally includes an MTF curve.

Resolution, acutance and MTF can be used to evaluate any part of the photographic system (for example, film, emulsion or projection), but MTF alone can predict the sharpness of a combination (say, lens and emulsion) from the MTF of each component. A lens that showed a high response at one spatial frequency would lose its advantage when combined with a stock that showed low response at the same frequency. Some lens manufacturers claim their lens' MTF complements Eastman Kodak's color negative stock, maximizing the potential of each.

Graininess and Granularity

The photographic image is composed of small grains of metallic silver, or, in the case of color films, masses of dye that occupy the areas where metallic silver was formed during the development process. When a sin-

gle frame is enlarged, it will show the roughness caused by these grains or dyes. The viewer's perception of this roughness is called *graininess,* and the objective measurement that attempts to quantify it is known as *granularity.*

A uniformly exposed and developed sample is scanned at great magnification to record density variations. A count of these variations gives a numerical value expressed as RMS granularity. A difference of 6 percent is barely noticeable. Figures range from under five for some color negative stocks to eighteen for some black-and-white stocks. Some manufacturers, like Kodak, publish the RMS granularity figure on their data sheets.

Graininess is usually considered to be an undesirable component of a film system, but different grain structures create a look that in some stocks, even those with high granularity, may be considered pleasing. You may like a sharp, clear grain in black-and-white. Some grain structures on color film look beautiful, while others merely impair the image.

Every emulsion has a built-in graininess for any particular development process, which is what granularity measures. In general, faster films are made up of larger silver halide crystals and thus appear grainier. *Fine grain emulsions* are found in slower film stocks. Black-and-white reversal films often exhibit less grain than negative films, because the larger, more light sensitive grains are exposed first and then washed away during the bleaching stage, leaving the finer grains behind.

Graininess in black-and-white is fundamentally different from graininess in color. Black-and-white grains are made of metallic silver, which is opaque to light. In color film, the grain pattern results from uneven distribution of silver grains that are replaced by dyes during development. The dye itself is transparent to light. Generally, slightly overexposing color negative film results in less graininess, whereas in black-and-white overexposure causes an increase in graininess. Color negative films are significantly less grainy than comparable speed color reversal emulsions.

Storage conditions of the raw stock or exposed undeveloped film can affect graininess. High temperatures or long storage periods cause more silver halide crystals to convert to metallic silver in development, resulting in more fog and grain. Force processing or increased contrast also make the image grainier.

Graininess, but not granularity, varies with subject matter. It is most readily seen in large areas of uniform density. A blue sky that is not overexposed and bleached out will show more graininess than the landscape. Color negative usually shows the most grain in uniform shadow areas that do not print as deep black.

Sharp images divert the eye from the grain: graininess is most apparent in blurry images. The most problematic aspect of graininess in motion picture film is that the grain is in motion during projection. Granularity does not measure this dynamic aspect of graininess.

Choosing a Raw Stock

Black-and-White versus Color

Color stocks have improved to the point where most filmmakers use them for all their work. Audiences expect a film to be in color, black-and-white now seeming to have an old-fashioned or historical look. But precisely for this reason—as well as the fact that black-and-white films have longer storage lives—did Martin Scorcese shoot his feature *Raging Bull* in black-and-white.

The ascendancy of color in the film industry makes it difficult to find laboratories that do high-quality black-and-white work. Black-and-white, when properly handled, can be exhilaratingly beautiful, but good contrast is the key to this beauty. When the blacks turn muddy or there are no clear whites, the image looks dull. On the other hand, a print with too much contrast has a short tonal range and looks harsh.

Part of the aesthetic challenge of black-and-white is to render the world through the range of gray tones from black to white. Some people think black-and-white gives a realistic look while others feel that it presents an abstract image of the world.

Lighting tends to be more difficult in black-and-white, because there is no color contrast to give snap to the image. For example, in black-and-white, a green leaf and red apple may photograph as the same gray tone showing no contrast, whereas in color they would be strongly differentiated. The Hollywood lighting style for black-and-white includes a rim light to guarantee a strong contrast between subject and background (see Chapter 9).

In the late 1960s, improvements in color stocks allowed filming in available light situations. Previously there were many technical advantages to shooting with black-and-white. For example, black-and-white film had higher speeds, and color film tended to be garish. Color negative now is less grainy, is available in high-speed emulsions, has a great deal of latitude and allows a fair amount of control in the printing. Using black-and-white film may lower stock and laboratory costs by one third, but due to the popularity of color films, they may be more difficult to distribute.

Negative versus Reversal

When minimizing costs is essential, you may choose to shoot reversal. Reversal camera original can be projected without making a print, sparing

you the cost of a workprint. Keep in mind, though, that projecting the original is not recommended (see Chapter 11).

Most reversal stocks are manufactured to look best when directly projected. A reversal original often looks wonderful, but when a print is made the contrast increases and the image looks hard and grainy. This is particularly a problem in black-and-white. There are low-contrast companion printing stocks for color reversal, but they usually do not produce a good optical sound track. Maintaining a low lighting contrast ratio during shooting (see Chapter 9) will result in better contrast in the prints. Shooting black-and-white reversal in available light with no supplementary lighting to reduce contrast often results in prints with chalky white faces (blocked highlights) or shadows that show no detail.

Color reversal and color negative have different *palettes,* the term used for the range and quality of color available to the cinematographer (analogous to its use in painting where it refers to the colors available to the painter). Different color camera stocks in conjunction with their companion printing stocks afford the cinematographer a range of color saturation, purity and other color qualities.

Cinematographers often prefer negative stocks since they usually offer more latitude than reversal films and can handle more variety in lighting conditions. Lights of mixed color temperature are less problematic, and a greater range of color corrections can be made in printing.

Reversal film is easier to handle than negative film. Its emulsion is usually tougher and less susceptible to scratches. Dust prints as black on reversal, which is much less noticeable than the white sparkle that results from dust in the negative-positive system. Reversal color has proved less susceptible than negative color to the fading of dyes over time. Reversal also allows for selective workprinting since it is easy to examine the original and cull out unwanted footage. Reversal allows white superimposed titles to be burned in a print in one step, whereas on negative, titles are more expensive, often involving an additional printing generation, which lowers print quality (see Chapter 13). If you intend to use a lot of supered titles or subtitles, consider working in reversal film.

Film Speed

Film speed is often the key element in selecting the raw stock. In general, the faster the speed, the more flexibility you have. Not only is it easier to shoot in available light, but supplementary lighting need not be as bright, cutting lighting costs and creating a better environment for the actors. High-speed film stock allows the lens to be stopped down to increase depth of field. On the other hand, high-speed films produce a poorer quality image, with more grain and less sharpness. As a rule, you should select the slowest film that allows you either to shoot at a pre-

ferred *f*-stop (this is the usual practice in studio production) or to get an adequate exposure in available light situations (often the case in documentary productions). At this time, almost all theatrical productions use color negative films rated anywhere from ASA 100 to 400. Documentary cinematographers who shoot in unpredictable available light situations often look for the fastest film of acceptable quality. They sometimes use two different stocks, a slow speed for exteriors and a high speed for interiors.

Different stocks respond to force processing with radically different results; some show unacceptable graininess when pushed even one stop. A stock that responds well to force processing gives you flexibility when encountering unexpected low-light conditions.

Other Considerations

Some stocks have simple processing requirements, enabling a school or small production unit to do its own processing. Sometimes local labs process only certain stocks. Not all stocks are supplied with magnetic stripe. Some stocks have an invisible magnetic coating on the film for recording time code and other information (see Chapter 8).

Some color stocks are offered in tungsten and daylight emulsions. If you are shooting under both daylight and tungsten illumination, choose the tungsten stock since tungsten-balanced stock can be converted for daylight use by a filter that only loses two thirds of a stop where you would lose two full stops in converting daylight to tungsten. Daylight-balanced stocks sometimes prove handy in high-speed cinematography and when there is low-level daylight illumination, for example, in a window-lit interior.

Specific Raw Stocks

The following discussion of specific camera raw stocks is not meant to be exhaustive, but will give you an idea of the range of stocks available and some of their advantages and disadvantages. Several caveats should be kept in mind. Manufacturers frequently change the characteristics of an emulsion without changing its name. New, improved stocks are continually being introduced. Different laboratories will often make the same stock appear quite different in terms of color, grain and sharpness. This seems to be especially true with black-and-white reversal and Ektachrome Commercial. Consult other filmmakers and the lab for advice.

We emphasize the use of Kodak stocks because of Kodak's dominance in the industry. We do not mean to imply that stocks of other manufacturers should not be tried. Fuji and Agfa Gevaert stocks are often similar to Kodak stocks and may cost as much as 20 percent less.

Black-and-White

KODAK PLUS-X REVERSAL FILM 7276 (SUPER 8 AND 16MM, ASA 50 DAYLIGHT, ASA 40 TUNGSTEN). Plus-X reversal has a good tonal range and relatively little graininess. The original looks quite good, but, as is the case with most reversal stocks, it is often difficult to get prints of proper contrast. If you need more speed, use a higher speed film, since pushing reversal films muddies the blacks (lowers D-max) and increases the possibility of blocking the highlights.

KODAK TRI-X REVERSAL FILM 7278 (SUPER 8 AND 16MM, ASA 200 DAYLIGHT, ASA 160 TUNGSTEN) AND KODAK 4-X REVERSAL FILM 7277 (SUPER 8 AND 16MM, ASA 400 DAYLIGHT, ASA 320 TUNGSTEN). Tri-X reversal is two stops faster than Plus-X reversal. Tri-X maintains a good tonal range, and has more graininess and about the same amount of sharpness as Plus-X. 4-X reversal gains another stop and is good for filming in fairly low-light levels. From our experience, 4-X does not have as nice a tonal range as Tri-X or Plus-X. We have also found that pushing 4-X results in poor image quality. If you need speeds higher than ASA 400 in black-and-white, use a negative stock.

EASTMAN PLUS-X NEGATIVE FILM 5231 (35MM), 7231 (16MM) (ASA 80 DAYLIGHT, ASA 64 TUNGSTEN); EASTMAN DOUBLE-X NEGATIVE FILM 5222 (35MM), 7222 (16MM) (ASA 250 DAYLIGHT, ASA 200 TUNGSTEN); AND EASTMAN 4-X NEGATIVE FILM 5224 (35MM), 7224 (16MM) (ASA 500 DAYLIGHT, ASA 400 TUNGSTEN). Plus-X negative is the film of choice if you wish to approximate the beauty of older black-and-white films and wish to avoid the difficulties of printing and little latitude of the reversal process. Plus-X produces a beautiful tonal range and an image that is often luminous, but its low speed often makes filmmakers choose Double-X. In the 1960s, Double-X was often used for available light filming because of its high speed and great latitude. At that time, many labs processed it as a matter of course at ASA 400, with little loss in quality. The film is fairly grainy, and since the grain tends to mask clear tonal separation, it lacks the fine tonal range of Plus-X. Although 4-X negative is one stop faster than Double-X, we have found that Double-X looks better when it is pushed than 4-X when it is processed normally. There is an increase in grain in 4-X that seems to affect adversely the overall rendition of tonalities.

Color Reversal Stocks

Manufacturers include "chrome" in the name of the stock to indicate color reversal—Gevachrome, Fujichrome, Ektachrome. Most reversal

stocks are made for direct projection of the original with a 5400°K light source and may appear slightly red on a projector with a tungsten bulb (see Chapter 15).

EASTMAN **EKTACHROME COMMERCIAL FILM 7252 (16MM, ASA 25 TUNGSTEN, ASA 16 FOR DAYLIGHT WITH A #85 FILTER).** Also known as *ECO*, this Ektachrome yields a low-contrast original that has excellent companion printing stocks for making high-quality reversal prints. Unlike most other reversal stocks, ECO is *not* meant for direct projection of the original, since it is of low contrast and its emulsion is relatively soft, making it susceptible to scratching and cinching. ECO combines the advantages of the reversal process—that is, low grain and high sharpness —with high-quality printing. Its chief drawback is an abysmally low speed. It can only be used for exterior daylight work or in situations where there is a great deal of artificial illumination. In general, it is impractical to light any large area to a level where ECO can be shot. Some filmmakers use ECO for exteriors and high-speed reversal for interiors. Since the contrast (gamma) of these two stocks differ, the higher-speed stock is sometimes flashed to match the contrast of ECO. Because of its low contrast, ECO has a great exposure range. During the 1960s, ECO offered the best color possible in 16mm. Color negative at ASA 100, which is much faster than ECO, yet is as sharp and has very little grain, now fulfills this role. Some filmmakers, however, prefer ECO's pastel rendition of color.

KODAK **EKTACHROME EF FILM (TUNGSTEN) 5242 (35MM), 7242 (SUPER 8 AND 16MM), (ASA 125 TUNGSTEN, ASA 80 FOR DAYLIGHT WITH #85B FILTER); EASTMAN EKTACHROME VIDEO NEWS FILM (TUNGSTEN) 5240 (35MM), 7240 (16MM) (ASA 125 TUNGSTEN, ASA 80 FOR DAYLIGHT WITH #85B FILTER); EASTMAN EKTACHROME VIDEO NEWS FILM HIGH SPEED (TUNGSTEN) 7250 (16MM, ASA 400 TUNGSTEN, ASA 250 FOR DAYLIGHT WITH #85B FILTER).** EF and VNF 7240 are available in daylight-balanced versions: EF 7241 and VNF 7239—both are ASA 160 Daylight and ASA 40 Tungsten with a #80A filter. Although EF and VNF have the same film speed, the stocks require different processing and look quite different. VNF is simpler to process, allowing a small production company to do its own development. Both EF and VNF can be force processed from one to three stops, although results vary dramatically from lab to lab and are highly dependent on subject matter. Forcing by one stop should result in acceptable quality, but the increased grain is often considered unacceptable when pushed further than this. High-speed VNF 7250 is almost as grainy as 7240 when 7240 is pushed two stops (that is, to an equivalent ASA 400). The color of 7250 is more saturated (some would call it garish) and the contrast is higher than 7240. Pushing reversal tends to make the blacks muddy, but VNF 7250 produces good

blacks at its rated speed. All these stocks have little latitude (an error of one stop is often serious), which is further diminished by force processing. Some film magazines produce small metal filings when unscrewed that create *blue comets* on EF; these are blue spots that result from a reaction in the developer. The VNF films are manufactured to avoid this defect.

KODAK EKTACHROME SM FILM (TYPE A) 7244 (SUPER 8, ASA 160 AT 3400°K TUNGSTEN, ASA 100 FOR DAYLIGHT WITH #85 FILTER). This stock is only available in super 8. It is a *Type A* (that is, balanced for 3400°K, which is often thought of as an amateur illumination). *Type B* stocks (like 7242 and 7250) are balanced for tungsten illumination at 3200°K. Type A stock can be converted for use with 3200°K illumination by a #82A filter. SM can be processed in-house with a special processor such as the Kodak Supermatic 8. The stock is ·not designed for force processing. When you want to force process super 8 color, use EF.

Color Negative Stocks

EASTMAN COLOR NEGATIVE FILM 5247 (35MM), 7291 (16MM); FUJICOLOR COLOR NEGATIVE FILM (16MM AND 35MM, ASA 100 TUNGSTEN, ASA 64 FOR DAYLIGHT WITH #85 FILTER). GEVACOLOR NEGATIVE (SAME AS FUJICOLOR). Eastman Color Negative is rated ASA 125 in 35mm (ASA 80 with #85 filter for daylight) and ASA 100 in 16mm (ASA 64 with #85 filter for daylight). Although the films are essentially similar, underexposure is more serious in 16mm, so an additional margin of error is added in the ASA rating.

When Kodak in the early 1970s introduced its new color negative stock, ECN II, 16mm documentary and feature film production switched almost overnight from color reversal to the new ECN II. Whereas color negative had been the standard in 35mm work, improvements were needed to make it acceptable in 16mm. In 1983 Kodak introduced 7291 as an improvement on ECN II (7247).

All the color negative films offered by Kodak, Fuji and Gevaert have tremendous latitude, yielding a fine print with as much as one to one and a half stop underexposure and even more overexposure. Their useful exposure range is quite long—some seven stops. Their palette is rich and can yield colors ranging from saturated to light pastel depending on exposure and printing. A wide range of color correction can be made in printing. Many labs have no problems balancing an original shot under daylight illumination without an #85 filter (see below). The stocks of the different manufacturers differ slightly in color rendition, some having brighter blues and others accentuating greens.

Some color negative stocks do not respond well to force processing; the blacks become muddy, sometimes picking up a color cast, and, in

16mm, the image gets grainy and begins to "fall apart." Underexposure of one stop with no change in processing sometimes yields a superior negative to one that has been pushed.

EASTMAN COLOR HIGH SPEED NEGATIVE FILM 5294 (35MM), 7294 (16MM) (RATED ASA 400 IN 35MM AND ASA 320 IN 16MM TUNGSTEN, ASA 250 IN 35MM AND ASA 200 IN 16MM WITH #85 FILTER FOR DAYLIGHT). FUJICOLOR HIGH SPEED NEGATIVE (16MM AND 35MM, ASA 320 TUNGSTEN, ASA 200 WITH #85 FILTER FOR DAYLIGHT). Although not as sharp nor as fine grained as the slower negative stocks, the high-speed negative films are close enough in color rendition to be intercut with the slower-speed stock of the same manufacturer (although not necessarily in the same scene). They are not quite as generous on the underexposure side as the slower-speed negatives. Although force processing causes a marked increase in graininess, combinations of force processing and underexposure can yield a fair image at speeds like ASA 750. These stocks round out the color positive-negative system in such a way that we advise thinking first of using negative stocks for a production, except for reasons of economy in workprinting and making white superimposed titles.

Packaging, Handling and Purchasing

Perforations

Super 8 film is perforated on one side (*single-perforated*, or *single-perf*), while 35mm film is perforated on both sides (*double-perforated*, or *double-perf*). Film in 16mm may be single or double-perforated (see Fig. 1-3). Use single-perf film in any camera that has only one pull-down claw. Some very old cameras and cameras for special uses, like high-speed cinematography, have two pull-down claws and require double perforated film. Double-perf film can be used in any camera.

Double-perf film has a slight advantage over single-perf when cement splicing the original; otherwise, the choice of perforations is not important, unless you are doing single system sound recording—magnetic stripe 16mm is only single-perforated. If you are adding sound to a film, print onto single-perf. If sound will be added to the original, use single-perf.

The *pitch* of the perforations is the measured distance from the bottom of one perforation to the bottom of the next perforation. 16mm camera original for high-speed cameras sometimes has a slightly longer pitch (0.3000″ rather than 0.2994″) and may be marked high speed on the label.

Cores and Spools

Films in 16mm and 35mm are supplied on cores *(darkroom load)* or daylight spools (see Fig. 4-10). Daylight spools are used for the shorter stock lengths. Darkroom loads up to 400' are on a 2″ core, and over 400' on a 3″ core.

You should load daylight spools in subdued light since the more subdued the light, the less danger there is of fogging the edges of the film. Use the shade of a tree or go inside a building to avoid bright daylight. Integral head and tail leaders protect the unprocessed film from stray light. Unexposed film is wound on the spool so that stray light cannot penetrate to the inner layers easily; after shooting, it is not as protected. If the camera runs out of film during the shot *(run-out shot)*, unload the film in a changing bag to protect the tail of the shot. Spool-loaded film for 35mm is generally only available in 100', while 16mm film is supplied on 100', 200' and 400' spools. Some cameras, usually those with an internal film chamber, will only take 100' loads on a spool. Most 16mm magazines have both core and spool adaptors. Core-mounted film is lighter than film on spools and, unlike 200' or 400' spools, rarely makes an annoying scraping sound in the magazine.

Raw stock supplied on a polyester base (like Kodak's Estar base) is thinner and allows 25 to 100 percent more film than a load of equivalent size on an acetate base. Raw stock may be ordered in special lengths on cores or spools, but the film manufacturer will require a minimum order and charge a higher price.

THE CHANGING BAG. Always handle unprocessed, core-mounted film in total darkness. Use a changing bag when a photographic darkroom is not available. A production unit usually relies on a changing bag for loading and unloading film on location. The bag is double zippered and lightproof. Bring the sleeves above the elbows to avoid light leaks. Check the bag for rips or tears that may cause light leaks, and make temporary

 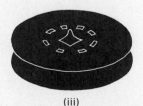

(i) (ii) (iii)

FIG. 4-10. Cores and daylight spool. (i) A 16mm core. (ii) A 35mm core. (iii) A 16mm, 100' daylight spool.

repairs with gaffer's tape or discard the bag. Keep the changing bag clean since dirt inside often transfers to the film or the aperture. Zipper the bag closed when it is not in use, and, after each day's use, turn it inside out and shake it. A cover for the changing bag helps protect it.

If you will be loading the magazine, develop a standard operating procedure for loading and unloading film. You should always put the feed reel to your left, have the bottom of the magazine toward you, remove the tape that holds down the end of the raw stock and stick it on the film can so that you know where it is. Make sure you do not inadvertently send to the lab the reusable core adaptor from the magazine with the exposed film. A standard procedure helps avoid panic when something goes wrong or if the crew puts pressure on you to work faster. Even though the changing bag is lightproof, avoid changing film in direct sunlight. If you must remove your arms before completing the operation, close all the magazine lids and make sure the film is in the magazine or a can. If this is difficult, remove one arm at a time, twisting the sleeve to make a light trap. After your arms are out, knot the sleeves.

In emergency situations you can change film in a windowless bathroom or a closet off of a totally darkened room. Make sure no light is entering at the base of the door. Tape the bottom of the door with gaffer's tape, or wait until night, but still leave the adjacent room dark. It's a good idea to tape light switches, so no one inadvertently turns on a light.

FIG. 4-11. Changing bag. A changing bag functions as a portable darkroom. (Ted Spagna)

Super 8 Cartridges

Most super 8 film is supplied on 50' or 200' cartridges, either magneti-cally striped for sound or without stripe for silent work. If you plan to add a sound track to the camera original, order the film with magnetic stripe. Although a stripe can be applied after editing, prestriped film has a better applied stripe and may ultimately be less expensive.

The cartridges are lightproof, but you should still avoid exposing them to direct sunlight. Do not break the cartridge's moisture-proof foil until you load the camera.

The cartridge automatically sets the ASA number on many super 8 cameras with automatic exposure. A black-and white cartridge will pre-vent a built-in color conversion filter from being used.

Double super 8 cameras take double super 8 film on 100' daylight spools. The film is double-perf, shot in one direction, turned over, shot in the other direction and split after processing to yield 200' of exposed footage.

Film Packaging

Moisture-proof tape seals the raw stock can. Core loads are wrapped in a lighttight bag *(black bag)*, and spools have a lightproof paper band wound on the outside. Unload the exposed film into the black bag and can (in the case of cores) or the paper band and can (in the case of spools). Taping the end of core-mounted film prevents the film from unraveling in transit. If the unprocessed film is to be subjected to any extremes of humidity before processing, it is important to reseal the can with the moisture-proof tape. Use some standard marking, such as tape across the can, to indicate that the stock is exposed.

Windings

Raw stock perforated on one edge and wound with the emulsion side in has two possible windings, designated *winding A* and *winding B* (see Fig. 4-12). Camera original is almost invariably in winding B. Stock in winding A is generally only used by laboratories for printing.

Another laboratory use of these terms exists that often leads to confu-sion; *A-wind* and *B-wind* are used to distinguish whether the picture "reads correctly" (i.e., not flipped left to right) when viewed facing the emulsion side (A-wind) or when viewed facing the base (B-wind). An easy way to remember this is that *B*-wind film reads correctly through the *base*. B-wind is also called *camera original position*.

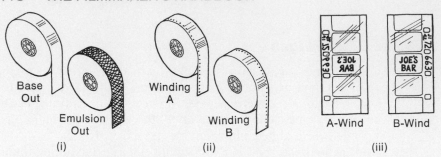

FIG. 4-12. Emulsion position and winds. (i) Film can be wound base out or emulsion out. (ii) Single-perforated film, wound base out, can be winding A or winding B, depending on the position of the perforations as shown. (iii) With the base facing you, B-wind film reads properly through the base, while A-wind film will be reversed or flipped. Note that the latent edge numbers usually read the same as the image. (Compare with Figure 14-1.)

Edge Identification

Manufacturers print a latent image on the edge of the film with information such as the name of the manufacturer and the name of the stock, which may be in code. Most 16mm and 35mm stocks (but, unfortunately, not super 8) have *latent edge numbers,* or *key numbers,* printed every foot (sixteen frames) in 35mm and every half foot (twenty frames) in 16mm (see Fig. 12-4). These numbers are indispensable for conforming original (see Chapter 13). Manufacturer's data sheets give the edge identifications for each stock.

Handling Raw Stock

Unprocessed film undergoes change over time. There is a gradual lowering of speed and contrast and an increase in the fog level. Color films are particularly vulnerable, since the changes may occur at different rates in the three emulsion layers, causing a color shift that may not be correctable in printing. Poor storage conditions not only cause changes in the photographic properties of the emulsion, they can also change the physical dimensions and properties of the film (for example, brittleness and shrinking).

As long as the original moisture-proof tape seals the raw stock can, humidity is less of a problem. But, high relative humidity (over 70 percent) can damage labels and cartons and produce rust on metal cans. If the moisture-proof seal has been broken, humidity conditions must be controlled.

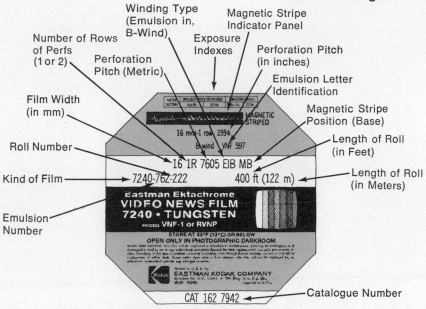

FIG. 4-13. The film label provides much useful information.

The lower the temperature, the slower the effects of the aging process on film. If raw stock is to be stored for longer than 6 months before exposure, keep it below 55°F. At high temperatures, change occurs rapidly. An automobile left in the sun can quickly heat up above 100°F, and film in the car can undergo significant changes in a matter of hours. Similarly, stock left on a radiator will show significant deterioration in a short time.

Eastman Kodak recommends using raw stock within 6 months of purchase, and, for longer periods, storing the film at 0°F to −10°F. If you need to ensure a high degree of uniformity in the film, always store raw stock at these lower temperatures.

Since relative humidity in a refrigerator or freezer is very high, pack film in plastic freezer bags to control humidity. After you remove the stock from cold storage, allow it to come to room temperature before breaking the moisture-proof seal. This prevents condensation and spotting on the stock. Minimum warmup times are 1 to 1½ hours for super 8 and 16mm stocks and 3 to 5 hours for 35mm. If the day is particularly warm and humid, increase the warmup period.

Once the seal is broken, expose the film as soon as possible, and then, after exposure, have it processed as soon as possible. If processing must be delayed, avoid high temperature and humidity, since the latent image is even more vulnerable than the unexposed stock to deterioration. If the cans are resealed with the moisture-proof tape, a household refrigerator may be used to store the film, although a freezer at 0°F is preferred.

X-rays can fog film. When you pass through airport inspection, demand a hand inspection. Do not let the inspectors convince you to send undeveloped film through the x-ray machine, especially if you will be boarding several planes with the film.

Static electricity discharges can expose raw stock and cause lightning-like streaks or blotches on the processed film. Low temperature and low humidity increase the possibility of static discharge. Black-and-white stocks are more susceptible than color. Improvements in stocks have made the problem less common now; in the past, cameras had to be grounded at times, to avoid the problem. You can help avoid static discharge by giving raw stock removed from cold storage adequate warm-up time and by rewinding raw stock at slow speeds.

Purchasing Raw Stock

Order raw stock from the manufacturer's catalogue by catalogue number and stock name. For example, ordering Kodak Ektachrome 7242 allows twenty-eight further possibilities, but the catalogue number 153 4478 identifies the stock as 7242, 16mm, 400' on core, B-wind, magnetic stripe, with 1R-2994 perforations (standard camera pitch, single-perf).

Use fresh raw stock. Order it to arrive a week or so before it is needed, rather than months in advance. To guarantee uniformity, order stock with the same *emulsion number,* since that stock is manufactured on the same day under the same conditions. The emulsion number is printed on the film label. If you encounter a raw stock of an unknown age, the manufacturer can tell from the emulsion number when it was manufactured. Of course, this tells you nothing about its past storage conditions.

It is often possible to purchase raw stock that was ordered by another customer and never used. There are businesses that buy and sell unexposed stock. Generally, they will allow you to return defective stock. Test a roll by sending about 15 to 20 feet of unexposed stock to the lab to be developed and checked for increased fog, which, if present, is a sign of poor storage. Buy previously owned stock of the same emulsion number to avoid having to test each batch. Raw stock less than 3 months old sells for about 15 to 25 percent off list price, and less if the stock consists of *short-ends* (parts of complete rolls). Stock older than 3 months sells at a greater discount, but you may be penny wise and pound foolish. The stock is only one of many costs.

Color and Filters

It is extremely helpful to be familiar with some elementary color theory to understand filters, illumination for color film and printing color films.

Primary Colors and Complementaries

If a blue, green and red light shine on the same spot, the spot will appear white. You can think of white light as made up of these three colors, called the *additive primaries,* and expressed as:

blue + green + red = white

Blue and green light together yield a green-blue color called *cyan.* Red and blue light produce a purple-red, *magenta,* and red and green produce yellow.

blue + green = cyan
blue + red = magenta
red + green = yellow

Cyan, magenta and yellow are the *subtractive primaries;* that is, gotten by subtracting one of the additive primaries from white light. For exam-

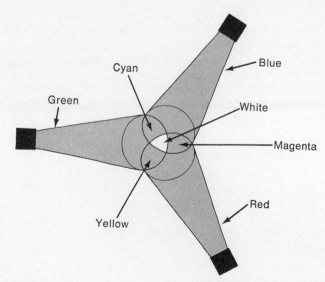

FIG. 4-14. Additive color. Spotlights of the additive primaries—blue, green and red—form white light where all three overlap. Where any two overlap, the subtractive primaries are formed.

ple, if the red component is taken away from white light, blue and green, or cyan, are left:

$$cyan = blue + green = white - red$$

Similarly,

$$magenta = blue + red = white - green$$
$$yellow = red + green = white - blue$$

Each additive primary has a *complementary color,* a color that when added to it produces white. From the above three equations, it becomes apparent that cyan is the complement of red, magenta the complement of green and yellow the complement of blue. A filter works by passing the components of its own color and absorbing the components of its complement. A yellow filter thus passes its components (red and green) and absorbs its complement (blue).

Color Temperature

The human eye adjusts to most lighting situations so that the color of the light source appears to be white. However, a light source will appear colored if it is strongly deficient in one or more of the primaries. If a light appears red it means it is deficient in its complement, cyan (blue + green). Daylight appears bluer than tungsten light when the two are seen together. For example, look inside a tungsten-lit room from outdoors on an overcast day. However, when there is only one source of illumination, such as a tungsten lamp, the light source appears white.

Although the eye accepts a broad range of light sources as white, different light sources are, in fact, composed of unequal amounts of the

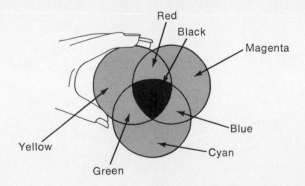

FIG. 4-15. Subtractive color. If you view white light through yellow, cyan and magenta filters, you get the additive primaries where any two overlap and black where all three overlap.

primaries. The reddish cast of sunset and the blue of an overcast winter day occur when one of the components of white light clearly predominates. Unlike the human eye, color film will not adjust to light sources with differing proportions of the primaries. Thus, a means of measuring the color components of a light source is needed.

If a piece of metal is heated, it first becomes red in color ("red hot"). Heated to a higher temperature, the metal starts to become blue and then white ("white hot"). You can correlate the temperature of an ideal substance, called a *black body,* with the color of the light it radiates when it is heated to different temperatures. This *color temperature* is measured in degrees Kelvin, which is a temperature scale equal to Celsius (centigrade) minus 273° (absolute zero).

Standard tungsten studio lamps have a color temperature of 3200°K (read "degrees Kelvin" or just "Kelvin"; color temperatures are increasingly written without the degree sign, but we use it in the book for clarity). A lower color temperature light source has a larger red component, while a higher color temperature source has a larger blue component. Light sources and images are thought of as being *warm* or *warmer* as they move toward red (think of red in fire), and *cold* or *colder* as they move toward blue (think of the blue light of an overcast winter day).

Color Film and Color Temperature

When a color film emulsion is manufactured, it is *balanced* for a light of a particular color temperature. The color temperature of the light source must match the film in order to reproduce natural color. Unlike the human eye, which accepts a wide range of color temperatures as white (or colorless), color film will have a color cast unless the color temperature of the source of the illumination matches the color temperature for which the film was balanced.

TUNGSTEN BALANCE. Films balanced for 3200°K are called *tungsten balanced,* or *Type B.* Some film stocks considered to be for amateur use are balanced for 3400°K, the color temperature of some photofloods (see Chapter 9). These stocks are called *Type A tungsten.*

DAYLIGHT BALANCE. Film balanced for color temperatures around 5600°K are balanced for daylight. Different manufacturers use slightly different color temperatures for their daylight film. For example, Kodak sometimes uses 5500°K, and Geva 6000°K. These differences are not very significant with the high color temperature of daylight (see p. 124). *Sunlight* (as opposed to daylight) is defined for photographic purposes as the color temperature of the light of the sun on an average sunny summer day at 12 noon in Washington, D.C. *Daylight,* on the other hand, is the

combination of sunlight with blue skylight. The color temperature of daylight is higher than that of sunlight, because of the blue. Daytime color temperature varies from 2000°, to well over 10,000°K (see chart below). During sunrise and sunset as the light of the sun becomes redder, the color temperature drops until it is far below tungsten.

Off-Balance Color Temperature

If the color temperature of the light source does not match the film's color balance, you can do the following: filter the lens to restore the proper balance (see below); filter or change the light source (see Chapter 9); make corrections in printing (see Chapter 10) or accept an overall color cast in the image. Some scenes seem to demand a color cast—candlelight, firelight, sunset and night scenes, for example.

Differences in color temperature are more significant at the lower color temperatures. The difference between 3000°K and 3200°K is marked, while the difference between 5400°K and 5600°K is not very significant.

Approximate Color Temperatures of Common Light Sources

Light Source	Degrees Kelvin
Match flame	1700
Candle flame	1850–2000
Sunrise or sunset	2000
40–60-watt household bulbs	2800
100–200-watt household bulbs	2900
500-watt household bulbs	3000
Studio tungsten lights	3200
Photofloods and reflector floods	3200–3400
Fluorescent warm white tubes*	3500
Sunlight one hour after sunrise or one hour before sunset	3500
Early morning or late afternoon sunlight	4300
Fluorescent daylight tubes*	4300
Blue (daylight) photofloods	4800
White flame carbon arc	5000
Average mid-day summer sunlight with some blue sky	5400
Xenon arc projector	5400
Average daylight (sunlight and blue sky)	5500–6500
HMI lamps	5600
Overcast sky	6000–7500
Summer shade	8000
Summer skylight with no sun	9500–25,000

* Fluorescent lights have a discontinuous spectrum and thus do not have a true color temperature. The color temperature indicated is a rough equivalent.

Measuring Color Temperature

The color temperature of a source of illumination can be read with a *color temperature meter*. A *two-color meter* measures the relative blue and red components of the light, whereas a *three-color meter* also measures the green component. A two-color meter is adequate for measuring light sources of continual spectral emission like tungsten, firelight and daylight. For light sources like fluorescents and mercury arc lamps, measure the green component with a three-color meter.

Most lighting situations do not require a color temperature meter since it is enough to know the approximate color temperature of a light source. Large differences can be corrected by a filter and smaller differences can be corrected in printing (see below). Color negative, in particular, allows for a very wide range of printing corrections.

Color meters prove most handy when balancing the color temperature of different light sources (see Chapter 9). For example, the meter can measure if adequate compensation has been made by putting gels on windows to match the color temperature of tungsten light fixtures. Use a two-color meter to measure the decrease in color temperature of tungsten light when there is a voltage drop or to measure the change in color temperature in early morning or late afternoon. If a sequence is shot over several days or weeks, but is supposed to appear as the same time period in the finished film, use the meter to match the light balance day to day.

The color temperature meter is sometimes used with a set of filters for color temperature compensation (see below). Filter the light source or lens to change color temperature. Some meters read in degrees Kelvin while others read in mired values (see below). Point the meter at the light source as you would do with an incident meter (see Chapter 5). In daylight, however, a meter with a wide acceptance angle may be pointed at the subject in order to include the influence of the blue sky as a fill light.

Filter Factors

All filters absorb some light, and compensation must be made for the loss of light to avoid underexposing the film. The *filter factor* is the number of times exposure must be increased to compensate for the light loss. Each time the filter factor doubles, increase the exposure by one stop. Manufacturers supply filter factors for each of their filters. You can divide the filter factor into the ASA number to calculate exposure directly from the exposure meter, or, if you know that a filter decreases exposure by one stop (a filter factor of 2), compensate by opening the lens one stop.

When two or more filters are used simultaneously, the filter factor of

the combination is the product of each of their factors. If one filter has a factor of 4 and the other a factor of 3, the combination will have a filter factor of 12 (3 × 4). If the film was rated ASA 250, the meter could be set at ASA 20 (250 divided by 12 then rounded off) and exposure calculated directly.

Film stock data sheets list filter requirements and factors for various light sources.

Filters for Color Film

CONVERSION FILTERS. When you expose daylight film under tungsten illumination or tungsten film in daylight, you should use a *conversion filter*.

Since tungsten film in daylight appears blue, you will want to warm up the daylight to match tungsten illumination. Filters that warm up a scene are red or yellow. Most cinematographers identify these filters by their Kodak Wratten filter numbers. The 85 filters have a characteristic salmon-colored appearance. A #85 (or simply, an 85) converts most color negative films and Type A tungsten (balanced for 3400°K) reversal films for use in daylight. An 85B (sometimes confusingly called an 85 in the U.S.) converts Type B tungsten (balanced for 3200°K) reversal films to daylight balance. Daylight film used under tungsten illumination will appear red-brown, so add blue. The 80A conversion filter is blue. An 80A converts most daylight reversal films (balanced for about 5500°K) for use under 3200°K illumination and an 80B for use under 3400°K illumination.

Color conversion filters are used so frequently that cinematographers tend to think of film speeds in terms of the ASA that compensates for the filter factor. The 85 has a filter factor of 1.6 (two thirds of a stop). A color negative balanced for tungsten and rated ASA 100, will be ASA 64 with an 85 filter when used in daylight (100 divided by 1.6 is approximately 64). The 80A (converts daylight to 3200°K) has a filter factor of 4—a loss of two stops. Conversion filters are often used in combination with neutral density filters (see p. 127).

COLOR COMPENSATING FILTER. According to current industry practice for printing camera original, all but the major color temperature corrections are left to the laboratory. Color negative films can often be acceptably printed even when shot in daylight without an 85 filter, but, before this is attempted, consult the lab. Of course, shooting without the 85 decreases the film's latitude. Color reversal always needs the conversion filter, since the lab cannot adequately compensate in the print.

If you shoot reversal film for direct projection, you should compensate at the time of original exposure. To do this accurately, you can use a color temperature meter and a set of *color compensating* (CC) or *light-balancing* filters. The most advantageous system in common use assigns

a *mired* value to every color temperature. To convert from one color temperature to another, subtract their mired values. If the result is a positive number, use yellow filtration to warm the scene since yellow increases mired value and decreases the color temperature. A negative number calls for blue filtration to decrease mired value and raise the color temperature. Unlike in degrees Kelvin, where a difference of 100°K is more significant at 3200°K than at 5500°K, mired values indicate a constant shift across the scale.

Mired values are used to measure any red-blue color shift. When you put gels on windows to lower the color temperature from 5500°K (mired value 182) to 3200°K (mired value 312), a gel with a +130 mired value is needed (an 85 gel is close enough, with its mired value of +131). If you want the daylight to appear cooler than the tungsten interior light, use a gel that does not lower the color temperature as much. A gel called a *half 85* (mired value +81) lowers the color temperature to 3800°K, so that the window light will appear bluer than the 3200°K interior lights. (Consult *The American Cinematographer Manual* for mired values of typical light sources and filters and for the Kodak Color Compensating filter system.)

Filters for Both Color and Black-and-White Films

HAZE CONTROL. Unlike the human eye, photographic film emulsions are sensitive to ultraviolet light. Atmospheric haze scatters large amounts of ultraviolet light, making the haze appear heavier when distant landscapes are photographed. To minimize this effect, use a *UV* or *1A (skylight) filter* with both black-and-white and color films. The UV is clear to slightly yellow in color, while the 1A is slightly pink. The filter factor is negligible, and no exposure compensation need be made. Haze filters have no effect on fog and mist because these atmospheric effects are composed of water droplets and are not due to the scattering of ultraviolet rays.

The 1A filter is useful to warm up the blue cast due to ultraviolet light present in outdoor shade, which is especially noticeable when snow scenes are filmed. Since the 1A and haze filters do not significantly affect exposure and, in general, have no unwanted photographic effects, they are useful in protecting the front element of the lens in difficult environmental conditions—for example, in salt spray or sand. Some filmmakers leave this filter in place at all times.

NEUTRAL DENSITY FILTERS. *Neutral density (ND) filters* are gray in color and affect all colors equally. They are used to reduce the amount of light passing through the lens without affecting color. They allow you to open the lens to a wider aperture to reduce depth of field, to film at an aperture that yields a sharper image or to shoot with a brighter reflex viewfinder.

Neutral density filters are generally marked in increments of .1ND, which is equivalent to one third of a stop; .3ND is one stop, .6ND two stops and 1.2ND four stops. When you combine ND filters, these numbers should be added, and not multiplied as is done with the filter factor. Sometimes ND filters are marked $2\times$ or $4\times$, in which case you are given the filter factors (one and two stops, respectively).

ND filters are often combined with color conversion filters for daylight filming at a lower ASA speed. For example, an 85N3 combines an 85 filter with one stop of neutral density (the decimal point is dropped in combinations with ND filters). An ASA 100 tungsten-balanced film would have a daylight exposure index of ASA 32 with the 85N3. Similarly, an 85N6 (two stops of neutral density) would give the film a daylight ASA of 16.

Graduated neutral density filters have one section neutral density and one section clear. The transition from dense to clear can be gradual or abrupt. These filters are primarily used to darken a sky that would otherwise bleach out and show no detail. Position the neutral density portion to cover the sky, and align the graduated region with the horizon line.

POLARIZING FILTERS. Aside from the graduated ND and special effects methods, the *polarizer* is the only way to darken a sky in color photography. A polarizer is somewhat like a neutral density filter in that it affects all colors equally; its difference is that it selectively cuts down light oriented in a single plane—that is, *polarized* light. On a clear day, some of the light from the sky is polarized, as is light reflected from glass and water, but not metal. Polarized light can be progressively eliminated by rotating the polarizer. Reflections from glass and water can sometimes be totally eliminated, but be careful not to overdo the effect; otherwise, a car may look as though it has no windshield or a pond as though it is dry.

As you pan or move the camera, the orientation of the polarizer to the light source may change, altering the amount of light that is filtered out. The exposure of an object may thus change during the shot. When the polarizer is used to darken the sky, this change is particularly noticeable when the camera pans. Maximum darkening of the sky occurs with the filter oriented at right angles to the sun. When it is pointed toward the sun or 180 degrees away (the sun directly behind), the polarizer has no effect. Similarly, polarized shots taken at different angles to the sun may not edit together well since the sky will appear different from one shot to the next.

The polarizer has a filter factor varying from 2 to 4 (one to two stops), depending on its orientation and the nature of the light in the scene. Side lighting and top lighting, when the sun is at right angles to the polarizer, may require a compensation of two or more stops. Calculate exposure compensation by taking a reflected light reading through the polarizer,

with the polarizer oriented as it will be on the lens. Clear blue skies can most easily be darkened with the polarizer. The hazier the sky, the less noticeable the effect will be. An overcast sky, whether in color or in black-and-white, can only be darkened by the graduated ND filter.

DIFFUSION FILTERS. *Diffusion filters* of varying strength soften hard lines and are often used to minimize facial lines and blemishes. They are sometimes used to indicate a dream sequence or an historical sequence. As diffusion increases, flare from bright areas creeps into adjacent areas. Diffusion can also be achieved by placing a Vaseline-coated glass or a stretched silk stocking in front of the lens. Diffusion filters generally require no exposure compensation. Since they cut down on image sharpness, they are rarely used in super 8 or 16mm, except for exaggerated romantic effect.

FIG. 4-16. Diffusion filter. The lighter tones spread out and soften the image. (Tiffen)

FOG FILTERS. *Fog filters* are available in various grades to simulate everything from light to heavy fog. In general, the more "contrasty" the scene, the stronger the fog filter needed. With too strong a filter, objects may lose so much contrast that they become invisible.

In natural foggy conditions, objects tend to become less visible the farther away they are. Most fog filters do not simulate this effect, so try not to photograph objects too close to the camera or let a subject move toward or away from the camera during a shot. *Double fog filters* lower image definition less than standard fog filters do. There is no exposure compensation for fog filters.

LOW-CONTRAST FILTERS. Low-contrast filters, available in various grades, reduce contrast without softening lines or losing as much definition as is lost with diffusion filters. The effect is similar to developing to a lower gamma. Colors are less saturated and the overall look is softer. No exposure compensation is required when using this filter.

SPECIAL EFFECTS FILTERS. There are filters (sometimes called *variburst*) that will take light sources in the image and break them up into spectral colors. *Star filters* break bright highlights into stars of four, six or eight points, depending on the type of filter you select (see Fig. 15-2). The filters may be rotated to position the directions of the points. Other filters are available that break the image into multiple repeating images of various patterns.

Split field diopters and the mounting of filters are discussed in Chapter 3.

Filters for Black-and-White

In addition to the filters discussed above, there is a set of filters primarily made for black-and-white film. These filters are mostly used to darken a sky or to change the relative exposure of two differently colored objects that would otherwise record as similar tonalities.

Equally bright red and green objects may photograph in black-and-white as the same gray tone. Since filters absorb their complementary color and transmit their own color, photographing the red and green objects with a red filter makes the green object darker than the red (since the red filter absorbs much of the green light). In black-and-white, *contrast filters* are sometimes used to obtain the separation of values achieved by color contrast in color film.

Earlier we discussed the use of graduated neutral density filters and polarizers to darken a sky. Black-and-white film allows the use of several differently colored filters to darken a blue sky but not a white, overcast sky. Since red and yellow filters absorb blue, they will darken a blue sky.

Unlike the effect with a polarizer, the darkening is consistent with expectation, so the camera may be panned without worry.

Some of the most commonly used black-and-white contrast filters are: Wratten #8 (K2) (yellow or light orange) for haze penetration, moderate darkening of blue sky and lightening of faces and Wratten #15 (G) (deep yellow) for heavy haze penetration, greater sky darkening and, especially, aerial work and telephoto landscapes. The red filters (for example, the #23A, #25, #29) have increasing haze penetration and increasing power to darken skies. The #29 can make a blue sky appear black with prominent white clouds. The green filters also darken the sky, but make foliage lighter. Blue filters lighten blue skies and blue objects and increase haze and ultraviolet effects.

5

The Light Meter and Exposure Control

Exposure

A scene is considered correctly exposed on film when the important elements in the scene are shown with sufficient detail. If a close-up of a person's face is filmed on reversal film stock and is significantly overexposed (that is, too much light is allowed to strike the film), the film emulsion remaining after the film is developed will be extremely thin and transparent, causing the face to appear mostly bright white when projected on a screen. If the shot were seriously underexposed, the film emulsion remaining after development would be thick and opaque and the projected image would look very dark. In both cases, facial details are lost—either because they are washed out or because they are indistinguishable from parts of the emulsion that have received no exposure.

If important details are visible on the film after processing, shots that are slightly too bright or too dark often can be corrected when the film is printed. In general, reversal stocks are less forgiving of exposure errors than negative stocks. If reversal films are to be shown in the original (without the benefit of exposure correction in printing) as is usually done in super 8, the filmmaker must be especially careful with exposure.

Exposure and Incident Light

The exposure of an object on film is related to the amount of light *falling on* the object—that is, the *incident light*. Incident light can be measured with an *incident light meter* that has a translucent plastic hemisphere (or *hemispherical diffuser*), which simulates the light-gathering ability of a typical three-dimensional subject—specifically, the human head. The incident meter is held at the position of the subject (or in the same light) and is *pointed in the direction of the camera*. The meter averages together the light coming from the front, the sides and, to a lesser extent, the back of the subject. Incident light readings are quick

132

FIG. 5-1. (left) The reflected meter is pointed at the subject from the direction of the camera. (right) The incident meter is held in the same light as the subject and pointed toward the camera.

and easy to do, and they usually result in the proper exposure of facial skin tones. They are used a great deal in filmmaking because faces, especially in close-ups and medium shots, are often the most important element in the frame.

Some scenes contain a great range of incident light. Consider the example of filming people by a building on a sunny day. If an incident reading is taken near the people in the shadows of the building with the film exposed accordingly, the people in the sun are likely to be drastically overexposed. Conversely, if the incident reading is taken in the sun, the people in the shadows will be underexposed. This happens to varying extents with all film stocks (see Fig. 5-2). To the naked eye, the detail of this scene is visible in both shadow and sunlit areas. This is because the eye's retina has a great sensitivity range and the iris constantly adjusts the amount of light that strikes it, thus allowing you to see objects that differ greatly in brightness. Film stocks, however, have a much narrower range of sensitivity.

The example described above exceeds the film's sensitivity range (sometimes called *exposure range*). In this case, the filmmaker might choose a compromise exposure that is between the readings taken in the dark and light areas. Alternately, supplementary light might be added to the shadow area, or a lower contrast film stock that has a greater exposure range might be used.

Exposure and Subject Reflectance

An object's exposure on film is more fully described as resulting from the *total amount of light reflected by the object* in the direction of the

FIG. 5-2. In a scene with a lot of contrast, if you take a light reading in the shadows and expose accordingly (left), the sunlit areas are overexposed. If you took your reading in the sunny area (middle), the shadows are underexposed. (right) A compromise exposure. (Ted Spagna)

camera's lens. This is determined not only by incident light but also by what percentage of the incident light is reflected by the object (that is, its *reflectance*). Subject reflectance is determined by color and surface texture; a dark colored, textured object reflects less light than a light colored, smooth one does. For example, a dark wool sweater in the sun might produce the same amount of exposure as a sheet of white plastic in the shade. That is to say, their *brightness* (*luminance* or *intensity*) is the same.

The amount of light reflected by the subject can be measured with a *reflected light meter*. This meter requires more care to use properly, but it can give more precise exposures than the incident meter, especially for subjects whose reflectance is not near that of facial skin tones. It can also be used in many situations, like filming through windows, where the incident meter would be useless. The reflected meter is *pointed at the subject* from the camera position (or closer). The reflected reading must always be interpreted and never taken at face value.

When film is exposed, developed and then projected on a screen, it can produce a range of tonalities from dark black (where the film holds back the projector light) to bright white (where most of the light shines through). The tone in the middle of this range is called *middle gray*. Reflected light meters are designed so that if you take a reading of any uniform object and then expose the film accordingly, the object will appear as middle gray on film. Thus, a reading of a black cat will produce the cat in middle gray when the film is projected, the cat appearing unnaturally light and other objects in the scene probably being very overexposed. So if you want dark objects to appear dark, you must give them less exposure than the reflected meter reading of the object would indi-

cate. Similarly, for light objects to appear light, they must be given more exposure than the meter suggests.

A *gray card*, or *neutral test card*, is a piece of dull gray cardboard that reflects 18 percent of the light that strikes it. This card is intended to represent an indoors object of "average" reflectance. If you take a reading of the gray card and expose the film accordingly, the tonality of objects in the scene will usually look natural on film—neither too light nor too dark. Since Caucasian skin is about twice as reflectant as the gray card—having approximately 35 percent reflectance—you could just as well base the exposure on a reading of the skin tone, as long as you remember to give the film *twice* as much exposure as the meter indicates. This is normally done by opening the iris diaphragm one stop.

Light Meters

Meter Types

Light meters, or *exposure meters*, may be either handheld or built into the camera; in super 8, built-in meters are often coupled to the iris diaphragm to allow automatic adjustment. Reflected light meters sometimes have a sliding or detachable translucent plastic bulb, called a *hemispherical diffuser*, making them useful as incident light meters too. These attachments are usually much smaller than the hemispherical diffusers found on true incident meters and do not respond as well to side and back light. Similarly, some incident meters have detachable parts to convert them for reflected readings; these often have too-large angles of acceptance (see p. 139) compared to true reflected meters. The filmmaker would ideally carry two different meters.

On some meters, a built-in calculator dial is used to convert light readings to useful exposure information (for *f*-stop or T-stop selection, see p. 139). *Direct reading meters* give you *f*-stops directly which can be a distinct advantage in many filming situations, especially when shooting on the run. Most of these meters have a needle that is read against an *f*-stop scale. *Digital meters* have an electronic display that shows the reading in printed numbers, which some filmmakers find easier to read. Some direct reading meters (like the Sekonic and the older style Spectra) use a set of slides that must be inserted to key the meter to the correct film and shutter speed settings. Keeping track of these slides can be difficult, and, for some meters, it is not always possible to buy slides for the particular film stock and processing combination you are using.

Virtually all meters will lock in place when the trigger is released so you can calculate the exposure at your leisure. Many meters have special features to facilitate exposure calculation; consult the owner's manual.

Most light meters operate with photoelectric cells that generate elec-

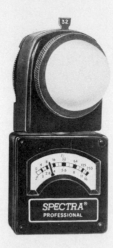

FIG. 5-3. Direct reading Spectra incident light meter. The upper scale reads foot-candles, the lower reads *f*-stops. The tab of the ASA 32 slide is visible at top. (Simon Associates)

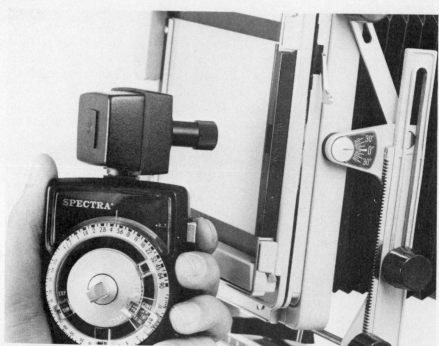

FIG. 5-4. The Spectra Professional II direct reading meter needs no slides. Film and shutter speed are set on the dial on the front face. Meter can take incident or reflected readings. Meter is shown with narrow acceptance angle attachment for spot reflected readings. (Simon Associates)

tricity when light strikes them. Meters with *selenium cells* use the cells' power directly to deflect the indicator needle. Meters with *cadmium sulfide (CdS) cells* use the electricity to control power from a battery that actually does the work of moving the needle. The advantages of selenium cell meters are that they require no battery and are usually less expensive. CdS cell meters are more sensitive and can work at lower light levels. They usually require expensive batteries, which are replaced infrequently. Some CdS meters have a slight "memory" effect; a reading is initially influenced by the level of the previous reading. Such meters may need a moment to readjust when taking a reading (in low light especially, cover the front of the meter with your hand and then remove it so the needle *rises* to its true position and then stabilizes), and they may need to be "woken up" with a few readings at the beginning of a filming session. *Silicon blue cell* meters surpass even CdS meters for sensitivity and operating range and do not suffer from memory effects.

All meters are most accurate in the *middle* of their operating range. Readings at the lower end of the scale tend to be the least precise. Reflected meters can sometimes be used with a white card to improve low-light response (see below). Light meters usually have a zeroing adjustment and/or a battery check. On many meters, a properly adjusted needle will read zero when the battery is removed.

Reading the Meter

In controlling exposure, you are regulating the amount of light that strikes each frame of film. The amount of light is determined by how long the shutter is open (the shutter speed, determined by the shutter angle and the camera speed) and how much light passes through the lens during this time (affected by the iris diaphragm setting, the filters being used, light loss in the lens and light loss in the viewfinder optics). Usually, the meter is set to compensate for all the other factors, then the light reading is used to determine the proper iris setting (that is, the *f*-number) for a particular shot.

For typical 16mm cameras, the shutter angle is about 180 degrees and, when run at sound speed (24 fps), the shutter speed is about 1/50 second. The shutter speed for any camera can be found in its instruction manual or can be easily calculated if you know the shutter angle (see Chapter 2). If you change the camera speed (for example, to produce slow motion effects), you will alter the shutter speed.

The meter must be set to the proper film speed (ASA) for the film stock you are using. Remember to compensate for filters you may be using (for example, when shooting in daylight with tungsten-balanced color film). Cameras with built-in meters usually compensate for filters automatically, and, in super 8, the basic film speed and shutter speed are set automatically as well. With direct reading meters, the shutter speed is

also set on the meter so that *f*-stops can be read directly when the trigger is depressed (see Figs. 5-3 and 5-4).

On meters with calculator dials, the indicator needle is read against a numbered scale. Set this number on the calculator dial. You will find the shutter speed on the *shutter speed scale* (sometimes labeled *time* or *zeit*), which is marked in fractions of a second ('60, '30, etc.). You can then read the *f*-stop opposite the proper shutter speed. With cameras equipped with 175° or 180° shutters, you may find it easier to read from the *cine scale*. This is marked in frames per second (64 fps, 32, 16, etc.) and usually has a bold mark at 24 fps, corresponding to 1/50-second shutter speed. After you have thus determined the *f*-number, you can set the lens' iris accordingly.

In most circumstances, it does not pay to be more precise than about one third of a stop when calculating exposures; few meters are accurate enough and few film stocks (especially negative stocks) will show the difference.

VIEWFINDER OPTICS. With cameras that have internal beam-splitter viewfinders (for example, most super 8 cameras and the 16mm Bolex),

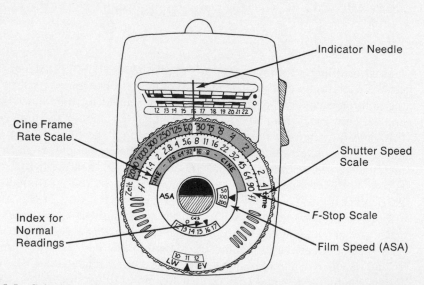

FIG. 5-5. Calculator dial found on Gossen Luna Pro reflected/incident meter. The film speed window indicates that the meter is set for ASA 100 film. The light reading (16) is set opposite the triangle in the window just below the ASA setting. A camera with a 180-degree shutter run at 24 fps has a shutter speed of 1/50 second (50 can be found on the time scale between '60 and '30). The *f*-stop is read opposite this point. Alternately, the *f*-stop could be read opposite the 24-fps mark on the cine scale (found between 32 and 16). The meter indicates a reading between f/5.6 and f/8.

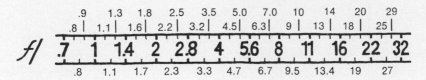

FIG. 5-6. Intermediate values on the *f*-stop scale. Above the scale are one-third stop increments; below the scale are half-stop increments.

some light is diverted from the film to the viewfinder (see Fig. 2-11). When you use a *handheld light meter* rather than a built-in one, do not set it to the *actual* shutter speed (based on shutter angle and frame rate); instead, use an *effective* shutter speed that compensates for light lost in the viewfinder. The effective speed is always faster. On some Bolexes at 24 fps, actual speed is 1/65 second, effective is 1/80. Your camera's manual should indicate the proper setting.

F-STOPS AND T-STOPS. *F*-stops do not take into account light lost internally in a lens, whereas T-stops do (see Chapter 3). When you use a professional zoom lens marked in T-stops (usually a red scale, sometimes on the opposite side of the iris adjustment from the *f*-stops), use the T-stops instead of the *f*-stops for all exposure calculations. *Ignore the fact that light meters are marked in f-stops.* T-stops should also be used whenever you are filming with more than one lens.

The Angle of Acceptance

All meters built into still and movie cameras are of the reflected type. Built-in, through-the-lens meters may average together the light from the entire frame (called *averaging meters),* they may read only the light from objects in the center of the frame *(spot meters,* see Fig. 5-7) or they may read the whole frame giving more emphasis to the center *(center-weighted meters).* Consult your camera manual to find out what part of the frame the meter reads.

A few cameras, like the Canon Scoopic, have built-in meters that do not read through the lens. This meter is comparable to having a handheld meter attached to the camera.

Handheld reflected meters have a window over the photocell that allows light to enter from an *angle of acceptance* (usually between 15° and 60°). Some meters are designed to simulate the angle of view of a "normal" lens, but the meter may read a wider or narrower area than the lens you are using. All the light reflected by objects within the angle of accep-

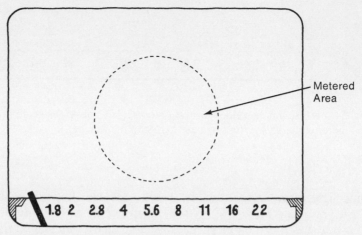

1.8 2 2.8 4 5.6 8 11 16 22

FIG. 5-7. Metered area in a camera with through-the-lens spot metering. The relative size of the metered area varies from camera to camera. The *f*-stop scale and pointer are often displayed outside the picture area.

tance is averaged together, so if you are trying to read the light from an individual object it is necessary to get close to it (but be careful not to cast a shadow with the meter or your body). Handheld *spot meters* are simply reflected meters that have a very narrow angle of acceptance, often 1° or less. They can be used to read the light from small objects at a greater distance. Cameras with zoom lenses and built-in, through-the-lens meters can be zoomed in for variable-angle spot metering.

Taking Readings

The Incident Reading

Because the incident light meter is easy to use and renders skin tones consistently, it is preferred by cinematographers in most filming situations. As previously discussed, the incident light meter measures the amount of illumination falling on the subject rather than the light reflected by it. For many scenes, taking an incident reading is faster than using a reflected meter. Incident meters are preferred when studio lighting is used because they conveniently indicate how much light is contributed by each light source. In this case, the hemispherical diffuser is often replaced with a *flat disc diffuser* that can more easily be aimed at one light at a time. Incident meters are often advantageous in those situations in which it is difficult to approach the subject to take a reading. If the subject is fairly far away outdoors, you can take an incident reading from

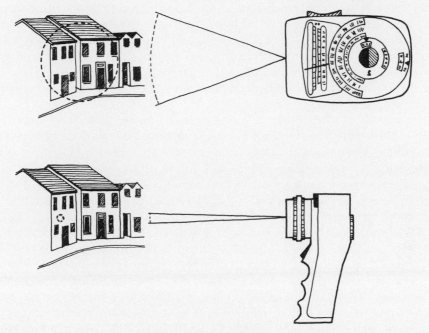

FIG. 5-8. (top) A typical reflected light meter has a wide angle of acceptance (about 40 degrees here) and averages areas of differing brightness. (bottom) A spot reflected meter (pictured here with a 5-degree angle of acceptance) can read a small area in the subject.

FIG. 5-9. Pentax digital spot meter. This meter has 1-degree angle of acceptance, approximately the angle of view of a 580mm lens on a 16mm camera. (Pentax Corp.)

the camera position (assuming it is in the same light), and, unlike a reflected reading, it will not be thrown off by large expanses of sky or other extraneous elements. Unlike the reflected meter, the incident meter is useless when you film something that *emits* light (like a television screen), when you film through something that *filters* light (for example, a tinted car windshield) or whenever the meter cannot be placed in the same light as the subject.

An incident meter is not affected by extraneous elements in a scene, and is therefore very good for exposing skin tones consistently. Even if, in printing, variations in exposure are evened out, the skin tones may still show differences in color, grain and contrast. Exposing some important area (here skin tone) the same in every shot is sometimes called *pegging the key tones*; a reflected meter and gray card can also be used for this purpose (see below).

Nevertheless, there are instances where the incident reading must be interpreted and not used directly. Often it is necessary to "bias" or "weight" an exposure reading to compensate for important parts of the frame that are especially light or dark. Say you are filming someone in the snow. The normal incident reading would expose their face fine, but the snow, because it is so reflective, would probably overexpose. As a general rule, if important subject matter is especially reflective (a white car, for example) close the iris a half to one stop from the incident reading; if it is especially dark and absorptive (dark clothing) open the iris by the same amount.

The Reflected Reading

The reflected light meter is more versatile than the incident meter, and it can give the filmmaker a more complete idea of the exposure of various elements in a scene.

CLOSE-UPS AND MEDIUM SHOTS. In medium shots and close-ups (see Fig. 6-2), it is important that facial skin tones be exposed correctly and consistently. One way to do this with a reflected meter is to use a gray card (see Exposure and Subject Reflectance, p. 137). Angle the gray card halfway between the subject and main source of light and take a reading from about 6 inches away with the reflected meter. Be careful not to block the light or cast shadows on the card with your body or the meter. This is essentially a measure of the incident light (since the gray card has the same reflectancy in every situation), and it should produce about the same reading as an incident light meter.

Since gray cards are cumbersome (and do not always reflect all the light sources which illuminate the subject), it is often better to take readings directly from the subject's face. Put the meter close enough so that

other areas are excluded from the meter's field of view. If your skin tone is similar to your subject's, you can read your hand instead, as long as it is in the same light. Since Caucasian skin is about twice as reflective as the gray card, you must give it about twice as much exposure as the meter indicates to render it appropriately light on film. Thus if the meter reads $f/8$, open up the iris to $f/5.6$. Black skin is usually less reflective than the gray card. A rule of thumb is to stop down the iris a half stop for medium black skin, a full stop for dark black skin (a meter reading of $f/8$ would then be exposed at $f/11$). Some people have black skin that is extremely dark and absorptive and may require more exposure compensation.

You can easily find out exactly how much to compensate for your skin tone or the skin of your subject by comparing a reflected reading of the skin with an incident reading (or a reflected reading of a gray card) taken in the same light. If the reading of your hand reads, say, $f/5.6$, and the incident reading is halfway between $f/4$ and $f/5.6$, you know to open the iris a half stop from a reading of your hand. You have thus "calibrated" your hand as a portable gray card.

Faces are normally lit so that part of the face is bright and part is in shadow. In general, if compensations are made as above, the exposure should be based on a reading of the brighter side. If the light is angled from the back so that more than half the face is in shadow (see Fig. 9–2, iii and iv), it may be important to see more detail in the shadows. In this case, you might increase the exposure a half to one stop from the exposure used for the bright side. (For exposing faces that are fully backlit see Backlight, below.)

WIDE SHOTS. In wide shots, landscapes and scenes where people do not figure prominently, instead of basing the exposure on skin tone, it is often better to take a reading of the *average amount of reflected light* in the scene. To do this, point the meter (or the camera, if you are using a built-in meter) at the scene from the camera position. If you are shooting outside, a bright sky will tend to throw off the reading; angle the meter downward somewhat to avoid reading too much of the sky. In general, you should avoid pointing the meter at any light sources.

A more precise way to read the average amount of light in a scene is to take a *highlight–shadow average*. To do this, get close to objects in the scene and read the light reflected by the brightest areas with important detail; then measure the light in important shadows where you hope to see detail. Normally you should take measurements only of the large or important elements in the frame and not such things as the shadows under cars or highlights caused by glints on glass. Next, find the average of the highlights and shadows, not the mathematical average, but one that is expressed in f-stops. Thus, the average of two readings (say, $f/2$ and $f/16$)

is the stop halfway between the two ($f/5.6$), not the mathematical average $\left(\dfrac{2 + 16}{2} = 9\right)$. Meters like the Gossen Luna Pro indicate light readings on a numbered scale, which can be averaged in the familiar way and then converted to f-stops.

Backlight

Light that comes from behind the subject in the direction of the camera is called *backlight*. Backlighting is often encountered outdoors when filming in the direction of the sun or when filming people in cars, or indoors when the subject is positioned in front of a window or a bright wall. Usually when you expose a backlit subject, it is desirable for the shaded side of the subject to appear slightly dark, which it is, but not so dark that the person appears in silhouette with no facial detail.

If you base the exposure on a typical reflected light meter reading from the camera position, the meter's angle of acceptance will include a great deal of the background. The meter then assumes that the subject is very light; it indicates that you should stop down quite far, throwing the person into silhouette. A rule of thumb to prevent silhouetting in this case is to open the iris one and one half stops above what the meter indicates (for example, open from $f/8$ to halfway between $f/4$ and $f/5.6$). Many super 8 cameras have a backlight button that does just that.

A more precise exposure calculation can be achieved by taking an incident reading or by getting very close to the subject to take a reflected reading of the shaded part of the face. Be careful to block any backlight from striking the meter directly. Since you do want the face to appear *slightly* dark, close the iris about one stop from the exposure you would normally use for the skin tone. For example, when exposing Caucasians with a reflected meter, the same effect can be gained by exposing at the f-number that the meter indicates (*without* the usual compensation of opening the iris one stop).

Special Exposure Conditions

Setting exposures may involve a series of compromises, especially when areas in the scene vary greatly in their brightness. If you are interested in seeing detail in bright areas, keep the iris slightly further stopped down; if detail in shaded areas is important, open up a little more. In backlit settings, it is common to have one exposure for wide shots that include a lot of the bright background and another for closer shots where shadow detail may be important. The latter might be opened up a half stop or so more than the former.

FLARE. If you are filming in the direction of a strong light source that is shining directly into the lens (for example, against a very bright window

FIG. 5-10. A backlighting problem. (top) Exposed for outside, the couple is silhouetted. (middle) Exposed for the couple, the outside is overexposed. (bottom) A compromise exposure, slightly underexposing the couple. (Ted Spagna)

or into the sun), you may pick up lens flare from light that reflects within the lens (see Fig. 3-11). Zoom lenses are prone to severe flare. Flare tends to fog the film, desaturating colors and increasing overall exposure. If there is no way to block this light with your hand or a lens shade, keep in mind that flare can increase exposure a half stop or more. When flare is severe in back-lit situations, you may want to close the iris a half stop *in addition* to the correction you made for backlighting.

SNOW OR SAND. When you film people on a sunny beach or in a snow-scape, a typical reflected reading from the camera position will be thrown off by the bright background. For close-ups and medium shots, use an incident meter or take a close reflected reading of skin tone in the normal way. If good reproduction of the snow or sand is important, decrease this reading by a half to one stop (especially for wide shots).

NIGHT SCENES. As long as some bright highlights, such as street signs, store fronts or narrow areas of street light, are visible, large areas of the frame can be rendered dark in night scenes. Similarly, if there are bright facial highlights recorded on the film, then the general exposure of the face can be lower than normal. (See Chapter 9, Special Lighting Effects.)

DISTANT LANDSCAPES. Haze, which may not be apparent to the eye, increases the exposure of distant objects on film. In hazy conditions, use a skylight or *haze* filter on the camera. Use a spot meter to average distant highlight and shadow areas, or, with an incident meter, *decrease* the exposure a half stop for front-lit scenes, one stop for side-lit scenes.

PARTIALLY OVERCAST SKIES. Thick clouds passing in front of the sun can decrease exposure by three stops and change the color temperature of the light. Do not forget to open the iris to compensate for the former. Fiction films are sometimes shot under *butterflies* (thin shades) to minimize the difference between sun and clouds (see Chapter 9).

SUNRISE AND SUNSET. For sunrise or sunset shots in which the foreground scene is mostly silhouetted, take a reflected reading of the sky but not the sun directly. Closing down the iris from this reading may deepen the color of the sun, but it will also make the landscape darker. When possible, bracket the exposure by giving it a half to one stop more and then the same amount less. If scenes are front-lit by a red rising or setting sun, no 85 filter need be used with tungsten-balanced color film. Back-lit scenes may look blue without it.

FLAT COPYWORK. For discussion on flat copywork see Chapter 13.

Built-in Meters and Automatic Exposure Control

Reflected light meters are built into most super 8 cameras and some 16mm cameras. Built-in meters are convenient and cut down the amount of gear to carry, but they have a number of disadvantages.

In most super 8 cameras, the ASA and shutter speed settings on the light meter are keyed automatically by the film cartridge and the camera speed selector. If the meter indicates that there is insufficient light for filming, you may decide to push process the film to increase its speed (ASA). However, when the needle is off the lower end of the scale, there is usually no way of telling how much light there actually is and whether a one-stop push will be sufficient (see Low-Light Readings, p. 148). In contrast, a handheld meter can be set for the new (pushed) ASA and you can see exactly where the light registers. Keep in mind that with most super 8 cameras, if you do decide to push one stop, the built-in meter is still set for the slower, unpushed ASA. You must therefore *close down* the iris one stop from whatever the built-in meter indicates (unless the needle is off the lower end of the scale, in which case leave the iris wide open or do not shoot at all).

If you only have a built-in meter to work with, you lack the ability to take incident readings and you must carry the camera around to take readings, which can be awkward (when filming on a tripod, for example).

AUTOMATIC FEATURES. Most cameras with built-in meters allow the filmmaker to choose between manual and automatic control of the aperture. Automatic control is certainly simple to use, but, although it performs adequately in some situations, it tends to expose film inconsistently.

Like all reflected light meters, the built-in meters that control the automatic exposure features can be thrown off by bright or dark backgrounds. If you are filming against a bright background or backlight, the camera assumes that the entire scene is bright and closes down the iris, possibly silhouetting the main point of interest. Some cameras have a backlight feature that compensates by opening the iris a stop or more. Cameras without this feature can sometimes be "fooled" by setting the film speed adjustment to half the actual ASA or less. This is not possible in most super 8 cameras.

Cameras on automatic exposure control often make iris adjustments when none is needed. If you were filming a shot of someone dressed in white crossing in front of the camera, the most natural exposure would be constant. The automatic feature, however, would stop down the iris as the subject passed in front of the camera (since the white clothes fool the meter into thinking that the scene is lighter than it is). Similarly, if the

camera were panned (turned horizontally) across a group of varied objects, the brightness of the background would fluctuate as the camera reacted to the differing reflectances of the objects. Automatic features vary in their response time to light level changes and in their ability to find the final setting without excess "searching."

Automatic exposure control works best in scenes that are front-lit (where the light comes from behind the camera position), that have relatively uniform backgrounds and where the subject and background are neither excessively reflective nor absorptive. The automatic feature can be used to advantage when you are filming on the run and your subject changes location rapidly. It is often fine to let the automatic feature set the iris and then lock it in place by turning to manual control at the same setting. Many beginners prefer the supposed security of automatic control, despite the sometimes odd exposures it produces.

Low-Light Readings

In low-light conditions, the meter's needle may register at the lower end of the scale where readings become less accurate. To obtain more accurate readings, or any reading if the needle is not registering at all, a reflected meter can be used with a photographic *white card*. White cards are often printed on the back of standard gray cards. If they are kept clean, they should reflect 90 percent of the light. To base an exposure on a white card reading, open up the iris about two and one fourth stops from what the meter indicates.

Measuring Footcandles

Filmmakers often need to measure the intensity of light in absolute terms (a reading of *f*-stops is relative to the shutter and film speed being used). One *footcandle* is the intensity of light emitted by a "standard candle" at a distance of 1 foot. (Light bulbs are sometimes rated in *candle power*.) Cinematographers often instruct a crew to light a set to a certain number of footcandles; a total film "system," including camera, lens and film stock, is sometimes evaluated in terms of how many footcandles it needs to operate.

Footcandles can be measured with an incident meter. Some meters will read directly in footcandles, others have a conversion chart on the back to calculate them. Shooting ASA 100 film at standard shutter speed with the lens set to *f*/5.6 requires about 260 footcandles of light. *Lux* are the metric version of footcandles.

Exposure and Film Stocks

Exposure Range

When we talk about exposure range, we are referring to the length of the straight line portion of the characteristic curve. This is the brightness range of objects that can all be rendered with good detail. It's important to have an idea of the useful exposure range of your film stock. Some stocks—for example, most color negative films—have such a great range that you can expose for a dim interior scene and expect to see some detail through a bright window visible in the background. Other stocks—like contrasty color reversal films—have much more limited ranges. With the same exposure, the window would most likely appear bleached out with these stocks.

You can determine the exposure range of a stock by shooting tests, asking the lab or checking the manufacturer's data sheet. Color negative has about a seven stop range; most reversal films have closer to five or six stops. With a reflected light meter, you can check the difference in *f*-stops between important light and dark areas in the frame. If the brightness range of the scene is too great for the film stock, it may be necessary to recompose the shot, add light, flash the film, change an actor's costume or makeup or redecorate the set (see Chapter 9, Setting Lighting Contrast).

Exposure Error

Some people refer to the exposure range as "latitude"; technically, latitude is the film stock's tolerance of exposure errors in a particular scene. The greater the range from bright to dark within the scene, the less latitude a stock has. With a typical subject, color negative can withstand exposure error of one or two stops, and sometimes more, and still produce a usable original. Contrasty reversal stocks may produce unacceptable footage if the exposure is off by a stop or more.

Various stocks react differently to overexposure and underexposure. If it is necessary to choose between overexposing or underexposing some large or important area in the frame, the picture will generally look better if it is underexposed, (as long as *some* bright areas are visible). Unlike still photographs, film images are constantly changing, and the viewer's attention tends to be focused primarily on the lighter tones, especially faces; underexposed areas that lack detail are therefore not as disturbing as they would be in stills.

Slight overexposure or underexposure (about one half stop) may be used to produce, or avoid, various effects. Color reversal produces richer, more saturated colors when it is slightly underexposed. Color negative produces a less grainy image when it is slightly overexposed, however black-and-white negative becomes grainier.

Exposure Control

In brief, the filmmaker has the following means of controlling exposure at his disposal.

1. Film speed. Aside from the choice of raw stocks, film speed can be altered via force development (pushing) and sometimes via underdevelopment (pulling). A film that is properly exposed in the highlights but contains areas of underexposed shadow can sometimes be helped with flashing (see Chapter 4).

2. The lens. The iris diaphragm is the primary means of exposure control. Neutral density filters can be used to avoid overexposure or for opening the iris to a selected *f*-stop (to control depth of field or maximize lens sharpness). Polarizing filters, and, in black-and-white, contrast filters can be used to alter the exposure of various elements in the scene (see Chapter 4).

3. Shutter speed. Cameras equipped with variable shutters can be set to increase and decrease exposure time, but may affect the smoothness of motion. Changing the camera speed affects exposure time, but also affects the speed of motion (see Chapter 2).

4. Ambient light. Light on the scene, or on selected parts, can be increased with artificial lighting fixtures or with reflectors that reflect sunlight. Neutral density and colored filters can be placed over lights and windows, and lightweight cloth *nets* can be used to cut down on the amount of light falling on a subject (see Chapter 9).

6
Filming

There have been three major technological revolutions in the history of motion pictures. The first obviously was the invention of the motion picture camera itself at the end of the nineteenth century—beginning the era of the Silent Cinema. The second began at the end of the 1920s with the introduction of sound ("the talkies"), which redefined acting, the narrative, and virtually the whole visual look of film. The third revolution started around 1960, with the introduction of highly portable, often hand-held, synchronous sound filming equipment.

In this chapter, we describe typical filming situations and techniques, noting some of the contributions from the three periods of film history. Do not think of the three periods as totally distinct, but think of a modern "shoot" as combining elements of all three.

The Large Production Unit

The following is a brief description of the roles of key members of a large Hollywood-type film production unit, which gives an idea of the range of tasks involved in a shooting session.

The *producer* raises the money for a production and often creates the "package" of script ("literary property"), director and actors. The producer is ultimately responsible for the budget and the overall production and can usually hire and fire personnel. The *director* is responsible for the production unit, translating the script into visual terms, and directing the actors. In television production, the producer is often more like the film director.

The *first cameraman,* also called *director of cinematography, director of photography* (or simply *DP*) or *lighting cameraman,* composes the shots, plans camera movements and decides how to light scenes, usually in consultation with the director. On small units, the DP may operate the camera, but on large units, the *second cameraman* or *camera operator* sets the controls and operates the camera during a take. The *first assis-*

FIG. 6-1. The large production unit on location. A production still from *Lady Tubbs* (Universal, 1935) shows a tripod-mounted, blimped camera (at left center) on a platform that serves as a dolly and can be pushed along the tracks by the grips. Note the microphone boom and the reflectors used to fill in the harsh shadows created by the sun. (Universal Pictures)

tant cameraman operates the follow focus, checks the gate for dirt and keeps the camera clean. The *second assistant* or *clapper loader* operates the clapper board, loads film and keeps the camera report sheet.

The *gaffer* and a staff of electricians place the lights. The *best boy,* an assistant to the lighting gaffer, oversees the positioning of cables. The *grips* move things around—place props, build scaffolds and do other similar tasks. The *sound crew* is run by the *sound recordist* or *mixer* who tapes the sound and directs the *boom operator* who maneuvers the microphone.

The *script supervisor* is responsible for continuity and making sure shots match in everything from weather to hairdo and that everything has been shot from the angles called for in the script. The *assistant director*

(or *AD*) maintains order on the set, makes sure the needed actors are present and controls extras in crowd scenes.

The *second unit* is usually responsible for stunts, crowd scenes, battle scenes and special effects—essentially those scenes that are shot without sound. These scenes have their own director and camera crew.

The *unit production manager* does a breakdown of the shots in the film so that they can be filmed as economically as possible. When the production is *on location*—that is, away from the studio—the unit manager arranges for food and lodging and supervises the relation between the production and outside labor and suppliers. He or she deals with emergencies and tries to keep the production on schedule.

Makeup, hairdressing, costume design, wardrobe on the set, art direction, set design, construction work, prop selection, animal training and countless other jobs are considered specialized tasks that each require one or more people to perform them. *Production stills* (photographs of the actors or crew on the set) are shot by a still photographer. On any size production, do not neglect to have production stills made (both color and black-and-white); they are invaluable in promoting the film and are very difficult to create after the production is finished. If need be, hire a still photographer for a half day.

Union rules determine much of standard industry practice, specifying everything from crew size to who may perform which task. For example, the camera crew often cannot touch a lighting fixture.

Finally, everybody has to "make the call," that is, be on the set on time.

The Small Production Unit

Some filmmakers make their films alone, running both camera and sound (see Filming Alone, Chapter 8). A typical small crew for a documentary may consist of a cameraman and a sound recordist, with either or both functioning as director. A third person may be needed to change mags, drive the car, set up lights and be a *gofer* (perform errands).

A small crew not only results in a significantly lower budget, but also allows a different approach to filmmaking. The small crew can work quickly and usually makes it much easier for actors (see p. 157). It also can gain access to all sorts of locations, such as city streets or mountain tops, that would be nearly inaccessible to a large crew. (Mobility is so difficult for large production units that sets duplicating real environments are often substituted for locations to save money. Shooting on a sound stage also avoids vagaries of weather and the problems with sound on location.)

In documentaries, the smaller the crew, the better the access to the people being filmed and the less the disruption to their lives. Advances in

film technology—faster film, faster lenses, smaller, quieter cameras and wireless microphones—allow the crew to remain relatively unobtrusive.

The Crew and the Subjects

Both in fiction and documentary work, the impact of the crew on the subjects can be minimized by keeping the crew as small as possible. Avoid shouting and arguments in front of the actors or subjects and do not involve them unnecessarily in your technical business and problems. Clapper sticks on documentaries are often disruptive (see Chapter 8).

Actors and people in documentaries should be treated with a great deal of respect and deference; they are often extremely vulnerable to disruptions of mood. Try to set up guidelines with your documentary subjects for what kinds of scenes may be filmed. Arguing with them when they ask you to stop is usually a mistake. Heavy lighting, a noisy camera or a disruptive crew can ruin a sequence.

Division of Shots

The Silent Cinema defined the basic vocabulary of the film image. Today, shots taken without sound are referred to as *MOS*. The story goes that when the German directors came to Hollywood in the early 1930s, they referred to silent footage as "mit-out sound," hence *MOS*.

A script is divided into a series of *scenes;* a scene is an event that takes place in one setting in a continuous time period. However, when someone walks from one room to another and the camera is moved and has to be set up again, it is usually considered two separate scenes in the script. Various *shots* or *camera takes* are filmed, each trying to render the scene written in the script. For example, "Scene 8, Take 14" is the fourteenth take that attempts to capture Scene 8 in the script. *Take* (or camera take) refers to the footage from the time the camera begins filming until it is turned off. *Shot* is used sometimes to mean camera take and sometimes to mean the edited take, that is, the portion of the take used in an edited version of the film. To confuse matters further, "scene" sometimes means shot. Usually the context distinguishes the meaning. Sometimes letters are used to indicate a particular angle called for in the script. "Scene 8B, Take 14" is the fourteenth attempt to get the second camera angle (B) of Scene 8.

Shots are divided into three basic categories—the *long shot, medium shot* and *close-up*. The long shot includes the whole body of the person in relation to the environment or is a fairly wide view of a landscape. The

FIG. 6-2. Shot division. The categories are not exact. (i) The extreme close-up fills the screen with a small detail. (ii) The big close-up fills the frame with a face. (iii) The close-up includes the head and shoulders. (iv) The medium shot includes most of the body. When two people are shown in medium shot, it is a two shot. (v) The long shot includes the whole body and the surroundings.

establishing shot is a long shot that defines the basic space or locale where the subsequent events take place. The medium shot is not too detailed, includes part of the subject and usually includes people from head to knee or from waist up. The close-up shows some detail of the scene; in the case of a person, it is a head and shoulder shot. In an *extreme close-up (big close-up)* just a face or part of a face fills the screen, or a small object fills the screen—for example, a watch or a fly. When it is an object, this shot is sometimes called an *insert shot*.

Two shots taken from opposite angles are called *reverse-angle shots*. A conversation between two people is often shot with each person alone in the frame in three-quarter profile—first with one person looking left, then the other looking right. This shooting–editing style is called *angle-reverse-angle*. In these shots, sometimes close-ups but sometimes the back of the other person is visible, the speakers are matched in size and are in the same relative position on the screen (see Leading the Action and the Director's Line, p. 157). Angle-reverse-angle cutting is often contrasted with the *two shot*, which is a single shot of two actors from the front showing them from the knees up *(knee shot)* or waist up. The *point of view (POV) shot* is taken from someone's or something's vantage point. It can be taken from behind an actor or as though from over his shoulder or at the position of his eyes. POV shots also include shots from extreme vantage points, such as from directly overhead *(bird's eye view)*.

The shooting and editing of *static shots* (that is, shots taken with no camera movement), can be contrasted to that of *moving camera shots*. A camera mounted on a moving support (see p. 166) can move from a long shot to a medium shot in a single take. Whether you use static or moving camera shots, the parsing or dividing of the action into various shots (instead of shooting scenes from one camera position in a single take) helps in both the shooting and editing of the scene.

One logical and traditional breakdown of a scene is the movement from the long shot to the medium shot to the close-up. This order suggests forward movement into the scene, as though the camera is delving deeper into the action. When a scene goes from a medium shot to a long shot, we expect action on a larger scale (for example, a new arrival in the scene) or a leave-taking from the action (as might happen at the end of a movie). Dividing shots also allows you to change the pace of the film in the editing room and to edit around mistakes (see below and Chapter 11).

Composition

Each shot is composed or *framed* in the camera viewfinder. When you film from a script, each shot is *blocked out,* or planned, before the take. In unscripted work, framing and movement are improvised based on both what is seen through the viewfinder and what is seen and heard outside the frame.

The notion of composition comes primarily from easel painting and secondarily from still photography, and refers to the arrangement of objects within the frame—their balance and tensions. Composition in motion pictures is quite different, since objects move within the frame *(subject movement)* and the frame itself can move *(camera movement)*. Furthermore, one shot is edited next to another, creating a whole new set of tensions and balances through time. Thus, although the placement of objects in the frame shares some of the importance that it has in painting and still photography, film acquires an additional definition of composition when it includes subject movement, camera movement and editing.

Since a shot often reveals its meaning through motion, it is possible to have strong film composition without well-composed still frames. When a *storyboard* is made for a scene, each shot is drawn as one or more still images, noting camera and actor movements (blocking). There is a tendency to compose for the frame, the result—if filmed directly from the storyboard—often being static. Composition that is dynamic usually resolves tension by the use of subject or camera movement or through editing.

Although there are no set rules for composition, there are expectations that compositions create and that may be used to surprise the audience

or to confirm or deny their expectations. For instance, camera angles from below are used to suggest the importance, stature and height of the subject. In horror films, compositional imbalance in the frame often suggests something scary lurking outside the frame (see Fig. 6-3).

Objects should be placed naturally in the static frame. Do not compose so the edge of the frame and important objects are so close that they seem to "fight." Keep objects comfortably within the frame or use the edge to cut them off decisively and to direct attention to important areas of the frame. Avoid large dead spaces, and do not lose the subject in a mass of irrelevant details. If you're unsure, put the subject's nose halfway up the frame in close-up or medium close-up shots. In medium shots, place heads one third of the screen height from the top. Keeping in mind the above, it must be pointed out that exceptions are legion.

Leading the Action

Whenever a subject has a definite movement toward the edge of the frame, place the subject closer to the edge from which he is moving. For example, if you track a runner running from left to right, frame him closer to the left side of the frame as if to leave room for running on the right. If the shot continues for some time, the runner can advance in the frame (still leaving room at the right) to suggest forward movement. Similarly, someone in profile looking off-screen to the right should be framed closer to the left side of the frame, leaving space on the right.

The 180° Rule

Screen direction refers to the right or left direction on screen as seen by the audience. If a subject facing the camera moves to his left, it is *screen right*. The *180° rule* (also called *the director's line* or *the line*) tells

(i)

(ii)

(iii)

FIG. 6-3. Leading the action. (i, ii) Leave more room on the side of the frame toward which the action points. (iii) The void at the right throws the frame off balance, and you expect something to happen (for example, the man may be attacked from behind).

how to maintain screen direction when different shots from the same scene are edited together. If a subject is moving or looking right in one shot, in general, it is best not to let screen direction change when cutting to the next shot. For example, when watching football on television, the blue team is seen moving from screen left to screen right. If the camera were now to shift to the opposite side of the field, the blue team would appear to be moving in the opposite direction (that is, their screen direction has changed from right to left). It is likely that the audience would be confused. To avoid this confusion, TV crews often keep all their cameras on one side of the field, and, when they wish to use a camera position from the opposite side of the field, a subtitle is flashed on the screen that says "reverse angle."

To help plan your shots, imagine a line drawn through the main line of action—be it a moving car, a football field or the eye line of a conversation. If all camera setups are on one side of the line, screen direction will be preserved from shot to shot. Shots on the line (for example, someone looking directly into the camera or a shot from the end zone in the football example) are considered neutral and can go with shots on either side of the line.

During a take, the camera can move across the line with minimal disorientation. But, if later in the editing room, you do not use a shot where the camera crosses the line, you may have to violate the 180° rule. Rule violations disorientate the audience, but rarely are they disastrous. Sometimes inserting a neutral shot minimizes disorientation. The problem is most serious when screen direction itself has been used to construct the space of the scene. For example, in an angle-reverse-angle of two people

FIG. 6-4. The 180-degree rule. If all the camera positions are kept on one side of the sight line, screen direction will be preserved in editing.

talking, they must be looking in opposite screen directions when there is a cut from one to the other, otherwise they will not appear to be talking to one another. Similarly, chase sequences depend on screen direction to establish whether one car is chasing another or if the two are headed toward each other.

Sometimes there are two different lines of action and there is no way to avoid breaking the rule. For example, a couple is talking in the front seat of a moving car in a scene that is shot angle-reverse-angle. When the driver is shot, the background is moving left; but when the passenger is shot, the background is moving right. Since the relation of the couple is most likely the key element of the scene, draw the line of action along their eye line to preserve their screen direction in the editing.

Continuity

Usually several takes of the same scripted action are shot, in part because actors blunder and crew members make technical errors, and in part because shooting multiple camera angles minimizes the chance of discontinuities in the edited sequence. Even if you plan to shoot the action in one take, allow for an *overlap of action* from one shot to the next in the scene to guarantee that there are no discontinuities in time in the editing. For example, when a medium shot of someone slamming a car door cuts to a close-up, shoot the first shot all the way through the slamming of the door. When you begin the second shot, film the actor from a point in the action *before* the first take ended including the slamming of the door. (Note: the two shots should usually be taken at different angles to make a smoother cut and to minimize any slight discontinuities.) This allows the two shots to be cut together at several points without discontinuity.

The same problem arises in documentary, but an overlap of action is usually impossible since subjects rarely repeat their movements. Sometimes documentary filmmakers shoot *cutaways* (shots away from the main action, see Chapter 11) to cover discontinuities or to condense the action. Whenever you feel there will have to be a cut made to another shot, change camera angles and focal lengths to make continuity editing easier.

When a character walks off camera, the viewer generally accepts a time jump when the next shot begins with him a bit later. For instance, if someone walks off frame toward the street, a cut to the person opening a car door, or walking down the street does not seem discontinuous.

In both documentary and fiction shooting, you should always have in mind what shot you can cut the present one with. In a two-way conversation, a close-up of one person will almost invariably cut next to a close-up of the same size of the other person (assuming the 180° rule is

observed), but two close-ups of the same person can rarely cut smoothly together. (See Chapter 11 for further discussion on continuity.)

Make sure you always cover for errors. While the beginning and end of a take may be good, the middle may have an error or just be too slow on the screen. Shoot a reaction shot or a cutaway as editing insurance even if you do not intend to use it. You may want one continuous take, but, too often, surprise errors show up during editing and it is essential to be able to cut around them. Getting a take exactly right is expensive, and, for long takes, very difficult. One saying has it that the best takes are the first and the eleventh (the advantages of spontaneity versus practice), but the production's budget may not permit eleven takes. Even if a long take is good, you may need to cut the sequence or film shorter and your beautiful 3-minute shot now becomes a burden.

While on location, never count on the weather. Crews have been stranded for weeks waiting for snow, sun or whatever else. Shoot interiors when the weather is not right, and have a backup schedule for when an actor gets sick or some special equipment does not operate. Duplicate wardrobes and props allow production to continue even when a prop has been misplaced or a shirt has gotten dirty.

Backup locations allow you to continue production if plans fall through. Shooting on city property often requires permits, which should be gotten during preproduction. You may need insurance bonds to shoot in some locations. Some states have film bureaus that will help filmmakers obtain permits and scout possible shooting locations.

Errors discovered while viewing rushes or during editing often necessitate *pickup shooting*, which entails going back to get additional shots to fill in a sequence. A documentary crew might return to get a cutaway from a car window, and, in a fiction film, there might be the need for a reaction shot of an actor. Make Polaroids of sets, lighting setups, makeup and costumes to help match shots that may need to be redone.

Other Elements in the Dynamic Frame

The focus may be pulled from the background to the foreground to shift audience attention. Some filmmakers consider this technique mannered unless it is used to follow a movement. Selective focus is used to accentuate a portion of the subject. In a close-up, it is advisable to focus on the eyes. Lighting may be changed within a shot; for example, car headlights might suddenly illuminate a person.

Shots tilted sideways (tilted horizon line) are called *Dutch angle* or *canted* and are sometimes used, often in medium close-up, to add tension to a static frame.

Cinematographers often shoot at an angle that reveals as many sides of the object as possible in order to enhance the feeling of depth. For example, a building filmed head-on reveals one side—shot from an angle it

FIG. 6-5. Dutch angle from *Citizen Kane*. Note the strong diagonal lines in the frame. (RKO General)

reveals two sides—and shot down and at an angle it reveals three sides. Hollywood directors frequently use camera angle, camera movement and lighting to create a feeling of deep space in the image. This allows them to clearly distinguish foreground from background and exclude large areas of unmodulated black or white. European directors often emphasize the flatness of the screen through their use of lighting and camera angle, sometimes shooting perpendicularly to a wall or allowing large areas of the frame to be overexposed or underexposed.

Shots may be framed with the aid of a *director's finder*, which is a small handheld finder for viewing a scene at different focal lengths.

Camera Supports

The Tripod

The *tripod* is a three-legged camera support. The camera mounts on the *tripod head*, which sits on the tripod's *legs*. If no camera movement

is needed, the tripod can be a simple affair with an inexpensive head and sturdy legs. Heads designed for motion pictures are able to *pan* (short for *panorama*), which is to rotate the camera horizontally, or to *tilt*, which is a vertical pan. *Friction heads* for tripods are the least expensive, but they take the most skill to pan smoothly. *Fluid heads* have a built-in hydraulic dampening device to make panning much easier. Their light weight and ease of operation make them the most advantageous for small crew work. Usually, tripod heads have locks that prevent them from moving inadvertently. The lock on the tilt movement is very important, since the camera and tripod can fall over if there is an untended tilt. Friction and fluid heads often have devices to control the amount of

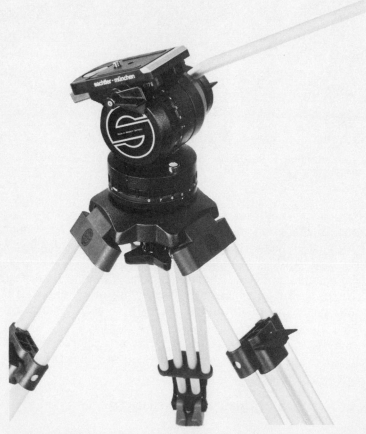

Fig. 6-6. Sachtler fluid head. A lightweight fluid head (6 lbs) that will support cameras up to 22 lbs. The head has an internal adjustment for balancing front- or rear-heavy cameras and a snap-on plate for attaching and detaching the camera quickly. (Sachtler Corp. of America)

friction or dampening for different panning speeds. *Geared heads,* mostly found on feature film sets, are bulky, heavy and the most expensive. When they are cranked by hand, they allow for very smooth, easily repeatable movements, but they cannot make very quick movements or follow fast-moving subjects.

Wooden tripod legs are generally heavier but are less expensive than the new lightweight metal and carbon fiber legs. *Standard legs* will telescope out to around 6', and *baby legs* raise to around 3'. The *high hat,* used for low-angle shots, does not telescope and is often attached to a board. Tripod legs and heads are rated by the weight they will support; do not use a camera heavier than the rating.

Level a tripod so that the horizon line is parallel to the top or bottom of the frame. Unleveled tripods result in canted shots and tilted pans. To level a tripod, extend one of the legs (loosen the knurled knob by turning from the outside of the leg in) and tighten at the proper length; loosen the other two legs, and extend them; hold the tripod in a vertical position and press down on it until the legs are even and then tighten them. Point one of the legs in the direction that you will shoot the camera, and place the other two legs to approximate an equilateral triangle. With a *ball-in-socket* head, loosen the ball and move the head until the bubble on the attached spirit level is centered. On other types of professional heads, there is usually a T-level—two spirit levels at right angles. Rotate the head so that the horizontal bar lies between any two legs, center the bubble on the horizontal bar by adjusting either of the legs and center the vertical bar by adjusting the third leg. The tripod is now level.

If the tripod has no level, use architectural horizontal or vertical lines to level the camera. If the camera is not pointed up or down, align a true vertical with the vertical edge of the frame; or align a true horizontal, viewed head on, with the top or bottom of the frame.

Tripod legs often have a point or spike at each toe that can be secured in dirt or sand. A *spreader* (also called a *spider* or *triangle*), a three-armed device that spreads from a central point and clamps to each tripod leg, prevents the legs from sliding out from under the tripod head. A *rolling spider* or *tripod dolly* (a spreader with wheels) facilitates moving the camera between shots. Do not use it for dolly shots except on the smoothest of surfaces. When no spreader is available, a piece of rug, 4' × 4', is often used. You can tie rope or gaffer's tape around the perimeter of the legs for an improvised spreader.

Some tripods (usually made for still photography) have devices for elevating the center of the tripod. This extension usually contributes to the unsteadiness of the image; it is more desirable to extend the legs. If additional height is needed, mount the tripod on a platform. On large productions *apple boxes*—strong, shallow boxes of a standard size—are nailed together to make low platforms.

Quick-release mechanisms save a lot of time mounting and releasing

FIG. 6-7. Sachtler tripod legs. A range of lightweight legs that accept fluid heads. The spreader fastens to the standard legs even when folded for travel. This saves a great deal of time when moving and storing the tripod. (Sachtler Corp. of America)

the camera from the tripod head without the usual screw threading. Safety locks prevent the camera from slipping off during a tilt. Some heads have a balancing device for specific cameras to facilitate tilting.

Heavy duty suction cups and clamps allow you to attach cameras to vehicles and other surfaces. The surface must be fairly flat, smooth, clean and dry to use suction cups. If the camera is mounted on a moving vehicle, tie it down with safety lines.

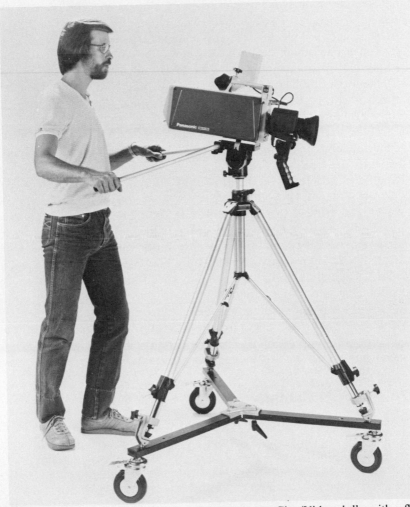

FIG. 6-8. Rolling spider, or tripod dolly. The Bogen Cine/Video dolly with a fluid head (for cameras up to 22 lbs) is shown with a video camera and two handles typical of a video setup. The legs can be adjusted from 12″ to 63″. (Bogen Photo Corp.)

PANS AND TILTS. Whenever possible, plan and rehearse pans and tilts. Adjust the tripod so the front leg points in the direction of the lens to maximize the amount of room behind the camera. On very wide-ranging pans, you may have to cross over a tripod leg, which is not easy to do without practice.

Pans work best when motivated by a subject moving through space. Panning with a moving subject makes the rate and movement of panning natural. Panning to follow a subject is sometimes called *tracking,* but this should not be confused with the tracking shot where the camera itself moves through space (see below). The most difficult pans are across landscapes or still objects since any unevenness in the movement is evident. These pans must be fairly slow to avoid strobing (see Chapter 2, The Shutter). A safe panning speed for landscapes under average lighting and subject conditions pans an object five seconds or more from one edge of the frame to the other. Following a moving subject minimizes the strobing problem, since the viewer's eye follows the moving object, making strobing in the background less important. The *swish pan,* a fast pan that blurs everything between the beginning and end of the movement, also avoids the strobing problem.

Panning is sometimes thought to be the shot most akin to moving your eye across a scene. If you look from one part of the room to another, however, you will see that, quite unlike the pan, equal weight is not given to all the intermediate points in the visual field.

Cinematographers sometimes say that shots with camera movements like pans, tilts, zooms and dolly shots are supposed to start from a static position, gradually gain speed, maintain speed and then slow down to a full stop. This rule is often honored in the breach, and shots often appear in films with constant speed movement.

Viewers tend to read images from left to right, and scene compositions should take this into account. Therefore, pans generally cross still landscapes from left to right, as though the world unfolds in this way.

The Moving Camera

When the camera moves through space, the viewer experiences the most distinctly cinematic of the motion picture shots. The moving camera is perhaps the most difficult and often the most expensive shot in the cinematographer's vocabulary. These shots are called *dolly, track* or *truck shots:* when the camera moves in, it is called *dolly in* (or *track in* or *truck in*); when the dolly moves out, *dolly out* (and the like). If the camera moves laterally, it is called *crabbing.* A wheeled vehicle with a camera support is called a *dolly* or, if it can move laterally, a *crab dolly.* Most dollies are large, although there are fold-up versions that will fit in a station wagon. If the support can reach great heights, it is called a *camera*

crane or *boom*. Industrial-type "cherry pickers" may be used to raise the camera up high for a static shot, but they do not have the proper dampening for ending a shot with the camera motionless. Dollies and cranes often require boards or tracks to be laid down to form a smooth running surface.

There are substitutes for professional dollies—wheelchairs, shopping carts, children's wagons, roller skates, a pushed automobile. In such cases, use air-filled tires for smoother motion. Large tires, especially when underinflated, give smoother dolly movements. Do not secure the camera rigidly to most improvised dollies. Handholding often insulates the camera from vibrations.

Shooting from a Moving Vehicle

When you need a tracking shot faster than what you can get from a dolly, use a motorized vehicle. An automobile, especially if it is equipped with a shooting platform, is extremely versatile. In general, the larger the car, the smoother the ride. Sometimes automatic transmissions are preferable, since manual shifting may create a jerky movement. Keep tire pressure low to smooth out the ride. The camera should be handheld to absorb automobile vibrations. It is easiest to achieve smooth camera movement if the car's speed remains constant and most difficult if the vehicle goes from a stop into motion.

Shooting in the same direction as the moving vehicle results in the motion appearing normally on the screen. Shooting at right angles to the direction of the vehicle makes the car appear to be going roughly twice as fast as it is. At intermediate angles, the speed is between these extremes. As is explained in the discussion on perspective in Chapter 3, wide-angle lenses increase apparent speed and long focal length lenses can decrease apparent speed. To determine how fast the vehicle will appear to move on the screen, take into account the lens focal length, the angle of shooting and the speed of the vehicle. You can film at higher camera speeds to smooth out unevenness in the vehicle's ride.

The Handheld Camera

The handheld camera was first experimented with during the era of Silent Cinema, especially in the films of Dreyer, Clair, Vigo and Vertov and in various MOS sequences during the studio era of sound film such as James Wong Howe shooting a boxing sequence on roller skates. However, not until the early 1960s with the New Wave in France and the new documentary film (*direct cinema* or *cinema verité*) in the United States was the potential of the handheld camera realized. With the advent of handheld cameras, new access to locations, people's lives and actors was obtained. Jean Renoir spoke of the heavy studio camera as an altar to

which actors had to be brought as opposed to the camera that could go out into the world. Not only could the camera now capture new subject matter in new locations, but handheld shooting, at its best, imparted electricity to the image. Handheld shooting is often best in unscripted situations—whether a documentary or with improvised acting. The extreme mobility of this camera permits following the action, achieving a feeling of intimacy impossible in a tripod- or dolly-mounted camera.

TIPS FOR HANDHELD SHOOTING. You should avoid handheld shooting of landscapes or scenes with strong architectural elements since any jiggles are obvious because of the stillness of the subject.

Shoulder-mounted cameras are the steadiest, because the operator's body braces the camera and dampens vibrations. Cameras that are held in front of the eye, like super 8 cameras, are more difficult to hold steady. Very light shoulder-mounted cameras like the Eclair ACL with a 200' magazine are apt to jiggle more than slightly heavier cameras, such as the ACL equipped with a 400' mag. To hold a camera like the Arriflex BL steady, use a body brace. Even well-balanced cameras can be held steadier with a brace. A brace does, however, encumber you and prohibits you from responding as quickly to unpredictable events. Some cinematographers feel the brace imparts a mechanical feel to the shooting, but, for those situations where the mobility of the handheld camera is needed and the action is predictable, a brace may work out well.

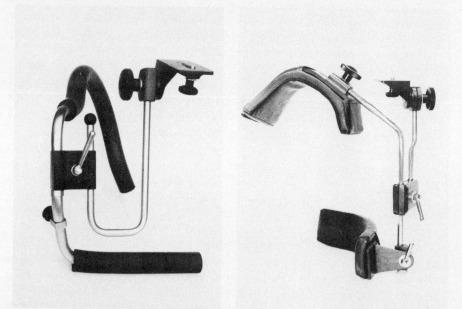

FIG. 6-9. The shoulder pod or body brace. (Cine 60)

You should know which way to turn the lens controls for focus, aperture and zoom. Make up your own memory aid such as "pull to bring infinity close and bright," which means (assuming the lens is operated with the left hand) pull counterclockwise for farther distances (infinity), to open up the aperture (bright) and to zoom in closer. Not all lenses turn the same way, so you may need to make up another memory aid for your rig.

To shoot a handheld camera over extended periods of time, it helps if you're in good physical shape. Find a comfortable position for shooting by practicing before you begin. Some people shoot with one foot in front of the other, others with their feet in-line, shoulder-width apart. Do not lock your knees tight; if you like, keep them slightly bent. Stand so you can smoothly pan in either direction and move forward or backward. For filming while walking, walk Groucho Marx style, with your knees bent and shuffling so that the camera does not bob up and down.

When you film without a script, avoid excessive zooming and panning, which could produce results that are unwatchable and uncutable. As a test, we often tell our students to count slowly to six without making any camera movements. If they feel their fingers itching to zoom or pan, they are not yet calm enough to shoot.

When you shoot while walking backward, have someone (like the sound recordist on a small crew) put his hand on your shoulder and direct you. Some camera eyepieces swivel so that you can walk forward with the camera pointing backward over your shoulder. Try cradling the camera in your arms while walking and shooting: use a fairly wide-angle lens, positioned close to the subject and keep in stride. To steady a static shot, lean against another person or a support, such as a car or building. Put the camera on your knee when shooting the driver in the front seat of a cramped car.

Documentary filmmaking creates some of the most difficult follow focus situations since the camera-to-subject distance constantly changes in unpredictable ways. When careful focusing is not possible, zoom to a wider angle to increase depth of field and move the distance ring to the approximate position. As your skill increases, it will become easier to pull something directly into focus by looking at the ground glass. As previously said, remember that the wider the angle of the lens, the less annoying any camera jiggle will be in the image (see Chapter 3).

Image Stabilization Devices

Image stabilization devices can be used to lessen unwanted camera vibrations and jiggles. These range from gimbal-headed tripods with a heavy weight suspended between the legs (effective for slow movements like those of a ship at sea) to a helicopter mount that will dampen fast vibrations such as those from a helicopter or plane.

THE STEADICAM. The *Steadicam* and other similar devices allow the camera to be body-mounted but absorb most shocks, enabling smooth movements. The camera movements possible are similar to those from a dolly, but a Steadicam permits much faster setups, shooting in tighter quarters and significantly increased mobility. Any vehicle—automobile, boat, helicopter or even skates—can achieve dolly-smooth movements. Pans, tilts, running shots and shots going up stairs can be made with the subtlety of the moves of the human body without any handheld jiggles. With a Steadicam, you do not look through the camera's viewfinder but, rather, at a small video monitor that displays a through-the-lens reflex image. Although you can respond to unplanned subject movement (unlike a dolly where each shot must be blocked), response is slower than that of the shoulder-mounted camera. Also, Steadicam shots have a floating smoothness that some people find more mechanical and less exciting than well-done handheld shots.

The Steadicam must be set up specifically for each camera and requires that the camera be equipped with a video tap. Cameras with *coaxial magazines* (mags with the supply and take-up compartments side-by-side; see Figs. 1-9, 2-6) work best, since the camera's center of balance remains more stable during a take. The Steadicam operator needs special training and plenty of practice. More experienced operators can respond to fairly rapid subject movements.

The implications of the Steadicam for theatrical feature film productions are monumental. Not only does it add to the repertory of dolly-like shots, but, more importantly, it creates new relationships between filmmaker and location and between filmmaker and actors. Quick, inexpensive setups relieve the pressure on actors and crew. The use of a Steadicam in a documentary is often limited, since the equipment would be overwhelming to most people in documentaries, and it is nearly impossible for even an experienced operator to respond to the unpredictable movements of people in unscripted films.

THE ARRIFLEX IMAGE STABILIZER. There are several devices, such as the Arriflex Image Stabilizer, that fit over the camera lens to decrease vibration. The Arriflex Stabilizer only works with longer focal length lenses (lenses over 35mm in the 16mm format) and will dampen vibrations from automobiles, helicopters and the like. It is small enough not to interfere with handholding and requires no special training for its use.

Production Costs and the Mobile Camera

The handheld camera offers the freedom and aesthetics of a moving camera at low production costs. Before the introduction of handheld sync-sound cameras and Steadicam filming, only expensive productions

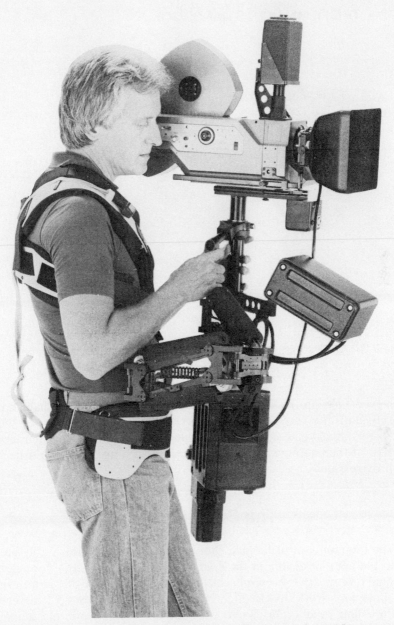

Fig. 6-10. Steadicam Universal Model III with Cinema Products 35mm camera. Note that the operator (Steadicam inventor, Garret Brown) is viewing a small video monitor. (Cinema Products)

could make substantial use of camera movements since dolly shots on location are costly to set up and execute. Movement in low-cost productions tended to be mostly subject movement and panning, with frequent cutting from one static shot to another. Dynamic filming was usually

FIG. 6-11. Arriflex Image Stabilizer. (Arriflex Corp. of America)

achieved through the composition of the still frame rather than through the dynamism created by the moving camera. However, despite the assets of handheld cameras and Steadicams, if you do not like their look on film (or if the equipment is out of your budget range), use the tripod and improvise a dolly.

The Shooting Ratio

The total amount of footage shot on a production is invariably greater than the amount of film in the final print. The ratio of total footage shot to final footage (the *shooting ratio*) is often higher than 40:1 in unscripted documentary work and is often on the order of 10:1 or 15:1 in scripted feature film production. Some experimental filmmakers and animators use almost all the footage they shoot. Laboratory expenses are often the most significant budget item on a low-cost production, and the shooting ratio is a key concern.

No matter how predictable you assume the action, the unexpected always seems to happen; there are weather changes mid-scene, flubbed lines and technical difficulties with picture, sound or lab. Additional takes are invariably needed in acted work, and the unpredictable nature of the documentary may mean that the hoped-for footage is never shot.

7

The Sound Recorder and Microphone

Sound

What you hear as sound is a series of pressure waves produced by vibration. A guitar string works by vibrating air rapidly back and forth. When a section of the string moves one way, it compresses the air (pushes it) in that direction; when it moves the other way that pressure is temporarily reduced. Like ocean waves breaking on a beach, sound waves alternately press forward and recede back.

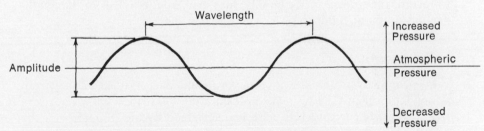

FIG 7-1. Graph of a simple sound wave at an instant in time. The height of the wave (or *amplitude*) corresponds to loudness. The distance from one peak to the next (the *wavelength*) corresponds to the sound's frequency.

Loudness

The *loudness*, or *volume*, of a sound results from the amount of pressure produced by the sound wave. Loudness is measured in *decibels* (dB), which are used to compare the relative loudness of two sounds. If a sound is increased in volume by 10 dB, it will sound about *twice* as loud as it did originally.

The softest audible sounds occur at the *threshold of hearing*. When we talk about the absolute loudness of sounds, the threshold is used as a reference point. For example, the volume of normal conversation is about 65 dB above threshold, thus its sound level is said to be 65 dB. The

173

threshold of pain is at about 130 dB. A sound level of 130 dB is equivalent to the noise of a jet passing within 100 feet.

Dynamic Range

For any passage of sound—be it music, speech or noise—the difference in volume between the quietest point and the loudest is called the *dynamic range*. The dynamic range of a symphony orchestra is about 80 dB, which represents the difference in volume between the full group playing fortissimo and a single violin playing softly. Actually, the dynamic range of the orchestra is somewhat lessened by the shuffling and coughing of the audience, which may be louder than the quiet solo violin.

Dynamic range is a term used in evaluating sound recording systems. The human ear has a dynamic range of 130 dB between the thresholds of pain and hearing. High-quality magnetic tape recorders have a dynamic range of 70 dB, or higher, between the loudest sounds recorded without audible distortion and the low volume sound of the tape noise. Tape noise, or *hiss*, is always present in magnetic recordings and, like the shuffling sounds of the symphony audience, it determines the lower limit of the dynamic range. The dynamic range of a tape recorder is sometimes called the *signal-to-noise (s/n)* ratio. The "signal" is the sound we want to record; the "noise" may be tape hiss or *system noise* from the amplifiers and circuits in the recorder and the microphone.

Frequency

Musical notes are *pitches;* the modern piano can produce pitches from a low A to a high C. The lower notes are the *bass,* the higher ones, the *treble.* What is perceived as pitch is determined by the *frequency* of the sound wave. Frequency is a measure of how frequently waves of sound pressure strike the ear; that is, how many pulses strike in a given length of time. The higher the frequency, the higher the pitch. Frequency was formerly measured in *cycles per second;* now the same unit is called a *hertz (Hz).* Musical notes are standardized according to their frequency. Orchestras usually tune up to concert A, which is 440 Hz. Doubling this or any frequency produces a sound one *octave* higher.

The male speaking voice occupies a range of frequencies from about 100 to 8,000 Hz. The female speaking voice is slightly higher, ranging from about 180 to 10,000 Hz. The ear can sense low frequencies down to about 20 Hz, but these sounds are very rumbly and are felt throughout the body. Extremely low frequency sounds, below about 17 Hz, sound like discrete pulses rather than constant tones. At the other extreme, sounds above 20,000 Hz are audible to dogs and bats, but seldom humans.

When sound volume is low, the ear is much more sensitive to mid-range frequencies (2,000 to 4,000 Hz) than to low or high frequencies. Thus, a low-frequency sound *seems* quieter than a middle-frequency sound if they have the same sound pressure (that is, the same reading in decibels). Home stereos often have a "loudness" control that increases the low bass when the volume is down to compensate for this deficiency. When sound volume is high, the ear responds much more evenly to all frequencies of sound; low, middle and fairly high frequencies of the same sound pressure all seem equally loud.

Harmonics

All naturally occurring sounds are made up of a *mixture* of waves at various frequencies. A violin string vibrates at a basic frequency (called the *fundamental*), as well as at various multiples of this frequency. These other frequencies are called *harmonics,* or *overtones,* and they are usually quieter than the fundamental. With tones that sound "musical," the frequencies of the harmonics are simple multiples of the fundamental. Most other sounds, such as a speaking voice or a door slam, have no discernible pitch; their harmonics are more complexly distributed. The relative strengths of the harmonics determine *tone quality* or *timbre*. When a man and a woman both sing the same note their voices are distinguishable because the man's voice usually emphasizes lower harmonics than the woman's. Pinching your nose while talking changes, among other things, the balance of harmonics and produces a "nasal" tone quality.

Frequency Response

Frequency response is used to describe how an audio system responds to various frequencies of sound. As noted above, at low volume the ear favors middle-frequency sounds, and at high volume its frequency response is more even or *flat*. A good tape recorder is capable of providing a fairly flat frequency response throughout the frequency range of human hearing.

Because all sounds incorporate a *spread* of frequencies, if you change the frequency response of your equipment by increasing or decreasing the response to low, middle or high frequencies, you can change the character of the sounds. The bass and treble controls on a stereo do this to some extent; most people like to turn the bass up in dance music to make the rhythm, carried by low-frequency instruments like the bass guitar and bass drum, seem more powerful. Sometimes *graphic equalizers* (see Fig. 12-2) are used in film work to change the character of sounds after they have been recorded. With such a device, you could boost the

low frequencies to make, say, a truck engine sound deep, rumbly or menacing, or you could diminish the bass and increase the treble or high frequencies to make its sound more thin or hollow. If we diminish the high frequencies without changing the bass, the effect is like putting cotton in your ears: the sound is muddy and dull.

The Sound Recorder

Today all original sound recording for film is done magnetically on tape. Although cassette recorders, which use ⅛″ wide tape, are being used increasingly in film, most filmmakers use *reel-to-reel* (also called *open-reel*) recorders with ¼″ wide tape because this wider format offers better sound reproduction.

Magnetic Recording

In simplest terms, magnetic recording converts sound energy in the air to magnetic energy, which can be stored on tape. When the tape is played back, the process is reversed to reproduce sound.

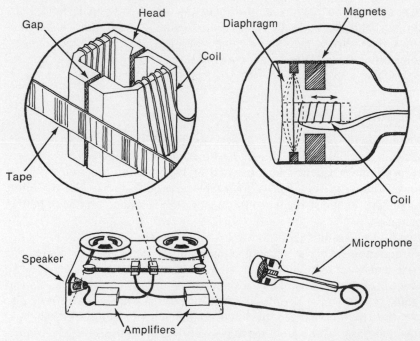

FIG. 7-2. The sound recording process. The playback head of the tape recorder is shown in a cutaway view (the width of the gap is exaggerated for clarity). The microphone cutaway shows the components of a dynamic microphone.

The *microphone* responds to sound waves by producing electrical waves that have essentially the same character in terms of frequency and amplitude. Most modern microphones employ an extremely light *diaphragm* that can move sympathetically with the slightest variations in sound pressure. The means by which the moving diaphragm generates electricity varies with different types of mikes. The common *dynamic microphone* that comes with many home tape recorders is also called a *moving-coil microphone* because it has a very light coil of wire attached to the diaphragm. When the diaphragm moves back and forth, the coil moves past a permanent magnet. By the principle of *induction,* the coil moving through the magnetic field produces an alternating electric current that flows through the wires in the coil. Thus, sound pressure is translated into electric pressure, or *voltage.*

This voltage travels from the microphone to an *amplifier,* which increases its strength, and then on to the *magnetic recording head.* A magnetic recording head is an electromagnet, not unlike the ones used in metal scrap yards or that kids sometimes play with. When electricity is passed through the head it generates a magnetic field. The head is a C-shaped piece of metal with wire coiled around it. On its front is an extremely narrow opening called the *gap.* Like the microphone, the head works by the principle of induction, only here the process is reversed. The magnetic head completes a flow of energy: advancing and receding sound waves become electrical waves, which finally result in a magnetic field that is oriented first in one direction and then in the opposite.

Like film, magnetic tape is made up of a thick support material or *base* and a thin emulsion that stores the information. Tape emulsion is called *oxide* and contains small particles of iron. Each piece of iron is a miniature bar magnet with distinct north and south poles. When a particle of iron passes the gap in the recording head, the magnetic polarity of the particle aligns itself with the magnetic field at the head; when the tape moves on, it maintains that orientation. Since the magnetic field is always alternating back and forth, any given stretch of tape contains groups of particles that alternate in their alignment. The alignment of the particles corresponds to the original sound in this simplified way: the louder the sound, the more particles will be forced to line up the same way; the higher the frequency, the closer together the alternating groups will be.

To play sound back, the tape is passed over the same head, or a similar playback head. Now the magnetic field stored in the iron particles induces an electric current in the wires coiled around the head. This signal is amplified and sent to a loudspeaker, which acts like a moving-coil microphone in reverse. The speaker employs a large paper cone, instead of a diaphragm, which is connected to the coil. When current passes through the coil, it moves the cone, which in turn pushes the air to produce sound pressure waves. If you stand in front of a large bass speaker, you can actually feel the wind generated by the paper moving back and forth.

The Tape Path

Most tape recorders used for film have the following components: a *feed,* or *supply, reel* of tape; an *erase head* that cleans the tape of any distinct magnetic pattern; a *record head* to record the audio signal; a *pilot head* to record and play back speed control information (see Double System, p. 203); a *playback head* to produce the audio; a *capstan* and *pinch wheel* to move the tape forward and a *takeup reel* to store the tape. Some machines only have erase and record heads, the record head serving as a playback head and sometimes a pilot head as well.

Many tape recorders have built-in speakers. Those without speakers are sometimes called *tape decks*. The word "deck" also refers to the top surface of the recorder where the tape transport is located.

Erasure

The first head in the tape path is the erase head, which clears any magnetic signal present on the tape. Erase heads work by exposing the tape to an inaudible, very high frequency tone. On most recorders, the

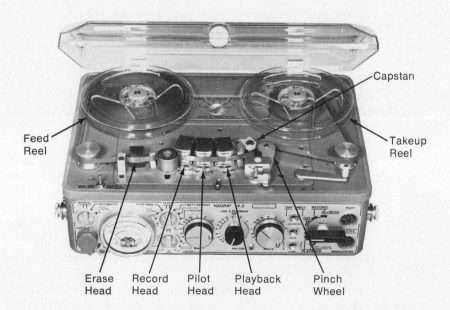

Capstan

Feed Reel

Takeup Reel

Erase Head Record Head Pilot Head Playback Head Pinch Wheel

FIG. 7-3. Nagra 4.2. This ¼″ tape recorder serves as a standard for the industry. (Nagra Magnetic Recorders, Inc.)

erase head turns on when the machine is switched to the record mode. Care must be taken not to erase a tape accidentally.

Although most erase heads work very well, some recordists prefer to use a *bulk eraser* to clean (demagnetize) recorded tapes before reuse. Using a bulk eraser may lower tape noise slightly, and it certainly removes any ambiguity between new and old sound. Bulk erasers, like most other kinds of *demagnetizers* (also called *degaussers*), involve exposing the tape or other object to a powerful, alternating magnetic field. Only when the eraser and the tape *are separated* does the magnetic field become weak and the particles in the tape settle into a randomized position with no net magnetic charge. It is imperative when you use any demagnetizer, to separate it from the magnetized tape or object *very slowly* (1 or 2 inches/second), especially when the two are within a couple of feet of each other. Move the tape onto the eraser slowly while rotating the tape; rotate the tape around a few times keeping it flat and remove the tape slowly, still rotating. Larger format material, like 16mm fullcoat, should then be turned over and erased again. After the tape or object is at arm's length from the demagnetizer, turn off the machine. Turning the machine on or off in close proximity will leave the tape more magnetized than it was at the start.

Bear in mind that the permanent magnetic field of an unshielded loudspeaker can partially erase a tape, so never store tapes on a speaker.

Recording

The second head in the tape path records audio.

TRACK POSITION. Most recorders used for film record monaural, or mono, sound (that is, one channel only) on a track that spans the full width of the tape. With this system, tape cannot be "turned over" to get twice the recording time the way most cassettes are.

Most cassette and nonsynchronous open-reel recorders and a few synchronous open-reel recorders use at least two tracks and are capable of recording in stereo. This may open up possibilities for alternate positioning of microphones (see Chapter 8, Multiple Microphones) or for building up complex overlaid sound tracks on the original tape (see Chapter 12). However, some studios are only equipped to handle tapes that are in the standard mono format. If you plan to have your multitrack sound professionally transferred or mixed, it may be necessary to bring your recorder with you to the session.

BIAS. As with film stocks, magnetic tape stocks have a threshold below which weak, low-energy signals will not be recorded. In order to boost all of the audio signal above this threshold, the recorder mixes in a *bias*

current. Bias current itself is not audible, but if its level is badly adjusted the effects are. Properly setting the bias reduces noise, distortion and the occurrence of *dropout* (momentary loss of recording). If the bias is set incorrectly, the recorder's response to low- or high-frequency sounds may be impaired.

Different types of tape require different amounts of bias. Some recorders have a switch to set the bias for two or three tape stocks; others have to be adjusted by a technician. If you are getting poor-quality recordings or if you switch to a new type of tape with a different oxide (see p. 183), the bias setting should be checked. Afterwards, use the tape stock for which the machine is adjusted.

EQUALIZATION. *Equalization* refers to balancing various parts of the audible spectrum—boosting or diminishing certain frequencies relative to others. One type of equalization called *pre-equalization,* or *pre-emphasis,* is used in the tape recorder's circuits to overcome its natural deficiency in reproducing high-frequency sounds. With pre-equalization, the high frequencies in the sound signal are boosted in volume prior to recording. Then, in playback, the recorder *post*equalizes the sound to diminish the high frequencies somewhat. The result should be a nearly flat frequency response that favors neither high nor low frequencies.

Different tape speeds and stocks require different amounts of pre-emphasis. Most high-quality recorders have an equalization switch (sometimes labeled EQ) that has settings for various tape speeds or stocks; on some recorders, one switch changes both speed and equalization. On many recorders, the user has no direct control over equalization.

Other types of equalization are discussed below and in Chapters 8 and 12.

Playback

A *two-head tape recorder* has an erase head and a second head that doubles as both a record and playback head. A *three-head recorder* has separate heads for recording and playing back, which offers a number of advantages. First, for good reproduction of high-frequency sounds, the gap on a playback head should ideally be narrower than the gap on a record head. Recent advances in head design make this is a less serious problem on newer two-head recorders. However, a major benefit of three heads is the ability to monitor the actual recording as you make it. When you are recording with a two-head machine listening through headphones, you hear the sound *before* it gets to the record head. With a three-head recorder, you can monitor what is actually recorded *on the tape* to determine if there is dirt on the record head, excess signal going to the tape or if the tape has run out.

Three-head recorders have a switch that connects the headphones

either to the sound directly from the microphone ("direct" or "source" position) or to the sound at the playback head ("tape" position). By switching back and forth, you can do an *A/B test* to hear if there is significant loss in quality from direct to tape. A *slight* change in volume is normal and is usually no cause for concern.

Head Care

Magnetic heads must be kept clean and free from magnetic charge; they must not be too worn and must make good contact with the tape as it passes. The first sign of a dirty, worn, magnetized or improperly adjusted head is the loss of high-frequency sounds—recorded material sounds muddy or dull.

Heads should be cleaned with commercially prepared head cleaner, which dries instantly, or with isopropyl (rubbing) alcohol. Buy some head cleaning swabs or use a Q-tip that has been twirled in your fingers to ensure that no hairs come off and lodge in the tape path. Heads should be cleaned at least after every couple of tapes to remove accumulated oxide.

Heads can become magnetized over time. Some recordists demagnetize the heads regularly (every 10 to 20 hours of operation); others wait until poor sound quality indicates they are probably magnetized. Have an experienced person show you how to demagnetize heads; beginners often increase the magnetic charge by doing it incorrectly. Always *turn off* the recorder before demagnetizing. Use a *hand degausser,* not the tiny *pencil* type used for erasing sections of tape or a large bulk eraser which may affect parts of the recorder (like the meter) that are supposed to be magnetized. Slowly move the degausser to within ¼″ to ⅛″ of the head; slowly wave the tip of the degausser along and then across the head slightly; then retract it slowly (see precautions on erasure, p. 178). The R. B. Annis Company (1101 N. Delaware Street, Indianapolis, Ind. 46202) makes an excellent hand degausser as well as a magnetometer, which helps you determine if the head is actually magnetized.

When a magnetic head becomes worn, the gap gets wider and its response to high frequencies is impaired. If the face of the head is not perfectly parallel to the tape path or if the face is parallel but the head is tilted to the side, the effect is the same. The terms used for various types of head alignment include *height, zenith, rack* and *azimuth.* If the heads are excessively or unevenly worn, have a technician check them for possible replacement or realignment.

Tape Transport

After the tape passes all the heads, the tape on most recorders runs by a *capstan,* which pulls it along. The capstan is a smooth, metal, vertical

cylinder that is rotated by a motor. Next to it is a rubber *pinch wheel* that holds the tape snugly against the capstan as it rotates. The capstan must move the tape smoothly with little variation in speed; many recorders employ a heavy flywheel to even out its rotation. For mobile film work, the recorder must maintain a constant speed even if it is jostled around.

If the capstan has dirt on it, or if the motor is malfunctioning, *wow* or *flutter* may result. Wow is any irregularity or variation in the speed that repeats less than ten times per second, and flutter is any variation that repeats faster than that. Your recorder's manual will specify the inherent wow and flutter. The two combined should not exceed 0.1 percent of tape speed. Recording and playing back slow piano music while listening critically for wobbling in the sound is a good way to determine if your recorder is running irregularly.

For proper operation, rollers and capstans should be kept clean. Do not let the pinch wheel remain pressed against the capstan for more than a few hours if the tape is not rolling or a flat spot may result. This happens on some recorders when the machine is left in the pause mode.

When batteries weaken, the tape may slow down during recording, and when the tape is played back with fresh cells, the sound will be speeded up (voices take on the familiar "chipmunk" sound). Sometimes such recordings can be salvaged by playing them back slowly on a variable-speed playback deck while re-recording them on another recorder running at normal speed.

TAPE SPEED. Most ¼" tape recorders offer a choice of two or three tape speeds: 3¾, 7½ and sometimes 15 inches per second (ips). Generally the faster the speed, the smoother the tape runs (that is, less wow and flutter). Faster speeds pass more tape per second so they allow the sound signal to be spread over a greater area of recording material. This increases dynamic range, reduces audible noise and improves the recorder's response to high-frequency sounds. Faster tape speeds facilitate editing of ¼" tape because sounds are farther apart on the tape, making it easier to cut them apart.

The standard speed for most film applications is 7½ ips. Speeds of 15 ips or even higher are sometimes used for critical music recording in which good high-frequency response is crucial (see Recording Problems, p. 187). On a good recorder, 3¾ ips can be used without much loss of quality, especially when recording voices in noisy locations. Some Hollywood studios record with extra long rolls of tape at 3¾ ips to avoid hiring someone to change tapes, believing that the quality lost will be inconsequential when the sound is transferred to an optical track (see Sound Quality, p. 190). Not all sound houses can transfer material recorded at 3¾ ips.

Cassette recorders normally run at 1⅞ ips. This slow tape speed, com-

bined with the narrow track area, makes noise reduction processing (see p. 190) necessary for good recordings. A few machines will run at twice that speed, which improves quality but restricts the availability of play-back equipment.

The Tape

Magnetic tape is made up of a thick base and a relatively thinner emulsion or oxide that actually stores the magnetic information. Tape is available in a variety of base and oxide types.

Most tape oxides are made of iron, called also *ferrous oxides;* if the package does not say otherwise, your tape is probably of this type. Various other more expensive emulsions, including *chromium dioxide,* or CrO_2, and "metal" formulations, are available, some of these offering lower noise and more even frequency response. Ferrous emulsions labeled "low noise–high output" can accommodate a louder sound signal (some 4 dB more) without saturating and causing distortion (see below). If they are properly recorded, these tape stocks can diminish noise by the same amount. Special tape formulations are more often used for cassette recorders in which tape noise is a serious problem. With ¼" recording, the quality is usually good enough to use the more economical iron oxide tape.

The base material of tape is either *acetate* or *polyester* (sometimes called Mylar). Acetate breaks easier, stretches and shrinks more with temperature and humidity and becomes brittle with age. Tape is usually made of acetate base unless labeled otherwise. Polyester base is stronger and more dimensionally stable but may be slightly more expensive in the ¼" format.

Tape comes in a variety of base thicknesses, which are measured in *mils;* 1.5 mil and 1.0 mil are the standards. 1.0-mil tape is thinner and may break or stretch more easily, but allows loading more tape on a reel. In critical applications, tapes less than 1.0 mil (sometimes labeled "extended play") should be avoided. A 5" reel that carries more than 900' or a 7" reel with more than 1800' probably contains a tape base of less than 1.0 mil.

The main problem with thin-base tapes is that sounds *print through* more often. Print-through occurs when the sound on one layer of tape becomes imprinted on the next layer out on the reel, causing a slight echo that can be heard during quiet moments before or after loud sounds. Print-through is mostly noticeable on material recorded at quiet locations where there is no background sound to mask the echo. It can be minimized by storing the tape tail-out on the reel (so the echo occurs *after* loud sounds where it will be partially masked), by keeping the tape in cool locations (less than 70°) and by rewinding it every now and then.

Standard ¼″ tape stocks used in filmmaking are 3M's Scotch 208 (1.5 mil) and 209 (1.0 mil), both of which are polyester base. Relative to other film costs, recording tape is very inexpensive. Ten minutes of processed color film costs twenty-five times as much as the same length of good-quality tape. Discount tape stocks are of irregular quality and may be insufficiently polished, causing unnecessary wear on the heads.

Most portable ¼″ recorders accept 5″ reels that carry enough tape to run at 7½ ips for 16 minutes with 1.5 mil tape or 24 minutes with 1.0 mil. This is for the standard monaural format in which the tape is run in only one direction. Some recorders accept 7″ reels or larger. With such large reels, some portables require that the cover be left open or that the machine be fitted with reel extenders or a special cover.

Setting the Recording Level

All magnetic tape has inherent noise. Even a *virgin* tape straight out of the package will play back a hissing noise. When sound is recorded on tape it must be louder than the tape noise to be audible. Ideally it should be significantly louder so that the noise can be heard only as a quiet background during pauses in the sound signal. If the sound is recorded too loudly, called *overmodulation,* it will be "clipped" and distorted. Overmodulation occurs when all the particles in the tape oxide become magnetized, which is called tape *saturation.* Overmodulated recordings are usually crackly and harsh, and the loud sounds seem to break up. Very loud sounds like laughter and applause often overmodulate on an otherwise properly modulated tape. The loudness of sound as it passes through a tape recorder, or other audio device, is called its *level* or *gain;* this is adjusted with a *volume* or *level control* or *pot* (short for potentiometer).

In general, the level should be set to record sounds *as loudly as possible without overmodulating.* Although there are exceptions to this principle, the idea is to minimize noise and provide the most flexibility for later stages of sound processing. In filmmaking, nearly all sound is re-recorded at least once from the original tape to another piece of tape or film. Loudly recorded sound that should ultimately be softer can be reduced in volume during re-recording.

Most recorders are equipped with a meter to guide you in setting the recording level. The most common meter is the *volume unit (VU) meter,* which is found on most inexpensive recorders and many costly ones. If a meter is not identified otherwise it is probably a VU meter. Many recordists feel that VU meters provide the best indication of the subjective loudness of sounds.

VU meters are calibrated in decibels; the scale usually goes from about −20 to +3 dB, with a bold change in the color or thickness of the markings at the 0 dB point. For typical voice recording, the level should

FIG. 7-4. Setting the recording level. (i) If the sound signal is recorded at a low level—near the level of the tape noise—when the volume is increased to a medium level in playback, the noise gets louder too. (ii) If the signal is recorded as loudly as possible without overmodulating, you can lower the volume in playback and the noise level will diminish as well. (iii) If the level is set so high in recording that the signal is distorted, it will still be distorted in playback even if the level is reduced (note the clipped peaks).

be set to produce a healthy deflection of the needle so that the highest swings rise to between about −7 and −1 dB. If the needle jumps above the 0 dB point the level should be reduced somewhat. Short, percussive sounds (called *transients*) like those of a hammer, scissors, a chirping bird or jangling keys will not deflect the meter much even if they are being recorded loudly, and you should not turn the level control way up to try to get them to do so (see p. 186).

Professional and European-made sound recorders often employ *peak-*

(i)

(ii)

Fig. 7-5. (i) VU meter. (ii) Modulometer on Nagra 4.2. Sound level is read on the top scale.

reading meters instead of VU meters (Nagra's version is called a *modulometer*). These are usually calibrated in decibels and often the dial is laid out much like a VU meter, but there should be some indication that the meter gives peak readings. Whereas the VU meter employs a relatively "heavy" needle that is slow to respond to quick peaks in volume and provides a reading of the *average* sound level, the peak-reading meter responds instantaneously to quick surges in volume and provides a reading of the *maximum* sound level. VU meters give too low a reading for fleeting sounds, like the hammer or the keys, because the volume peaks have passed by the time the needle is finished responding. The peak-

reading meter, on the other hand, responds quickly enough to give an accurate reading of sounds of short duration. Volume peaks are of concern because these are the first to saturate the tape and become distorted. With a peak-reading meter you can be fairly certain that quick peaks are not overmodulating, but with a VU meter you can only make an educated guess.

Modulometers like the one found on the Nagra 4.2 are perhaps the most common peak-reading meter used in film work. For normal voice recording, the level should be set so that the highest deflections of the meter read between about -8 and -2 dB, which is easy to remember because the needle will be roughly in a vertical position. Though some recordists are careful to avoid letting the needle pass the 0 dB mark, it is usually the case that occasional, loud peaks can read higher without causing problems. However, if the needle does so more than once every several seconds, the level should be reduced somewhat.

Instead of a meter, some recorders employ a set of small lights, called *light-emitting diodes* or *LED's*. Some of these simulate the VU system, others are peak readers. Some recorders have normal VU meters with a single peak LED (these LED's are often set to light up when the signal reaches $+3$ dB). If there is a peak-reading LED, turn the volume up until this light comes on frequently and then turn the volume down a bit, so the light only shines occasionally, for especially loud peaks.

Whether you use a VU meter or a peak-reading meter, the actual point of overmodulation and distortion is really determined by the type of sound, the recorder's amplifier and the tape being used. Some sounds may read a few decibels above the zero point without serious distortion, some will distort and some will not be badly harmed by the crackle and break-up produced (a gunshot, for example).

The meters on most recorders only inform you of the strength of the signal as it goes to the record head, not what is actually taking place on the tape. Tape stocks vary in noise and saturation levels. Whether or not you are under- or over-recording can really only be determined by listening to the tape playback with good headphones or a speaker superior to the one built into the recorder. Low-quality headphones and speakers often fail to reproduce the noise or break-up that will show up later on a good sound system.

If your recorder has an adjustment for headphone volume, set it at a comfortable level and leave it there. In those situations in which it is difficult to watch the meter, this will help you to estimate proper recording level by the way it sounds in the headphones.

Recording Problems

In general, recordings sound better if the level is not changed a great deal during recording. This usually means setting the level at a compro-

mise position between, say, the loud and soft voices of two people talk-
ing. (Another solution might be to move the microphone closer to the
softly spoken person.) Try to anticipate surges in volume, choosing per-
haps to under-record slightly an orator whose every sentence is greeted
with loud cheers from the audience. You might allow the applause to
overmodulate and plan to replace it with a better-recorded piece during
sound editing. (This is a situation where a good limiter could be very
helpful; see p. 189.) Usually, a certain amount of level adjustment (called
"riding the pot") is unavoidable. Level changes that are made gently and
not suddenly will be less disturbing.

When recording music, level adjustments are more noticeable and de-
tract from the integrity of the piece. Try to find the highest level that can
accommodate loud passages in the music and then leave the pot alone
(this is easy to do when recording from records). For live performances,
professionals sometimes follow the musical score and make slight adjust-
ments during rests or pauses between soft and loud passages. Live music
and other sound that contains loud high-frequency sounds may distort
when recording at tape speeds less than 15 ips even if a VU meter indi-
cates that the level is safe. This is because the recorder's pre-emphasis
circuit boosts high frequencies after the sound has passed the meter.
When recording music at less than 15 ips, it is a good idea to keep the
level about 5 dB or more lower than you would otherwise.

One reason for always recording sounds as loudly as possible is to
minimize noise. If the level of the recorded sound is very high, the vol-
ume can be turned *down* to a comfortable level in playback and the level
of tape and system noise will be reduced as well. This is especially im-
portant when recording on sets or at quiet locations where tape noise is
easy to hear. If you are recording at a noisy location (a city street, for
example), the noise of the location will mask the tape noise because it is
louder. In this situation you could keep the level lower than before,
allowing more "headroom" for unexpected loud sounds, without concern
about tape noise. In such locations, it is necessary to put the microphone
close to the sound source to get a good recording.

When quiet sounds seem under-recorded, do not turn the level control
beyond three fourths of its full range since this will usually add system
noise to the recording. Instead, get closer to the sound source. If ex-
tremely loud sounds (like live rock music) require that the level control
be set at less than one fourth of its travel, this too will degrade the sound
signal. If this is the case, get an *attenuator,* or *line pad,* to place on the
cable between the microphone and the recorder (some mikes have built-
in attenuators). The attenuator cuts down the strength of the signal.

Automatic Level Control

Many tape recorders and most single system cameras are equipped with some form of automatic control of recording level. The names for the various types of automatic adjustment are not entirely standardized; you can usually tell what kind you have by reading the recorder's manual. Some types work better than others, but often the effectiveness depends more on the sophistication of their design than on the particular type used.

Automatic level control (ALC), or *automatic gain control (AGC)*, works by automatically choosing a predetermined recording level. If the sound signal coming into the recorder is too quiet, it will be boosted, and if it is too loud it will be cut down in volume. ALC requires no attention on the part of the operator, and it can be quite effective in straightforward recording in which the sound level does not vary too much. However, most ALC devices do not handle sudden volume changes well. Say you are recording someone in a kitchen. While the person speaks, the level is set appropriately, but when he stops, the recorder responds to the quiet by boosting the level, thereby bringing the sound of the refrigerator to full prominence. ALC's often have a slow recovery time and, if a sudden, loud sound occurs while someone is speaking, the recording level will drop, reducing the level of the speech, and return to normal some moments later.

On the average, most ALC systems cannot out-perform a competent recordist who sets the level manually, but some ALC's work quite well. Test your own system and judge for yourself.

Semiautomatic level control systems can be useful in many recording situations. These systems usually require that the recordist set the basic recording level but when the sound threatens to overmodulate, the device cuts down the volume. *Limiters* cut in sharply when the sound is close to overmodulating, protecting against sudden volume peaks. Some limiters work so well that they are virtually unnoticeable; others cut in very sharply and produce an unnatural, flattened effect in the sound. Recorders like the Nagra SN have a limiter and a *compression meter* instead of a VU meter. The recording level should be increased until the meter deflects, indicating that the limiter is cutting in, and then it should be decreased until the limiter operates only on loud peaks.

Limiters can be helpful when sound levels change suddenly and in situations where the filmmaker or recordist cannot constantly watch over the recorder. If limiters are relied upon too heavily (that is, if the recording level is set so high that the limiter is constantly working), the sound loses much of its dynamic range and can seem flat and without texture. A *compressor/expander* like the dbx unit (usually used for noise reduc-

tion; see below) opens up the possibility of compressing (reducing) the dynamic range of the sound during recording—to accommodate any loud volume peaks without overmodulating—and then expanding the dynamic range again during playback. This method can be used to make high-quality recordings when the filmmaker is unable to make any level adjustments during the recording.

Noise Reduction

Many tape recorders are equipped with noise reduction units such as the Dolby system. Dolby B works by boosting the level of high-frequency sounds as they are recorded and then diminishing their level in playback, leaving the sound signal normally balanced. Tape hiss is also a high-frequency sound; however, since it is inherent in the tape it is thus not affected by the Dolby during the recording. It is diminished, though, when the Dolby reduces the high frequencies in playback.

If a recorder has a noise reduction unit, it should be used; this is most important for cassette recorders where tape noise is significant. Tapes recorded with noise reduction should be played back with it, on a machine that employs the same system (there are various types available). Always indicate on the tape box whether a recording was made with noise reduction. Tapes made without noise reduction should not be played back with it or quality will be degraded (for example, with Dolby B, high frequencies may be lost).

Sound Quality

Most 16mm and 35 mm films are released with optical sound tracks; a few 16 and 35mm films and most super 8 films are shown with magnetic stripe sound tracks. Optical tracks are extremely deficient in their response to high frequencies (see Chapter 12). As a result, the sound track loses much of its clarity and richness. Also, due to high noise levels on optical tracks, quiet sounds tend to be lost (see Chapter 12, Compressors). Although magnetic tracks have much better quality, both magnetic and optical tracks suffer from the small speakers in many projectors and television sets, which fail to reproduce the high- and low-frequency ends of the audio spectrum.

This means that many filmmakers who produce films primarily for release with an optical sound track accept much more noise and a more limited frequency response in their equipment and recordings believing that it will never make a difference. In many cases they are right. However, if high quality is maintained, the difference often does show up when the sound has to be copied through several generations (which increases noise), when the film is shown in theaters with good sound

systems and when films are released on video tape (which employs a magnetic sound track).

The Microphone

Microphone Types

There are three basic types of microphones in film use. *Dynamic* or *moving-coil microphones* are the standard equipment used by musical performers, amateur recordists and many professionals. They are usually quite rugged and resistant to hand noise (see p. 196) and they require no batteries or special power supply. Many inexpensive microphones that come with home recorders are dynamic mikes.

Condenser microphones are used extensively for motion picture sound recording. They are often more fragile and more expensive than dynamic mikes. Condenser mikes use a capacitor circuit to generate electricity from sound, and they must have power supplied to them to function. This may come from batteries in the microphone case, on the mike cable or in the tape recorder itself. *Electret condenser microphones* employ a permanently charged electret capacitor. They can be made very cheaply and often require no power supply. Sony's ECM series of electret condenser lapel mikes are used widely. They do require batteries for the preampli-

FIG. 7-6. Electro-Voice 635A omnidirectional dynamic microphone. (Electro-Voice)

fier, but the mike is about the size of a large peanut and is extremely versatile.

Ribbon or *velocity microphones* were once used extensively but they are usually large and few manufacturers still make them. They are sometimes used in sound studio applications for their even response to all frequencies of sound.

Directionality

Every mike has a particular pickup pattern, that is, the configuration of directions in space in which it is sensitive to sound. *Omnidirectional microphones* respond equally to sounds coming from any direction. *Cardioid mikes* are most sensitive to sounds coming from the front, less sensitive to sounds coming from the side and least sensitive to those coming from behind. The name derives from the pickup pattern, which is heart-shaped when viewed from above. *Hyper-cardioid microphones* (sometimes called *in-line, short tube shotgun* or *mini shotgun*) are even less sensitive to sounds coming from the side and behind. *Super-cardioid microphones* (or *super in-line, long tube shotgun* or *shotgun*) are extremely insensitive to any sounds not coming from directly ahead. However, some hyper- and super-cardioid mikes are manufactured with a certain amount of sensitivity to sound emanating from directly behind as well. *Bi-directional mikes* have a figure-eight pickup pattern with equal sensitivity directly ahead and behind; these mikes are often used in the studio placed between two people talking to each other. Since the names for these microphone types are not entirely standardized among manufac-

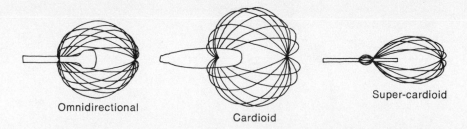

Omnidirectional Cardioid Super-cardioid

FIG. 7-7. Representations of the directional sensitivity of omnidirectional, cardioid, and super-cardioid microphones (not drawn to the same scale). These suggest the general pattern of the mikes' response to sound coming from different directions. Imagine the omni mike as being at the center of a spherical area of sensitivity; the diaphragm of the cardioid mike is at about the position of the stem in a pattern that is roughly tomato-shaped. Though the lobes of sensitivity are pictured with a definite border, in fact, sensitivity diminishes gradually with distance.

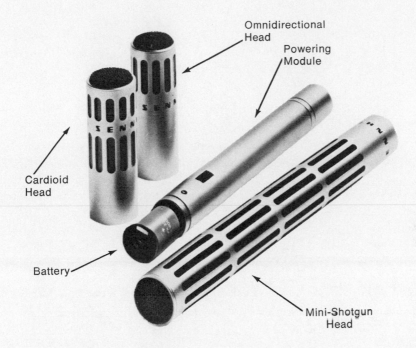

FIG. 7-8. Sennheiser K3-U modular condenser microphone system. (Sennheiser Electronic Corp.)

turers (one company's "hyper-cardioid" is another's "super-cardioid"), be careful when you purchase a microphone.

Manufacturers print *polar diagrams*—graphs that indicate exactly where a microphone is sensitive and in which directions it favors certain frequencies. It is extremely important to know the pickup pattern of the mike you are using. For example, many people are unaware of the rear lobe of sensitivity in some hyper- and super-cardioid mikes, which results in unnecessarily noisy recordings (see Fig. 7-9).

Hyper- and super-cardioid microphones achieve their directionality by means of an *interference tube*. The tube works by making sound waves coming from the sides or back of the mike strike the front and back of the diaphragm simultaneously so that they cancel themselves out. In general, the longer the tube is, the more directional the mike will be. For proper operation, it is important not to cover the holes in the tube with your hand or tape. Usually, the more directional a microphone is, the more sensitive it will be to wind noise (see p. 196).

Contrary to popular belief, hyper- and super-cardioid microphones

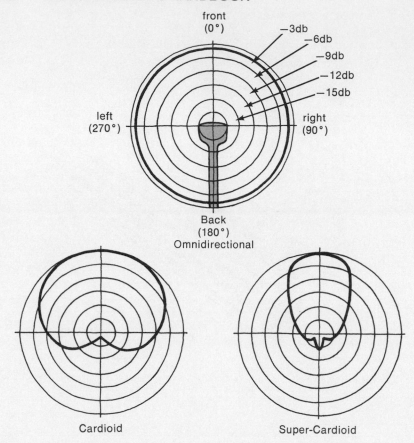

FIG. 7-9. Polar diagrams indicating the sensitivity of omnidirectional, cardioid, and super-cardioid microphones. Imagine each diagram as a cross section of the mike's sensitivity, with the microphone lying along the vertical axis (as the omni mike is here). The microphone's diaphragm would be positioned at the center of the graph.

usually are not more sensitive to sounds coming from directly ahead than are cardioid mikes. Unlike zoom lenses, they do not "magnify" sound. However, directional mikes do exclude more of the competing background sound, so that they can produce a good recording at a greater distance from the sound source—as recordists say, the "working distance" is greater. The disadvantage of highly directional mikes is that a filmmaker often encounters situations where it is difficult to capture important sounds within the narrow lobe of sensitivity. A classic case is found in recording a two-person conversation with a super-cardioid microphone: when the mike is pointed at one person, who is then *on-axis*, the other person will be off-axis, his voice sounding muffled and

distant. Panning a long microphone back and forth is an imperfect solution if the conversation is unpredictable. In such cases, it may be better to move far enough away so that both speakers are approximately on-axis. Unfortunately, the best recordings are made when the microphone is close to the sound source.

Microphone Sound Quality

Microphones vary in their frequency response. Some mikes emphasize the bass or low frequencies, others the treble or high frequencies.

The frequency response of a microphone or tape recorder is shown on a *frequency response graph* that indicates which frequencies are favored by the equipment. Favored frequencies are those that are reproduced louder than others. An "ideal" frequency response curve is flat, indicating that all frequencies are treated equally. Most mikes emphasize high-frequency sounds more than mid-range or bass frequencies. Filmmakers often choose mikes that favor mid to high frequencies to add clarity and *presence* (the sensation of being close to the sound source) to speech. Some people prefer the sound coloration of mikes that emphasize lower

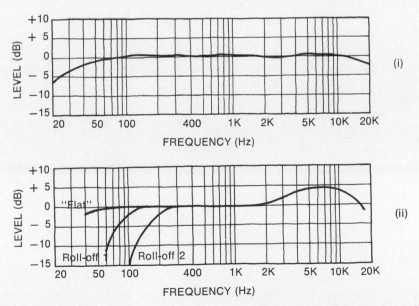

FIG. 7-10. (i) The relatively flat frequency response of a quality tape recorder. Where the graph deviates from the 0 dB line indicates diminished response (below the line). (ii) A microphone frequency response curve. This mike is more sensitive to high frequencies. The three parts of the curve at left represent increasing amounts of bass roll-off actuated by a built-in, three-position switch (see Bass Filters, Chapter 8).

frequencies. A male vocalist, for example, might want to bring out the deep bass in his voice to produce a fuller sound.

When you purchase a mike, check the frequency response graph published by the manufacturer. An extremely uneven or limited response (high frequencies should not drop off significantly before about 10,000 Hz or more) is some cause for concern. The microphones that come with recorders and cameras are very often of low quality and should be replaced. Set up an A/B test where you can switch from one mike to another and record sound from both mikes. You may find that you prefer the sound of the less expensive of two mikes. An A/B test is especially important if you need two matched microphones for multiple microphone recording (see Chapter 8).

Wind Screens and Microphone Mounts

The recorded sound of wind blowing across the mike does not in the least resemble the rustle of wind through trees or the moan of wind blowing by a house. What you would hear instead are pops, rumble and crackle. When recording, do not let wind strike a microphone (particularly highly directional mikes) without a *wind screen*. A wind screen blocks air from moving across a mike.

A minimal wind screen is a hollowed-out ball or tube of *acoustifoam*— a foam rubber-like material that does not muffle sound. This kind of wind screen is least obtrusive and is used indoors and sometimes in light winds outside. Its main use is to block the wind produced when the mike is in motion and to minimize the popping sound caused by someone's breathing into the mike when speaking.

For breezier conditions, a more substantial wind screen called a *zeppelin* is used. Like its namesake, this wind screen is large and tubular; the mike is completely encased in it. In strong winds, an additional sock-like covering can be fitted around the zeppelin. Zeppelins are expensive to buy, but you can make one with mesh and foam. A good wind screen should have *no* noticeable effect on the sound quality in still air. When you are caught outside without an adequate wind screen, you can often use your body, the flap of your coat or a building to shelter the mike from the wind. Often, a bass roll-off filter helps minimize the rumble of wind noise (see Chapter 8).

Besides wind noise, microphones are extremely sensitive to the sound of any moving object, such as hands, clothing, etc., that touches the microphone case. *Hand noise,* or *case noise,* becomes highly amplified and can easily ruin a recording with its rumbly sound. The recordist should grip the microphone firmly and motionlessly, grasping the looped microphone cable in the same hand to prevent any movement of the cable where it plugs into the mike. The alternative is to use a pistol grip that

FIG. 7-11. A zeppelin wind screen for a shotgun mike shown with pistol grip and mounted on a microphone boom.

has a shock mounting to isolate the mike from any hand noise. This makes the mike slightly bulkier, however. A shock mount can also be attached to the end of a *fishpole* (collapsible) *boom*, which enables the recordist to stand away from the action. Studio microphone booms are mounted on a pedestal to relieve the recordist of considerable fatigue from holding the boom for long periods of time.

Wireless, Lavalier and Lapel Microphones

To allow the camera and subject greater freedom of movement, a *wireless*, or *radio, microphone* can be used. With this system, a small mike is clipped on the subject, along with a concealed radio transmitter that is about the size of a pack of cigarettes. A receiver mounted on the recorder picks up the signal with a short antenna.

This system opens up many possibilities for both fiction and documentary filmmaking. Camera angles need never be compromised by considerations of microphone placement since the mike is always close to the subject but out of view. In unscripted documentaries, there are great advantages to letting the subject move independently, without being constantly followed by a recordist wielding a long microphone. However, although a radio mike frees both subject and crew, the use of such a mike

FIG. 7-12. Micron wireless microphone. Transmitter (at left), shown with lapel mike, is smaller than a cigarette pack. An additional short wire is needed as an antenna. Receiver is at right. (Micron Audio Products)

makes some people uncomfortable in knowing that whatever they say, even when it is said in another room, can be heard. Some filmmakers object to the way radio mikes affect sound perspective: unlike typical sound recording, when the subject turns or walks away from the camera wearing a wireless, the sound does not change.

Wireless transmission is not completely reliable. Depending on the physical obstructions and competing radio transmissions in the area, wireless signals may carry up to several hundred feet or they may be blocked altogether. Newer, "diversity" radio mikes that employ two or more antenna systems or radio frequencies make the system more dependable. Wireless sound quality is usually not as high as that of *hard-wired mikes,* but some of the systems are extremely good. On some productions, a radio mike is rented by the day for particular recording situations.

Lavalier microphones are small mikes designed to be hung on a cord around the subject's neck. *Lapel mikes,* sometimes also called lavaliers, are usually even smaller and are generally intended to be clipped on the subject's clothing. Either mike may be used with a wireless transmitter or may be hard wired to the recorder with a cable running along the floor. These mikes are usually omnidirectional, although a hyper-cardiod lapel

mike has been developed. Because they are so close to the subject, they tend to minimize other sounds in the environment.

Lavaliers are designed to de-emphasize the low frequencies that emanate from the chest cavity and to accentuate high frequencies that are lacking, in part, because the mike is so far out of line with the subject's mouth. One lavalier made by AKG has a movable collar that can restore a normal, flat frequency response for general recording. Most modern lapel mikes are made with a fairly flat frequency response.

Most anchorpersons on television news wear lapel mikes clipped to their clothing. For film work, mikes are often concealed *beneath* a lightweight piece of clothing. If you do this, listen closely for case noise caused by the cloth rubbing on the mike. Some lapel mikes are relatively insensitive to case noise.

Fig. 7-13. Sennheiser MKE 2 miniature electret lapel microphone shown on a necktie (Sennheiser calls it a "clip-on lavalier"). A dark microphone is often easier to conceal on a subject's clothing. (Sennheiser Electronic Corp.)

Connections Between Microphone and Recorder

Not all microphones and recorders are compatible; many need various adaptors or devices between them.

Impedance is a measure of the resistance of any audio device to the flow of electric current. Impedance, sometimes represented by Z, is measured in *ohms*. The impedance of a microphone may be low or high, the same is true for the microphone input on the tape recorder. In general,

low impedance is 600 ohms or less, and high-impedance devices measure in the thousands of ohms. It is extremely important to use a low-impedance mike with a low-impedance mike input, or a high with a high. Exact matching is not necessary. Usually, microphones with XLR connectors have low impedance. The manuals for the recorder and microphone should list their impedances.

In general, it is an advantage to have low-impedance equipment because it allows you to use up to several hundred feet of microphone cable —which is very useful when you cannot work near the sound source— without picking up hum and interference from AC wall current and radio stations. With high-Z (impedance) equipment, 20' may be the maximum. If your mike and recorder impedances are mismatched, it is necessary to put a *matching transformer* on the microphone cable. Try to put it closest to the piece of equipment with the higher impedance.

Picking up hum and interference from nearby power lines, automobile engines, fluorescent lights and radio stations can be a problem even with low-impedance equipment. The best solution is to use a microphone and recorder that are connected by a *balanced cable*. In a balanced microphone cable, the two wires of a standard cable are enclosed in a sheath-like third wire that insulates them from electric interference (see Fig. 7-14). Balanced cables can usually be recognized by the three contacts, instead of two, in the connectors at either end. Not all microphones or recorders will accept balanced cables. Whenever you get electric interference, try moving the recorder or the cable to another position. Sometimes wrapping the microphone cable, especially the connectors, or even the recorder, in aluminum foil helps.

The electric power needed to run a condenser microphone may come from a battery in the mike or on the cable, or from the recorder's batteries (the latter is called *phantom powering*). Phantom power frees you from carrying an extra set of usually expensive batteries for the mike. The disadvantage is that, on some recorders, if the microphone input is set up for phantom powering, it will not accept dynamic mikes or condensers that have their own power. Other recorders have a switch that permits input from any type of microphone. Phantom powering often involves rewiring microphone cables to reverse or "flip" the phase, making them not interchangeable with normally wired cables.

Most recorders have a *line input* for connecting the output from a phonograph amplifier or from another recorder. The line input is designed to accommodate the strong, usually high-impedance signal these machines generate. Sometimes when you connect two pieces of equipment, a low (60 Hz) humming sound results if either piece is plugged into the AC wall current. If this happens, connect a *ground wire* between the case of one machine and the case of the other. Most phonograph turntables have such a wire connecting them to their amplifiers.

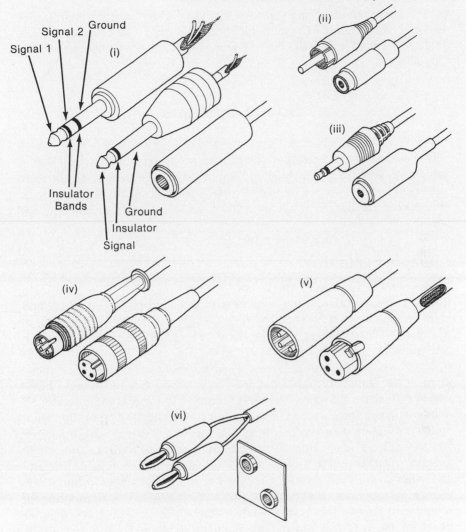

FIG. 7-14. Audio connectors. (i) ¼″ males and female. A three-contact stereo plug is at left, a two-contact mono plug is in the center. The three-contact version can also be used for balanced cables. (ii) *RCA* or *phono* male and female. (iii) *Mini-phone* or simply *mini* male and female. This is a miniaturized version of the ¼″ connector (diameter is ⅛″ instead of ¼″). Sony makes a stereo version of this plug, recognizable by the two black insulator bands (see i). (iv) Three-pin *Tuchel* male and female. The sleeve on the female engages the threads on the male. This Tuchel is a variant of a *DIN* connector. (v) Three-pin *Cannon* or *XLR* connectors. The male and female snap together. Both XLR and Tuchel connectors may have more than three pins. The female XLR is pictured with the insulation cut away to show the balanced or stereo cable with the two signal wires encased in the sheath-like ground. (vi) *Banana* plugs and jacks.

It is worth remembering the names of connectors used for microphone cables as they can be extremely difficult to describe. All connectors have male and female forms; the male is sometimes called the *plug*, the female, the *jack*.

Sound Systems

As discussed in Chapter 1, synchronous motion picture sound is usually recorded either directly in the camera on magnetically striped film or with a separate recorder specially equipped for film work. These techniques are known as *single* and *double system*, respectively; the names refer to the number of strands of material needed to reproduce sound and image.

Single System

The chief advantage of single system is its simplicity. One person can easily carry and operate the camera with the microphone attached, and, with automatic level control, the filmmaker is free to concentrate on the shooting. If little editing is to be done, this is an extremely convenient way to work.

Single system recording is now used far more extensively in super 8 than in the 16mm format. In super 8, the sound quality is good but is inferior to that of a good ¼" tape recorder or even some cassette recorders. When the camera is operated at sound speed (24 fps), the sound quality is better than when it is run at the slower silent speed (18 fps). Most single system cameras have automatic gain control; some have manual override and a VU meter for setting the level (on some cameras the meter can be read through the viewfinder for adjustments while shooting). Most cameras accept an ear plug, which allows you to monitor the sound as it goes to the record head. A few 16mm cameras have separate playback heads for monitoring the magnetic stripe.

Although many single system cameras accept detachable mikes, and sometimes separate volume controls, that can be operated by someone other than the camera person, a good deal of single system filming involves microphones that are mounted on the camera or held by the camera operator. The mike is thus too far from the sound source and too close to the noisy camera. Many cameras have an extendible microphone boom, which helps somewhat (see Fig. 1-7). The camera should generally be positioned so that the mike stays close to the sound source. Very noisy cameras should be fitted with a sound-dampening barney.

Camera-mounted microphones usually have an omnidirectional or cardioid pick-up pattern so that they are sensitive to sounds coming from

FIG. 7-15. Cinema Products CP-16/A camera outfitted for single system recording. The amplifier and level controls for the sound system attach as a unit to the camera's right side; the magnetic sound head is plugged into a receptacle in the film path. As these cameras were once the standard of the news industry, used CP-16/A cameras can often be purchased cheaply now that they have been largely replaced by video equipment.

directions other than the one in which the camera is pointing. Far better recordings can be made by handholding a more directional mike (see Chapter 8, Filming Alone).

If you are making a film that you plan to edit in single system, there are advantages to shooting film stock that has been *prestriped* by the manufacturer (rather than *poststriping* during editing) even if you plan to record the sound after the footage has been edited (see Chapter 12, Magnetic and Optical Tracks).

Double System

Virtually all professional filmmaking is done with double system equipment. Although double system seems complicated and somewhat cumbersome, the quality and flexibility of the equipment far outweigh the drawbacks. With double system, a sound recordist can properly monitor and control the recording level, can use multiple microphones and, since the camera and microphone need not be connected via cable, can place microphones optimally for recording.

Any camera and recorder can be used to record nonsynchronous, double system sound (see Chapter 1, Double System). However, for synchronous sound recording, the speeds of the camera and the recorder must be precisely controlled. If the recorder were to run too fast relative to the camera, when the film was projected you would hear sounds *after* you saw the images of whatever produced them. As the film played, the sounds would become increasingly late. For synchronous sound to look natural, the sound of a word must be heard within about $\frac{1}{24}$ second (one frame) of the moment the lips move on screen.

Various systems have been devised to ensure good synchronism between sound and picture. Most modern 16mm and some super 8 equipment employs a method called *crystal sync*. With crystal sync there is no cable between camera and recorder. The camera employs a crystal motor that ensures that at sound speed the camera runs *exactly* 24 fps.

Since the magnetic tape used in most recorders does not have sprocket holes and tends to slip slightly as it goes through the recorder, its speed cannot be controlled as easily as film speed. Within the recorder there is another crystal that records a very regular pulse on the tape similar to the ticking of an extremely accurate clock. You can think of these pulses as magnetic sprocket holes. When the tape is played back, the recorder reads these "sprocket holes" to make sure that the proper number pass the playback head each second. This process is called *resolving* (see Chapter 12, Sound Transfer).

The pulses produced by the recorder's crystal are called *pilotone* or, simply, *pilot*. The pilot used in most equipment in the U.S. produces sixty pulses per second, the same rate as the 60 Hz alternations of household wall current. On monophonic recorders such as the Nagra 4.2, the pilot is recorded on two narrow tracks in the center of the tape; these are out of phase so that the audio playback head is not affected by them. On stereo recorders, the left or right channel may be given for pilot or sometimes a third track is used.

Nonsynchronous stereo recorders can often be converted for sync work by attaching a crystal, which is usually less convenient than having a built-in crystal. It can sometimes be difficult to find resolving equipment for synchronous cassette and stereo $\frac{1}{4}''$ tapes. Some synchronous recorders are self-resolving.

The great advantage of crystal sync is that it allows the complete independence of camera and recorder, enabling them to be positioned separately and moved at will. Also, several cameras and recorders can be used together with perfect synchronization between them. There are a number of sync systems, however, that require a cable between the camera and recorder. In the most common of these, the camera generates an approximately 60 Hz pilot tone, which is carried by cable to the pilot head in the recorder.

Super 8 cameras sometimes employ *digital sync,* a system in which the camera sends one pulse per frame (sometimes called a 1/f signal) instead of a 60 Hz pilot tone. To use digital sync, super 8 cameras must be equipped with a *prontor contact (PC) jack,* the kind built to trigger strobe lights for time-lapse filming. Cable sync systems can be used with cheaper cameras that have governor motors (see Chapter 2) and recorders that lack crystals. With cable sync, it is easy to have automatic slating (see Chapter 8).

Recording on Magnetic Film

Because of the cost, weight and bulk of sprocketed magnetic film (usually called *fullcoat* or *mag stock*), most people do not use it for recording in the field. Instead, they record on ¼" or cassette tape and then transfer the sound to mag stock later in a sound studio. However, super 8 filmmakers working within a limited equipment budget may be interested in a machine like Super 8 Sound's Mag IV fullcoat recorder. This versatile device records good-quality sound on super 8 mag stock using either

FIG. 7-16. Super 8 Sound Mag IV portable fullcoat recorder. This is a modified version of the Uher 4000 ¼" tape recorder. (Super 8 Sound)

crystal or cable sync systems. It is self-resolving and can be used to transfer sound to or from single system projectors, cassettes, ¼″ tape or other fullcoat recorders. It is lightweight enough to be used in the field. It does, however, still have the drawback of the high cost of super 8 fullcoat (minute-for-minute, about four or five times the cost of ¼″ tape).

8
Sound Recording

Assembling Equipment

Recorders

The professional standard is the Nagra 4.2, a ¼″ tape recorder (see Fig. 7-3). The 4.2 is expensive to buy or rent, but its quality and dependability are so high that the cost is often justified. The Nagra III (no longer manufactured) is an older ¼″ model that is very good and costs much less to rent. A used one sells for a quarter to half the price of the 4.2. Nagra

FIG. 8-1. Nagra IS. Compact, lightweight ¼″ tape recorder. (Nagra Magnetic Recorders, Inc.)

FIG. 8-2. Nagra SN miniaturized ⅛″ tape recorder. (Nagra Magnetic Recorders, Inc.)

FIG. 8-3. Sony Walkman® Professional cassette tape recorder. Stereo with Dolby noise reduction. This recorder can be modified for crystal synchronous sound recording. (Sony Corporation of America)

makes a number of smaller, lighter weight ¼" recorders, including the E and IS, as well as the miniaturized SN ⅛" tape recorder, which fits in a coat pocket. Many manufacturers (Sony, Uher, and Teac, for example) make good ¼" or cassette recorders, some of which can be easily converted for crystal or cable sync recording (see Chapter 7, Double System).

Microphones

Unless you have the luxury of carrying several mikes, your choice of a primary microphone will be extremely important. Many recordists prefer a super-cardioid, or *shotgun,* mike like the Sennheiser 816. This mike allows you to stand farther back from the subject and is good for isolating voices in noisy environments, such as a train station or a parade. A shotgun microphone is very long and offensive looking, and it tends to intimidate people when recordists point it at them. Also, it is often too directional for recording in tight quarters (see Chapter 7, Directionality). For these reasons, some recordists use a slightly less directional microphone (a hyper-cardioid, like the Sennheiser 416), which forces them to get closer to the sound source but is excellent for general uses. This type of microphone is good for unpredictable documentary filming.

Both Sennheiser and AKG make modular microphone systems that allow you to purchase one power supply and several heads of varying directionality (omni, cardioid and hyper-cardioid; see Fig. 7-8). This is a good option for a filmmaker with a restricted budget and provides a great deal of flexibility.

Always try to have at least one backup microphone and cable as insurance. If the second microphone is less or more directional than your primary mike, you will have more flexibility in recording. Lapel microphones are very small, pack easily and can be used for general recording in a pinch. If the backup mike uses the same cables and preamplifiers as your main mike, you will not need as much spare equipment.

Headphones and Other Equipment

The choice of headphones is quite important. For fiction and controlled documentary filming, it makes sense to get headphones that have good fidelity and high *cut-off ear pads*—ones that block any sounds coming directly to the recordist without having gone through the microphone first. With these headphones, you can be sure of the recording without being misled by other sounds around you. The problem with high cut-off headphones for unstaged documentary filming, especially when a directional microphone is used, is that the recordist can only hear sounds he or she expects to hear; if someone speaks outside the mike's range of sensitivity, the recordist will not hear or react to it. Recordists wearing

these headphones live in their own acoustic environment and often seem dazed. Many documentary recordists work with no headphones at all so that they can better relate to people and react to uncontrolled events. Low cut-off headphones, such as the kind that often comes with small cassette recorders, are very comfortable but some fail to reproduce defects that can be heard on a better sound system. Pressing low cut-off ear pads to your head will help to block out background sound. Stereo headphones should be used with a mono plug (or can easily be rewired) when you are recording monaural sound so that you can hear the signal with both ears.

Collapsible microphone booms are especially useful for fiction filming where the action is predictable. The boom allows greater freedom for the camera, since the recordist can stand farther out of the shot. But the boom is fairly intrusive in documentary situations. Some documentary recordists use a short boom with a shock-proof microphone mount to isolate hand noise; the boom is extended only when necessary. A short table stand for the mike can be handy or a stand borrowed from a lighting kit can be used.

Spare batteries, fuses and an AC power connection for the recorder should be kept on hand. *Alkaline batteries* are more costly than regular dry cells, but they are far preferred because of their longer life. To conserve batteries, avoid rewinding or fast-forwarding tapes on battery power.

A Supply and Repair Kit

Having a few tools can mean the difference between easily fininshing a film shoot and cancelling it. Many repairs are very simple. After phoning a technician, inexperienced persons can often make adjustments or isolate what needs to be repaired or replaced.

Preparing the Recorder

Equipment should be checked thoroughly before using. This is especially important if it has just been transported, used by someone else or come from the rental house. School equipment is more likely to be malfunctioning than working properly. Many recordists check their equipment whenever they arrive at a new location for filming.

1. *Clean the Heads*. See Chapter 7, Head Care. Clean the deck (top surface) of the recorder as well.
2. *Check the Batteries*. If possible this should be done with the machine in ''record'' position, with tape rolling to see how the batteries read under load. *Ni-Cad (nickel-cadmium)* rechargeable

Recordist's Tools and Supplies

For recording:
 Head cleaner or a small bottle of isopropyl (rubbing) alcohol
 Cotton swabs or head-cleaning sticks
 Permanent felt-tip marker (e.g., Sharpies)
 Spare take-up reel (for ¼″ recorders)
 Single-edge razor blades (for breaking polyester tape)
 Small roll gaffer's tape (similar to duct tape, sold in film supply houses)
 Spare reel retainer nut (if recorder is so equipped)
 Spare batteries for recorder and mike
 Log book or paper

For repairs:
 Swiss army knife w/scissors
 Screwdriver handle and detachable blades: two sets, medium
 and jeweler's size
 Small needle nose pliers w/wire cutting edge
 Small volt/ohm meter (costs about $15)
 Battery-operated soldering iron, rosin core solder
 Short length of light wire
 Fuses for the recorder
 Head demagnetizer

batteries will read fairly high on the meter until they are ready to give out, then the voltage drops sharply, so be prepared if the reading seems at all low. When replacing any type of battery, be sure the polarity is correct (that is, the plus–minus orientation of each cell) and never replace less than a full set. Reversed or dead cells will drain the others.

3. *Pilot Level.* On sync recorders, it is worth checking that the pilot signal is actually being recorded on tape. Some recorders have a meter setting for this purpose, while others allow you to hear the pilot through the headphones. Otherwise, it is necessary to play the tape with a resolver to make sure the pilot is there. Do not neglect this test if you plan to shoot a great deal of footage or go on an extended trip.

4. *Test Audio.* Do a test recording, which you can erase when you begin filming. Check the meter. Make sure you can move the level control without causing static. If not, moving the control rapidly back and forth a few times often helps. Set the headphone level adjustment, if there is one. Gently shake the recorder, cable and microphone while listening through headphones to be sure there are no loose connections. This should not produce noise or static. Many people put tape over the microphone cable connectors to keep them from rattling. Play back the tape and listen carefully for any defects. If the sound is muddy, try recleaning the heads.

If the sound does not improve, this *may* indicate that the heads need demagnetizing (see Chapter 7).

If you cannot get the recorder to work properly, systematically isolate various components. Try a different mike or mike cable; plug the mike into a different input; make sure the recorder is not in "pause"; check the AC/battery power switch (if there is one); try running the recorder on AC power; try cleaning the battery contacts with an eraser or grit-free abrasive and so on.

Before going out to shoot, tape up excess cabling and make the recorder package as neat and compact as possible. It is much easier to concentrate on recording if you can move without getting tangled up. Wear the recorder on the side of you that allows easiest access to the controls and the meter, and put some padding under the strap to spread the load. Wear soft-soled shoes and clothing that does not rustle.

The Sound Person's Role

Recorded Information

The sound person should record certain data at the head of each roll. Usually, this information, which is spoken into the microphone and written on the tape box, includes the name of production company or filmmaker, title of film, date, sound roll number and number of the camera roll being filmed. When a camera roll is changed, an announcement should always be made on the tape. Additional information often written on the tape box includes tape speed, type of sync signal (for example, 60 Hz pilot), if any, and name of recordist.

Many recordists then record about 10 or 15 seconds of *reference tone,* which helps in setting the level of the transfer to sprocketed mag film (see Chapter 12, Sound Transfer). Many recorders have built-in tone generators that work at a preset level. On recorders with VU meters the tone usually reads 0 dB. The tone on the Nagra 4.2 is usually preset to read -8 dB on its modulometer. On the Nagra III, the recordist usually sets the tone to -6 dB. Whatever level the tone, you should announce on the tape before the tone what level it reads on the meter and what kind of meter you are reading from. After the tone is heard, run off a few feet of tape so print-through will not spoil anything important.

In fiction filming, scene and take numbers are usually recorded on tape at the beginning of each take. The recordist also keeps a written log of each take, noting the length, any problems and whether the director considers the take good or bad. In addition, it is helpful to assign a *sound take number* each time you roll tape. This identifies each piece of sync and wild sound. Since sound take numbers advance chronologically

throughout the production (unlike scene numbers), in conjunction with the log, they aid in locating pieces of sound and picture. In unstaged documentary filming, shots are not usually given numbers and there is no time for meticulous log keeping. Instead, the sound person should record a quick message after every shot or two, describing what was filmed, if there were problems with the slate and so on; this can save a great deal of time in the editing room. An announcement should be made on tape before sections of wild sound (sound recorded without picture), and a verbal note should be recorded when MOS shots (shots without sound) are filmed. It is a good idea to keep an informal log on the tape box, listing the contents of each sound roll.

Recorder Operation

The sound person is responsible for placing the microphones (although someone else may hold them), operating the recorder and making sure that the quality of the recording is good. In fiction filmmaking, the recordist, who is sometimes called the *mixer,* can usually experiment with various mike positions and monitor the level of a rehearsal take before filming begins. There is an established regimen for beginning each take. The director calls for quiet and then says "sound." The recorder is then started, and the recordist says "speed" when the tape is running smoothly. The director then says "camera" and the camera operator calls "rolling" when the film has come up to speed. At that point the slate is done (see p. 215), and the director calls for "action." Normally, the camera and recorder are not turned off until the director says "cut."

In unstaged documentary filming, it is important that the recordist be ready to roll tape at a moment's notice. If shooting appears imminent, the recorder should be put in the test position (on some recorders this is done by pressing the record button, but not the forward button) and the recording level should be set. If the scene looks interesting, the recordist should not hesitate to roll tape. Tape is cheap. If the scene does not pan out, simply say "no shot" into the mike and stop recording. If the scene is good, the camera should roll. The first part of the scene that has no picture can usually be covered with another shot or a cutaway. There is no advantage to rolling vast amounts of tape, but often if you wait too long to start the recorder, the take will be useless.

If your recorder is equipped with a separate playback head, it's a good idea to monitor the "tape" position and not the microphone directly (see Chapter 7, Playback). This allows you to check the recording quality and whether you have run out of tape. Running out of tape is unnecessary and can be embarrassing. Some recordists routinely change tapes at the end of every camera roll (or two) even if some tape is remaining, thus ensuring adequate supply and minimizing time wasted threading-up. In a rush, it is often more efficient to replace both feed and take-up reels, thus

saving the time it would take to wind up what remains of the old tape. If you do not have enough tape to complete a film shoot, in emergencies you can switch to a slower tape speed, but do not forget to log this and to inform the person transferring the sound to magnetic film.

Develop a system to keep track of which tapes have been recorded and which are fresh (if you reuse tape, it is especially easy to get confused). Tape cassettes have little tabs on the edge opposite the one where you see the tape that can be punched to prevent accidental recording. These tabs can be plugged up or taped over later if you change your mind.

In most documentary situations it is preferable that the recordist remain alert and involved in the filmed action and not be glued to the meter. With time, your judgment will make you less dependent on both the meter and the headphones. For intimate documentary filming or for times when the sound person is called on to interview, you can wear the headphones around your neck, for reference from time to time. Be careful not to point the mike at the headphones or you will get a loud whistling *feedback* or sometimes a slight echo on the track. Low cut-off headphones can sometimes be heard on the track even when you are wearing them on your ears.

Decision-making

In the traditional filmmaking hierarchy, the director operates no equipment. However, on small productions, especially documentaries, the recordist or camera person may also be the director or codirector. On all films, crew members must communicate with each other. The camera operator must be able to signal to the recordist that he is in the frame, and the recordist must be able to indicate his need to change postion. Often in documentary work, only the recordist can hear whether a scene is worthy of being filmed. For all of these reasons, the filmmakers should have a set of signals with which to communicate silently. Should these signals be by hand, they should be sent with minimal commotion, especially in documentary work where the subjects are easily distracted by the filming. This requires that crew members watch each other as much as the action. The recordist, or whoever is operating the microphone, should not position himself on the camera operator's blind side (which is usually the right), and the camera operator should frequently open his other eye so that he can see the recordist while shooting. This is most important when filming improvised or unstaged action. After a crew works together for a while they begin to predict each other's needs, and eye contact precludes the need for hand signals.

If circumstances are such that a good-quality recording cannot be made, the recordist should say so. Most directors appreciate this. The solution may be to reposition the mike or to wait until a distracting noise

ceases. If there are no other alternatives, the decision to continue, with the possibility of postdubbing or otherwise covering the sound, should be made in consultation with the director.

Slating

In double system filmmaking, after the sound has been transferred to magnetic film it must be lined up with the picture it accompanies—that is, it must be put in sync. This is much easier to do if there is some distinct event that can be seen clearly in the picture and heard on the sound track. For example, the closing of a car door might suffice. A *slate* is an event in sound and picture that can be used to facilitate syncing.

The traditional slating device—called variously a *clapper board, clap sticks* or, simply, *sticks*—is literally a piece of slate on which information can be chalked, with a hinged piece of wood on top that makes a sharp noise when it makes contact with the board. Information written on the slate includes the production company, name of film, director, camera person, scene and take numbers, sound take number, camera and sound roll numbers and date. A gray scale or a color control scale is often included to assist the lab in timing the workprint.

The clapper board is usually handled by an assistant who writes and reads off the scene and take numbers and/or the sound take number before snapping down the hinged part of the slate at the beginning of each take. The numbers are often written on pieces of tape that can be stuck

FIG. 8-4. Clapper board. (Victor Duncan, Inc.)

in place quickly. Traditional clapper boards are sometimes held upside down to indicate a tail slate (see below).

Another slating device is the *slate light,* which is connected to the recorder. When its trigger is pushed, it flashes a small light (some flash consecutive numbers to identify takes) and it produces an audible beep. The slate light can be very handy for documentary filming, although the light is sometimes hard to see in daylight. Cameras using cable sync systems, or a special radio slate transmitter, sometimes employ *bloop lights,* which flash a few frames of film *inside* the camera while sending a beep tone to the recorder. Crystal sync rigs sometimes use *time coding.* With this technique, appropriately equipped cameras print out a code every second or so on the edge of the film. With some systems this code must be read by machine, while others, like the Aaton system, print legible numbers. Other systems magnetically record the code on film stocks prepared with an invisible magnetic coating in the base. A generator in the recorder puts a similar code on the tape which is ultimately printed or recorded on the magnetic film. The great advantage of these systems is that they allow automatic silent slating of any number of cameras and recorders, identifying every foot of film by the date and time of shooting and, with a properly equipped editing table, providing automatic synchronization of the workprint and magnetic film.

Slating can also be done by gently tapping the microphone once or twice or even by snapping your fingers within range of the recorder. When you make any slate, it is imperative not to turn off the camera or recorder between the slate and the shot itself, as novices sometimes do. Make sure that the slate is really visible and clear to the camera to avoid spending unnecessary time synchronizing the rushes. It's a good idea to say "slate" into the mike after a slate made by finger snapping or mike tapping to aid in finding the sound later.

When possible, *head slates,* which are done at the beginning of the shot, are used. Head slates speed the process of putting the sound and picture in sync in the editing room. *Tail slates,* done at the end of the shot, are often preferable for unstaged documentary filming since they are less disruptive and do not announce to the subjects that filming is about to begin. If the film runs out before the last tail slate on a roll and the camera operator says "run out," you can use this as an approximate slate. In any situation, a gentle, quiet slate helps put actors or film subjects at ease. Generally, actors should not be rushed to begin the action immediately after the slate.

It is more difficult, but certainly not impossible, to put shots in sync without a slate (see Chapter 12).

The term *slate* also refers to the recording of information on film or tape. MOS takes are slated, not for synchronization, but to identify the scene number on film at the head of the take ("MOS" should be written

on clapper board and the hinged bar should not be raised). Each roll of film is normally slated at the head by shooting the camera roll number and date on a card or clapper board so the number will be visible on film. Similarly, sound tapes are slated at the head with information on the roll number or the content.

Recording Technique

Basic Strategy

The general objective in sound recording is to place the microphone close enough to the sound source to produce a loud and clear sound track. A good track should be easily intelligible, should lack strongly competing background sounds, unpleasant echo or distortion and should be reasonably faithful to the tone quality of the original sound. Once a good recording is in hand, you have a great deal of freedom to alter the character of the sound later as you choose.

The ideal placement for many mikes is between 1 and 3 feet in front of the person speaking, slightly above or below the level of the mouth. If the microphone is directly in line with the mouth it may pick up popping sounds from the person breathing into it (see Chapter 7). If a directional mike is too close, it will bring out an unnatural bass tone quality. This is the *proximity effect;* which results from the particular way low frequencies interact with directional microphones. If a microphone is too far from the subject, background, or *ambient, sound* often drowns out the speaker's voice. Also, the undesirable acoustic qualities of the recording space, like echo and boominess, become more noticeable (see below).

The microphone's position is almost always compromised by the camera's needs. It is important, however, that the sound source be solidly within the pickup pattern of the microphone. Keep in mind that sound, like light, diminishes in intensity with the *square* of the distance (see Fig. 9-4). Thus, moving *twice* as far from the sound source diminishes the sound to *one quarter* of its previous level. If the recording level of the sound seems low, especially with respect to louder background sounds, you must get closer to the sound source and not try to correct the problem by turning the level way up.

Many beginners think the recordist should try to capture all sounds in a general fashion, standing back from, say, a party, a conversation or a street scene to record all the sounds together. The result of such recordings is usually an indistinct blur. The recordist should instead select individual sounds and get close enough to record them clearly. If an overall mélange of sounds is desired, it may be necessary to mix together

several distinct tracks later. For documentary filming in noisy conditions, it is often necessary for the recordist to get closer to the subject than he may feel comfortable doing. If this should happen, the camera person must insist that the mike be brought closer; a sense of professional detachment helps to overcome shyness.

Putting the mike very close to the sound source minimizes both ambient sound and the natural echo or reverberation of sound reflections in the recording space. In some situations, a close mike sounds artificial. For example, if the camera is filming a distant long shot and the mike is very close, the recording will lack the proper *sound perspective*. Although distorted sound perspective is found regularly in films, some people object to it. To correct this, the recordist could move farther back, but at the risk of sacrificing clarity. Alternately, after the sound has been recorded, a *reverb unit* can be easily used to give a sense of distance to the sound. Similarly, any missing ambient sounds can be easily added later by mixing in a second track. These kinds of effects are often better handled under the controlled conditions of sound editing than they are while making a live recording. You can always add background sounds, distance effects and equalization during sound editing and mixing, but nothing can make a noisy, echoing or weak recording sound pleasing and clear.

Ambient Sound

Ambient sounds are the background sounds that surround any recording space. They can come from birds, traffic, waves, refrigerators, fluorescent lights, stereos and the like. The best way to minimize their effect, when possible, is to eliminate them entirely. Don't shoot the birds, but do unplug refrigerators, turn off air-conditioners and close windows facing out to the street. For fiction filming, locations should be planned with ambient noise in mind. Try not to set up shooting in an airport flight path or by a busy highway. Sometimes you can get permits to block off a street temporarily while you are shooting; otherwise, plan to shoot at a quiet time of day.

Audible ambient sounds should ideally remain consistent throughout a scene. Consistency is important for editing since much condensing and rearranging of the film's chronology are done at that time. An editor needs the freedom to juxtapose any two shots without worrying if the background tone will match. The audience will tune out the gentle ambience of an electrical fan, but may notice if it pops in and out in every other shot. If you begin shooting a scene with the window closed, do not open it during the scene. In situations where you can not control some background sound (a neighbor's auto, for example), record some of the offending sound alone in case during editing you need to cover sections

of the scene that lack it. In some cases, an inconsistency in the background sound will seem logical and need not be disguised.

Make every effort to turn off or lower any music that is audible at the filming location. Discontinuous music is a glaring sign that the chronology of shots has been changed. Recording copyrighted music may also create legal problems. If ambient music cannot be eliminated, or if it is part of the scene you are filming, plan your editing around it when you shoot.

You should always record about a minute of ambient sound at every location. Even if nothing in particular is audible at the location, every site has its distinct *room tone*, which is quite different from the sound of dead tape that has nothing recorded on it. Room tone—an expression that refers to outdoor sound as well—is used in editing to bridge gaps in the sound track, providing a consistent background.

Recording in Noisy Locations

If strong ambient sound is overpowering the sound you want to record, there are a number of ways to resolve this. First, try to get the microphone as close to the source as possible. Using a microphone boom sometimes helps; you can often get closest by miking from the top or bottom of the frame rather than from the sides.

Lapel or lavalier mikes are often useful for close recording. These are especially effective for a single subject or for situations where two persons are near each other. These mikes can usually be concealed on the subject. They can also be hidden, for example, in a piece of furniture. Placing a lapel mike in the center of a small table is sometimes the best way to mike unpredictable dinner table conversation. (The mike should not be placed directly on the table surface or it will pick up the vibration of objects being put down onto the table.) When they are used with a wireless transmitter, lapel mikes can provide good-quality sound in scenes with lots of subject movement and long shots where handheld mikes would be impractical.

Often the best solution to block out loud ambient sounds is to get a more directional microphone and use its pickup pattern to its best advantage.

When you are using any microphone, never let the subject come between the mike and a major noise source, like the street. Stand in the street to mike someone on the sidewalk; do not stand with your back to the buildings where you will pick up the sound of your subject and the street noise equally. With a super-cardioid microphone, if you can point the mike upward from below (or down from above), you can minimize street level background noise, including sound reflected off buildings.

As camera noise is a constant problem on sound tracks, always avoid

pointing the microphone in the direction of the camera or its reflected sound (see Fig. 8-5).

Acoustics of the Recording Space

The size, shape and nature of any filming location affects the way sound travels through it. An empty room with hard, smooth walls is acoustically *live*, reflecting sound and causing some echoing. Bathrooms are usually acoustically live; sound may reverberate in them for a second or more before dying out. A room with carpets, furniture and irregular walls is acoustically *dead*; sound is absorbed or dispersed irregularly by the surfaces. Wide-open outdoor areas are often extremely dead, because they lack surfaces to reflect the sound. Listening to the way a hand clap or whistle dies out is a good way to test the liveness of a recording space.

The acoustics of a location affect the clarity of the sound track and the loudness of camera noise. It is hard to hear clearly in an overly live room (a *boomy* location) since high frequencies are lost and rumbly low frequencies predominate. If you have tried to talk in a tunnel, you are familiar with what it does to the intelligibility of voices.

There are a number of ways to improve an overly reverberant location. You can use a directional mike and move closer to the sound source. A room can be deadened by closing curtains or by hanging blankets on the walls and spreading them on the floor (many recordists carry *sound blankets* for this purpose). Avoid positioning a microphone near a smooth wall where it will pick up both direct and reflected sound, since echo may

FIG. 8-5. Microphone positioning. (A) An improperly positioned directional microphone is pointed directly at reflected camera noise. (B) Microphone positioned to reduce response to both direct and reflected camera noise. (For clarity in the illustration, the microphones are shown further away from the subject than is optimal.)

be increased or sound waves may cancel each other, weakening the microphone's response. This may also occur when mikes are mounted on a short table stand over a smooth, hard surface. Avoid placing the mike in a corner or equidistant from two or more walls where reflected sound may cancel or echo. Sometimes boominess can be reduced by filtering out low frequency sounds below about 150 Hz (see below).

If a space is too live, even a quiet camera's noise will sound loud. When you point the mike away from the camera, you often are aiming at reflected sound bouncing off a wall. When this happens, deaden the space with blankets, move closer to the subject or use the pickup pattern of the mike to cancel out both direct and reflected camera noise.

Bass Filters

Many recorders and microphones are equipped with filters that reduce the level of low-frequency sounds. These filters are variously called *bass cut, bass roll-off, high pass* and *low-frequency attenuation*. Some filters cut off bass relatively sharply at some frequency, say 100 Hz. Others roll off low frequencies more gradually, often diminishing them 12 dB per octave; thus the filter might reduce 150 Hz somewhat, 75 Hz quite a bit and 37 Hz almost entirely.

Microphones and recorders often have a two- or three-position bass roll-off switch. The first position (sometimes labeled music or M) provides a relatively flat frequency response with no bass filtering. The next position (voice or V) provides filtering below a certain frequency. If there is a third position, it rolls off bass starting at an even higher frequency (see Fig. 7-10). It is extremely important to do test recordings with the filter to judge its effect. On some mikes, the "M" position is optimal for most recording, and the "V" position should be used only for excessive rumble or wind noise or when the mike is very close to someone speaking. Sometimes, the third position removes so much of the low end that recordings sound very thin and hollow.

Filtering, also called *equalization,* is done to the low frequencies to minimize the rumble caused by such things as traffic or machinery and wind or handling noise on the microphone. The low-frequency component of these sounds is disturbing to the listener and can cause *intermodulation interference,* which distorts higher-frequency sounds. If low-frequency sounds are loud, the recording level must be kept low to avoid overrecording, and this diminishes the quality of the sounds that are more important (such as speech).

There are two schools of thought on filtering bass: one is to filter liberally in the original recording, the other is to hold off as much as possible until the transfer to mag film or until the production of the final magnetic or optical track. The first school argues that the low frequencies will be filtered out eventually, and a better recording can be made if this

is done sooner rather than later. Although this is true, the problem is that frequencies that are rolled off in the original recording may not be replaceable later. The sound studio is a much better environment in which to judge how much bass needs to be removed.

A more prudent approach is to filter bass only when excessive rumble requires it or when trying to compensate for a microphone that is overly sensitive to low frequencies, to wind or to handling noise. Then, filter only slightly—perhaps at the second position on a three-position roll-off switch. During the transfer to mag film or in the sound mix, a quality equalizer can be used to remove what is unnecessary (see Chapter 12). If bass filtering is done, it should be kept consistent throughout a scene.

Multiple Microphones

There are many situations in which it is preferable to use more than one microphone. Typical examples of this are when recording two people who are not near each other, recording a musical group or recording a panel discussion. Many recorders have provisions for two microphone inputs, and some machines can record from microphone and line inputs simultaneously. Mikes can usually be fed into the line input with the proper preamplifier or matching transformer on the cable. Portable microphone mixers, which can be rented cheaply, allow several mikes to be fed into the recorder. Try to get microphones that are well matched in

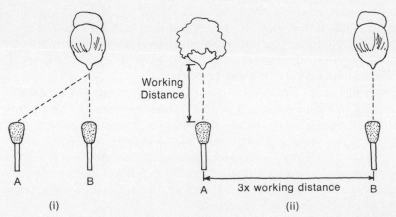

FIG. 8-6. Multiple microphones. (i) Distance from woman to microphone A is only slightly longer than distance to microphone B, leading to possible phase cancellation. (ii) Separation between microphones is three times the distance from each mike to its sound source. Now the distance between microphone A and the woman at right is sufficient to minimize the chance of phase cancellation.

terms of tone quality. Sometimes a filter can be used on one mike to make it sound more like another.

The main problem with recording with more than one microphone is the risk of diminishing the strength and quality of the sound signal. If the peak of a sound wave reaches one mike slightly before or after it reaches another mike, *phase cancellation* results. In phase cancellation, the diaphragm of one mike is pushed by the sound pressure while the other mike's is being pulled and the two signals cancel each other out. The rule of thumb for avoiding phase cancellation is that the microphones should be at least three times farther from each other than the distance from each mike to its sound source. Directional microphones that are angled away from each other can often be placed closer together.

Whenever you use multiple microphones, carefully check that the strength of the sound signal is increased, and not decreased, by adding mikes. Watch the level on a VU meter when you plug the second mike in. Sometimes two microphones are wired differently, so that even if the mikes are placed correctly, they cancel each other anyway. Also, to avoid unwanted noise, try to keep the level down on the mikes covering people who are not speaking; this is often difficult when recording unpredictable dialogue.

If the recorder can record more than one track at a time, several possibilities are opened up by using multiple microphones. With a stereo recorder, you can place two mikes in different positions and choose whichever sounds best later. If different subjects have their own mikes and recording channels, their lines of dialogue can be separated for editing and mixing purposes. Director Robert Altman developed a sixteen-track recording system fed by wireless microphones on individual actors, with each transmitter on a different frequency. With this system, the actors can freely improvise, and everyone's lines will be recorded well, something that is difficult or impossible to do with only one mike. Phase cancellation can be avoided with multiple recording tracks since the editor can choose the sound from one microphone or another without trying to mix them together. The stereo Nagra has three recording tracks; the third channel is available for slating and recording information. With this, you can shoot with several cameras simultaneously and not disrupt the recording for slates—a real boon for filming musical performances. The same is true of equipment that employs time coding.

Recording Music

Below are listed some suggestions for recording a musical sound track.

1. When you record an individual instrument, place the mike near the point where the sound is emanating (for example, the sound hole of a guitar or the finger holes and bell of a saxophone).

2. When you record a number of instruments with one microphone, experiment with various mike placements to find the one that balances the instruments nicely. The mike should usually be somewhat above the level of the instruments, closer to the quiet ones than to the loud ones. One well placed omnidirectional mike can often achieve good results. Sometimes a second mike is added to capture a vocalist or soloist.

3. When you use more than one mike, be careful to avoid phase cancellation.

4. When you record amplified vocalists or instrumentalists, it is usually necessary to place the mike in front of the loudspeaker, not the person. When you record a speaker at a podium, you will probably get better sound by miking the person directly, but you must get the mike very close. Often with amplified speeches or music you can get a line feed directly from the public address system (or a band's mixing board) to your recorder. By doing this, you avoid using a microphone and you usually get good-quality sound (in the case of the band's mixer, you get premixed sound from multiple microphones).

5. When you record music from records, do not use a microphone. Instead, connect the line output of the phonograph's amplifier to the line input of your recorder.

6. When you record a musical performance, avoid using the automatic level control or adjusting the recording level a great deal during the performance. Ideally, the musicians should control the level of the sound. Sitting in on a rehearsal or following the score is a good way to prepare yourself for sections that will need level adjustment. Also, slow tape speeds may require keeping the recording level slightly lower than normal (see Chapter 7).

7. When you film a musical event, be sure to shoot a number of cutaways that can be used to bridge various shots or tie together two takes from different performances. Performance sound must be relatively continuous, and you will need film footage to cover much of it (unlike, say, a lecture which can be easily excerpted). Shooting with more than one camera helps ensure that you will have sufficient coverage.

8. If you plan to use music in your film, you should be familiar with music copyright laws (see Chapter 16).

Recording Sound Effects

Sound effects (SFX) are nonmusical, nonspeech sounds from the environment. The sounds of cars, planes, crowds and dripping water are all considered effects. Effects usually have to be recorded individually. Do

not expect to get a good recording of effects during scenes that involve dialogue. An effect may be difficult to record well either because of practicalities (positioning yourself near a jet in flight, for example) or because it does not sound the way the audience has come to expect it to sound (for example, a recording of a running brook can easily sound like a running shower). It is often better to try to simulate an effect (crinkling cellophane to produce "fire" sounds, for instance) or to purchase pre-recorded effects from a sound library or mix studio (see Chapter 12).

Filming Alone

Filmmaking is sometimes called the collaborative art, because it normally requires the input of large numbers of creative and technical personnel. It is possible, however, for a filmmaker to shoot sync-sound films with a very small crew or even alone. A small crew or solo filmmaking opens up possibilities for making movies on extremely low budgets, and allows the filmmaker personal creative control over his work similar to that of a painter or writer. In documentary work, a crew of one may permit filming subject matter that would be inaccessible to a larger crew. Much of the "personal" documentary cinema that began in the late 1960s only became feasible with the development of portable, lightweight sound recording equipment.

The filmmaker working alone may decide to record sound in a single system camera or with a lightweight double system recorder, like the Nagra SN or a small cassette recorder. Larger recorders can be used, but they are often unwieldy. Some people use camera-mounted microphones to keep both hands free for operating the camera and the recorder. The disadvantage of this method is that the microphone is always pointed in the same direction as the camera. Better sound can usually be recorded by handholding a directional microphone, which makes operating the camera and lens controls more difficult, but not impossible. A few filmmakers shoot this way regularly, using wide-angle lenses (10mm on 16mm cameras or about 6mm in super 8) that have great depth of field and require little focus adjustment. With cameras that do not rest on the shoulder, it makes sense to use a shoulder or body brace to steady the camera and relieve some of the weight from the right hand.

As long as the microphone is attached to the camera, it is necessary for the filmmaker to stay relatively close to the subject to record good sound. More flexibility can be had by mounting the microphone on the subject. This can be done with a wireless transmitter that feeds a receiver on the recorder or the camera. For example, Cinema Products makes a wireless receiver that mounts neatly on their single system 16mm camera. Alternately, a small recorder can be placed on the subject (in a coat pocket, for example) and operated either by the filmmaker, by the subject

or by remote control from the camera. Slates can be done by snapping your fingers in front of the lens within range of the microphone.

For all single-person filming, it is helpful to have some form of automatic control for the recording level.

A Technique for Single System Filming

One of the biggest drawbacks of working in single system is the 18 or 26 frame separation between sound and picture that can make editing so difficult (see Chapter 12, Single System). Unless you plan to transfer your single system footage to video or to double system, it makes sense to tailor your shooting style to the limitations of the medium. Plan your shots so that they go together with as little editing as possible. Shoot longer takes than you might otherwise, and do not divide a scene into many separate shots or angles. If you begin and end each shot when no one is speaking (or at least when nothing crucial is being said), when you splice shots together you will not lose important sections of the sound track. Of course, if there are scenes for which you will not use the synchronous sound, you can take more liberties with short shots and quick cuts.

9
Lighting

Light

The Function of Lighting

The impact of a filmed image is as dependent on lighting as it is on framing, composition, camera movement or any other element the filmmaker may control. Lighting allows the viewer to see the scene and directs his attention, since the eye is naturally drawn to bright areas of the frame. The direction from which light strikes an object or a face also influences how the object is seen. Side lighting casts shadows that emphasize depth, dimension and surface texture, while frontal lighting tends to flatten, compress and smooth over features. Also, the quality of light in a scene sets a mood, just as changes in the sky evoke various feelings. Painters are often celebrated for the way they manipulate light and create particular moods. Andrew Wyeth, for example, evokes the gray, quiet feeling of the Maine landscape with extremely flat and even illumination. Rembrandt creates a much more dramatic effect by using a "chiaroscuro" style, in which pools of light and shadow are used to obscure as much as they reveal of a subject. Cinematographers too are frequently known for a particular "look" that they achieve through their lighting technique.

In fiction filmmaking, lighting is usually a top priority. Lights are positioned painstakingly, consuming much time and expense. The director of photography is usually responsible for the lighting design, which is as important as his mastery of cameras and lenses. In documentary filmmaking, light is sometimes treated in an auxiliary way, less for its mood than for its exposure value. In such films, lack of time or control over the film subjects often makes careful lighting impossible. Many films are made entirely in available light, with no additional lighting introduced by the filmmakers. Artificial lighting is often needed to reduce the contrast of a scene so that it can be rendered properly on film.

227

Qualities of Light

The shadows cast by a light source are determined by its *hardness*. *Hard light,* also called *specular light*, like direct sunlight on a clear day, is made up of parallel rays that produce clean, hard shadows that neatly outline the shapes of objects. The *soft, or diffuse, light* of a hazy or overcast day is less directional; it emanates from all parts of the sky at once. If it casts shadows at all, they are dull and indistinct.

Hard light can be produced artificially with lensed or focused lamps that emit a clearly directed beam. The spotlights used to single out a performer on stage are extremely hard. Soft light is usually made by bouncing lamp light on a white or silvery surface that is often scoop shaped. Soft light creates a broad and even glow, not a beam of light.

Because hard light casts distinct shadows, it is used to delineate shapes. It brings out surface textures and the contrast between areas of different color or tonal value, but when used alone it tends to be harsh. Hollywood often uses hard lights on male actors to bring out rugged facial features.

Hard light can be produced with relatively compact lighting fixtures. The *key light* on a film set is usually hard, the key functioning as a primary

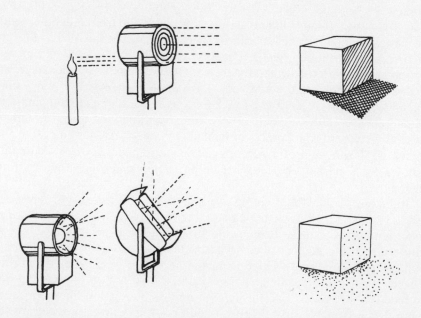

FIG. 9-1. (Above) The relatively parallel rays of hard light casting a clear shadow. (Below) The scattered, more random rays of soft light casting a diffuse shadow.

source of illumination that casts bold shadows and gives the impression that the lighting in the scene comes mostly from one direction (see A Basic Lighting Setup, p. 248).

Soft light is relatively gentle and tends to smooth out features and textures. Traditionally, female actors are lit with soft light to disguise any facial wrinkles or imperfections. A single soft light off to the side can provide delicate modeling of curved surfaces such as the face, because of the way it "wraps around" the curve with gradual shading; hard lights would produce shading that is more sharp edged.

Soft light fixtures are used on the set as *fill lights* to fill in the shadows cast by harder lights without adding more shadows of their own. Soft lighting has become increasingly popular in fiction filmmaking and television commercials. It is sometimes claimed that soft lighting looks more natural.

Directionality

The direction of illumination greatly determines how the subject appears on the screen. Light striking the subject from the direction of the camera is called *front light*. *Front axial light*, which emanates from very near the camera's lens, casts shadows that are mostly not visible from the camera position but may unpleasantly outline a subject standing in front of a wall. Camera-mounted fixtures, such as those used for flash photography, provide front light, which illuminates all the visible surfaces of the subject. Full frontal lighting is usually uninteresting, since no modeling shadows are visible and dimensionality and surface texture are minimized. The flattening effect may, however, be desired.

You can think of full frontal lighting as projecting from the number 6 on a clock face whose center is the subject. (Think of the camera as also positioned at the number 6.) *Offset* (the light at number 5 or 7) and *three quarter front light* (around 4:30 or 7:30) can be used for portraiture when more shadowing is desired.

Full side light (around 3 or 9) provides good modeling and indication of texture (since texture is indicated by the pattern of tiny individual shadows visible from the camera position). Side light can be quite dramatic. It produces shadows that fall clearly across the frame and distinctly reveal the depth of various objects in space.

Back light originates from behind (and, in studio lighting, usually above) the subject. It tends to outline the subject's shape and to differentiate it from the background. Backlight can produce a bright edge or halo on a subject's hair and shoulders. When backlight predominates, called *contre-jour*, it can create a moody and romantic effect, giving a sense of isolation to the subject. If the background is bright and no light falls on the camera side of the subject, the subject will be in *silhouette*.

The effect of lighting is also determined by the height from which light

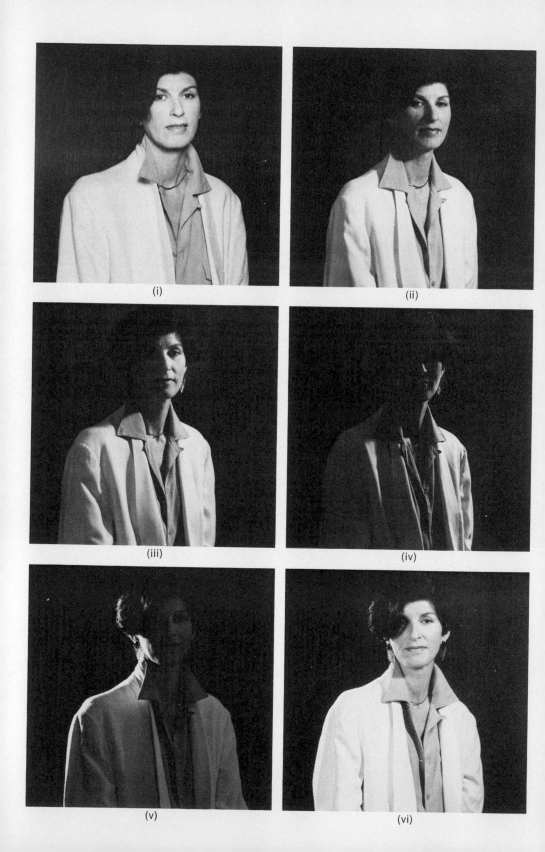

(i)　　　　　　　　　　　　　　　(ii)

(iii)　　　　　　　　　　　　　　(iv)

(v)　　　　　　　　　　　　　　　(vi)

FIG. 9-2. Directionality of light. The model is predominantly lit by one light. (i) Full frontal. (ii) Three-quarter front. (iii) Side. (iv) Three-quarter back. (v) Back light or rim light. (vi) A three-light setup with key and fill lights in three-quarter front positions and a backlight for edge lighting. (Ted Spagna)

strikes the subject. *Top light,* which shines down from directly above the subject, can make deep shadows in eye sockets. It can also make landscapes seem more two-dimensional, since few shadows are visible. Most film lighting is done with the key lights angled about 40 degrees from the floor or slightly higher for the best modeling without casting excessive shadows. *Underlighting,* which lights from below the subject and casts shadows upward, occurs in nature infrequently and is sometimes used in films to lend a ghoulish look to faces.

Lighting Contrast

Much of the atmosphere of a lighting scheme is determined by the *lighting contrast*—that is, the relationship in light intensity between the brightly lit areas and the shadow areas in the frame. With great lighting contrast, there is a great difference in intensity between the bright areas and the deep shadows. With low lighting contrast (often achieved by using secondary lights to fill in the shadows), the lighting appears fairly flat and uniform throughout the frame. The degree of lighting contrast is often expressed numerically in terms of the *lighting contrast ratio* (see p. 255).

A *low-key lighting* design has high lighting contrast and a Rembrandt-like look, with dark shadow areas predominating over light areas. Low-key lighting is associated with night, emotion, tension, tragedy and mystery. *Film-noir* films, as well as *Citizen Kane,* are lit in moody low-key lighting, the dramatic look of the lighting being well suited to the black-and-white image. With *high-key lighting,* the lighting contrast is low and light tones predominate, making everything appear bright and cheery. High-key lighting is used for daytime scenes, comedy, straightforward material (like documentary interviews) and most studio television shows. Since high-key lighting has even distribution, it is useful for scenes where several cameras are shooting from different angles simultaneously or when an actor must be able to move freely without walking into areas of deep shadow.

The terms *high key* and *low key* are sometimes confusing since the key light is actually *lower* in intensity relative to the fill light in high-key lighting designs. One means to distinguish the terms is to remember that actors in comedies are usually high-key personality types.

FIG. 9-3. The single candle produces fairly hard light (note the crisp shadows) and a very low-key lighting scheme with no fill illumination and deep shadows. (*The Penitent Magdalen* by George de La Tour, The Metropolitan Museum of Art, Gift of Mr. & Mrs. Charles Wrightsman, 1978)

FIG. 9-4. Light from the large window is fairly soft (note gentle shadow angled downward from window sill). The lighting scheme is relatively high-key, but would be more so if stronger fill light were added from the right side of the frame. (*Young Woman with a Water Jug* by Vermeer, The Metropolitan Museum of Art, Gift of Henry G. Marquand, 1889)

Lighting Equipment

Lighting Fixtures and Light Intensity

In professional movie lighting jargon, the lighting fixture is called a *luminaire* or *lighting unit*. The *lamp* is the bulb, and changing a bulb is *relamping*. Lighting units are identified by type and power consumption. A 5K spot is a 5000 watt (5 *k*ilowatt) spotlight. Lights are balanced for tungsten (3200°K) unless stated otherwise. Do not confuse degrees Kelvin with use of "K" that indicates wattage.

If you work on the lighting for a production, you will discover a special argot for various pieces of equipment. *Aces* and *deuces* are 1K and 2K lights, respectively. A 5K lensed focusing spotlight (see below) is often called a *senior*, while the 2K is a *junior*, and the 1K a *baby spot*. An *inky* has only a 200-watt bulb.

The brightness of a light bulb is usually discussed in terms of wattage. *Wattage* is actually a measure of how much electric power is used (see Location Lighting, below); some bulbs and fixtures put out more light than others for the same power consumption (that is, they are more efficient). In the case of two lights that employ the same type of bulb in the same fixture, a doubling of wattage implies a doubling of light output.

FIG. 9-5. The inverse square law. 1). Light falls off rapidly as you move away from the source: Moth B is twice as far from the candle as Moth A but receives *one quarter* the amount of light. Moth C is three times farther from the candle than moth A and receives *one ninth* the amount of light. 2). Light falloff is less severe when you are farther from the source: Moving from B to C is the same distance as moving from A to B, but the light falloff is much less (it falls off to about half the previous level instead of to one quarter).

With the exception of certain focusing lighting fixtures, the intensity of illumination decreases the farther the subject is from a light. This is known as light *falloff*. The rule for typical open bulbs is that the falloff in intensity is inversely proportional to the *square* of the distance. Thus, moving an object twice as far from a lamp results in it being lit by *one quarter* the amount of light. Because of this, falloff is especially acute when you are near the light source. An end table lamp, for example, could light a person at the near end of a couch four times as brightly as the person sitting next to him (an exposure difference of two stops). For even illumination, lights should be kept far away from the subjects so that slight changes in distance do not cause large changes in exposure. Focused specular light falls off more gradually than light from open bulbs.

Bulbs

HOUSEHOLD BULBS AND PHOTO BULBS. Common household incandescent bulbs can be used for black-and-white filming. Their color temperature, however, is about 2900°K, so the light they produce looks reddish-orange instead of white on tungsten balanced color film (see Chapter 4, Color and Filters).

Photo bulbs are available that use tungsten filaments similar to those in household bulbs, but the light emitted is designed to match tungsten-balanced film. Both 3200°K and 3400°K versions are available. A bluer, "daylight-balanced" version (rated at 4600 to 4800°K) can also be purchased.

Photo bulbs may be either *photofloods* or *reflector floods*. Photofloods look just like household incandescent bulbs. Reflector floods are mushroom-shaped with a built-in reflecting surface that projects a more directed beam of light (see Fig. 9-11). Photo bulbs are the least expensive kind of artificial lighting for film, and they can be used with many home and amateur fixtures. They become very hot, however, and should only be used with fixtures that allow good ventilation upward. They are not very bright compared to other types of bulbs (about 1000 watts maximum) and their life span is short (often as little as 5 or 6 hours), although a longer life version has been developed. After a few hours, photo bulbs darken from internal deposits, diminishing both the brightness and the color temperature, giving the film a reddish cast. Use only fresh bulbs since the color change is visible on film but not to the naked eye. Some people buy bulbs rated at 3400°K for use with tungsten film balanced for 3200°K, figuring that, with the inevitable drop in color temperature, the original film will look better and a print will need less color correction.

TUNGSTEN-HALOGEN BULBS. Also called *quartz-iodine* or *quartz,* these bulbs employ a tungsten filament surrounded by halogen gas that is en-

cased in a quartz glass bulb (see Fig. 9-8). Quartz bulbs are far smaller and more efficient than photo bulbs. The brightest ones are rated at about 10,000 watts. Unlike photo bulbs, they burn for hundreds of hours, do not diminish in brightness or color temperature over their life span and are more resistant to breakage during transport. Quartz bulbs become very hot and are mostly used in heavy-duty fixtures for maximum safety and control. However, there are screw-in quartz bulbs that can be fitted in well-ventilated household fixtures. Finger grease damages quartz glass so use gloves or paper when handling the bulb. If a bulb is touched, it should be wiped with alcohol. Carry a metal clamp for removing hot bulbs. Since quartz bulbs can explode, point them away when turning them on.

Quartz bulbs are normally rated at 3200°K for use with tungsten-balanced film. These bulbs, and any other tungsten-balanced light source, can be raised in color temperature to better match daylight illumination with a blue *dichroic filter* or with *blue gel* material (see p. 258). This normally cuts the light's output by about half.

HMI Bulbs. *Halogen-Metal-Iodide bulbs*, and *Compact Source Iodide (CSI) bulbs* which are similar, are relatively new lighting sources that produce "daylight-balanced" illumination (about 5600°K) that is more than three times brighter than tungsten-balanced quartz for the same

Fig. 9-6. Arnold and Richter (Arri) HMI lights with ballast units. HMI's efficiently supply daylight balanced illumination. (Arriflex Corp. of America)

amount of electric power used. This improved efficiency means that bright lights can be run off a small power supply without the need for generators or special lines. Since matching daylight with tungsten sources requires a dichroic or some other filter, HMI's are far more efficient for daylight applications. HMI's also give off much less heat than tungsten lights, which makes them more popular with actors and crews.

HMI lamps must be powered by heavy *ballast* units, and some models, if used improperly, will produce a flickering effect on film. In most technically advanced countries, the mains (wall current) are very stable and the alternating frequency is constant. In these countries, crystal-controlled cameras with shutter angles from 90° to 200° can be used safely with HMI's. However, if there is any variation in the alternations of the power line or in the camera speed, flicker may result. In the U.S., where the current alternates at 60Hz, a shutter angle of 144° at 24 fps will allow for the *maximum variation* in these speeds without danger of flicker. In countries where the current alternates at 50Hz, a 180° shutter at 25 fps offers the same leeway. If you are using your own generators to supply power, they must be crystal-controlled. These principles apply to all AC discharge lamps, including HMI, CSI, sodium vapor and mercury vapor lamps (the latter two are often found in sports stadiums and parking lots; they require special filtering to match tungsten-balanced film).

CARBON ARC LAMPS. *Carbon arc lamps* (the 225 ampere model is called a *brute*) are powerful, heavy lights used on large-scale productions, often to simulate or augment daylight. The search lights used to announce super market openings and other gala events are carbon arcs. They can be trimmed with *white flame carbons* to match daylight or *yellow flame carbons* which burn at 3200°K. Carbon arc lamps require special low-voltage DC power supplies and should only be operated by an experienced electrician.

FLUORESCENT BULBS. Fluorescent lighting is usually undesirable for film work. The spectrum of fluorescent light is discontinuous and matches neither tungsten nor daylight illumination. Unfiltered fluorescent light gives an unpleasant blue-green cast to color film. There are several types of fluorescent tubes available (daylight, cool white, warm white), which vary in color. As long as all lights in a scene are the same type fluorescent, filters on the lights or the camera can be used to improve color rendition. Daylight and cool white tubes can be used with an FLB filter for tungsten-balanced films or an FLD filter for daylight-balanced stocks. Many filmmakers prefer to use no filter at all with color negative stocks and to let the lab correct the color in printing. Consult with your lab before doing so.

Fluorescent lighting causes similar but less severe flicker problems as HMI's. The rule of thumb is simply not to use shutter speeds faster than

1/60 second; it is not necessary to have a crystal-controlled camera. Mixing fluorescents with other sources of light can also cause problems (see p. 259). Fluorescent fixtures at workplaces often shine straight down resulting in overexposed hair and deep eye and nose shadows. Many cinematographers choose, whenever possible, to turn off existing fluorescents all together and relight with some other source.

Spotlights and Floodlights

The most controllable kind of lighting unit is a *focusing spotlight*. Some spots have a *fresnel lens* (silent "s," pronounced "freh-NEL" or "fray-NEL") in front of the bulb. These lights emit focused, parallel rays of light that do not spread out much or diffuse over distance. They are often used in the theater to project a crisp circle of light on an actor. Non-lensed spots are called *open spotlights*. These are lighter and cheaper than fresnel units and are used far more often for location and small-scale

FIG. 9-7. Colortran 1000-watt fresnel-lensed spot. Though heavy for location work, fresnel fixtures provide a great deal of lighting control. (Colortran, Inc.)

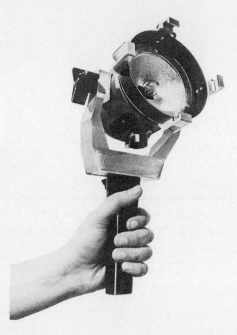

FIG. 9-8. Colortran Mini-Pro 650-watt (maximum) open spot with hand grip. The quartz bulb is clearly visible. (Colortran, Inc.)

filming. These units are less controllable or *cutable* (because the beam is not as sharp edged), and the quality of light is not as hard.

Most spotlights are *focusable,* which means the bulb can be moved back and forth relative to the reflector or lens to produce either a hard, narrowly directed beam of light or a more diffuse, wider beam. These bulb settings are the *spot* and *flood positions,* respectively.

Sealed-beam lights, which look like automobile headlights, are non-focusing spotlights. They are referred to as *PAR lamps* (for Parabolic Aluminized Reflector); some versions project a quite soft, wide beam, others throw a narrow beam over great distance. PAR's, and the similar FAY bulbs, may have dichroic filters to produce daylight-balanced light. Daylight-balanced HMI's are also available in sealed-beam configuration. PAR and FAY lights are usually mounted in 2 × 3 or 3 × 3 groups on a frame (called *six lights* and *nine lights,* respectively) and are effective for simulating sunlight through a window or for filling in daylight shadows.

A typical floodlight is also not focusable. The light from any flood unit is softer and less well directed than that from a spotlight. *Scoops* are dish-shaped floodlights; *broads* are rectangular and have a long tube-shaped bulb. Floodlights are sometimes used on the set as fill lights or to provide even illumination over a broad area.

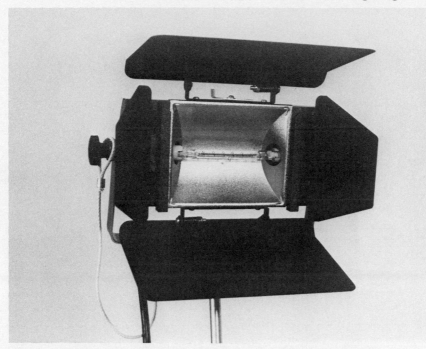

Fig. 9-9. 1000-watt broad. Bardwell & McAlister Mini-Mac with four-leaf barn-door. Note the tubular bulb. (Bardwell & McAlister, Inc.)

Soft Lights and Reflectors

The relatively hard light produced by a spot or a flood unit can be softened by placing some *diffusion material* in front of the unit. Diffusion spreads the light, disrupts the hard parallel rays and cuts down the light's intensity. The most common diffusion material is a light fiberglass matting called *spun glass*. This and various other kinds of commercially available diffusion matter (like Rosco's Soft Frost, which looks a bit like translucent shower curtain material) are especially good because they will not burn under the high heat of quartz lights. If they are placed *far enough* from the heat of the fixture, any number of materials can be used for diffusion, including thin cloth, silk, paper or actual shower curtains.

To obtain softer lighting, the light from the bulb can be bounced off a white or silvery surface; the larger the surface and the farther it is from the bulb, the softer the light. A *soft light* is a large, scoop-shaped fixture that blocks all direct light from the bulb so that only bounced light escapes. Studio soft lights are quite bulky, but there are collapsible models available that pack into a thin suitcase for travel.

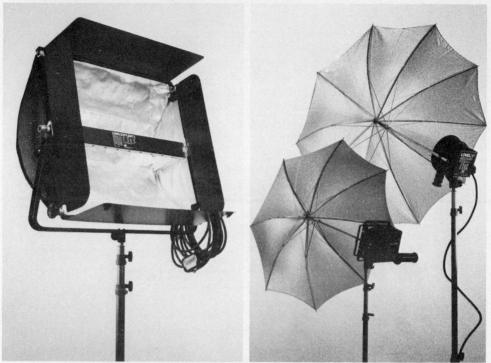

FIG. 9-10. Soft lights. (left) Lowel collapsible soft light. (right) Umbrella reflectors. (Lowel-Light Manufacturing, Inc.)

Soft light can also be created with a spot or flood light by using a large reflector. This is often done by bouncing the light off walls or ceilings, especially for quick setups. Otherwise, *foam core sheets* or white cardboard *show cards* can be mounted on stands or taped to a wall as reflectors. Foam core is lighter and more rigid. With color film, it is important that the reflecting surface does not have a color cast, or the light reflected will not be white. An extremely lightweight *space blanket* or a foil sheet can be taped shiny-side-out to make an excellent reflecting surface on a colored wall, and it will protect the wall from burning. (Some space blankets, have a blue side that can be used to match daylight when bouncing tungsten lighting units.) Another way to create soft light is to use a photographer's *umbrella,* which is silver or white on the inside. The lighting unit is mounted on the stem and is directed toward the inside of the umbrella. Umbrella reflectors fold to a compact size for traveling.

Reflectors of various kinds are also used outdoors to redirect sunlight. This is commonly done to fill shadows on a sunny day. Smooth, silvered reflectors provide relatively specular light, while textured silver or white surfaces reflect a more diffuse light. Sometimes reflectors are curved

concavely to focus the reflection in a narrow beam. A simple reflector can be made by covering a show card with aluminum foil. On windy days, reflectors must be carefully steadied or the intensity of light on the subject will fluctuate.

Fixtures for Photofloods and Reflector Floods

Lowel makes an extremely versatile set of fixtures that can be used with photofloods, reflector floods or even standard household bulbs. The Lowel-light kit comes with a set of adjustable sockets that can be clipped, hung or taped on just about anything. Collapsible brackets clip onto reflector floods to mount baffles called *barndoors* (see p. 243), which block off unwanted light. The whole kit (without bulbs) packs into a small box.

Photofloods are often used in simple fixtures with dish reflectors. A piece of aluminum foil around a photoflood can turn it into a serviceable reflector flood light. Photofloods and screw-in quartz lights are sometimes

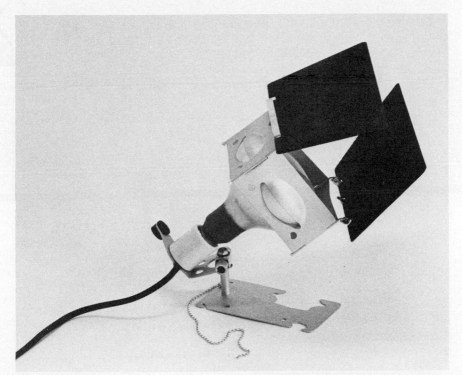

FIG. 9-11. Lowel-Light fixture shown with R40 reflector flood and two-leaf barndoor. These fixtures can be used for a very handy, lightweight location kit. (Lowel-Light Manufacturing, Inc.)

used in household fixtures which are placed to be visible in the shot. Fixtures used this way are called *practicals*. Use only fixtures that allow the heat to escape upward, otherwise a practical may burn or melt.

Camera Lights and Handheld Lights

Camera-mounted lights are commonly used for home movies (for which they are called *movie lights*), news gathering (where they are often called *sun guns*) and feature films (where they are referred to as *bash lights* or *obie lights*). The advantages of camera-mounted lights are their portability and their ability to provide constant, shadowless illumination when both camera and subject are moving. This shadowless light can be a blessing if it is filling the shadows cast by other, stronger lights. However, if it is the only light on the subject, it can be a curse since full frontal lighting tends to be flat and harsh.

Sun guns (actually a trade name that gained wide use) are often handheld and powered by battery. Even typical quartz spotlights can be used with 30-volt bulbs and powered with 30-volt battery packs or belts. Some packs run for less than 10 minutes. One belt may run about 50 minutes with a 150-watt bulb, or 20 minutes with a 250-watt bulb. Lights and power packs vary in capacity, and most require several hours to recharge. When the batteries run down, light intensity and color temperature drop.

When a scene is illuminated with only one light, it is difficult to make the lighting pleasant. With a handheld light, it is probably best to position the light a few feet to the side of the camera. The harsh shadows can be

FIG. 9-12. Cine 60 handheld light with case, charger, power belt and power pack. This is a 100-watt, 12-volt system. The 12-lb pack will run the light 29 minutes; the 20-lb belt will run it for 1.7 hours. (Cine 60)

FIG. 9-13. Lighting accessories. (i) French flag. (ii) Snoots. (iii) Full scrim and half scrim. (iv) Cookies. (v) Century stand with three gobo heads and flag. (vi) Hanger for mounting on pipes or small beams. (vii) Pole cat mounted in window well. (viii) Gator grip. (Representations are not drawn to same scale.)

softened with diffusion material although this does sacrifice brightness—but if you are shooting at close range this may not be a problem. Some people prefer to bounce the light of handheld units off the ceiling or a wall, producing a very diffuse lighting effect. To maintain constant illumination, these units must be held very steady. It is advantageous to have an assistant hold them.

Lighting Accessories

Spilled light, or just *spill,* is light usually from the edge of the beam that illuminates areas that are intended to be left dark. Spill is primarily controlled with *barndoors,* which are adjustable flaps that mount on the front of the lighting unit. Barndoors come in two- and four-leaf versions, the latter providing more control. They can be opened wide or closed down to produce a relatively narrow beam of light. A narrower beam can be made with a *snoot,* a cylindrical baffle that fits over a spotlight.

Flags, which are also called *cutters* or *gobos,* are either rectangular metal cards, dark cloth on wire frames or pieces of cardboard that are

usually mounted on stands or attached to walls to cut off unwanted spill. *French flags* are small metal cards attached to a flexible stem for easy positioning. These are often mounted on the camera as an effective lens shade to block light shining into the front of the lens.

There is often a need to flag off a light softly, creating a gradual transition from light to dark rather than having a hard shadow line. This may be done with a *net,* which is a piece of very thin, dark fabric that can be used in multiple layers for increased shadowing. Spill leaking from the back of a lighting unit can cause flare in the lens, or, if dichroic filters are being used, it can disrupt the lighting scheme with a light of the wrong color. This spill can usually be blocked off with cards or flags.

A *cucoloris* (usually called a *cookie* or *kook*) is a cutout piece of material placed in front of a light to cast a patterned shadow. Cookies are typically used to project the shadow of a window frame or Venetian blinds. By its color and angle, this simulation of window light can suggest a mood or indicate the time of day. Sometimes abstract, dappled patterns are used to break up uniform expanses of walls or floors or to create a transition zone between sunlit and shade areas. The shadow cast by any cookie or flag will be sharpest if it is placed closer to the subject than to the light and if the light source is hard.

Dimmers are used in home and theatrical lighting to regulate light intensity. Dimmers are used mostly for black-and-white filming since they lower the voltage, resulting in a lowering of color temperature as well, giving color film a reddish cast (see Location Lighting, p. 261). There are, however, certain situations where lowered color temperature may not be a problem (see Mixed Color Temperature Lighting, p. 258).

Scrims are circular wire mesh screens that can be placed in front of a lighting unit, usually inside the barndoors, to reduce the intensity without changing the color temperature or the quality of light. A *double scrim* reduces the intensity about twice as much. On a *half scrim*, half of the circle is left open. A half scrim can be used with a unit that is angled downward to dim the light falling near the unit without affecting the light directed farther away. With this technique an actor can move toward the light and remain in relatively constant illumination. "Scrim" also refers to a thin cloth used for diffusion.

Studio lighting is sometimes dimmed with *shutters,* which act like Venetian blinds. Of course, light intensity can be reduced simply by moving the unit farther from the subject.

Dichroic filters, sometimes called *dikes,* are a special blue glass filter used to raise the color temperature of 3200°K tungsten sources to about 5000°K or 5200°K to match the color of daylight. These usually transmit about 50 percent of the light, reducing intensity by about one stop. Dichroics often become less blue as they age, and older FAY units with dichroics sometimes need additional blue filtering. A large variety of filter material also comes in *gelatine,* or *gel,* form on large rolls that can be cut

and mounted on lights in *gel frames* or clothespinned to the barndoors. Gel filters can be purchased in *full, half* and *quarter* intensity versions, from deep color to pale, to make large or slight changes in color temperatures for precise matching of light sources. The full blue can be used to raise a 3200°K lighting unit to 5700°K. The deeper the color of the gel, the more it cuts down the light intensity; the deepest cuts out more light than a dichroic. Gels should be replaced when heat from the lamp causes the center of the gel to become paler. Gels and the more rigid *acrylic filters* are often attached to windows to filter daylight (see p. 258).

There are many devices available for supporting lights and mounting them on various surfaces. Lights are usually supported by *stands*, which are collapsible for transport. *Century stands* have low-slung legs at different heights that allow several stands to be positioned close together. *Gobo heads* with multiple locking arms can be positioned in endless

FIG. 9-14. Open spot light with attached gel frame. (Lowel-Light Manufacturing, Inc.)

ways. An *alligator,* or *gator, grip* is a spring-loaded clip for attaching lights to doors, pipes and moldings. A *polecat* acts like an expandable closet bar to create a lighting grid over the action so that no stands will show in the scene. These can also be positioned vertically from floor to ceiling. A *wall plate* for mounting fixtures can be screwed or taped to vertical or horizontal surfaces.

MOUNTING LIGHTS SAFELY. In close quarters a hot, falling light can do serious damage. Whenever possible, spread light stand legs wide for maximum stability. Tape down all light stands with gaffer's tape (a gray fabric tape sold in equipment houses) or weigh them down with sand or water bags. Tape all power cables neatly to the floor so that no one will trip on them. Use a liberal amount of good-quality gaffer's tape when you attach lights to a wall, and, if possible, place lights where they will not strike anyone if they fall. Remember that tape loses its stickiness when hot. Gaffer's tape will often remove paint and wallpaper, so peel the tape back slowly as soon as possible after filming to minimize damage.

FIG. 9-15. Lowel Tota-light location kit. Four 1000-watt (maximum) broads. Accessories include two-sided reflector, flags with flexible stems, door/wall brackets, clamps, gel frames and umbrella. Everything fits into the carrying case. (Lowel-Light Manufacturing, Inc.)

Lighting Technique

Lighting Styles

Before beginning any film that involves controlled lighting, choices should be made on the lighting style you hope to achieve. The cinematographer and director can look at films, photographs and paintings. In documentary films, flat bounce lighting is used sometimes to ensure that the entire filming space is sufficiently bright and to allow the camera and subject to move without the lights being repositioned. The fact that a location looks deliberately lit rather than naturally lit may be of little concern or perhaps defended on the grounds that this is "truer" to the reality of filmmaking. The black-and-white fiction films of the 1930s look lit in a different and highly stylized way. These films were usually made on sets with scores of lights that bathed the actors from lighting grids above and around the sets—places where lights could never be located in a normal building interior. In many feature films today, the prevailing lighting aesthetic is naturalism. Although many lights may be used, the intent is to *simulate* the light that might occur under normal conditions in the filming space.

The essence of naturalism in lighting is to ensure that the prevalent light on the location is "motivated," that is, seeming to come from a logical source. Window light is a good example of a motivating source. Often a few household fixtures are placed in a scene as *practicals,* either to actually supply light or to act as motivation for light from professional lighting units.

The quality of fast lenses and film stocks has improved and it has become increasingly feasible to shoot film indoors entirely in *available light,* without bringing in any special lighting equipment. Feature filmmakers sometimes restrict themselves to available light in a scene to achieve a feeling of realism or perhaps to simulate a "documentary look." For the documentary filmmaker, especially those making unscripted films, the decision of whether to use available light can be fundamental to the film. Since unscripted documentaries often involve intimate filming of family life, personal experiences and similar situations, there is usually a great premium on minimizing the disruption caused by the film crew. Bright lights can create an "on-the-set" feeling, and people under the lights often feel like they should perform. Also, since it is difficult to light an entire house or location, the use of lighting transforms some areas into filming spaces while others remain living space. All of this disrupts the natural flow of life that the filmmaker may hope to capture.

Although some filmmakers argue that lights do not add significantly to the distraction caused by a film crew's presence, especially in scenes that are inherently public, there is no question that the reliance on bright lights detracts from a crew's mobility. Filmmakers who work primarily with available light have more freedom, carrying perhaps a few photofloods or screw-in quartz lights in case they need to film in very dark interiors. However, the use of larger lighting units may sometimes be needed at night or for large interiors.

A Basic Lighting Setup

An effective lighting setup for a simple subject can be done with three lights: the *key, fill* and *backlight*. Each light has a particular function. In a complex lighting design, many units may be used to provide the same three-point lighting over a broader area.

KEY LIGHT. The key is the brightest light and casts the primary shadows, giving a sense of directionality to the lighting. Traditionally, hard

FIG. 9-16. A basic lighting setup. Fill light (at left) is close to camera. Key light is higher and more offset. Backlight is usually quite high. Lighting should be judged by eye and not done by formula.

lighting units like a spotlight (in either spot or flood position) are used for the key. The light is frequently softened, however, with diffusion material. The shadows cast by the key provide modeling of the face. The light is usually placed somewhat off the camera-to-subject axis, high enough up so that the shadow of the subject's nose does not fall across the cheek but downward instead. This height helps ensure that body shadows will fall on the floor and not on nearby walls where they may be distracting.

FILL LIGHT. The main function of the fill light is to fill in the shadows produced by the key without casting distinct shadows of its own. Fill lighting is almost always softer than the key; it is usually achieved with a soft light fixture or a bounced spotlight. If the fill light is placed near to and at the same level as the camera, its shadows will not be visible on film. The fill is normally not placed on the same side of the camera as the key. Sometimes light is bounced off the wall or ceiling to provide flat, even fill over a broad area.

BACKLIGHT. Backlights, sometimes called *hair, rim* or *edge lights,* are placed on the opposite side of the subject from the camera, high enough to be out of view. Backlight should be fairly specular, or hard, to produce highlights on the subject's hair. If a backlight is at about the same level as the subject and somewhat off to the side, it is called a *kicker.* Kickers illuminate the shoulders more than hair lights do. All backlights function to outline the subject brightly, defining the subject's shape while separating it visually from the background. The contemporary lighting style for color film calls for subtle, not pronounced backlight in most situations.

SET LIGHT. A fourth basic light, the *set light,* may be used to illuminate the background. Usually the background is partly lit by the key and fill lights, as well as by several set lights.

Lighting Faces

In medium and close shots that include people, the lighting on faces is extremely important. Although facial lighting depends on the overall lighting of the location or the set, the general lighting scheme is often designed around providing proper light on faces.

Start by positioning the key light alone, paying close attention to the shadows of the nose and eye sockets on the face. In television and documentary interviews, it is common practice to eliminate these shadows almost entirely. To achieve this, the key is placed frontally—that is, near the camera and on the side to which the subject is looking. If the key is moved farther off to the side, especially if the side is opposite the one to which the subject is looking, the shadows from the nose and the side of

FIG. 9-17. Frontal facial lighting. Key is slightly offset to provide some modeling. Nose shadow falls near the "smile line" from the side of the nose to the corner of the mouth. Though the lighting is fairly flat, the background is dimly lit, and thus provides strong contrast with the foreground figure. (*Portrait of Jacques Louis Leblanc* by Ingres, The Metropolitan Museum of Art, Purchase, Wolfe Fund, 1918)

the face provide more interesting modeling. A rule of thumb is to position the key so that the nose shadow falls along the line from the side of the nose to the corner of the mouth. Normally, the key should be placed frontally and low enough so that this shadow does not extend all the way down to the mouth (see Fig. 9-17). More dramatic effects can be achieved by moving the key even farther to the side. If the subject is positioned so that he is not looking toward the camera and the key light is placed on the far side of his face, the subject will be rim-lit with strong shadows falling across his face (see Fig. 9-18). This kind of look is well suited to nighttime scenes where only one or two light sources are visible in the scene.

Facial shadows can be made less harsh and distinct by using a soft light or a bounced spotlight or floodlight as the key. Many people like the gentle look this gives. When Hollywood cinematographers use soft frontal keys for lighting women, nets are often used to shade the forehead and mouth subtly, giving some sense of dimensionality. Diffused lights do not "throw" as far as specular ones and need to be placed closer to the subject to produce sufficient illumination.

After the key has been placed, the fill light should be added. Put this light close enough to the camera so that it does not create a second set of distinct shadows. You must pay attention to the intensity of the fill relative to the key, for this will determine lighting contrast (see p. 255).

FIG. 9-18. Side facial lighting. Key light positioned on far side of subject produces a rim of light on the nose and brings out skin texture. Virtually no fill light in scene produces a low-key dramatic look, which could be used for a nighttime scene. (*Portrait of Martin Baer* by Johan Hagemeyer, The Metropolitan Museum of Art, Gift of The Estate of Johan Hagemeyer, 1962)

Backlights should be placed high enough to avoid flare and angled down so that they do not strike the tip of the subject's nose. If it casts a visible shadow forward in front of the subject, flag the light with the barndoors or a gobo. Since backlighting can easily have a theatrical, artificial look in some scenes, it should be used sparingly.

Feature filmmakers often use a low-powered *eye light* to produce a lively reflection in the subject's eye, making the subject appear alert or alluring. A bright reflection from a light is variously called a *catchlight, glint* or *kick*. An eye light should be flagged off with a snoot or a net to prevent it from covering the face with flat fill. Sometimes a *clothes light* is used to bring out particularly dark or absorptive clothing. Like the eye light, this should be selectively and not broadly aimed.

Lighting of faces can be individually tailored. Large facial features can be played down with more frontal lighting or by turning the face toward or away from the camera. Specular light will accentuate skin defects and makeup more than soft light. In fiction filming, makeup is usually applied to all actors. A light brushing of translucent face powder, which is itself invisible, cuts down glare from the skin and should be reapplied regularly. Waterproof mascara is often used for the eyes of both actors and actresses so that facial expressions will read better on film.

Long Shots versus Close-ups

It is usually more difficult to light long shots than close-ups because of the greater area to be covered and the problem of hiding lights and light stands. Long shots should be lit to establish mood and to cover the actors' blocking (movements). Proper facial lighting is a lower priority. Keep in mind that the eye is naturally drawn to light areas of the frame. Thus, the area in which the actors move is normally lit slightly brighter than the background or extreme foreground. Flags or nets can be used to diminish the light falling on unimportant areas such as broad expanses of wall. Much of the mood of the shot is established by the relation between the brighter action area and the darker background. Try to maintain this balance when you change camera position or lighting.

When you light any scene, it is usually more interesting to have pools of light and areas that are relatively dark than to have flat, even illumination throughout the frame. This distribution will also create a greater feeling of depth; a corridor, for example, seems longer if bright and dark areas alternate. Use fill light to provide illumination between the brighter areas. If a flat effect is desired (to cover unpredictable movement perhaps), keep lights a good distance away from moving actors.

For a naturalistic look, every location needs to be examined for appropriate "motivating" sources for the lighting. Most daytime scenes include light coming through a window. Actual window light can often be used,

but it must sometimes be simulated because it changes during the course of filming. If the window itself is not visible, this may be done by bouncing light off a large white card for an overcast or "north light" look or by using a group of focused spotlights to simulate sunlight streaming in. If the window is visible, put the lights outside; in place of bounced light, use diffused flood lights for the overcast effect to get sufficient brightness. For color film, when tungsten units are used to simulate the look of overcast light or indirect sunlight, they are sometimes fitted with quarter blue gel material to raise their color temperature slightly relative to interior tungsten sources (see p. 258). If tungsten light is mixed with actual window light, some filtering must be done (see p. 258).

In some scenes, practical household fixtures with photofloods can be used for significant illumination. However, their use may be undesirable because very bright bulbs may melt fixtures or cause them to be drastically overexposed on film. Also, if the subject is near the light, falloff will be significant and the lighting will seem very uneven, especially if the

FIG. 9-19. Cross lighting. Each spotlight keys one subject and back lights the other. Lights are used in part to simulate practical illumination from the table lamp and are thus flagged off of it. Fill light is placed near the camera.

subject moves around a great deal. Filmmakers often prefer to simulate the illumination from a practical with a spotlight or floodlight. If you do this, make sure the additional light is flagged off so it does not shine *on* the practical and cast a shadow—a dead giveaway. To look natural, the lampshade of the practical should read about two to three stops brighter than the faces of nearby actors. This varies, of course, with the type of shade and fixture. It is often necessary to place neutral density gel or diffusion material inside a practical to cut down the brightness of its lamp shade or its spill.

Frequently, one light can be used to accomplish several functions. If two people are conversing across a table, a light can key one person while it is backlighting the other. This is called *cross lighting* (see Fig. 9-19). When an actor moves through his blocking, a given light may change from a key light to a backlight.

Try to avoid shooting multiple sharp shadows cast by several lights. This may require keeping actors away from walls, placing them against dark rather than light walls, positioning furniture or props to break up the shadows or heavily diffusing secondary lights. Moving a light closer to a person will diffuse the shadow he casts.

Bright, shiny surfaces in the frame attract the eye and are usually undesirable. Glints or kicks can be diminished by repositioning a shiny object or by applying washable dulling spray or even soap. Sometimes raising or lowering the camera a few inches will do the trick. Reflections from smooth, non-metal surfaces such as plastic, glass and water can be reduced by putting a polarizer filter on the camera. You can often reduce reflections further by putting a polarizing filter on the light source as well. Avoid shooting glass or mirrors that will pick up the lights or the camera. If it is necessary to film against white walls, take care not to over light them. Usually, broad expanses of wall are broken up with pictures or furniture.

When a scene is to be filmed with both long shots and medium or close-up shots, it is typical to determine the blocking, set the lighting and shoot the long shots first. Then, as the camera is positioned closer to the subject, the lights can be "cheated," or moved, to maintain the general sense of the long shot while providing more desirable facial modeling. Close-ups are usually lit with slightly lower contrast lighting than long shots are so that facial detail will be clear. When the camera angle changes significantly, many changes can be made in the lighting without the audience noticing.

Often Polaroid pictures are taken to see how a lighting design will look on film (although the motion picture film may respond differently) and to aid in relighting in case the scene needs to be reshot. (Polaroids are also very helpful for continuity purposes to record how props were arranged and how actors were dressed.)

Before you roll film, scrutinize the frame to make sure no light stands

or cables are visible. Be sure no lights are producing flare in the lens; flag off those that do. Rehearse the shot to check that movements of the crew and especially the microphone boom do not produce visible shadows.

Setting Lighting Contrast

Because film has a limited exposure range, filmmakers must pay close attention to *lighting contrast* (see Lighting Contrast, above). To the eye, scenes always have less contrast than they do on film. On film, shadows often become black and without detail and bright highlights easily over-expose and are rendered as featureless white areas.

The *lighting contrast ratio* is a numerical representation of lighting contrast. It is the ratio of key plus fill lights to fill light alone (K + F : F). For a typical close-up, the lighting contrast is measured by reading the light on the bright side of the face, which comes from both the key and fill lights, and comparing it to the light in the facial shadows, which comes from the fill light alone. The measurements are most easily taken with an incident light meter, blocking or turning off the key light(s) to take the second reading. Some filmmakers prefer to use the incident meter's flat-disc diffuser when doing this to make it easier to read the illumination coming from individual sources.

If the bright side of the face is one stop lighter than the facial shadow, the ratio is 2:1. Two stops would be 4:1; three stops, 8:1. To the eye, 2:1 and 3:1 look quite flat, but this lighting contrast is considered normal by Kodak. This is a conservative standard. Kodak recommends that contrasts of 4:1 or higher be used for special lighting effects only, but it is common for filmmakers to work with these contrast levels. Low-key scenes, nighttime effects and many outdoor sunlit scenes are shot at ratios higher than 4:1. You should use lighting contrast to create the mood and look that you want. If you choose a high lighting contrast ratio, bear in mind that you may lose detail in shadow or highlight areas, depending on the film stock and exposure.

If the contrast seems too high, the fill light can be moved closer to the subject or a brighter unit can be used. Alternately, the key light could be dimmed with a scrim or moved back, but this may disrupt other elements in the lighting scheme. Lighting contrast should be evaluated with respect to *all* parts of the frame, not just the light and shadow on faces. Thus, if the background is in deep shadow, it may need additional light to keep the overall contrast down. Most filmmakers do not work with precisely calculated lighting contrast ratios. Instead, they may check the ratio with a light meter, but work mostly by eye, using their experience with a particular film stock and perhaps using a contrast viewing glass (see below).

Along with the lighting contrast ratio, which is a measure of the inci-

dent falling *on* various parts of the subject, the filmmaker is concerned with the *brightness range (luminance range)* in the scene, which is a measure of how much light is actually *reflected by* various parts of the subject (see Chapter 5). The brightness range can be determined with a reflected light meter by taking readings of brightly lit reflective areas (light-colored objects near a lamp, for example) and dark, absorptive areas (textured surfaces in shadows).

If the subject brightness range is great and exceeds the film's ability to handle it, the darkest, most absorptive areas or the brightest, most reflective areas may be rendered without detail. The useful exposure range of color negative stocks is about seven stops. Most color reversal stocks are more contrasty, having a range of about five or six stops.

Some areas of the frame usually fall outside the film's exposure range and are rendered without detail. If these are areas you wish to show with detail, you can take various steps to lessen the brightness range of the scene. This can be done by lowering the overall lighting contrast, using additional lights to boost the exposure of selected dark areas, diminishing the light on bright areas with a flag or net, or by redecorating the set. Often actors are asked not to wear very bright or very dark clothing, high-contrast props are replaced or set walls are repainted in medium shades. In general, it is less disturbing if some areas of the frame are underexposed than if large or important areas are significantly overexposed.

LIGHTING CONTRAST IN DAYLIGHT. In normal, sunny conditions outdoors, direct sunlight acts as the key light; skylight and, to a lesser extent, reflections from buildings, objects and clothing act as fill. On a bright day, the lighting contrast ratio may be too great for the film, making shadows deep and harsh. Typically, dark eye sockets on faces and deep shade areas under trees cause the most problems. Reflectors or, if large areas are involved, daylight-balanced lighting units can be used to fill shadows. In some situations, shadows can be softened more naturally by using dark silks or diffusion material to diminish the direct sunlight. A *butterfly* is a large frame on a stand that can be placed over the action to hold some type of diffusion material. Butterflies must be used with care so that the shadow of the frame does not show in the shot nor does the brightly (and more harshly) lit background. They must be held down securely when the wind blows. If sunlight is diffused in this way, it is easier to maintain consistency in the light over a day's shooting, since the material can be removed if a light cloud passes.

When you film in cars or near windows, lighting contrast can be extremely high between the shaded foreground interior and the brightly lit exterior. The filmmaker might choose to add light to the interior or put neutral density gel on the windows. Without these steps a compromise exposure is normally used (see Chapter 5, Backlight).

CONTRAST VIEWING GLASSES. Some professionals set their lighting with the use of *contrast viewing glasses,* which are smoked glass monocles that cause the scene to appear to have higher contrast, more like the way it will appear on film. These glasses must be held to the eye only briefly since the eye gradually adjusts, lowering the apparent contrast. To use contrast glasses properly, you need experience viewing scenes and then seeing them rendered on film. Different glasses are used for black-and-white and color film.

Color Contrast

Differences in color between various objects, or their *color contrast,* help us to distinguish them and to determine their position in space. On black-and-white film, a red bug and a green leaf may be indistinguishable because their tonal values are the same (they reflect the same amount of light). Thus, when filming in black-and-white it is usually necessary to use slightly higher lighting contrast than you would with color film and to make sure that there is adequate shading and backlighting to differentiate various objects from each other. It is also possible to use contrast filters to separate tonally similar areas (see Chapter 4).

Color contrast is also important when filming in color because the shades and intensities of colors in the frame play a large part in setting the mood of a scene. Color scheme is best controlled in wardrobe planning, set design and choice of film stocks (for example, fast color reversal stocks tend toward snappy, saturated color rendition; a stock like Kodak's Ektachrome Commercial is much more pastel). To produce pastel, desaturated colors with high-contrast stock, diffusion or low-contrast filters can be used on the lens and the scene illuminated with low contrast and diffuse lighting. Underexposure and overexposure also affect color saturation (see Chapter 5).

Lighting and Exposure

When setting lights, the question arises: How brightly should a scene be lit? Many cinematographers work at a given *f*-stop consistently throughout a film, which helps them judge lighting setups by eye. Lens sharpness, more of a concern in super 8 and 16mm, can be maximized by shooting at apertures two or three stops closed down from wide open (on an *f*/2 lens, between approximately *f*/4 and *f*/5.6). Higher or lower *f*-stops may be used to increase or decrease depth of field. As a rule, the discomfort of both crew and actors, or documentary subjects, rises with the number of footcandles.

Mixed Color Temperature Lighting

With the proper filters, color films can be shot in either daylight or tungsten light. No color film, however, can be shot with *both* daylight and tungsten light sources without rendering the former blue or the latter yellow-red relative to the other. This problem typically arises when window light illuminates an interior scene, but is insufficient for proper exposure. If you use film balanced for 3200°K tungsten light and augment the illumination with tungsten light, the window light will look blue on film.

There are a number of ways to deal with this problem. One possibility is to put dichroic filters or blue gel on the lights so that all the illumination will be balanced for daylight. However, the filters on the lights reduce light intensity by half, or more, and the 85 camera filter, which is necessary for tungsten-balanced film, cuts intensity almost as much again. This may not leave enough light for exposure. If all the light is blue filtered, the use of daylight-balanced film is advantageous—with reversal films it saves about a stop.

Another solution is to filter the window light with gel or acrylic sheets. Gel comes in large rolls and is easy to transport, but it must be taped to the windows carefully or it will show in shots that include the windows. Also, it creases easily and will reflect the lights if mounted sloppily. Acrylic sheets are inconvenient to carry, but they are good for mounting outside the window where they will not show. They are also optically sharper for shots that involve shooting *through* the window. Both gel and acrylic come in various colors, in several intensities (see Lighting Accessories, above), in neutral density shades and in combination color–neutral density (for example, 85 N6) versions that can be extremely useful for dimming overly bright windows.

If the windows are filtered with full 85 gels or acrylic, the incoming daylight will approximately match tungsten's color temperature and additional tungsten lights can be used without problems. By using only a half 85 gel, which is paler and allows the light to look slightly blue, less window light is lost. In feature filmmaking it is becoming increasingly popular to generally let window light look slightly blue, especially if warmer tungsten practicals are visible in the shot. This allows *some* of the natural color difference between daylight and tungsten to be preserved.

If daylight predominates in a scene, it is often necessary to augment the unfiltered daylight with daylight-balanced artificial light (and then use an 85 filter on the camera for tungsten-balanced film). Since so much light is lost by putting blue filters on tungsten lights, you may need more

efficient daylight-balanced HMI's or carbon arcs, or FAY units for large areas.

If window light is insignificant in a scene, it is frequently easiest to block the daylight out altogether (using curtains or show cards) and then light with tungsten.

Fluorescent light mixed with daylight or tungsten sources requires filtration. Fluorescent light can be thought of as daylight with a green spectral element. Thus, window light can be filtered with Rosco's Windowgreen to match "cool white" or "daylight" fluorescents better; HMI's can be filtered with Tough Plusgreen and tungsten sources can be filtered with Tough Plusgreen 50.

Alternatively, the fluorescent tubes themselves can be filtered with Minusgreen to match daylight better or Fluorfilter to convert to 3200°K tungsten. If filtration is not possible, fluorescent lighting fixtures, such as the Molescent unit by Mole, can be brought in for additional light. Mixing fluorescent light with other sources and mixing various types of fluorescent tubes can be risky without checking the light with a three-color color temperature meter. Many problems can be avoided by simply replacing tubes in fluorescent fixtures with 3200°K *Optima 32* tubes or 5000°K *Chroma 50* tubes available at rental houses.

Special Lighting Effects

NIGHT-FOR-NIGHT. Often filming outdoors at night is impossible without supplementary lighting, although with the new, faster film stocks and lenses it is sometimes possible to shoot on city streets using existing street and building lights. If lights are to be used to simulate a nighttime effect (that is, the flood of moonlight or perhaps street light), use hard lighting units in an extremely high contrast, low-key lighting scheme. Lights should be used to produce sharp highlights or rim lighting with very little fill. Shadows should be crisp and not diffused. Create pools of light—not flat, even illumination.

There is a convention that moonlight should be represented with blue-gelled lights. This effect should not be overdone. Some filmmakers like to wet down streets and surfaces at night so that they reflect highlights.

Since night scenes can require many lights, especially if you are shooting wide shots, it is often better to shoot at the "magic hour," just before sunrise or just after sunset when there is enough light to get exposure on buildings and the landscape but it is sufficiently dark so that car headlights and interior lights show up clearly. Although beautiful, the magic hour is fleeting, often lasting only about 20 minutes, depending on the time of year and geographic location. It is necessary, therefore, to rehearse and be ready to go as soon as the light fades. It helps to have some supplementary light on hand for additional fill in the waning moments and

for shooting close-ups when it gets darker. When you shoot magic hour scenes with tungsten-balanced color film, a #85 filter should not be used. In general, avoid shooting the sky during the magic hour because it will photograph too bright.

DAY-FOR-NIGHT. Hollywood filmmakers sometimes shoot night scenes during the day, using filters and underexposure to simulate a night effect (the French call this "American night"). *Day-for-night* often looks fake and is best suited to black-and-white filming where a red or yellow filter can be used to darken a blue sky (see Chapter 4). In color filming, a *grad,* or graduated neutral density filter can be used. Ironically, day-for-night works best on bright, sunny days. Shoot early or late in the day when distinct sidelight or backlight casts long shadows. Avoid shooting the sky and use intense lights in windows to make interior lights look bright relative to the exterior. The film should be underexposed two or three stops while shooting (*after* making the normal compensations for any filters). Do not rely on printing down a normally exposed negative.

RAIN, SMOKE AND FIRE. Rain, smoke and fog should always be lit from behind in order to read on film. Aim the lighting units as close to the camera as possible but flag them off so that no light shines directly in the lens and causes flare.

Sometimes fire light is simulated with an amber gel placed over the light and strips of paper or cloth suspended from a horizontal bar and jiggled in front of the light. For candlelight effects, keep other sources dim so the candle looks bright and use a double-wicked candle for more intensity. Tiny light bulbs are often hidden in fake candle sticks and "flickered" with a dimmer to simulate candlelight. Extra bright bulbs plugged into household current are sometimes run in flashlights and simulated oil lanterns to get sufficient intensity.

Shooting Film for Video Transfer

The useful exposure range of video is even more limited than that of film. When film is transferred to videotape, the brightest and darkest areas that show detail on film become washed out or lack detail. Thus, it is of utmost importance when shooting film intended for video transfer to maintain low contrast in the lighting (ratios of 2:1 to 3:1), as well as in the set design and in the composition of each shot. Important areas of detail should all read within a four-to-five-stop range with a reflected light meter.

Avoid shooting scenes that are backlit or that take place against a light background, since these scenes will look silhouetted on many television sets. Avoid having broad, uniform expanses in the frame, such as plain

walls, especially if they are dark, since this will bring out video "noise" and imperfections in the signal.

Bear in mind that video has much less resolution than film, so fine detail will be lost. Close-up and medium shots are much more common than long shots on television because they are clear and easy to read. Use bold differences in color and contrast rather than subtle detail when composing the frame. Art direction and the choice of props can also be kept simpler.

Since television screens cut off the edges of the film frame, avoid composing shots where significant action takes place at the edges of the frame, especially if the center is empty. A typical problem shot is that of two people at a table, conversing in profile, each on opposite sides of the frame. (See Fig. 13-7 for the television *safe action* frame.) Absolutely essential information, such as titles, should be within the television *safe title area*, which is even smaller.

Have at least a small area of bright white (*white reference*), no more than 1½ stops brighter than a Caucasian face, in each shot to aid technicians in setting the proper video level. If possible, before you begin shooting check with the video transfer facility on the capabilities of the transfer device you plan to use; some allow for shot-by-shot adjustment of color and contrast while others do not (see Chapter 15). When you submit a film for television broadcast, keep in mind that television engineers have rigid standards for contrast and exposure of broadcast material. They may try to reject footage that you think looks fine.

Location Lighting

The Location

Whenever possible, scout locations prior to filming to assess lighting needs, the availability of electric power and to formulate a plan for shooting. When you go to check a possible interior location, bring a light meter and try to estimate the natural illumination at various times of day and in varying weather conditions. Bring a camera or a director's finder to block out actors' movements and camera angles. Examine interiors for available space for equipment and crew, the number of windows to be gelled and the need for sound blankets to dampen excessive noise or reverberation. A cramped location will help you appreciate why films are often made on sets with high ceilings and overhead lighting grids and where each room has three walls that are often movable to allow the crew plenty of work space. Film crews on location often break furniture and mar walls with lighting gear. You can save a lot of time by coming prepared with paint and repair supplies.

Electric Power

Lights for movie making consume a great deal of electric current. It is important to determine if there is sufficient electricity for your needs; otherwise, fuses may blow or a fire could erupt during filming.

To estimate your power needs, use the formula: volts × amps = watts. You will want to find the number of amps required by a given light because this is what overloads circuits and causes fuses to blow when too many lights are put on one circuit. Standard household current in the U.S. is delivered at about 110 volts which can be rounded off here to 100. Every lamp is rated by the number of watts it consumes. In the home, a 75-watt bulb is typical, while, for filming, 1000 watts is more common. If you simply read the bulb's wattage and divide by 100, you get the number of amps the lamp requires (this formula includes a safety margin). A typical home fuse can handle 15 (or 20) amps, which is thus enough to run three (or four) 500-watt bulbs. Any more power drain will blow the fuse.

To determine how much power is available at the location, examine the fuse box. Count how many circuits (fuses) there are and the maximum amperage of each one (amps are indicated with a number followed by "A"). Circuit breakers, which can be reset by flipping a switch when they are tripped, are found in some houses. Keep a few spare fuses in your lighting kit. Never replace a fuse with one of higher amperage since the fuse is designed to blow before the wiring in the wall catches fire.

To find out which wall outlets belong to which circuits, plug lights into all of them, unscrew one fuse at a time from the fuse box and see which lights go out. Extension cables can often be run to distant outlets to distribute the load. Do not use thin, home extension cords as they increase the load and may melt.

When too many lights or overly long cables are used, the voltage may drop (the equivalent to summertime brownouts), which lowers the color temperature of the lights. A 10-volt drop in supply lowers tungsten lights about 100°K. If there is no window light and all light sources are on the same supply, the lab can correct slight color changes in printing. To get around this and other typical problems of location power supplies, professionals usually "tie in" to the electric supply as it enters the house and use their own set of circuit breakers. This should only be done by a licensed electrician.

In outdoor locations, generators or sets of car batteries can be used for power. Silent generators, sometimes mounted in trucks, are often used for film work. Ten 12-volt car batteries wired in series (see Chapter

2) can run regular tungsten lights at normal color temperature. As the batteries weaken, the color temperature and light output drop.

OUTSIDE THE UNITED STATES. Household power in the U.S. is supplied at 110 to 120 volts. It is alternating current (AC), that is, it pulsates back and forth; it does so sixty times a second (60 Hz). In many European countries, power is supplied at 220 to 240 volts, alternating at a frequency of 50 Hz. In some countries, the current is direct (DC) and does not pulsate at all.

Most AC equipment works equally well at frequencies of 50 or 60 Hz. However, clocks, sound resolvers, some battery chargers and AC camera motors will not run properly if the frequency of the current is incorrect. Tungsten lights work fine with either system, but AC discharge lamps, including HMI's and fluorescents, may be incompatible with the camera speed or shutter (see HMI Bulbs, above). Outlets found outside the U.S. have a different kind of plug that is usually two or three round pins or angled blades for which adaptors or new plugs must be purchased.

Virtually all equipment should only be used with the proper voltage. Tungsten fixtures can be converted by using a different set of bulbs. Some equipment may have a switch to select 110 or 220 volt use. Other equipment requires a voltage changing device, of which there are two types. The *transformer* is relatively heavy for the amount of power (wattage) it can handle. It can be used with any equipment, but should not be overloaded. Transformers do not affect the frequency of the current. *Diode-type voltage changers* are extremely light (usually, a few ounces) and, for their size, can handle much more power than can transformers. They should only be used for lights. Since these work by converting AC current to DC, they should not be used with anything that is frequency dependent. Check with a technician on the requirements of your equipment.

10

The Laboratory During Production

This chapter is primarily concerned with the laboratory during pre-production and production—the handling and processing of camera original and the making of workprint. See Chapter 14 for post-production laboratory services and optical effects.

Dealing with the laboratory is, at times, the most difficult and frustrating technical aspect of filmmaking. To avoid the usual lab problems, know what instructions the lab needs, what can be reasonably expected of the lab and how to evaluate their work. Although laboratories sometimes do careless work and make errors, their number of errors seldom equals that made by filmmakers. Filmmakers tend to blame all technical photographic faults on the laboratory, and it is a rare lab that will admit that *it* has made an error.

Choosing a Lab

Many professional filmmakers continually change labs throughout their filming career. Recommendations of labs will vary from person to person; for any single lab, someone will tell you it is the best while someone else will tell you it is totally incompetent. You are forced, therefore, to experiment to find the lab that is best suited to your needs.

As labs are places of business, a good one should observe good business practices. Labs have been known to overcharge, promise impossible delivery times and indulge in other bad practices.

Labs vary greatly in their services. They may do machine edge-coding, optical effects, conform original and perform various sound services. A lab may sell raw stock (usually at a small surcharge over the manufacturer's price) and may spool footage down for you. One lab may specialize in reversal work, another in 16mm and 35mm color negative. If you choose a lab specializing in the film stocks you are using, the price is likely to be lower and the work quality better. Since the volume of black-

264

and-white processing has fallen off, it is easier to get satisfactory work done in color than in black-and-white. Some labs are particularly good in handling the problems of inexperienced filmmakers.

If you are lucky enough to find a satisfactory lab in the city in which you are filming, service will probably be better since there is no need to ship film (thereby avoiding both shipping costs and risks) and person-to-person exchanges often make things go more smoothly. Nevertheless, many filmmakers ship their footage to another city, often to New York or Los Angeles, where they feel a particular lab can do superior work. Some labs are better equipped to handle out-of-town filmmakers.

You should ask the lab what service you can expect given the amount of footage you will process, the number of release prints you want and the schedule you are working on. If your work needs a lot of special handling and you will consult the lab often, you may be better off with a small lab. If you are shooting on location, find out how thorough the lab will be in its lab report. Look through the lab catalogue. Do they have surcharges for rush work? Are there minimum footage charges? Pushing? Catalogue prices are often negotiable, but only *before* the work is done.

To deal effectively with a lab, find out whom to contact if problems arise. At medium to large labs, it is best to have one lab person route your work through the various departments. Some labs have *expeditors* to oversee particular productions. At very large labs, there may be expeditors who are independent contractors who can be hired for about a 10-to 15-percent surcharge on the lab bill. They often know when the best lab workers and timers are on duty and personally oversee your work. Large labs often have different people to handle original processing, dailies, answer prints, release prints, credit, scheduling, technical questions, shipping and customer services. In a small lab, these services may be handled by two or three people.

If you are shooting in color, make sure the lab uses additive rather than subtractive color printers (see Chapter 14). Some labs process specialty stocks. For example, Gevachrome 9.03 is preferred by many filmmakers for color reversal printing since it has low contrast and takes a decent optical sound track.

If you do not have a cool, safe place with low humidity to store the original, have the lab store it until it is conformed. Find out if the lab charges for this service, and get a tour of the lab's *vaults*—a romantic name for what is often a chaotic, dusty room on the 12th floor. There are also warehouses that specialize in film storage where film can be stored in temperature and humidity-controlled spaces for an additional charge.

Business Arrangements

Try to arrange for credit at the lab. Since filmmakers are notorious for being bad credit risks, you may encounter problems until you establish a

clean track record. Usually the credit terms are net (the full amount) within 30 days. Labs will, at times, defer payment until a film is completed and may waive an interest charge on unpaid balances.

If you cannot establish credit at a particular lab, you may want to find a lab with a more lenient credit policy. If you obtain no credit, you must pay COD or in advance. Advance payment avoids the inconvenience of getting personal checks cashed and may expedite the return of dailies. If you do not have lab credit and must pay for the work before you see it, you lose an important negotiating position should you feel the lab has made an error and the work should be redone. An outstanding balance increases your leverage in negotiations.

As mentioned above, some labs will discount their catalogue prices or not charge extra for services like pushing or making exposure tests. Make sure you settle these questions during preproduction. Some labs offer student filmmakers and independent filmmakers discounts of 10 to 15 percent.

Processing the Original

Processing Super 8

A great deal of super 8 processing is done through the mail. When processing fees are included in the price of the raw stock, the total cost is usually less. However, this restricts you to a particular processor, and should you discard the cartridge for any reason, you still pay for processing. The quality of mail-order processing is variable. Processing by the film manufacturer is generally safe but more expensive. Other than that, you have to seek advice and experiment. Some labs that process 16mm and 35mm film also process super 8. They usually charge more than mail-order processors but offer more diverse services, although not necessarily better quality. If you opt for this route, most of the discussion below applies to you and the use of super 8.

Processing Original at the Lab

You should deliver the film to the lab as soon as possible after it is exposed. Pack core-wound film in its black bag and tape down the end so the film does not unravel in transit. Tape the edge of the can (see Chapter 4). It is preferable to use the original raw stock can to avoid confusion.

Prominently mark "Exposed" on the can, so no one mistakes it for unexposed stock (sometimes tape is placed crosswise on the can to mark exposed stock). If the original label is not on the can, note the type of stock on the outside. If the film was exposed normally, mark "process

normal." Alternately, some filmmakers mark the ASA number that was used to calculate exposure. This sometimes leads to confusion since the exposure index differs for different color temperatures of light (for example, 4-X Reversal is ASA 400 in daylight and 320 in tungsten). When pushing, note how many stops (for example, "push one stop"). Include any special instructions. For example, if a daylight spool was unloaded in the dark to preserve a run-out shot, mark "only open in the dark" on the can. A complete list of instructions for the lab is given below.

SPECIAL PROCESSING INSTRUCTIONS. In tricky lighting situations, you can make a test to determine if any compensation need be made in processing. Sometimes, for convenience, the exposure test footage is included on the same roll as other footage. Make sure the test section is representative of the whole roll. The test can be at the beginning of a roll (*head test*) or at the end (*end test* or *tail test*). Tail tests are preferable, since they avoid the need to rewind the film and are easier to find (there is no standard amount of threading leader at the head). End tests are generally 10 to 15' long. Clearly identify the test footage on the can (for example, "end test 15'''"). The lab processes the test according to your directions and then it is viewed by lab personnel or the filmmaker. After consultation, the whole roll is processed according to the results of the test.

If the film is to be postflashed (see Chapter 4), mark it on the can. Make arrangements beforehand to ensure that the lab provides this service and to determine the amount of flashing required. An end test can be used to determine whether postflashing is needed.

The Lab During Preproduction

After you have selected a laboratory, make tests before you begin production. Tests are sometimes made of camera, sets, actors *(screen tests)*, costumes and makeup, but what is of greatest concern here are tests of film stock, processing and flashing. For testing, use lighting and locations similar to that used in the final production. Print the tests in the same way you will make the release prints (see Chapter 14). Reviewing tests at the workprint stage often gives misleading results, especially in 16mm and with reversal stocks.

The Workprint

On most productions, camera original is considered too valuable to use for editing; therefore *workprint*, or *editing copy*, is struck from the cam-

era original. The edited workprint is used to conform the camera original (see Chapter l3).

If the budget for production is low, some filmmakers do some or all of their editing with original. This is best done with reversal stocks, both because the image is positive and because most reversal stocks are fairly tough and will not scratch as easily as negative stocks. Negative stocks may be transferred to video, their image electronically made positive and the video tape used for determining what shots should be made into workprint. A video "workprint" can also be made (see Chapter 11).

The workprint is called the *rushes,* or *dailies,* because the lab turns them out quickly. A day's filming is usually viewed the following morning or evening. The workprint is nearly always an A-wind contact print (see Fig. 14-1).

Timing the Workprint

A workprint is sometimes made on a printer that can make exposure changes for each shot (labs usually refer to shots as "scenes"). There are two basic types of workprint that can be ordered—timed and untimed. An *untimed print,* also called a *one-light print,* is made with the same printing light for the entire camera roll; no compensations are made for exposure differences from one shot to the next. A one-light print is sometimes made with a standard light, which is around the middle of the printer's scale. For example, a Bell & Howell Model C printer has a range of lights from l to 50 points, the lab's standard light being around 25. Cinematographers working in controlled environments, such as the film studio, often request the standard light print, which makes any errors in exposure or color balance immediately apparent.

Sometimes the one-light print is made for *best light.* The lab technician, called the *timer* or *grader,* looks over the whole roll and decides if, on the whole, exposures need compensation. A compromise is made, and a light is selected that will give a good overall result. If there are gross differences from shot to shot, the lab will sometimes make a few corrections even on a one-light print. Color workprint is also color balanced (see Chapter l4).

Labs also will make scene-to-scene corrections on the workprint, choosing the best light for each take (and, in the case of color, the best color balance), but there may be a surcharge of 30 percent or more for this service. This is called a *timed, graded* or *color-balanced workprint.* You should not expect these corrections to be as accurate as those on an answer print (see Chapter l4).

Some labs, as a matter of course, include the *timing sheet* with your workprint. The timing sheet is a record of the printer lights used when making the workprint. If a best-light or timed print is ordered, it is impor-

tant to get a timing sheet and interpret it. Timing corrections can cover mistakes that you need to know about for future shoots. If you know the lab's standard light, it is easy to see which exposure or color balance errors are being compensated for. For example, with negative, if the lab is using more light than standard, then the negative is too dense, that is, overexposed. With reversal, more light than standard means that the reversal was underexposed. If your results are consistently overexposed or underexposed, check your equipment.

Usually, the filmmaker working within a tight budget cannot afford a timed print. If sections of a one-light workprint are badly timed, it may be worthwhile to have them reprinted, since the workprint is often viewed by many people.

Sometimes the lab needs special instructions for workprinting. The timer may attempt to bring intentionally underexposed scenes (for example, mood or day-for-night shooting) or scenes shot with colored gels (for example, at a nightclub) back to normal unless he is given special instructions, preferably in writing.

In feature film production, send the lab a *camera report* or *camera sheet*, which, among other things, lists all the takes by footage number and circles those takes to be printed. To save money and screening time, print only those camera takes the director feels are usable. However, to cut down handling, labs will not usually selectively workprint 16mm film. The camera report should also include timing information, for example, exterior ("Ext") or interior ("Int"); "Day" or "Night"; special instructions ("print slightly red") or special effects (a light was switched off as part of the scene or "day-for-night").

Before the use of the video analyzer (see Chapter 14), *Cinex strips,* or *Cinex,* were more commonly used as a timing aid in 35mm lab work. Test frames, one from each scene, are printed with different printing lights and color balances. Timing is judged by examining the strips on a light box. They are especially useful for matching shots within a sequence.

Single- or Double-Perforated Workprint

In 16mm, workprint may be ordered on double- or single-perforated stock. Single-perforated workprint allows the editor to know which end is heads and which is tails. Splicing base to base with single-perf film also makes it impossible to put a shot in upside down. With double-perf film, a short shot is occasionally spliced upside down. On the other hand, it is often easier to run double-perf through synchronizers and other equipment. If you order workprint with a magnetic stripe (see Chapter 12) or plan to stripe the workprint at a later date, then you must use single-perf film. Although the choice is not crucial, except in the case of magnetic striping, it is a good idea to get all double-perf or all single-perf workprint.

Saving Money on Workprint

Some labs charge a few cents less for workprint on spliced stock. The workprint will have a few cement splices, which is not too serious, but, occasionally there is a color balance shift or slight fogging of a few frames at the splice.

Printing color rushes on black-and-white print stock saves a few cents per foot but sometimes proves to be a dangerous option for several reasons. Tonalities are not correctly rendered, since black-and-white printing stocks are generally only sensitive to blue light. Some types of fogging do not show up in black-and-white but will appear on a color print. Furthermore, editing choices that depend on color are made more difficult. An even less expensive option is to print on various black-and-white stocks not designed for workprint. These usually render an image with extreme contrast, but save an additional few cents a foot.

Edge Numbers on Workprint

Most camera stocks, other than those in super 8, have latent edge numbers, or key numbers, photographed on the edge of the film (see Fig. 12-4). *Always* instruct the lab, in writing, to print these numbers on the workprint, which should be done at no extra cost. When the workprint is returned, make sure the print-through edge numbers are legible. They are essential for conforming camera original and workprint. They also can help in locating a shot extension when editing. If the lab forgets to print them, they should make another workprint at no extra charge. They may offer to print matching machine edge numbers on original and workprint, but this is not a good practice (see Edge Code, Chapter 12).

The Lab Report

Many laboratories supply a lab report with the rushes. The *lab report* lists gross camera errors and damage to the film (for example, significant exposure errors, scratches and edge fog). When you are filming on location, someone at the lab can read the report to you over the phone.

When you choose your lab, find out which errors the lab will check for in its report. If you cannot view the rushes on a daily basis, try to get the lab to include information about bad focus, improper collimation on a zoom lens, dirt in the gate, flicker, breathing, poor image registration, dirt (or "sparkle"), cinching or static marks. Certainly any processing errors should be noted. Make sure the lab sends you the workprint timing sheet.

Screening the Rushes

The cinematographer and director should look at the rushes as soon as possible, preferably the day after shooting. View the workprint on a projector, since editing tables may hide errors such as image flicker, slight softness of focus and bad registration. Sometimes the cinematographer screens rushes without sound to concentrate on camera problems. Evaluate whether scenes need to be reshot and what remedial action can be taken to remedy errors.

Troubleshooting Errors

SCRATCHES OR CINCH MARKS. If you see a scratch during the screening, check immediately for its source. The lab report may note whether the scratch is on the emulsion or base (*cell* scratch). If there is no notation on the lab report, stop the projector and hold the scratched film at an angle to a light source so that you can see the reflection of the light on the film. Twist the film in relation to the reflection to see if the scratch is actually on the film. If it is not on the workprint, the scratch is on the original. If it *is* on the print, check whether it is also on the projector feed reel. If it is, the scratch was made before projection. If not, the projector is making the scratches. Clean the projector and check for emulsion build-ups or tight rollers before continuing the screening.

Most scratches on original come from the camera, although some come from laboratory or manufacturer errors. A scratch test (see Chapter 2) prior to filming will usually show a manufacturer error or a camera scratch. If a scratch is precise with no wobble or if it has a slight fuzziness on the edge of the scratch (a sign of a preprocessing scratch) it is probably a camera scratch. Emulsion scratches are usually camera scratches since most lab rollers touch only the base side. Further questions to help detect the origin of scratches are: Does the camera scratch now? Do only those rolls shot in a particular mag show the scratch? Did an inexperienced person load the camera? If uncertainty remains, discuss the matter with the lab and ask (though do not necessarily trust) their opinion.

Base scratches can generally be removed by buffing. Liquid-gate printing (see Chapter 14) often hides base scratches and some very light emulsion scratches. You can ask the lab to check whether a scratch is on the emulsion or on the base. A base scratch defracts light (that is, it does not let light pass) so it will appear black on reversal and white (and uncolored) on a positive print from negative. Emulsion scratches let light through; they appear white or colored on reversal and black or colored on a positive print from a negative.

Cinch marks appear as discontinuous oblique scratches usually caused by handling film poorly, such as pulling unraveled film tight or squeezing dished, core-wound film back into place. Liquid-gate printing or buffing may remove cinch marks on the base. Thin camera original (underexposed negative or overexposed reversal) will print with more noticeable scratches and cinch marks.

WORKPRINT CHATTER. Old shrunken film or recently processed unlubricated film *(green film)* often chatters during projection. If the workprint makes noise and is unsteady, it may only need lubrication. In any case, the problem generally stops after projecting the film a few times. Check whether the lab forgot to lubricate the film. If you wish to perform the task yourself, use film cleaner with lubricant.

DIRT ON THE FILM. Dust or dirt that shows black on the screen is less noticeable than when it is white. Dirt on reversal films shows up as black, while dirt on the processed negative original will appear white when printed (called *sparkle*). If the print itself is dirty, the dirt shows up black. If you see dirt on a projected print, clean the print by running it through a felt moistened with film cleaner (see Chapter 11). A noticeable amount of dirt on the felt (assuming this is the first projection) warrants a complaint to the lab. If the dirt is on the original, it may be due to lab handling, dirty changing bags, mags or cameras. The lab's ability to handle film cleanly, especially in the more critical negative-positive process, is a key consideration in lab selection.

EDGE FOG. Edge fog is caused by a light leak that fogs the film before processing. Edge fog lowers contrast, often unevenly, and changes as the camera moves in relation to the light source. The effect is similar to lens flare, but, unlike lens flare, edge fog appears on camera original outside the image area. On color film, it often has a strong color cast.

Light leaks can be caused by a loose magazine lid, a loose camera door, a bad magazine-to-camera fitting, a hole in the changing bag, not packing core-wound film in the black bag or inadvertently opening a can of unprocessed film. Edge fog at the head or tail of film on spools is to be expected. See Chapter 2, Light Leak Test.

STATIC MARKS. Static marks appear as lightning bolts or branches of light (see Chapter 4).

PROCESSING ERRORS. Consult the lab immediately to find out if a processing error is on the original. In the event of their error, most labs will only replace stock and refund the cost of processing, but this may be negotiable.

Reticulation is the breaking up of the image into cell-like patterns caused by a sudden change in the temperature of processing solutions. Chemical staining appears as blotches, often of one color on color stock. *Blue comets* are blue streaks that occur on some color stocks when metal reacts with the film in the developer. The metal may come from the camera magazine and may not be the lab's fault. Uneven development shows up as waviness in the tonalities and sometimes as an overall mottled appearance. Exhausted developer may show up on print as uneven development or, sometimes, as low contrast. Spotting, mottling and streaking can be caused by improper drying.

RAW STOCK DEFECTS. Defects in the raw stock are often difficult to distinguish from processing errors. Mottling may come from defects or processing errors. The manufacturer will usually accept responsibility for replacement of defective stock and sometimes processing costs. Out-of-date or improperly stored stock will show increased fog and graininess and decreased contrast and film speed (which may show up as underexposure, see Chapter 4).

DIRTY GATE. Dirt may be in the projector gate. Change the frame line adjustment in the projector. If the dirt moves with the frame line, it means the dirt was in the camera aperture.

CAMERA DEFECTS. For bad registration and breathing in the gate, see Chapter 2. Flicker in the image may be a camera motor defect. A partial vertical ghost-like blurring may mean the camera shutter has a timing error. If vertical blurring covers the entire image, most likely the pressure plate was not holding the film in place (lost loop) and the claw never engaged the film. (See Chapter 3 for lens problems.)

OTHER WORKPRINT ERRORS. Workprint usually projects properly when it is wound base out. If you find that the print must be loaded emulsion out in order to project properly, it may be because the lab has printed the original flipped. An optical print (see Chapter 14) may be printed in camera original position (which does project emulsion out), but this is extremely rare for workprint. If the film seems flipped and the camera original was reversal, *be careful:* you may be projecting the original (see Chapter 11).

There is sometimes a choice of workprint stock. If the overall look or contrast of the print is different from other workprint, the lab may have used a different print stock.

Information To Be Sent to the Lab

Each film shipment to the lab should include the following information (labs will often supply a form for these items or use a camera report). The first 8 items should be on each can of unprocessed camera original.

1. The company name, address, telephone number and name of person to contact in case of questions (or the name of director and cinematographer, if applicable).
2. The working title of the production.
3. The gauge (for example, l6mm) and the amount of footage. Mark if super 16.
4. Both the common name of the film (for example, ECN or Plus-X negative—PXN) and the film type number (7291 or 7231). This serves as a double check.
5. Special processing instructions, including force developing, for example, ''Push one,'' ''Push two'' or instructions for flashing.
6. The camera roll number.
7. The approximate footage where camera jams or torn perfs occurred. The lab will do a hand inspection to see that no problems will occur in the processing machines that will ruin your footage and possibly footage from another production.
8. For a daylight spool on which you wish to save a run-out shot or a darkroom (core) load, mark ''open only in dark.'' If the core has popped out, mark ''no core'' or ''air wind.''
9. Any tests, for example, ''15-foot tail exposure test.'' Include information about whom they should contact and how.
10. What should the lab do with processed original? ''Hold original'' means it should be stored in the lab's vault.
11. Do you want a workprint? If so, do you want:
 a. Color or black-and-white? Any special stock?
 b. Single- or double-perforated?
 c. One-light print? Best light? Standard light? Timed and color corrected?
 d. For returning workprint: Pickup? Parcel post? Insurance? How much?
 e. Return on reels or cores? Different camera rolls spliced together? Request that they mark camera roll numbers on workprint leader.
 f. Request the timing sheet.
 g. Special instructions, for example, day-for-night scenes or unusual color balance.
 h. In 35mm, make sure the camera report details which takes are to be printed.

11
Picture Editing

Editing is the selection and arrangement of shots into sequences and the sequences into a film. It is sometimes thought to be the most important element in filmmaking. Many films have been "saved" in the editing room.

The earliest filmmakers made films from one unedited camera take or shot. A few years after these earliest pictures, it became obvious that shots could be trimmed and placed one after another, with the viewer accepting that the action occurs in the same setting. The joining of two shots, with the abrupt ending of one shot and the immediate beginning of the next, is called a *cut,* which refers both to the actual physical joining of the film *(splicing)* and to the effect on the screen. Editing is also called *cutting.*

Some Film Theory

Montage

Perhaps the most developed theory of film comes from the silent era and is called Russian *montage theory*. The word "montage" comes from the French and means to "put together" or "edit." The Soviet filmmakers claimed that the ability to change images instantaneously was unique to film, and constituted its potential as an art form. In editing, the image can shift from one person's point of view to another's; it can change locales around the world; it can move through time. The Soviets, for the most part, looked at the shots themselves as meaningless atoms or building blocks and claimed that meaning first emerges from the images through the juxtaposition of the shots.

In the early 1920s, Lev Kuleshov, a Soviet film teacher, created experiments to show how the meaning of a shot could be totally altered by its context. He took a series of shots of Mosjoukine, a famous contemporary actor, looking at something off screen with a neutral expression on his

275

face. He then constructed a few different sequences. In one sequence, he cut from a medium shot of Mosjoukine to a close-up of a bowl of soup and then back to a close-up of Mosjoukine. In the next sequence, the middle shot, called an *insert shot,* was replaced with a shot of an injured girl. Kuleshov's students commented that the last shot in each of the sequences, called the *reaction shot,* showed the actor's great acting ability to convey subtly hunger in the first sequence and pity in the next.

In another of the Kuleshov experiments, a sequence was constructed as follows: an initial shot of Mosjoukine smiling, an insert shot of a gun and a reaction shot of Mosjoukine frowning. Kuleshov then rearranged the order: to the frowning shot, the gun and finally the smiling shot. In the first sequence, the actor's reaction seemed to be one of fear; in the second, one of bravery. The important point of these experiments is that

FIG. 11-1. Three-shot sequence. (i) The meaning of the actor's expression depends on the insert shot. (ii) The meaning of the actor's expression depends on the ordering of the shots.

the actor's expression is constant, but the viewer attributes changes in emotional states to him on the basis of the editing.

A girl looks off screen; there is a cut to a bomb blast and then a reaction shot of the girl. The audience assumes the girl is looking directly at the blast, even though the blast could have, in fact, occurred in another part of the world at another time. Sergei Eisenstein, the most renowned of the early Soviet filmmakers, claimed that *film space* was the constructed space of montage, not the space photographed in the shot. Film space was more than the simulation of real space; it could also be abstract. It is possible to cut from a shot of Kerensky, who was head of the Provisional Government and is a villain in Eisenstein's *October* (1927), to shots of a glass peacock to suggest that Kerensky suffers from the sin of pride. There is no suggestion, however, that the peacock and Kerensky share the same physical space. Two shots, edited together, produce a new meaning, and film space allows for these kinds of metaphorical relationships between images. In addition to narrative content and metaphor, shots can be held together by abstract elements like movement, tone, compositional weight and image size.

Similarly, Eisenstein saw film time not as the duration of real movement but as the time set up by the rhythms and juxtaposition of montage. An event may only take a split second in real time, but, as its importance may be great, its duration should be lengthened in film. In *Potemkin* (1925), Eisenstein extended time by showing a crying baby in a carriage teetering on the edge of a steep flight of stairs and then cutting to other shots before returning to the baby. Suspense is heightened by prolonging the event. Real time can also be condensed. Cutting from a horse race to a reaction shot of the crowd (a shot away from the main action is called a *cutaway*) and then back to the race allows a large portion of the race to be deleted. Similarly, a character's walk will seem continuous if you cut from him walking offscreen to a point much further along in the action. Like film space, film time is also a construction created in editing.

Eisenstein also experimented with the montage of very short shots. In *Potemkin,* a sequence of brief shots of statues of lions in different positions cut quickly gives the illusion of their movement. A few frames of an attacking Cossack convey horror. There is no absolute rule for the minimum length of a shot; the minimum depends on the nature of the shot and the context. During World War II, it was found that plane spotters could recognize a female nude in one frame, but it took them much longer to recognize a Messerschmitt.

The directors in Hollywood never adopted the Soviet concept of montage in its broadest sense. In Hollywood, a "montage sequence" is a sequence of short shots that condenses a period of time. For example, the hero of a film might be shown growing up through a sequence of five or six shots that show him at different ages. The aspect of montage that was accepted by Hollywood (indeed the Soviets had discovered it in early

American films) was the three-shot sequence—that is, actor looks off screen, cut to a shot from his point of view and then cut back to the reaction shot. Alfred Hitchcock constructed *Rear Window* (1954) almost entirely using this cutting technique.

Today montage theory underlies much advertising and some experimental films. The juxtaposition of women, happy teenagers and jazzy music with automobiles, soft drinks and other products is used to manipulate consumers. In experimental films the tradition of montage seems to find new life. In Bruce Connor's *A Movie* (1958), *stock footage*—that is, footage purchased from a service (also called *library footage*)—from widely disparate sources, ranging from pornography to newsreels, is cut together to form a unified whole. Although the images come from different times and places, the viewer integrates them into a flow.

In Woody Allen's *What's Up Tiger Lily?* (1967), a Japanese action film is dubbed by Allen to change the story line completely. It is not that the original film has lost its meaning. The joke is the ease with which meanings are changed by editing, in this case, by altering the relationship of sound and image.

Staging versus Montage

André Bazin, the French film critic often credited as the decisive influence on the French New Wave, thought it characteristic of advanced film directors of sound pictures to be concerned with the integrity of the photographed space. In the *deep focus shot* (see Fig. 11-2), the whole frame is in focus and primarily camera and subject, not editing, determine film movement. The meaning of the scene thus develops in the deep space of the frame, which is in sharp contrast to the principles of montage theory. Directors adopting Bazin's theory look to the staging of the shot, or the *mise-en-scène*, which includes lighting, camera movement, subject movement, costume, dialogue and so forth. In such shots, film space is the space of the real world (or at least a world created through staging), not the space created in the editing room.

The *long take*—that is, a shot of long duration—allows the action to unfold in real space and underlines the fact that the shot's meaning comes from filming, not from editing. If you think of dangerous stunts, it is easy to grasp the visceral effect of seeing the events photographed rather than constructed. Out of all the silent filmmakers, Buster Keaton seemed to understand best the power of unmanipulated space. His stunts, often performed in long shot, were clearly incredible feats. Much of the attraction of unmanipulated documentary is its ability to convince the viewer that what is seen on the screen actually occurred.

FIG. 11-2. Deep focus from *Citizen Kane*. A wide-angle shot with both foreground and background in focus allows the action to develop within the frame. (RKO General)

Cutting Styles

Invisible Cutting

In its simplest form, editing is a guide to focus audience attention. The editing style should have its reasons and every cut a motivation. *Invisible,* or *match, cutting* usually refers to the construction of sequences (or scenes) in which space and time appear to be continuous. Usually both fiction and documentary sequences are match cut to appear continuous. On a film set, however, shots are rarely done in the order that they will appear in the final film. It is the role of the director to photograph scenes with adequate coverage so that the editor can construct continuous sequences. Every cut made in a documentary that was filmed with one camera, in fact, alters continuous time.

There are various ways to make action seem continuous. If the eye is distracted, a cut becomes less noticeable; therefore, editors "cut on the action" (a door slam, punch or coin flip) to hide a cut. The action draws the viewer's attention away from the cut and from any slight mismatch from one shot to the next. Overlaps of action (see Chapter 6, Continuity) allow the editor to cut just before or just after the action or on the action itself. Cuts tend to propel time forward and to pick up the pace. Sometimes the action looks too fast due to cutting, and the editor must include a few frames of action overlap between two shots.

Changing camera angle and focal length between consecutive shots disguises discontinuities and may make the cut "work"—that is, look as though it matches and is not jarring. Cutaways and reaction shots are tools that maintain continuity between shots that do not match. Cutting away from the main action to a reaction shot allows you to delete uninteresting dialogue or mistakes in the main action. Cutaways and reaction shots also allow the tempo of the film to be controlled through editing, which would be impossible with a continuous take.

The Jump Cut

The sequence of cuts that moves from long shot to medium shot to close-up is generally made up of match cuts. In other words, each of the cuts appears to occur in the same space and time period. A disconcerting mismatch between shots is called a *jump cut*. To cut from a shot of a person sitting to a shot of the same person standing in the same spot creates a disconcerting jump in time. A slight change in image size from one shot to the next (for example, two medium shots of the same person cut next to each other) makes the cut appear to jump and feel unmotivated. A larger change in image size or angle could make the same cut in action seem natural.

The director Jean-Luc Godard, in the early 1960s, began to use the jump cut as a creative element in his filmmaking. He cut out what he felt were boring middle parts of shots or spliced together two close-ups of the same character with a definite jump in time. Not only did these jump cuts comment on the nature of film space, but they also created exciting rhythms that seemed to express the feeling of modern life.

The jump cut is often used for comic effect. In *A Hard Day's Night* (1964), director Richard Lester showed the Beatles cavorting about the landscape in a series of jump cuts. Jump cuts, however, may seem dated and often do not work, and it makes sense to cover yourself with alternate shots, cutaways and the like rather than be forced to resort to jump cuts to salvage a sequence.

Screen Direction

A basic rule of film editing is to try to preserve screen direction at cuts (see Chapter 6). Cutting from a shot of one person looking off screen to the right to a shot of another person also looking off screen to the right makes it appear that the two people are looking in the same direction rather than at one another. Much of the directional information in a chase sequence comes from screen direction.

When two shots violate the 180-degree rule (see Chapter 6) and there is no shot available where the camera crosses the line, you should try to separate the shots with a neutral shot (for example, a shot taken on the line).

Screen direction to the right is accepted by audiences as meaning travel to the east; to the left, is travel to the west. A plane flying from New York to Paris that was shown on screen traveling right to left would be disorienting. In editing, if a character walks off screen right, he should come in from screen left to appear that he is continuing on his walk. If he comes in screen right, he appears to be returning to his previous spot.

Joining Sequences

One traditional method of editing connects shots into a sequence with straight cuts and then brackets the sequences themselves with fades and dissolves. Fades work like theater curtains opening and closing on an act or like a sunset followed by a sunrise. Dissolves, on the other hand, suggest a closer connection between one sequence and the next. Like fades, dissolves convey the passage of time—sometimes short time gaps within a sequence and sometimes long periods, as when a close-up of a person dissolves into another close-up of the same person shown at a much older age. When dissolves are used within sequences to signal short time gaps, their only function often seems to be to avoid jump cuts. Sequences can also be joined by other optical effects (see Chapter 14).

Many filmmakers like to join two sequences together with a *straight cut* (that is, one follows directly from the other with no effects). This creates the problem of distinguishing cuts within sequences—those that signal no significant time change—from cuts between sequences where there is a significant change of location or time. Filmmakers like Luis Buñuel and Alain Resnais like to explore this ambiguity. On the other hand, change of sequence may be signaled by such devices as change of sound level, lighting, color, dress, locale, image grain and contrast. Even dream and fantasy sequences may be introduced with a straight cut,

unlike in the American films of the 1930s and 1940s in which they would be signaled by eerie music and a ripple or oil dissolve.

It is not unusual to see a contemporary movie with no effects other than a fade-in at the opening of the film and a fade-out at the end. In the past, the fade-out and fade-in were the most common connection between sequences. Now a fade-out is sometimes followed by a pop in (a straight cut in).

You may join two sequences by *intercutting,* or *parallel, editing*—for example, the perils of the heroine may be intercut with the hero's race to arrive in time to save her.

The Mechanics of Editing

The Editing Room

Editing rooms have their own rites and rituals. Work space is usually cramped, and there is often footage stored from other productions. Make certain you store all your footage in cans and wrap every can around the edge with tape marked with the (working) title of the production, the name of the production company and the roll number. Store the camera original elsewhere (for example, at the laboratory vault) until completion of the editing of the workprint. Mark cans and leaders of original material and leader attached to original "camera original," preferably with tape and leader of a different color from that used on the workprint.

THE LOG BOOK. Organize the editing room so that any piece of film can be located with minimum searching. Enter all footage in a log book identified by camera roll number, latent edge number and machine code number (see Fig. 12-4). Describe each scene by content, and, for scripted films, by scene and take numbers. On documentaries, you may only need a description of the contents of the roll rather than a shot-by-shot description.

THE EDITOR AND ASSISTANT EDITOR. The editor, usually in consultation with the director or producer, decides how the film is to be cut. Sometimes the editor marks the shots to be cut and an assistant editor performs the physical act of cutting. The assistant editor also keeps the log book, synchronizes rushes, reconstitutes out-takes, keeps track of *trims* (the sections deleted from a shot that has been used in a cut), cleans up and makes sure needed supplies are available, such as grease pencils, leader, film cleaner, fresh splicing cement and editing gloves.

CLEANLINESS. When working with original material, keep the editing room clean and dust free. At the end of each day's work, cover the tables

and bins with plastic. Keep the floor, in particular, clean. Original material is irreplaceable and needs special care, but workprint, too, should be kept as clean as possible. A clean workprint allows you to judge the film better. It is likely that you will show the film during the workprint stage to non-filmmakers—investors, trial audiences, distributors and the like—who may have little understanding or tolerance for scratched and dirty film.

DISTINGUISHING ORIGINAL FROM WORKPRINT. If the original is negative, there is generally no problem distinguishing workprint from original since the workprint is a positive. If the original is reversal, you can generally distinguish the workprint by looking at the latent edge numbers. Original is almost invariably B-wind (see Fig. 4-12) and has latent edge numbers that read through the base. Reversal workprint is A-wind, and its latent edge numbers read through the emulsion. Intermediate materials (see Chapter 14) rarely have edge numbers.

EDITING FOOTAGE FROM DIFFERENT SOURCES. On some productions, stock footage is used and edited with workprint footage from camera original. Sometimes the stock footage is of the wrong wind and will either project flipped or will have to be spliced in base-to-emulsion and will be out of focus during projection. When you use stock footage, be sure the footage is available in a wind that will match the camera original (B-wind). Workprint is usually A-wind. Check the stock footage for wind and, if it is B-wind, send it to the lab to be workprinted or, if it is A-wind, to be duped to change winds.

Check frame lines on stock footage to make sure they match the camera original (see Chapter 2). Sometimes optical printing must be done to correct significant differences. If stock footage has no latent edge numbers, machine code it and its copy for conforming (see Chapter 13). If you are only using some of the stock footage, it is sometimes less expensive to do clip-to-clip printing (see Chapter 14).

Editing Shots into Sequences

When the production is scripted, every shot has a script number. The first cut—*rough cut* or *rough assembly*—puts the shots in the order called for by the script, using the best takes. In unscripted documentary films, the rough cut is sometimes constructed by ordering sequences chronologically.

Trim each shot, using only the best part of the take. Remove slates, flash frames, camera errors and the like. Store the trims so they are easily retrievable. Usually an editor attempts to assemble the rough cut fairly quickly, worrying not about the pace of scenes and getting everything to work well, but about establishing the overall direction of the work. It is

easier to cut out footage than it is to add to a sequence. For this reason, most editors prefer to edit rough cuts on the long side. Rough cuts are often two or more times as long as the final film.

One way to keep track of unused footage (the *out-takes,* or *outs*) is to *reconstitute* them—that is, return them to their workprint rolls. Use latent edge numbers or machine code numbers to determine their proper order. If the footage has sync sound, reconstitute in sync (see Chapter 12).

Successive edited versions, called *fine cuts,* create their own out-takes. Incorporate these out-takes into the first out-take rolls; otherwise, if a trim roll is made for each version, it becomes difficult to find the extension of a particular shot since it could be on any one of a number of rolls. It is easy to locate an extension if all the out-takes are reconstituted by edge number.

While editing sequences, individual shots can be hung on pins in the *trim,* or *film, bin.* Some editors put the shots in order in the bin before splicing them together. You can also use the bin for reconstituting. Arrange shots by edge number before putting them back into the out-take

FIG. 11-3. The film, or trim, bin. You can make your own trim bin by bolting a wooden rack to a garbage can lined with cloth or plastic. (J & R Film)

rolls. You will find that you can locate many shots that have mysteriously disappeared by looking at the bottom of the bin.

If you want, you can fine cut from the beginning instead of making rough cuts. Even though this approach requires more time to complete the first cut, you may be better able to judge the editing. However, you may find it easier to fine cut and pace individual sequences once you see the overall direction of the film as expressed in the rough assembly.

Since the transition from the small screen of the editing machine to the large projected image can be startling, you should project the film at various stages. It takes experience to predict the outcome of the transition; sometimes the pace of the film seems to speed up and sometimes to slow down. Screen various versions before small audiences. Interestingly, even the filmmaker seems to see the work more clearly in the presence of an audience.

If one shot is to dissolve into another, find the overlapping frames. For example, a forty-eight-frame dissolve has a forty-eight-frame overlap, twenty-four frames from each shot (see Fig. 11-4). Check the overlap to make sure there are no flash frames or unwanted movements. Store the workprint overlap frames in a special place so that they may be checked at any time for sufficient frames. Too often, the negative cutter (see Chapter 13) comes across a marked dissolve on the workprint and cannot find the extension in the original.

Check the beginning and end of each shot for *flash frames* (overexposed frames caused by the camera stopping with the shutter open or when the camera changes speed at the beginning or end of a take) by

FIG. 11-4. Trim and put aside the workprint extensions of both shots to be used in a dissolve. A forty-eight-frame dissolve needs a twenty-four-frame overlap from *each* shot.

holding the end of the shot up to a white wall or a light box. Sometimes a slight flash seen at cuts is an indication of flash frames. You must check carefully, since often a drastically overexposed frame is surrounded by several subtly overexposed ones.

Short shots (those fewer than twenty frames in l6mm) may not have a latent edge number. Write the closest edge number on the shot in grease pencil to aid the negative cutter when he or she is conforming (see Chapter 13).

When original is conformed to workprint in super 8 or 16mm, at least one frame at the head and tail of each shot is needed to make the cement splice. If you are using two parts of the same take (a *split shot*), delete some frames between the two shots to allow for the cement splice. Some conformers lose only one frame, especially if they are warned that it is a split shot, but others, as a matter of course, leave a frame or more at each end of every shot pulled from the original. To be safe, you may want to leave three or more unused frames between the shots.

Leader

Blank film for threading and writing information on, called *leader,* should be attached to the beginning (the *head leader*) and the end (the *tail leader*) of every roll of rushes, camera original, magnetic film, assembly and out-takes. Use at least 5 to 6 feet of leader at the beginning and end of each roll and write on every leader the film title, name of production company and roll number, as well as "head" or "tail," depending on its position in the roll.

Lightstruck, a white to yellow leader available from film manufacturers, is usually the least expensive. You can write on it with an indelible marking pen such as a Sharpie. Lightstruck has a dull emulsion and a shiny base. The emulsion can be distinguished from the base in two ways. Hold the film obliquely to a light source to distinguish the dull from the shiny side, or place the leader or film between slightly moistened lips or fingers to see which side sticks, the sticky side being the emulsion. Polyester leader (for example, Starex) has no emulsion (both sides are shiny) and is available in a range of colors.

Slug, or *fill,* is footage used to replace damaged or missing film in a cut and to prepare sound tracks for mixing (see Chapter 12). Often discarded release prints can be purchased for less than a cent a foot, and may be used for slug. When this footage is used for picture slug, it is usually cut in upside down to distinguish it from the workprint. Some filmmakers find it distracting and use leader instead.

Leader and slug are available in l6mm, both single- and double-perforated. You can use double-perf leader as head or tail leader only if everything on the roll is double-perf. Otherwise, use single-perf so that the film

will not be threaded incorrectly and rip the single-perf sections. 16mm magnetic film must have single-perf head and tail leaders since mag film is single-perf. Use single-perf slug in mag film rolls, because double-perf slug may cause head wear and unwanted noise. Single-perf leader enables you to distinguish easily when a roll is head or tails out. Because of the advantages of single-perf, some editing rooms only use single-perf leaders and fill. When using magnetic film with leader or fill that has an emulsion side, make sure you splice the emulsion side of the leader to the *base* of magnetic film to avoid having the emulsion clog the sound heads. Avoid shrunken leader or film since they may chatter and jam during projection.

Editing Equipment and Its Use

The *editing bench* (see Fig. 1-11, ii) is a table that may be equipped with the following.

MANUAL REWINDS. A pair of rewinds permit the film to be rewound or searched. You should be able to grip the rewind handles with all your fingers. Avoid the flimsy handles typically found on super 8 equipment. Rewinds equipped with a friction or tension adjustment permit drag to be increased on the feed side to prevent film from *spilling* (unwinding without control) during rewinding. Drag can also be increased if rewinds develop the nasty habit of rotating by themselves, sometimes resulting in an unattended reel spilling its film on the floor.

Rewinding is accomplished with one hand adjusting drag on the feed

FIG. 11-5. Moviola rewind with long shaft, spacers, spring clamp and support. (J & R Film)

reel, using the adjustment or your hand to produce tension, and the other hand cranking. Leave no slack between reels, since the slack may suddenly be taken up and the film broken.

Rewinds may be fitted with long shafts to accommodate more than one reel (as when working with sound). Use an end support if more than four 16mm reels are mounted on a shaft. Use reel spacers or common camera cores between reels and use clamps to hold the whole assembly in place (see Fig. 11-5).

THE LIGHT BOX. Before motorized editing machines like the upright Moviola were introduced, editors working in 35mm would judge shots on a *light box* (a frosted plate of glass that covers a light, often fitted into the editing bench). Use of a light box is practical for editing 35mm silent film, but 16 mm is too small. The light box is now used primarily to check for flash frames, to read latent edge numbers and to identify shots.

THE VIEWER (ACTION EDITOR). If you are editing original, it is best to have a viewer with a simple film path to minimize the chance of scratching film. Never whip film through a viewer at rewind speeds. The better-quality viewers allow you to mark the frame on the viewer screen with a grease pencil. Avoid devices on viewers that mark the frame by notching or nicking the film.

Viewers are helpful for cutting MOS (silent) sequences and for searching rolls for particular shots. The viewer image is generally not sharp

FIG. 11-6. Hervic/Minette super 8 editor/viewer. (Hervic Corp.)

enough to judge the quality of the focus on a shot. Use the projector to evaluate footage for focus and quality.

Viewers equipped with a built-in sound head or used with a synchronizer (see p. 291) can play sound and picture together.

THE SPLICER. Cement and tape are the two basic types of splices. A cement splice is made by scraping the emulsion off one shot and then bonding the bases of the two shots together with fresh film cement for a strong union. One frame is lost where the emulsion is scraped at each cement splice. This makes cement splicing inconvenient when editing workprint, since each time a shot is extended, the lost frames have to be slugged (replaced with leader or fill). Cement splices are generally used for splicing original, intermediates and release prints.

Some older cement splicer models cut into frames on both sides of the splice, but the preferred newer models only cut into one of the frames. *Negative splices* are slightly narrower and cover less picture area than *positive splices,* but, when properly made, are as strong. In 35mm, the cement splice is outside the projected picture area, so the splice does not show on projection. In super 8 and 16mm, on the other hand, the splice does cut into the picture area and is visible on projection. A & B roll printing allows cement splices to be hidden in the smaller gauges (see Chapter 13). Consult Appendix C for techniques of cement splicing.

Tape, or *Mylar,* splices were a major advance over cement splices in editing workprint since they need no cement or scraping and lose no frames. Tape splices encourage experimentation since extending a shot no longer involves losing frames. On the other hand, placing many tape splices close together makes it difficult to judge a cut. Tape splicing is faster and easier to do than cement splicing. However, cement splices jump less in the projector's gate and are preferable for repairing breaks on release prints. During projection, tape splices may throw a couple of frames out of focus at the cut and, over time, the tape may discolor. Forewarn the lab if footage to be printed has tape splices since ultrasonic cleaning may remove them (see Chapter 14).

Whereas picture is spliced with clear tape, sound is usually spliced with white tape (see Chapter 12). Old tape splices on color film sometimes pull off some emulsion layers when removed. You should, therefore, splice on the base side of film, unless this interferes with a magnetic stripe. Splicing on only one side is faster in both making and removing the splice, but some projectors and editing machines will only take picture spliced on both sides *(double spliced).* Single-spliced picture may jam or jump in these machines. Double splices are stronger and do not stretch *(telescope)* like some single splices.

Tape is available in three basic forms: unperforated in rolls, perforated in rolls and precut perforated. The *guillotine splicer* (made by various

Fig. 11-7. Splices. (i) 16mm cement splice (shown here) extends into one frame. 35mm cement splice does not show up in the picture area. (ii) Tape splice that extends past the frame line. (iii) Tape splice that falls on the frame line. (iv) Tape splice on a Rivas splicer showing jagged edge. (v) Diagonal splice on magnetic sound film made with a Rivas splicer. (vi) Tape repair of torn perforations. (vii) Super 8 guillotine tape splice that does not cover the main magnetic sound stripe but does cover the balance stripe.

manufacturers) is used with unperforated tape. The tape is stretched over the film and the splicer punches out the perforations. The tape lies across the frame line and is less visible on projection. Some models also have a diagonal cut for sound editing (see Chapter 12). Unperforated tape is the least expensive, costing about one fourth as much as perforated tape. The splicers themselves are fairly fragile and must be kept clean of glue and

punched perforations. The tape is relatively thin, allowing it to pass through projectors well but may telescope over time.

Perforated tape in roll form is used in 16mm and 35mm with the Rivas or Hollywood Film splicers. Some models cut the tape straight, along the frame line, making the physical cut less obvious than on those models that cut with a jagged edge that rests in the picture area. In either case, the tape is fairly thick and is noticeable upon projection. These splicers need less maintenance than guillotine splicers and do not leave little punched perforations to gum up the works. Each splice costs about one cent.

Precut splices, the most expensive of the tape splices, are made primarily for the amateur market. They are very thin, easy to remove and make the best-quality splice for picture, but are relatively slow to apply and are not often used in the professional editing room. Kodak Presstapes show in the picture area but can be cut with scissors to make a splice that extends only to the frame line. They make the least noticeable splice of any and are sometimes used in emergency situations (as when original must be spliced without losing frames). Precut splices may be used with a Rivas splicer or an inexpensive *splicing block,* a grooved block with registration pins to hold the film and a slot to guide the single-edged razor blade when cutting the film.

You should check each tape splice you make. Remove air bubbles by rubbing. Trim tape that overlaps the edge of the film (which happens with dirty guillotine splicers or poorly manufactured perforated tape) with a razor blade or sharp scissors; otherwise, the film may jam during editing or projection.

THE SYNCHRONIZER. A synchronizer keeps film and sound track (or tracks) in the exact same relation to each other as you move from one part of the film to another. Although the synchronizer has applications in silent film, it is used primarily for sound film. (The reader unfamiliar with sound film editing should refer to Chapter 12.) A synchronizer has one or more sprocketed wheels, called *gangs,* mounted on a revolving shaft. Sound and picture are usually mounted on separate gangs and are kept in sync frame by frame as the sprocket wheels engage the perforations of the picture and sprocketed magnetic sound. You can mount a sound head on one or more of the gangs to reproduce the magnetic sound through an amplifier and speaker *(squawk box).* If you also use a viewer, place it a standard number of frames from the sound reader and find a point where picture and sound are in sync. Place a point on the sound (like a slate or start mark) under the sound head, and place the corresponding point on picture in the viewer gate. The picture and sound will now be kept in sync by the synchronizer.

To get decent sound reproduction, the film has to be cranked at around

FIG. 11-8. Moviola four-gang synchronizer. The fourth gang is shown with a magnetic sound head attachment. The dial on the first gang is an adjustable frame counter. Most synchronisers also have a footage counter; this one has a time counter. (J & R Film)

24 fps. If the sound is low pitch, speed up the cranking; if high pitch, slow down. Sound through a squawk box is often barely intelligible. Nevertheless, almost all editing tasks can be done with the synchronizer equipped for sound reproduction. Additional gangs allow more sound tracks to be held in sync with the picture.

The synchronizer is also used to measure leader or film. Measure footage in feet and frames by setting the frame counter disc to 1 at the first frame, setting the footage counter to 0 and cranking the length through. Equal lengths of film can be measured by sandwiching the two strips together in one gang or placing them in different gangs. Most synchronizers read footage from left to right. Synchronizers are available with one to six gangs and may be ordered with gangs of different gauges—for example, one 16mm and one 35mm gang or one super 8 and one 16mm gang.

REELS. If reels are used to store footage, use *double-key reels*—which have two square holes on each side for mounting the reel onto projectors

or rewinds. (*Single-key reels* have one square hole and one round hole.) The round hole prevents the film from being loaded in a projector backward, making them good for release prints but troublesome in the editing room.

Since reels are cumbersome for storing large quantities of film, most editors keep film on camera cores. Flat bed editing tables (see below) can accommodate *core wound,* or *tight wound, film.* When the film needs to be mounted on a reel for projection or work on an editing bench, it is mounted on a *split reel* which is made up of two halves that screw together. You can tightly wind film with a tight-wind attachment that fits on the rewinds, or you can use a split reel. Camera raw stock cores are generally 2", but 3" cores, since they put less stress on long rolls of film, are better for editing room use.

A *flange* is like half of a split reel and allows film to be wound on a core. Some flanges allow film to be wound around itself without a core. Short takes are often stored this way.

Handle core wound film carefully, especially if it is not very tightly wound. Hold the film flat like a pie, with your palm underneath; otherwise, the center may fall out *(dishing)*. If dishing should happen, find a splice, or make a cut, and separate the two halves. Place the half without the core on the plate of a flat bed editing table and attach the inside end of the film to a core put in the empty center. The plate is made to spin and the outer end is held in position as the film winds onto the core. After both halves are rewound, splice them back together.

SUPPLIES. Mark your workprint with China marker (grease pencil), which rubs off easily. White and yellow are the easiest colors to see on picture. Do not use grease pencil on sound (see Chapter 12). Use editing gloves when you handle original or any footage that needs special care to prevent skin oils from getting on the film. Other supplies include splicing tape, fresh film cement, sharp scissors, single-edge razor blades, film cleaner and cleaning felt, masking tape, tape for marking cans, indelible marking pens and a hole punch.

Upright and Flat Bed Editing Machines

The upright Moviola (there is also a flat bed Moviola) is a motorized viewer with a sound reader that shows synchronized picture and magnetic sound film. This machine dominated feature film editing from the time it was introduced in the 1920s until recently. The Moviola is used for marking shots and judging cuts, but the actual splicing is done on an editing bench with synchronizer and rewinds. Short shots are fed by hand and deposited behind the machine in a bin. Moviolas equipped with reel spindles can show longer lengths, but the machines are not gentle and

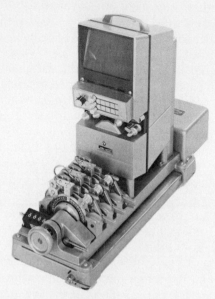

FIG. 11-9. Moviola editor/viewer with three sound heads combines synchronizer, viewer and sound head—a less expensive alternative to a flat bed editing table. (J & R Film)

FIG. 11-10. Moviola upright editing machine. (J & R Film)

when used with reels often damage sprocket holes, especially in 16mm. The image in the machine is small but sharp. Additional sound or picture heads can be added when you are working with more than one sound track or when a scene has been shot with multiple cameras.

Editing on a Moviola is usually intense and demands a great deal of energy. The machine is noisy and the editor is often standing. Flat bed editing tables (see Fig. 11-11), on the other hand, are relatively quiet and you can work sitting down. An assistant editor is less important when using a flat bed, since you can cut on the machine itself. The machines harm film rarely, permit splices to go through easily and are sometimes even used for editing original. On flat beds, film may be run at high speeds, whereas, on the upright Moviola, sound can be run no faster than 24 fps. The high speed allows better access to footage and more experimentation in cutting. The editing of 16mm film is now done almost exclusively on flat beds. In 35mm, there are many old-timers who still prefer editing on the upright Moviola.

Fig. 11-11. Moviola six-plate flat bed editing table. (J & R Film)

You can do rough cut editing on a flat bed by dividing the footage into the ins and the outs as you view the film. Whereas uprights encourage the editing of one or two sequences at a time, flat bed editing is often done with half-hour segments.

Flat beds have larger viewing screens but, in general, are not as sharp as the uprights and should not be used for judging focus. Some machines have a *hollow,* or *flickerless, prism* that cuts down on the image flicker present in the conventional prism. There is a story about a low-budget, independent feature film edited on a flat bed that was never projected to check the footage. The flicker of the flat bed masked a flicker present on the film caused by camera malfunction. Only after the film was blown up to 35mm was it discovered that the image was unwatchable, and the film was never distributed.

Some flat beds are modular (for example, the KEM Universal), allowing the machine to be expanded to various combinations of sound and picture heads. The size of machines is given by the number of plates: two plates—feed and take-up—are needed for each picture or sound head. The Steenbeck eight plate, a nonmodular machine, has two picture and two sound heads. The Moviola M77 is a six plate, with two sound heads and one picture head. Modular machines sometimes allow for a combination of super 8, 16mm or 35mm heads.

Most picture heads will play back single system magnetic sound. Such heads can also be used to play back an additional sound track from

FIG. 11-12. Steenbeck eight-plate flat bed editing table. (Steenbeck, Inc.)

magnetic sound in place of the picture. Some editing tables have record heads for sound mixing.

Editing rooms, usually equipped with a six-plate machine, may be rented by the day, week, month or longer.

Handling Footage

Hold film by the edges to avoid getting skin oils on the picture or sound oxide. Store rolls in cans, preferably upright. Do not allow food and smoking in the editing room.

Cinch marks are caused by pulling the end of a loosely wound roll to tighten it. Pushing down on the center of a tight-wound roll that has started to dish will also cause cinch marks. To fix dishing, rewind the roll on a split reel or flat bed table.

Clean film with any of several commercially available cleaners, such as Kodak Film Cleaner or Ecco 1500. When you clean magnetic film, be sure to use a cleaner that does not remove the oxide coating. Slightly moisten a lintless cleaning pad or felt with cleaner and sandwich the film in the folded pad as you slowly wind the film from one end to the other. Hold the pad near the feed reel and go slowly enough so that the cleaner will evaporate before the film is wound on the take-up reel; otherwise, there will be a mottle on the film, which can usually be removed by cleaning the film again. Reposition and clean the pad often to avoid the buildup of dirt that may scratch the film.

Editing Film on Video

Transferring film to video tape and editing on sophisticated video equipment offers interesting possibilities for films intended for film or video distribution. Modern video editing decks can be coupled to computer controllers that can record sequences of shots and automatically rearrange them at a later time. This is done with the aid of SMPTE time code (an electronically encoded signal on the tape), which, like the latent edge numbers in film, allows every section of video tape to be identified and located.

If film footage is to be released solely in video, all postproduction work may be done on tape. Negative original can be transferred directly to a master tape and electronically switched to a positive image (see Chapter 15). Transfer is often to the 1″ format, and the tape can be edited *on-line*, that is, with high-quality machines that produce a finished product. Transfer to 1″ is expensive. You may save money by roughly editing the film footage before transfer. Timing and color correction can be done when making the master tape. Depending on the sophistication of the editing equipment, you can add effects such as dissolves, fades, split screen images, slow motion, freeze frames and video titling.

On-line editing is also very expensive. To save money *dub,* or copy the master tape onto a smaller format (often ¾″) for *off-line editing.* This tape is like a video "workprint" that can be edited on a less costly system, allowing more time for editing and experimentation. Afterward, the 1″ master is "conformed" to the dub, using the SMPTE time code that has been recorded on both copies. The transfer and editing equipment at one facility is sometimes incompatible with equipment at another; in particular, watch out for incompatability in the placement of the time code. *Before* beginning the video editing process, seek advice.

Film editing involves far simpler equipment than video editing does. Some people claim that the hand manipulation of footage in film editing creates a closer relationship to the film than is possible with the push-button editing of video. Hand manipulation does make it easier to remove and add sections of picture and sound. Video editing relies on the sequential recording of shots, and, since the tape is not spliced but recorded, the adding or dropping of shots requires re-recording the entire tape. Improvements in computer control and the ability to make dubs with less loss in image quality are making it easier to drop or add in video editing. There are filmmakers who prefer to edit on video because of the ease of image manipulation, the ability to generate and immediately evaluate effects (many of which would require expensive and time-consuming optical printing in film) and the ability to save various versions of edited sequences for later review. Even when you cut film, edited sequences can be saved on video. Some flat bed tables are set up for easy film-to-tape transfer.

Video editing offers additional advantages for super 8 film editing. The lack of latent edge numbers and the scarcity of quality editing equipment and lab services make film editing difficult in super 8. Transferring single system super 8 to video lets you avoid the editing problems encountered in single system film editing (see Chapter 12). Video tape playback machines are easy to find, and the tape itself is far less fragile than is super 8 film, making it a better distribution medium. Many super 8 movies are released in video even if they were edited on film. Alternatively, you can edit the film with a video workprint and then conform the film to the video version to avoid much of the handling of the camera original. Video tapes that originated as super 8 film often have better sharpness and color than tapes done on inexpensive video cameras.

12
Sound Editing

Most 16mm and 35mm films are made in double system, as discussed in Chapter 1. Sound is usually recorded on ¼″ tape and then transferred for editing onto 16mm or 35mm *magnetic film,* called variously *mag film, mag stock,* or *fullcoat.* Mag film has sprocket holes like camera film and a brown or black magnetic oxide onto which sound can be recorded. Some 35mm magnetic film is only partially coated with oxide and is thus not called fullcoat.

Some filmmakers edit the ¼″ tape instead of mag film. Without sprocket holes, however, there is no way to keep the sound and picture in line during the editing process. This technique should only be used if it is not crucial that the sound and picture maintain a fixed position with respect to each other.

During editing, several strands of mag film may be put together with the picture. These strands (called *tracks*) may contain dialogue, sound effects or music. When the editing is complete, a *sound mix* is done to combine the various tracks into one final track. This mixed track is ultimately combined with the picture when a print is made. The print's sound track may be photographic *(optical track)* or magnetic *(mag stripe).*

Most super 8 and some 16mm films are shot in single system where the sound is recorded in the camera. Films shot in single system may be edited as such, or the sound can be transferred to super 8 or 16mm fullcoat for double system editing.

Double System Sound

Synchronous, or *sync, sound* is sound that is matched to the picture in the way in which you are accustomed to hearing it: when something on screen (like a person's mouth) seems to be generating a sound, you hear it at the same time. If you use *nonsynchronous equipment* (like a camera with a typical home tape recorder), the difference in speed between the two machines results in the sound and picture appearing *out of sync.*

Sound recorded with nonsynchronous equipment or with a sync recorder that is operated when the camera is not running is called *wild sound*.

Sound Transfer

Double system sound must be re-recorded from its original material onto mag film for editing. This process is called *transferring*. Although not standard industry practice, filmmakers sometimes cut out the useless sound prior to transfer to save money. Usually, whenever sync-sound picture is workprinted, the accompanying sound is transferred to magnetic film. Wild sound rolls may be transferred as needed. One advantage of sound transfer is that it protects the original from damage during editing.

Mag film comes with either an *acetate* or a *polyester base*. Acetate base tends to shrink with age and low humidity, and it is more brittle than polyester, a condition that worsens as it ages. Polyester is cheaper, more resilient, and less likely to tear. Initially, there were difficulties applying ink edge code to polyester, but inks cured in ultraviolet light have overcome this difficulty. Force of habit seems to be the main reason some editors still choose acetate. Polyester can, however, be tougher on equipment since it is so hard to break.

A roll of mag film may be slightly magnetized sometimes when you buy it. At some sound houses, it is standard operating procedure to demagnetize virgin mag film before it is used (see Chapter 7). Filmmakers hoping to cut costs sometimes buy used mag film or discount brands. In principle, there is nothing wrong with used stock, since, as long as it is unworn, it can be erased and reused. However, if a roll has shrunk from age, is heavily spliced or has a worn emulsion, do not buy it. Shrunken perfs can tear or chatter when they go through equipment, and splices lift the mag film as it crosses the record head, causing a brief sound dropout. The quality of "white box" and other discount mag film varies greatly. Some discount stocks are old material that has been *washed* (the old emulsion is removed and a new one applied). These stocks may become brittle and break. This often happens during the sound mix where the fullcoat is loaded on high-tension machines. Avoid "white box" tape in critical applications.

Sound transfers are typically done by sound houses that charge $40 or more per hour (it may take as long as two hours to transfer one hour of tape). It is often possible to get access to transferring equipment through schools or filmmakers you know, and doing your own transfers is not difficult.

Wild sound is transferred simply by playing the original tape and re-recording it on a magnetic film recorder, or *dubber*. (The word *dubbing* comes from *doubling,* that is, to copy. "Dubber" is sometimes used to mean a machine that only *plays back* magnetic film.)

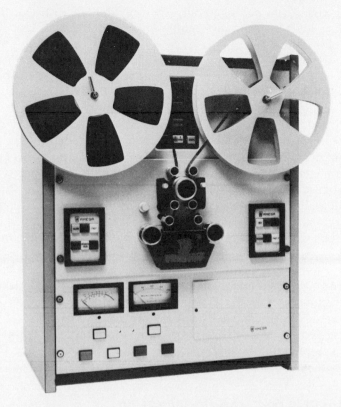

FIG. 12-1. Amega 16mm magnetic film recorder/reproducer. (Rangertone Research, Inc.)

Sync-sound tapes must be put through a process called *resolving* while they are being transferred. Resolving ensures that the original tape is played back at precisely the right speed.

RESOLVING. When a tape is recorded using either a cable or crystal sync system, there is, in addition to the regular audio track, a pilot track that contains a series of pulses used to control the tape's speed. In most American systems, sixty pilot pulses are recorded every second. The resolver ensures that sixty of the recorded pulses pass the playback head every second.

For example, let's assume that you are recording normally both the sound signal and the sixty pilot pulses each second. Suddenly, the batteries give out and the tape slows down slightly. Since less tape is now passing across the heads in any given second, the pulses will be spaced closer together on the tape. Suppose you take the tape home and play it

with fresh batteries. The tape will be replayed faster than it was recorded, and the sound will be unnaturally sped up and high-pitched, the voices taking on the characteristic "chipmunk" quality. This tape would be useless for sync-sound.

If, instead, the tape were played back on a recorder equipped for resolving, the resolver would sense that at normal playback speed more than sixty pulses were passing the playback head each second. The resolver would slow the tape down until exactly sixty pulses passed each second, and the tape would then be played back *at the same speed it was recorded*. The sound will be normal, fit for sync-sound work. This example of dying batteries is, however, for illustrative purposes only; most resolvers cannot make such gross adjustments in speed. Resolvers normally adjust for speed variations caused by stretching and shrinking of the tape, slippage in the recorder and small changes in the recorder's speed.

If, while resolving, you transfer the sound to a magnetic film recorder (which runs accurately at 24 fps and, unlike a ¼" tape recorder, has sprocket teeth that do not allow the tape to slip), as far as speed is concerned, it is as though you had recorded on sprocketed magnetic film in the first place. Now both sound and picture are recorded on strands of sprocketed film, which can be run synchronously together.

The above describes the basics of resolving tapes recorded with crystal sync. The principle behind resolving cable sync and other 16mm and super 8 transfer equipment is similar.

Transfer Level and Equalization

Sound transfer is a re-recording of sound from one tape stock to another. As with all recordings, it is necessary to control the volume and quality of the sound. You can do transferring yourself or give instructions for volume and equalization to the sound house that will do the job.

With most 16mm and 35mm films, a sound mix is done before the final print is made; most adjustments in the sound can be made in the mix. With some films, there is no mix and the final track is made directly from the mag film used for editing. If this is the case, more care needs to be taken when the transfer is done.

If a mix is to be done, the following general rules apply. To minimize system and tape noise, the transfer level should be kept as high as possible without overmodulating (see Chapter 7, Setting the Recording Level). Do not make frequent or sudden adjustments in the level. If possible, warn the person transferring of any unusually loud or soft sections in the ¼" or cassette tape. If a reference tone was recorded on the original tape, the transfer level will normally be set so that the tone reads 0 dB on the transfer equipment's VU meters (this is true even if the

reference tone was originally recorded at −8 dB on a Nagra 4.2 modulo-meter). The reference tone helps to calibrate the transfer level to the original recording level, guaranteeing that sounds not over-recorded originally will not be in the transfer. Many sound houses ignore reference tones because they assume that recordists do not set their levels properly.

A minimal amount of equalization (also called *EQ* or *filtering*) should be done during the sound transfer. The mix is a better point at which to make subtle adjustments in equalization, since at that stage the sound can be judged in the context of the picture it accompanies. Heavy equalization prior to the mix would limit the mixer's flexibility. However, more extensive filtering in transfer may be warranted by certain kinds of sound interference (such as a refrigerator's hum) or the need to show the film a great deal in its rough form (for fundraising, perhaps).

A basic equalization for all tracks is to *roll off* (reduce) bass frequencies sharply below about 100 Hz and treble frequencies above 10,000 Hz or so. Sounds beyond these extremes do not contribute anything useful to most magnetic tracks. The frequency response of 16mm optical tracks does not even extend to this upper limit. Filtering out the bass helps to minimize wind noise, rumble and boominess; it removes unwanted, possibly loud sound that, if left in, could force you to transfer at too low a level.

If no mix is planned, the transfer level should be adjusted appropriately for each scene (although some further adjustment can be made when the final optical or magnetic track is recorded). One common equalization pattern that is used to improve the clarity and intelligibility of many tracks is to roll off bass below about 150 Hz and treble above about 9000 Hz (to diminish rumble and hiss respectively), and to increase the mid-high frequencies between about 2000 Hz and 5000 Hz to improve the clarity of speech (see Fig. 12-2). This equalization is normally done with a graphic equalizer. If this piece of equipment is not available, the effect can be approximated with the bass and treble controls found on most amplifiers, sound systems and projectors. To improve clarity, turn the bass down and the treble up somewhat.

Equalizing and Sound Processing Equipment

GRAPHIC EQUALIZERS. *Graphic equalizers* permit selective emphasis or de-emphasis of frequencies throughout the audio spectrum. They can be used to improve the intelligibility of tracks; as a fine-tuned bass and treble control for equalizing music or changing the character of other sounds; for special effects such as simulating the sound of a voice over the telephone (increase frequencies between about 500 and 2000 Hz, decrease all others).

Notch-Peak Filters. Also called *dipping filters,* these filters work somewhat like graphic equalizers. They allow usually two bands of frequencies to be either *notched* (diminished) or *peaked* (increased) relative to the others. Notch-peak filters are much more precise for fine-tuning than graphic equalizers. They are useful for pinpointing and removing a given frequency, like the 60 Hz hum caused by fluorescent lights, with minimal disturbance to the rest of the track. Many kinds of interference are audible at both fundamental frequencies and harmonics; notching at two or three frequencies may be necessary for complete removal. This kind of equalization is sometimes best done during the transfer, not the mix, because it may take a long stretch of track to locate precisely the interference. Some notch-peak filters also allow adjustable roll-off of high and low frequencies.

Compressors. *Compressors* reduce the level of loud sections of the sound track. They can be set to act like *limiters* (see Chapter 7), cutting in sharply to protect against overmodulation, or they can be set to take effect at lower volume levels, cutting down the volume more gently. After the sound track passes through the compressor, it has a *compressed* dynamic range—that is, all sounds are closer to the same volume level. Many people use compressors for material that is to be released on television, or for films that are likely to be shown with the projector in the same room as the audience. With compression, relatively quiet sounds are brought closer to the level of loud sounds and are thus less likely to be lost in the ambient noise of the screening environment. However, tracks that are excessively compressed have a flat and unnatural quality.

Reverb Units. *Reverb units* increase the time it takes for sounds to die out. Increasing reverberation can make it seem as though a sound is coming from farther away. Reverb units can make voices postdubbed in the studio seem more like they were recorded on location. You can create reverb simply by playing the sound track through a loudspeaker in a reverberant space and re-recording it with a microphone.

De-essers. Compressors used to reduce the *sibilence,* or whistling, caused by *s* sounds in some people's speech are called de-essers. You can hear sibilence distortion sometimes by turning the volume very high on a small radio. Sibilence can be especially disturbing on an optical track; the de-esser compresses the high-frequencies (where sibilance distortion occurs) without affecting much else in the sound.

Other Sound Processing Equipment. Ambient and tape noise are perhaps the biggest problem in sound recording. *Noise gates* act like

automatic level control in reverse: they *reduce* the recording level when no clear sound signal is present (it is during the pauses that noise is the most conspicuous). Noise gates can make a noisy track clearer, but, with the background level constantly rising and falling, the track may sound noticeably processed. Noise gates can also be used to make an overly reverberant track "drier," that is, with less echo. *Noise reduction units* such as Dolby and dbx (see Chapter 7) are especially useful for cassette tape and for recordings that have to be recopied through several generations.

Handling Magnetic Tracks

Although the workprint is usually marked with a grease pencil, in general it should not be used for marking mag film since it may rub off one layer onto the next on the roll and eventually clog the playback head. Instead, on mag films, use a permanent felt-tipped marker such as a Sharpie.

It is often necessary to splice leader into the sound track. Leader that has an emulsion should be spliced so that the emulsion does not come in contact with the sound head and clog it. *Always splice the emulsion side of the leader to the base side of the mag film.* Use only single-perforated leader for sound rolls, especially at the head and tail, to prevent misthreading and creating noise.

SPLICING. Tape splicers designed to cut picture usually work fine with mag film. White sound splicing tape may be used instead of clear tape, because it is easier to see on the mag film and it does not stretch as much, thereby avoiding sound dropouts. This is not always true with nonperforated guillotine tape.

Some editors cut the sound on the diagonal, using either a diagonal Rivas splicer or a guillotine splicer equipped with both straight and diagonal cutting blades (see Fig. 11-7). (Note: various makes of diagonal splicers cut at different angles; film cut with one often cannot be butted to film cut with the other.) The advantage of diagonal splices is that if a straight splice stretches or is badly made, when it passes over the playback head, there will be a brief moment when *no* mag film makes contact with the head; a diagonal splice, even if slightly stretched, ensures that some mag film will contact the head, thus minimizing dropout. A straight cut at the beginning of a loud section of track can produce a popping or clicking sound; the same can happen if the mag film or splicer is magnetized. Diagonal cuts minimize these effects. The main drawback of diagonals is that if you are using the Rivas system, you will need to use two splicers.

If noisy splices indicate that your splicer is magnetized, demagnetize it

immediately with a bulk eraser or a hand degausser. Make several test splices on blank mag film, and listen closely with the playback volume all the way up. This is best done on a dubber to avoid being misled by mechanical noises at the splice (which are heard on some editing machines).

Picture is often double spliced (that is, taped on both base and emulsion sides) for greater strength and rigidity. However, never splice the oxide on magnetic stock, or sound reproduction will be interrupted.

In super 8, usually straight splices are used. When you use guillotine splicers with single system film, make sure the magnetic stripe is not covered with the wrap-around tape (see Fig. 11-7). With some splicers, the tape covers the balance stripe but not the main stripe, which may interfere with your plans to record on the balance stripe.

Synchronizing the Rushes

For movies shot with synchronous sound, the picture is always matched up with the sync sound accompanying it before true editing begins. This process is called *synchronizing the rushes* or, more commonly, *syncing up* (pronounced "sinking"). When syncing is complete, each roll of picture has a roll of mag film of equal length that can be played back with it; every sync-sound shot on the picture roll is matched in frame-for-frame correspondence to the appropriate section of sound track.

Typically, with sync-sound footage, there is more sound than picture. This is because the recorder is usually turned on before and off after the camera and because other wild sound is deliberately recorded when the camera is not running. (Of course, there is also a certain amount of MOS picture.) Some people remove all the wild sound during syncing and spool it up on separate rolls. Others leave most of it in place and splice the same length of leader into the picture to keep it even with the sound roll. In general, no footage is removed from the picture roll during syncing unless absolutely necessary; moving picture from one roll to another can result in confusion when searching for footage, and throwing picture away is often later regretted.

Syncing up requires an editing bench equipped with rewinds, a synchronizer, a viewer, a sound head and an amplifier, or an editing machine like a Steenbeck or Moviola. There are many methods of syncing up—one is outlined in Appendix B.

In 16mm, two 400' camera rolls are usually spliced together during syncing to form one roll for editing, which fits comfortably in a 1000' capacity can. Longer rolls can be difficult to handle during editing, resulting in wasted time when searching for a particular section of footage. When the syncing is complete, each roll should have *one* set of *start*

FIG. 12-2. Graphic equalizer. On the model illustrated, each slider controls a band of frequencies a half octave above and below the indicated frequency. When a slider is above the 0 db line, the volume of sound in that frequency band will be boosted; below the line, diminished. The equalization indicated here is a basic one for improving the clarity of many tracks (compare it with Fig. 7-10 ii). Equalization should always be done by ear and not by formula.

marks (see Fig. 12-3) at both the head and tail, along with proper labeling so that footage can be easily identified and put in sync when needed.

Many people find syncing up complicated at first and later wonder why it seemed so confusing. Entry-level jobs in film editing often require proficiency in syncing, so it is a skill worth mastering for the beginner who hopes to get employment as an editor.

FIG. 12-3. Properly marked head leaders for editing. The start marks are the X's that cover one frame and are directly opposite each other on picture and sound.

Syncing Nonsynchronous Footage

Footage that was shot with nonsynchronous equipment or with mal-functioning sync-sound equipment can still sometimes be put in sync. The trick is to run the playback deck *slightly* too slow during the transfer to mag film; the transferred mag film will then be slightly longer than the accompanying picture. While you are syncing, if the footage begins to drift out of sync, you can splice out a few frames of mag film, correcting the error. Playback decks with fine-tuning speed adjustments should be used to make the transfer. Some sound houses have recorders with rotating heads or digital pitch shifters that can make large speed corrections without altering the pitch of the sound.

Accuracy, Slates and Lip Syncing

Most sync footage is filmed with the help of a *slate,* whether it be a clapper board, a slate light or a microphone tap. When syncing up a slated shot, be sure to line up the *first* point in the picture where the slate makes contact and the *first* point where it is audible in the sound. Sometimes the picture slate occurs between frames. Simply line up the exact point where you think the picture slate occurred with the first point of the sound slate and then shift them slightly so that the two closest sprocket holes line up.

At some point you will undoubtedly have to sync up a shot that has not been slated. To do this, find a surrogate slate in the scene—the closing of a door or an object being placed on a table. Learn to sync up the movements of people's lips with their spoken words. Look for words that contain hard labial sounds like *b* and *p* for which the sound becomes audible just as the lips part. The *m* sound can be used, but it is not as precise.

After approximate sync has been determined, experiment by sliding the picture two frames ahead or two back to see if you can improve synchronization. Then try moving it one frame each way. A sync error of one or two frames is usually noticeable to attentive audiences. Syncing should be checked on a projector (not the little screen of a viewer) before edge coding (see below). Sync errors detected after coding are annoying or, after a print is made, very upsetting.

Edge Code

After footage has been synced up, it is extremely useful to have it *edge-coded.* Edge-coding involves applying inked numbers between the sprocket holes identically on both sound and picture rolls. In 16mm, edge

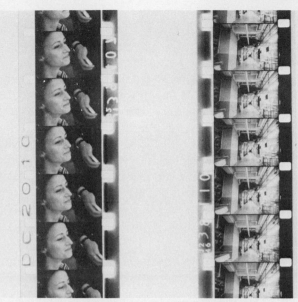

FIG. 12-4. Latent edge numbers are only found on picture (the strip on the right shows J2/46 38 110). The machine edge code on the left is DC 2010. Both picture and track can be machine coded identically for editing. (Ted Spagna)

code is printed every 16, 20 or 40 frames, depending on the setup of the coding machine. Edge-coding is sometimes called *edge-numbering, machine edge-numbering* or *inked edge-numbering,* but do not confuse edge code with the latent edge numbers (also known as *key numbers*) that the manufacturer prints photographically on each roll of picture (see Fig. 12-4).

When an editor sends footage to be coded, he or she chooses what code will begin each roll (for example, AA0000, AB0000). Every pair of sound and picture rolls will then have the same set of numbers printed on them every half foot or so.

The benefit of edge-coding is twofold. First, the footage can be put in sync at any time simply by lining up the numbers on picture and sound. Second, the code aids enormously in identifying and organizing every piece of footage, especially for sound stock, which is made without latent edge-numbers and can be difficult to recognize. Edge-coding costs about 1½ to 2 cents per foot (3 to 4 cents for both sound and picture), and there are usually discounts for large orders.

While printing the edge numbers, the ink bleeds. This is especially a problem in super 8 where it may bleed into the picture area of the film. In general, inked edge-numbering on the original should be avoided.

Work Tracks

Editors working on well-budgeted films often make *work tracks*, which are protection copies of the synced-up mag film that are used for editing. Work tracks are made on high-speed dubbers that record from the "original" mag film to the copy at several times the normal speed. The dubbed track is then edge-coded identically to the original and is edited along with the workprint. After editing, the original mag film is conformed to the edited copy by edge code. The sound mix is then done with a pristine track that has been spared the often substantial wear and tear of the editing process. Without work tracks, it is often necessary to retransfer footage that has been damaged prior to the mix.

Postsynchronized Dubbing

If footage is shot without sync sound or if the sync sound is unusable, it is possible to record dialogue in a sound studio while watching the picture. *Postsynchronized dubbing*, or *looping*, is typically done for feature films shot on noisy locations or when dialogue is to be redone by another actor or dubbed in a foreign language for distribution abroad. A short section of picture is spliced head-to-tail with some leader to form an endless loop. With the help of a *scratch track*, which is a low-quality sync recording made during shooting, the actors attempt to synchronize their speech to the lip movement on the screen. The loop is replayed until a successful take is recorded.

Dubbing is extremely difficult to do well. Often the timing is wrong or the voices sound "canned" and unnatural. A sound mix must be done to equalize the dubbed tracks, to add reverb and to try to match the tracks to sound effects and any tracks recorded on location. While dubbing, the projector noise should be isolated from the actors (see Chapter 15). One low-budget technique is to use mag striped film and a single system projector, recording right on the film as it is projected.

Double System with ¼-inch or Cassette Tape

Filmmakers who do not have easy access to sync-sound equipment, especially those working in super 8, often edit with conventional nonsynchronous tape recorders in either ¼" or cassette formats. The drawback with this is that no matter how carefully the sound tracks are constructed, you cannot guarantee that the sound and the picture will stay synchronized as they were intended. Let's say you are working with a projector and a reel-to-reel tape recorder, timing sequences with a stop watch and

cutting together a sound track to accompany them. Errors are introduced because you must start the two machines together by hand and because non-sync projectors and recorders do not all run at the same speed. If you play the film on someone else's equipment, the timing might be very different. It helps to get a *common start device* as well as a *tape synchronizer,* which mounts on the side of the recorder and allows you to fine-tune the tape speed to match approximately the speed of the projector.

Nevertheless, not all sound tracks require precise timing and there are certain advantages to editing on ¼″ or cassette tapes. It is easier to get access to high-quality home recording equipment than to sync-sound machines. A ¼″ tape can be spliced with an inexpensive splicing block and a razor blade. Also, many home recorders can accommodate up to four distinct tracks on the same tape and have such features as *sound-with-sound* (which allows you to record a second track while listening to the first) and *sound-on-sound* (which permits mixing a recorded track with another recorded track or with a live source). With these features, complex sound montages can be built up that may be difficult to execute with traditional film editing setups. However, certain sound-on-sound systems, which are sometimes called *sound-over-sound,* lower the quality of the first-recorded track (see Magnetic and Optical Tracks, p. 238).

The fact remains, however, that double system with ¼″ or cassette sound is not a format to use for film distribution. If distributing the film is your goal, you must make a composite print with an optical or a magnetic track. You can record a magnetic track yourself on a mag sound projector, playing the track on the same cassette or ¼″ machine used to record it originally. This gives you a good chance of getting the timing the way you want it. If an optical track is to be made, it is worth dubbing the sound on super 8 or 16mm mag film first so that you can check the timing on a sync-sound editing setup. Otherwise, you may be unpleasantly surprised after paying for an optical negative and a print.

Single System Sound

Filmmakers who choose to work in single system usually do so for the low cost and simplicity of the equipment. However, they miss out on much of the versatility of double system techniques. In single system editing, the picture must be cut whenever the sound is (and vice versa), which can be extremely frustrating to editors accustomed to cutting them independently. Other problems are caused by the separation between sound and picture. In super 8, the sync sound accompanying any given frame of picture is found 18 frames ahead of the picture; in 16mm, the separation is 28 frames (see Fig 1-10). Thus when two shots are spliced together, the sound accompanying the first 18 (or 28) frames of the second

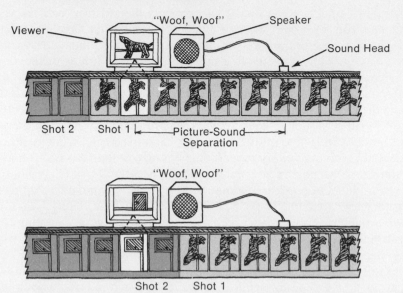

FIG. 12-5. Edited single system film. (top) Picture and sound of the dog barking are seen and heard at the same time. (bottom) The film has advanced slightly and the beginning of the door opening is now seen while the sound of the dog is still heard. This problem occurs when two pieces of single system film are *cut* (from their original positions in the camera roll) *and spliced together*. If the film in the illustration had come straight out of the camera, the sound for the first frames of the door opening would be positioned alongside the last frames of the dog's picture. The separation between the picture and sound head is 18 frames in super 8, 28 frames in 16mm.

shot comes from the magnetic stripe at the tail of the first shot. It is not possible for the editor to make a cut in which both sound and picture change simultaneously at the cut (the way in which most double system cuts appear). Such a transition occurs every time the camera is stopped —it just cannot be done in editing. Furthermore, if the editor trims a shot to start at the moment some sync-sound event is beginning in the picture (say, a door just opening), the first 18 (or 28) frames of sound for that event will be cut off.

There are a number of ways to circumvent these problems. One is to transfer the sound to double system. This also provides a protection copy of the sound, which can be extremely valuable. To make the transfer, play the film on a dubber that is set up to run picture without scratching or on a synchronous projector (that runs precisely at 24 fps) and re-record the sound on a sync recorder. A regular, non-synchronous projector can be used if both it and the recorder can accommodate a cable sync connection between them (this will usually be digital sync, see Chapter 7).

Another option is to use a *displacement recorder,* which shifts the sound 18 (or 28) frames back on the mag stripe. After the film has been run through a displacement recorder, every frame of picture and its sync sound are in line with each other on the film. Some editing equipment can play displaced sound in sync, but most projectors and other editing setups will not allow you to view the film in sync while you are editing. However, with practice you can judge where to make the cuts. After editing, the film is put through the displacement recorder again, and the sound is restored to its original position, ready to be projected in sync.

If you choose to edit single system in its original form, certain shooting techniques can be used to minimize the discontinuities at splices (see Chapter 8). Sometimes it is preferable to have a shot begin in silence rather than to have it accompanied by the sound of the previous shot. Use a pencil degausser to erase the last few frames of track on the outgoing shot. It is easy to erase too much, so be careful. Sometimes it is best to replace the entire track with a continuous piece of wild sound or with postdubbed dialogue.

In single system sound editing, especially in super 8, the projector often plays an integral role in the creation of the sound track, a role assumed by multiple tracks of mag film in double system editing. Many projectors are capable of recording a second sound track, which may be used to mix in music, sound effects or background sound (all of which help mask discontinuities at splices). (See Magnetic Tracks, p. 328.)

Sound Editing Technique

There is a general bias in filmmaking that picture is more important than sound. Much more attention is given to producing the visual than the aural aspects of a movie, and audiences are more likely to comment on interesting camera work than on the creative use of sound. This is due in part to the priority given to seeing over hearing in perceiving the world.

Yet the advent of sound brought new meanings to film and the way images are interpreted. The same shot can be invested with a vastly different sense of mood, location and context, depending on the sound that accompanies it. Some of these impressions come from direct cues (the sound of birds, a nearby crowd, or a clock), while others work indirectly through the volume, rhythm and density of the sound track. Furthermore, the emotional content of a scene (and the emotions purportedly felt by characters on screen) is often conveyed as much or more by music as by any visual display. Even if a film has no sound track, the effect of viewing it in silence (or accompanied by the sounds of the projector and the audience) is key to the way the film comes across, and should not be underestimated.

Sound Quality

The filmmaker's first concern for sound should be the quality of the recording. Bad sound, sometimes even more than a bad picture, conveys an immediate sense of low production values and can easily alienate an audience. This problem is especially acute in sound recorded on location and in documentary production where lack of control over situations makes good sound recording difficult. If the audience has to strain to understand what is being said or if the track is harsh and noisy, the viewers can quickly become tired and give up trying to follow the film.

The editor should reject sound (and picture) that is of poor quality, at least relative to the rest of the film. But beware of sound reproduced with editing equipment. Tracks played on a synchronizer and squawk box tend to be harder to understand than when they are played on a dubber; tracks played on a flat bed editing table tend to be easier to make out because the small speakers on the machine filter out the low- and high-frequency sounds reproduced by better equipment. If a line of dialogue seems marginally intelligible to you, play it for someone who is unfamiliar with it. If few people can make out the line, it is probably not worth keeping. With experience, you will learn to distinguish sound that can be salvaged later by equalization from that which is beyond redemption (when in doubt, have a section of the track retransferred and equalized). In some situations, postsynchronized dubbing may be necessary.

Tracks that contain a great deal of noise (from wind, microphone handling, squeaky camera magazines and the like) should be examined closely for possible remedies. If the noise occurs on only a few frames or is intermittent, it is often possible to remove these frames and replace them with background tone (it may also be necessary to smooth over the entire section with another piece of background sound on another track, see p. 315). Otherwise, the track may need to be re-recorded or replaced with purchased sound effects. Bear in mind that any track noise that is mildly annoying on the editing table (where it is partially masked by machine noise) will be far worse in a screening room with a good sound system and a critical audience.

Sound and Continuity

Sound can be extremely important in establishing a sense of time or place. Fiction film production is often done on acoustically isolated *sound stages* where only the sound of the actors' voices is recorded. Then in editing, *all* of the other sound effects that are eventually heard (for example, footsteps, cars pulling up, rain) are laid in. This editing process is

sometimes called *sweetening* the track. Although editing in this way entails a great deal of work, it affords tremendous control over the sync sound and sound effects in the film.

It is often of utmost importance in both fiction and documentary films that shots filmed at different times can be cut together to give the impression that they all occurred in continuous time. Smooth sound continuity is extremely important for achieving this effect. When you are editing, be attentive to changes in the quality, content and level of sound and use them to your advantage. If your goal is to blend a series of shots into a continuous flow, avoid making hard sound cuts that butt up two pieces of track that differ greatly in quality, especially if there is also a cut in the picture at the same place. (Certain differences in quality and level can be smoothed over later in a sound mix.)

Audiences will accept most gradual changes in sound quality. An editing machine that plays two sound tracks simultaneously with the picture allows the editor to make long overlaps where one track blends slowly into another. This *sound dissolve (cross fade)* is later recorded in the mix. The use of multiple tracks opens up numerous possibilities for reinforcing the illusion of continuous time. One technique is to add in a background

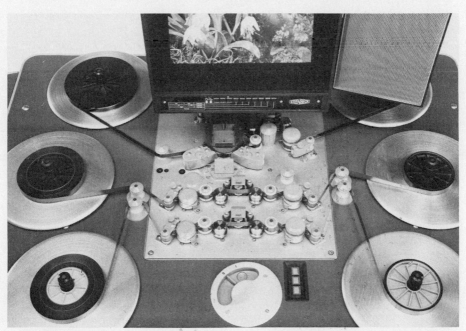

FIG. 12-6. Steenbeck 16mm six-plate flat bed editing table with two sound tracks and one picture head. Each track can be moved independently or in sync with the others. (Steenbeck, Inc.)

track that remains constant and masks other discontinuities throughout the scene. Another is to insert sounds that distract the audience from jumps in the sound. For example, when scenes with ambient, rather than added, background music are cut, the addition of a short, sudden noise (like a cough or a car horn) will sometimes disguise the fact that phrases or sections of music have been removed.

Multiple tracks are often used to blend an isolated noisy shot containing, say, an airplane sound into quiet ones. In this case, airplane sound (which is often purchased from a sound effects library) is introduced before the shot, gradually faded in and gradually faded out after the shot. This combination gives the impression that the plane passed overhead during the three shots. As long as the sound as it is finally mixed does not cut in or out sharply, many discontinuities in the track can be covered with this technique. Much multitrack work is best done after picture editing is complete, while you are preparing for the mix (see p. 318).

While gradual sound dissolves ease viewers from sequence to sequence, it is often desirable to have hard, clear changes in sound to produce a shock effect. Opening a scene with sound that is radically different from that of the previous sequence is a good way to make a clean break, start a new chapter. Sounds can be used as punctuation to control the phrasing of a scene. It is not unusual for the rhythm of sounds to be as great a determinant of how a scene is edited as the visual content.

Editing Dialogue

In film there is usually a premium on terseness. Often you can begin sequences after most of the setup has already taken place. It may be possible to begin a sequence when it comes to the key point, doing away with much of the preceding exposition. Sometimes a pivotal line can be moved to the beginning of a sequence, allowing the rest to be made more succinct. Not every scene needs a beginning, a middle and an end. Most people's speech contains false starts, digressions, long pauses or uninteresting detail, some of which can be removed to speed the pace of the scene.

The use of simple cutaways is the most common method of condensing or rearranging speech. This style is familiar to watchers of television news or interview programs like "60 Minutes." A three-shot pattern is used. While the subject being interviewed is speaking, the picture cuts to a shot of the interviewer, or, perhaps, the subject's hands. During the cutaway, the speaker completes a thought and the sound cuts to another sentence; to the audience this sounds like the normal flow of speech. Before the picture cuts back to the subject's face, pauses, words and whole sections of dialogue can be removed or added. The editor can construct any number of possible sentences from the collection of recorded words.

Some editors dispense with cutaways altogether; instead they use match cuts or jump cuts (sometimes smoothed over with picture dissolves) in the interest of condensing the dialogue.

Cutting away from sync-sound dialogue can be useful for providing a sense of dynamic flow in a conversation. Say you cut from one person asking a question to a shot of someone else responding. If the picture cuts from the first person to the second before the question is finished, assuming there is sufficient room in the footage, the editing may take on a more natural, less mechanical feeling. Showing the person being spoken to, and not just the person speaking, can give the audience insights into the characters as well as clues on how to react to what is being said. Alfred Hitchcock insisted that what is said on the track should contrast with what is seen. Cutaways may be chosen to provide an interesting counterpoint to the spoken dialogue.

In fiction films, where the pacing of dialogue is often quite consistent from one take to the next, it is frequently possible to substitute the sound from one take with that of another. Pauses between words usually need to be trimmed or expanded slightly to maintain sync.

When you are cutting speech, it is often necessary to separate words that are spaced closely together on the track. This is a skill that improves with practice. A useful aid is to put a piece of low-tack masking tape (sold in architectural supply stores) on the emulsion side of the track, beginning or ending on the frame you plan to cut. (The recorded track area on U.S. standard 16mm and super 8 mag film is the top quarter of the film opposite the edge with sprocket holes.) This way you can try different versions of the cut without chopping the track to shreds. Be sure to remove any tape goo from the track or it will clog the heads.

Editing Music

Music may be disembodied background music or it may be made to appear to be emanating from some source in the scene (for example, from a radio or a pianist next door). To preserve continuity, music is almost always added to a film during editing and is rarely recorded simultaneously with the dialogue. (Of course, in documentary film, recording ambient music may be unavoidable.) Music meant to appear to be emanating from the scene is usually equalized or processed to simulate its supposed source. For example, if a character turns on a car radio, the music laid in later, which is usually recorded from a phonograph, should be equalized to roll off much of the bass and treble frequencies that would not be reproduced by the small, low-fidelity speakers found in most cars.

When music is used, especially if it is louder than other sounds on the track, it can easily dominate a sequence in terms of the sense of rhythm and mood projected. Sequences edited for one piece of music will look extremely different when another is substituted. Audiences naturally

draw connections between the phrasing of the music track and the editing of the picture; various cuts or shots will be given emphasis (or will seem out of step), depending on the passage of music that accompanies them. Music also provides an emotional cue that informs the audience, say, if a given scene is meant to be straightforward or ironic.

It is extremely risky to edit the picture independently of the music that will eventually be laid in, in particular if the music was not scored specially for the film. If possible, preview the potential music track early in the editing process. Music scoring and editing are often left until the end of postproduction, but there are real advantages to starting these tasks earlier. Many filmmakers prefer to use no background music because it can so easily manipulate the audience and compete with the imagery. On the other hand, fiction films often seem extremely flat without music tracks.

Editing picture and music together is easier if you are familiar with the mechanics of music. Some picture cuts are best made on the up-beat, others on the down-beat. Locating the beats on the mag film can be difficult at normal speed and impossible at slow speeds because the sense of the music is lost. Some editors jab at the mag film with a felt-tipped marker as every beat passes the playback head at normal speed and then cut the track accordingly. When the need arises, if you are careful you can remove phrases, verses or passages from the music to make it conform better to the sequence. Also, music can be faded in or out at the mix, thus avoiding an abrupt cut at the end of a sequence. A musical note or another sound (like some sirens) that holds and then decays slowly can be shortened sometimes by removing frames from the *middle* of the sound rather than from the beginning or end.

Music and sound editing is much easier in 35mm since there are four sprocket holes for each frame, allowing more precise trimming. Editing equipment is available that plays 16mm picture with 35mm track.

If you have music composed for your film, you must arrange for musicians and a recording session. If you use prerecorded music from a record, you must pay for copyright clearances. If you purchase "canned" music from a music library, you pay only one charge for re-recording and copyright (see Chapter 16).

The Sound Mix

Sound mixing accomplishes two things. First, it allows the filmmaker to build the sound track from a number of different sound sources—sync sound, music, sound effects. During the later stages of sound editing, each type of sound is carried on a different strand of mag film and can be positioned and manipulated separately. (In documentary films, the sync sound track usually contains dialogue and most effects.) During the mix,

all of the different tracks are combined onto one track. The second reason for mixing is to provide control over the level and equalization of sound for each shot. The sound from various shots in a sequence can be balanced to create a coherent whole.

To save time, many filmmakers edit the picture with only one strand of mag film (two sound tracks require six splices instead of four every time a section of footage is added). When picture editing is complete (called *picture lock* or *picture freeze*), this track is split into two or more strands according to some simple rules to make the mix easier (see below). Additional tracks can be built up at this time.

In the mix studio, each sound track is loaded on its own dubber and all the dubbers are *interlocked* so that they will run synchronously and can be started and stopped in unison. The sound mixer, sometimes called a *re-recording mixer,* has a console or *board* that has a volume control and equalizer for each dubber; like an orchestra conductor, the mixer determines how each track will blend into the whole. Also interlocked to the dubbers are a projector to show the picture in sync and a master record dubber that records the mixed sound on either 16mm or 35mm mag film (see Fig. 12-7).

Mixing super 8 mag film is unusual, but it is possible (see Some Alternatives, p. 327). More commonly, the sound track for a super 8 film is transferred to 16mm for mixing or the sound is mixed on the super 8 projector while recording the mag stripe.

Previewing Sound Tracks

Ideally, any sounds that are to be included in the finished film should be previewed with the picture prior to the mix. The picture and a single sound track can be played on a double system projector (see Figure 15-1). Since most film sound tracks involve overlapping elements (for example, music that is audible under the dialogue), it is helpful to check the sound on an editing system that can play more than one track simultaneously. Filmmakers often rent such equipment when they begin sound editing; a six-plate flat bed editing table can play two tracks with the picture (or three without it). Multi-gang synchronizers with sound heads can be used but the sound quality is poor (see Fig. 11-8). Mix studios usually offer reduced rates to filmmakers who want to preview all their tracks together in an *interlock screening*—something that can be well worthwhile both to check for errors and to see how well you like the editing.

Setting Up to Split Tracks

Tracks are split to segregate different types of sounds (for example, dialogue, music or narration) on different rolls. Mixing is usually done

FIG. 12-7. Mix studio dubbers. Six playback transports are at left, one master record transport is at right. All can be run in interlock. (Rangertone Research)

with at least two tracks, but a complicated feature film may have thirty or more. In these films, all the sound effects are added during editing, and it helps the mixer if the footfalls, car horns and telephone sounds for a sequence are all on separate tracks so they can be balanced together. When many tracks are used, a *pre-mix* is done to consolidate many of the effects. A typical documentary can be mixed with four tracks: two for sync sound, one for narration and one for miscellaneous effects (background tone and the like).

Split tracks are a little like A&B rolls for printing picture (see Fig. 13-2); on each roll, sections of mag film alternate with sections of nonmagnetic leader that act as spacers. Clean, unshrunken slug or fill, spliced with the mag film emulsion-to base, is usually used for this purpose.

Tracks can be split on a flat bed editing machine, but it is far easier to use an editing bench with a synchronizer and rewinds. Put the edited sound track rolls on the left; the splices where they are to be split should already be marked (see p. 322). Also put on the left as many rolls of leader as you will ultimately have tracks. This is limited by the number of gangs on your synchronizer; the rolls may have to be done in two or more groups. It is crucial to load up the picture also to be able to check for cutting errors.

Put all the rolls in sync on the synchronizer. At the head of each roll, splice about 15 feet of single-perf white leader that is properly labeled with production company name, film title, "head" and the track number (many people identify tracks by letter, not number).

Only on the picture roll, splice a Society of Motion Picture and Television Engineers *(SMPTE)* head leader between the first frame of picture and the white leader. *SMPTE* or *Society leader* (sometimes erroneously called Academy leader, which is a different system) contains the familiar countdown from 8 to 2, followed by a short section of black leader (see Fig. 13-6). If you can't get SMPTE leader from the lab, you can fake it by marking the proper frames on your own leader. The frame at 8 is marked "picture start"; this is a good point at which to synchronize all the rolls. Use a hole punch (available at stationery stores) to punch the same frame on each of the sound rolls. On the 144th frame after the picture start (that is, 3 feet, 24 frames in 16mm, 9 feet in 35mm) is the 2 frame. This frame should be spliced out on the *sound rolls only* and replaced with a frame that has a distinctive tone (about 1000 Hz is standard) or, more simply, left in with a stick-on *sync beep* (also called a *sync pop*) applied to the track area. In the U.S., the track is located in the top quarter of the oxide on the side that has no sprocket holes. The European standard has the track in the center of the mag film.

When the film is projected, all the tracks should beep when the number 2 appears on screen, which tells the mixer that all the tracks are in sync, and, if he listens to them individually, that all the dubbers are functioning.

The sync beep is also necessary for lining up the optical track in printing. The first frame of the movie appears on the 192nd frame after the "picture start" frame (4 feet, 32 frames in 16mm, 12 feet in 35mm).

Mix dubbers run at high tension. Rivas splicers, which use preperforated tape, make stronger splices than guillotines and should be used for the final splicing if possible.

For mixing and printing, films are broken down into segments of convenient length called *reels*. Most mix studios and labs will not accept reels longer than about 1100' in 16mm because the raw stock used for optical tracks comes in 1200' rolls. Occasionally the two reels for an hour-long film are spliced together, but such splicing places great strain on the original in printing. After a film is printed, however, two reels can be spliced together for projection. If this is contemplated, the first 26 frames of sound for the second reel should be mixed *on the tail of the first reel* (in 16mm); this is done because, when the two reels are spliced together after printing, you must work around the same sound-gap problem encountered when editing any single system film (see Fig. 12-5). If you do not take this precaution, when you splice the reels together, the first will end in 26 frames of silence and the second will begin with the first 26 frames of sound cut off. Note: sound is displaced 26 frames in 16mm optical sound prints and 28 frames in magnetic sound prints.

If you are making a 16mm film that is longer than 2400' (about 65 minutes), the film must be printed on at least three reels. Sometimes it will be shown with these reels spliced together; other times they are kept separate. Keep in mind that the points at which you divide the film into reels for the mix are the points at which there will be short breaks to change reels in some screenings (see Chapter 15).

At the end of the film, splice on a SMPTE tail leader and put beeps at the tail sync mark on all the sound tracks to be able to check that all the rolls remained in sync throughout the mix. Add about 15' or 20' of white leader after the beeps, which is needed so that the dubbers can be run past the end of the film and then back, and properly label the tail leaders.

Splitting Tracks

When you split tracks, sound should not be randomly divided among the various rolls. Most mix studios prefer that the sound rolls be laid out according to the following scheme: the first tracks contain dialogue, the next narration, then music, and finally effects. If there is no narration or music, the effects tracks would follow immediately after the dialogue tracks.

This layout is used partly so the mixer knows what to expect from various tracks, but also so that he can minimize the number of adjust-

ments made during the mix. If a track contains only narration (which is usually recorded at a constant level and quality), the mixer can set the level and equalization once for that dubber and then leave it alone. However, if a film has only a little narration, other types of sounds can be put on the same roll as long as there is adequate separation.

Dialogue or sync sound is usually divided among two or three tracks. It is not put on one strand because frequently the sound for one scene is recorded significantly lower or higher than that of a previous scene. If both scenes were on the same track, it would often be impossible for the mixer to make an instantaneous level adjustment when the cut flew by. If the scenes are on separate tracks, and thus carried on separate dubbers, the level and equalization for each can be set beforehand on separate controls. At the cut, the sound switches from one dubber to the other.

In general, tracks should be split when two sections of mag film differ from each other in level or quality and you want them to sound similar or if they are similar and you want them to sound different. Thus, if two parts of a sequence are miked differently and need to be evened out, you should put them on separate tracks. If the difference is due to a change of background tone, it often helps to overlap the head and tail extensions of the shots to ease the transition by doing a subtle sound dissolve. You may want to bring out the difference between two pieces of sound. For instance, if you have filmed the same activity day after day, you might want to show the passage of time by fading out the sound at the end of one day's sequence and beginning the next day's loudly. This is done more easily if the tracks are split onto different rolls. All this said, if you can perform a desired level change at the editing table on one track, there is usually no need to split the track for the mix.

If you plan a sound dissolve from one scene to another, you must put them on separate tracks and overlap the head and tail extensions of each scene (just like a picture dissolve). This usually requires going back to the out-takes and using the edge numbers to find the extensions. In the mix, the outgoing scene will be faded down, the incoming scene faded up. If you put in extra overlap, the mixer will have more flexibility.

It is important to remember that the mixer can only respond as quickly as is humanly possible. If you split from one track to another and then back within a foot, that does not leave him much time to react. If you go to a third track, he can set all three comfortably beforehand and let them run. Usually, if you can do the adjustments yourself on an editing table, the mixer will be able to as well, especially since most mix studios are equipped to stop and start at any point. Some editors mark cues on the picture to prepare the mixer for adjustments that require critical timing. As long as there is sufficient separation between sounds that require adjustment, it is advantageous to keep the total number of tracks to a minimum.

Room Tone, Loops and Sound Effects

When a sequence is edited, the background ambience or *room tone* should usually remain consistent throughout. The sound person is usually careful to record about a minute of room tone at every shooting location. This tone is then used to fill holes, bridge cuts and cover sound that is added to the edited sequence. If no room tone was specially recorded, some can be found in pauses (retransferring the scene may be necessary). Tone from another scene or light traffic noise sometimes works. For scenes that have no distinct ambience, *white noise,* which sounds like the steady hissing of steam, may be used; a sound studio can record some for you.

If the film is to be printed with an optical track, the sound track should never go *completely* dead or you will hear noise from the optical track. Therefore, never use plain leader for "silent" sections of a sound film; insert some quiet room tone, instead.

Great amounts of room tone or other types of sound can often be created by splicing a piece of mag film or ¼" tape into an endless loop. For most 16mm dubbers, loops should be at least 6 to 10' long, although some mix studios can accommodate much longer loops. Sometimes loops are brought to the mix for use as needed; otherwise, they are transferred beforehand and the sound is actually cut into the film. Avoid distinct sounds whose repetition will be obvious. In particular, choose the position of the splice so it will not be noticed.

A large variety of sounds can be purchased from a sound library, recorded from a sound effects album or provided by a sound studio during a mix. Using prerecorded effects can save considerable time, especially for those effects that are difficult to record well (see Chapter 8). These sources often offer an astounding selection, with such choices as crowd at baseball game, crowd whispering, and so on. Some effects do sound fake, others quite realistic. If you plan to use the mix studio's effects, try to audition them in advance to avoid unpleasant surprises.

Cue Sheets

Before the mix, *cue sheets* (also known as *log sheets*) are drawn up, which act like a road map to show the mixer where sounds are located on each of the tracks. Since the filmmaker or editor is usually present at the mix to make aesthetic judgments, the cue sheets need only provide basic information about the location of tracks and whether they are to come in sharply, fade in or out, be cross-faded (dissolved) with other tracks or be set significantly louder or quieter than other tracks. Do not bother with intricate cue sheets since mixers tend to ignore them anyway.

FIG. 12-8. Mix cue sheet. This is for a four-track mix with occasional loops indicated on the effects track. In this documentary most of the effects are part of the sync-sound dialogue tracks. Bracketed comments are intended only for readers of this book—they would not appear on a typical cue sheet.

Location is indicated by footage count; picture and dialogue cues often help as well, especially the last line of dialogue on out-going tracks. The footage counter should be zeroed at the "picture start" frame on the SMPTE leader. You can usually round off the foot/frame measurement to the nearest quarter foot (for example, in 16mm, 10 feet, 22 frames is about 10.5 feet).

Some mixers will want the footage indicated in 35mm feet—especially if the sound is being mixed onto 35mm mag film—which allows sounds to be more precisely located. 35mm film travels through the projector two and a half times faster than 16mm film; thus, one minute of time is 36′ in 16mm, 96′ in 35mm. To convert 16mm footage to 35mm, you can get a 16mm/35mm synchronizer which allows you simply to crank out the footage in 16mm and read the equivalent in 35mm; get a conversion table or calculator or use any electronic calculator. To make the conversion with an electronic calculator, first determine the 16mm footage in frames. For example (since there are 40 frames per foot in 16mm), 12 feet, 12

frames is 492 frames. There are 16 frames per foot in 35mm, so simply divide the frame count by 16. In this example, the 35mm footage is 30.75 feet.

Preparing the Picture

Prior to the mix, the workprint should be double spliced and run through a synchronizer or projector to check the splices; with guillotine splicers, the sprocket holes are often incompletely punched out. Many filmmakers make a *slop print* (a workprint of the workprint) to have a splice-free copy for the mix since every minute of delay in the mix is very costly. Making a slop print also allows the negative cutter to conform the original to the workprint before the mix is complete.

Arranging for the Mix

Professional sound mixes are extremely expensive (from about $100 to $350 per hour or more); some studios offer discounts to students and for special projects. Since most studios employ a number of mixers, it is a good idea to get references before deciding on one. After you have chosen a mixer, ask if he has any preference on how the tracks or cue sheets are prepared.

Traditionally, sound mixes were done in 10-minute reels without stopping. If there was a mistake, the mixer had to go back and redo the 10-minute segment. Now all professional studios use dubbers equipped with *phased-erase* record heads (sometimes called *pick-up recorders*) that allow the mixer to stop at any point, roll the tracks back and re-record a segment with no noticeable transition from the first version to the second. This system, known as *roll back,* or *rock and roll,* allows great control and experimentation and permits the mixing of a full 1200' reel in one piece. Many mix studios now have computer controllers to operate the console, which can save a great deal of time on complicated mixes.

Many studios offer the option of mixing onto either 16mm or 35mm mag film. This master recording is then transferred to make the final optical or magnetic track in the proper format. 35mm provides better quality, since the film is moving faster, and provides the ability to mix onto three tracks at once (multitrack recording may be available in 16mm at some studios). The mixer can record dialogue on one track, music and effects on another, narration on the third; if the mixer makes a mistake on one track, he need not redo the others. If release in another language is anticipated, make sure the mixer keeps dialogue and narration off the *M and E (music and effects)* track. This means that if a film is distributed abroad, the narration can be reworked or the dialogue dubbed in another language without remixing all the other elements.

Mixing onto 35mm costs more, but the time saved by multitrack recording often makes up the difference. Usually, the 35mm mag stock can be rented for the duration of the mix, saving you the cost of buying it. After the mix, the master track is usually transferred to ¼" tape or to 16mm mag film. Even if the studio will make you an optical track directly from the 35mm mag, it is a good idea to get a ¼" protection copy.

Depending on the complexity of the tracks and the mixer's facility, a sound mix can take two to ten times the length of the film or more. Some feature films are mixed for weeks, with significant re-editing done during the process. Some studios allow you to book a few hours of "bump" time in case your mix goes over schedule; you pay for this time only if you use it.

Communicating with the Mixer

The mixer will help you make decisions about the relative volume of sounds, their equalization and the pacing of fades and dissolves. You can trust a good mixer not to make major errors. Nevertheless, as it is your film, you should trust your own sensibility when making the many decisions for which there is no "correct" choice.

Perhaps the greatest conflicts come up over equalization. For dialogue, choices must be made between mixing for maximum intelligibility (by boosting the mid-high frequencies and cutting the bass) and aiming for a track that is less harsh but harder to understand. At either extreme you run the risk of tiring the audience, especially when the film is shown under poor screening conditions. Filmmakers and mixers often differ on whether intelligibility or overall fullness is most important.

You cannot expect an optical track to be as good as a magnetic one. Unless you have adequate experience, rely on the mixer's opinion of what equalization measures are needed to compensate for deficiencies in the optical track (see p. 330). If you are releasing a film with both optical and magnetic tracks, some of the EQ for the optical can be done when transferring the mixed track to the optical.

Some Alternatives

With some flat bed editing machines, it is possible to do mixes with an interlocked dubber or, in some cases, with record heads right on the machine. Such mixes can save a great deal of money. They are especially useful for simple mixes and slop mixes, which are done to project a multitrack film before the final studio mix is made.

Some studios allow you to book the mix facilities without a mixer. Although this is cheaper, you lose the considerable benefit of a sound mixer's expertise.

In super 8, it is possible to mix fullcoat using a four-channel ¼" tape recorder and a single fullcoat recorder whose speed can be controlled by an external sync signal (this is called *slaving*). Super 8 Sound's Mag IV (see Fig. 7-16) will do this. Record the first fullcoat track on one channel of the ¼" tape while laying down the sync pulse from the fullcoat recorder on another channel. Two more fullcoat tracks can then be recorded on the tape, using the sync signal on the tape to control the speed of the fullcoat playback. Then all three channels can be played back and recorded on fresh fullcoat using the same sync reference.

Magnetic and Optical Tracks

Films shown in the original may have magnetic stripe sound tracks; composite (single system) prints may have magnetic *or* optical sound tracks.

Magnetic Stripes

Most super 8 films and some 16mm and 35mm films are released with magnetic-striped tracks. Mag stripes provide better quality but are more expensive than optical tracks if a number of prints are to be made. The frequency response of 16mm magnetic tracks ranges to about 12,000 Hz or slightly higher. The lower limit is usually set by the mix studios or transfer houses that roll off frequencies below about 100 Hz. The dynamic range of mag tracks is excellent and can be enhanced with a number of noise reduction systems. Super 8, being a slower-moving format with narrower track area, is of lower quality than 16mm.

Virtually all super 8 projectors will play magnetic sound while very few 16mm projectors can. Films made for television are shown with magnetic tracks, often in double system. First-run, wide-screen feature films in 70mm and 35mm are often released with mag tracks, while small-town theaters show the same films with optical tracks. Magnetic-striped prints are vulnerable to being erased or to picking up noise when sent out for distribution. If you decide to change something or try out sounds, a magnetic track can always be re-recorded.

Prestriped film stocks are magnetically striped by the manufacturer. Not all camera raw stocks and few print stocks are available in prestriped form. Single-perforated film can be *poststriped* after it has been developed, as long as it is not shrunken and has no torn perfs and the like. This is done by the lab, the manufacturer or with the use of a home striping machine. With some home machines it is difficult to lay down an even, well-adhering track; since most of these machines do not produce a bal-

ance stripe, the film will wind unevenly on the reel, and in super 8 various recording possibilities will be limited.

If you are going to poststripe original or a print, make as few splices in the footage as possible. When a splice goes through the striping machine, there is usually a brief gap in the track, which results in a sound dropout in recording. Beveled cement splices produce less skip than standard cement splices; tight tape splices applied to the side opposite the track may also produce less skip.

The magnetic stripe can be recorded from ¼", cassette or mag film sound track by the lab, or you can do it yourself. For non-sync films, all you need is a magnetic sound projector and a tape recorder or dubber. With two projectors you can copy the track from one mag stripe film to another directly without making a tape or mag film copy first.

For sync-sound work, the stripe can be recorded from mag film or from another striped film with a double-system projector (see Fig. 15-1). Alternately, you could use a synchronous projector (one that runs at precisely 24 fps) with an interlocking dubber or use a normal, nonsynchronous projector with a playback machine that can be slaved to it (see Alternatives, p. 327). There are a number of systems available, especially in super 8.

If you have not done a mix, when submitting your sound track to the lab to have a magnetic or an optical track recorded, it is a good idea to warn them of any especially quiet or loud sections on the track. Many people record a reference tone at the head of the track to aid the lab in setting the recording level (see Chapter 8). If you record the magnetic stripe yourself, see the discussion in Transfer Level and Equalization, above.

In super 8, where magnetic sound is the norm, there are several projectors available that allow versatile recording and re-recording of sound. Many projectors will record on both the main mag stripe and on the balance stripe (the latter produces somewhat lower quality sound). True *stereo* projectors have separate amplifiers and speakers for each stripe. *Twin track* or *duoplay projectors* will record on each stripe separately, but they are played back together in mono through one speaker. Some projectors allow sound to be moved from one stripe to another, erasing what was there, while others can be set not to erase so that the sound on both tracks can be combined onto one (sometimes with the addition of another source, like a microphone or a tape deck.) The latter process, called variously *sound-on-sound* (a not entirely standardized term), *double or trick recording,* actually works on some projectors by partially erasing the sound on the first track while superimposing the sound from the second. This is not a true mix—like that which you would get in a sound studio—and it may result in compromising the quality of the first track, especially the loss of high frequencies. Make a protection copy of

the sync sound and prepare other tracks on tape before re-recording the stripe so as not to accidentally ruin a valuable (or irreplacable) recording. On some projectors, fades and superimpositions can be pre-programmed, allowing complex sound montages to be executed automatically.

Optical Tracks

Optical sound tracks are exposed on the film print photographically, and, after the film is processed, they are read by a light-sensitive photo-cell in the projector. They are standardly used world-wide in 16mm and 35mm. In super 8, they are infrequently used (at least by film*makers* as opposed to big film *distributors*) because of the poor optical sound repro-duction in this small format.

The quality of optical tracks is far inferior to that of magnetic tracks. The frequency response of 16mm optical sound only runs up to 5500–7000 Hz and is usually rolled off no lower than 50 Hz. The optical sound track itself is capable of greater range, but few projectors are adjusted to make use of it. Because of their high noise levels, optical tracks also have limited dynamic range (often less than 40 dB). When the film print gets dirty, the noise, which sounds like a gentle boiling or crackling, increases. In general, during the mix or transfer, quiet sounds should be boosted to a medium level to avoid losing them in the noise, and higher frequencies should be accentuated to offset the optical track's deficient high fre-quency response.

Both optical and magnetic tracks suffer from bad adjustment and small speakers of many projectors, which cut off both high and low frequen-cies, and the fact that films are often shown with the projector in the same room as the audience, which masks quiet sounds.

Today, optical tracks are almost all of the *variable area* type, which uses a pair of wavy lines to modulate a beam of light (see Fig. 1-3). The earlier system, *variable density,* uses variations in the opacity of the track to modulate the light. Optical tracks are printed directly on each release print from an *optical sound master*. Unlike magnetic tracks, opticals cannot be applied to a film that has already been processed.

In super 8 and 16mm, optical tracks are printed only on single-perf film, on the opposite edge from the sprocket holes. In black-and-white, the edge is processed normally, the same as the middle (picture area) of the film. With color film, almost all of the silver in the emulsion is nor-mally removed during processing and the colors are rendered with col-ored dyes that remain. If the area of the optical track is processed the same as the picture area, it will be rendered with these dyes. *Dye tracks* are relatively transparent to infrared light, which is what most projectors use to reproduce sound, so prints made with dye tracks suffer a signifi-cant loss of volume. To avoid this problem, a viscous fluid is applied to the track area of most color print films, which prevents the silver in the

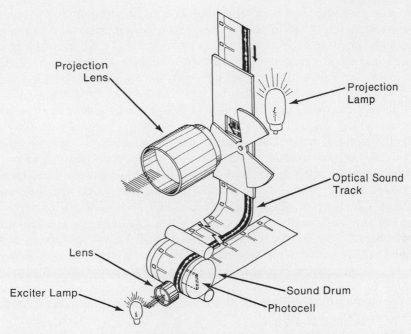

FIG. 12-9. 16mm projector. Light from the exciter lamp shines through the optical sound track The resulting variations in the light are registered by the photocell (shown in cutaway). The sound reader is separated by twenty-six frames from the film gate where the image is projected.

emulsion from being bleached out in later stages of development. *Silver tracks*, which are much more common than dye tracks, have higher density (they are more opaque to light) and provide better sound reproduction. Thus, with silver tracks, the track area is processed differently from the picture area of color film. Since this is always a negative-positive process, optical sound masters are normally negatives, even ones made for color reversal print films.

The optical sound master is exposed in a photographic film recorder, which transforms the final magnetic sound track into a moving pattern of light; it is then developed and printed on the release print. At each step, the density of the track must be precisely controlled, and the effects of the several steps must be well coordinated for proper sound reproduction. Therefore, it may be advantageous to have the optical master prepared by the lab that prints the film. If you have a sound house do it instead, it is imperative that you choose one that has a working relationship with the lab and has calibrated their equipment in concert with them. Specifically, they must periodically run a *cross modulation test*, or *cross mod*. When you get a low-quality optical track, you should request such a test. The test can be done at the head or tail of your track. It is an

exposure and printing check that involves a middle-frequency tone and a low-frequency tone. If the track is properly exposed, the lower frequency should be maximally cancelled out.

The quality of optical sound varies with the print stock being used. For example, the low-contrast reversal print stocks sometimes used with high-contrast original films often have especially poor-quality sound.

Each optical sound master is made so that it can be placed in emulsion-to-emulsion contact with the release print stock for printing (see Chapter 14). If you have an optical master made for prints struck directly from your original and then decide to have an intermediate (for example, an internegative or CRI) made, you will usually need a new optical master since the release prints struck from the intermediate will normally have a different emulsion position than before. Thus, some optical masters are A-wind, others B-wind. To save money when an intermediate is planned, sometimes only one optical master is made, and it is used for the answer print even though it is of incorrect wind. This method gives you poor sound on the answer print and makes the print useless for judging the quality of the mix or the optical track. An answer print and an intermediate may be of the same wind if the intermediate is made on an optical printer (see Chapter 14).

When a magnetic sound track is submitted to the lab for making the optical sound master, it should be prepared according to the standard SMPTE leader format with an audible beep at the "2" (see The Mix, above). On the master, the beep will appear as a frame of squiggly lines in an area where the track is otherwise quiet and even. The lab will position this frame twenty-six frames ahead of the 2 (in 16mm) when it makes the release print (see Fig. 13-6). Without the beep, the lab usually has no accurate way to put the track in sync with the picture.

If optical sound masters or prints with optical tracks need to be spliced together, the splice line should be covered in the track area with a diamond-shaped "bloop" mark which avoids a loud click at the splice. Blooping ink or precut blooping tape can be obtained at the lab.

Electroprinting

Electroprinting is a technique used mostly on the West Coast for producing an optically read sound track right on a print without first making an optical sound master. Electroprinting may be used to save money when only one print is to be made or perhaps to apply a sound track to an answer print when an intermediate is planned. Many feel that electroprinted sound is inferior to optical sound printed in the standard way.

13

Preparing the Film for Printing and Titling

After the editing is completed and the picture "frozen," it is ready to be prepared for printing. During editing, certain precautions should be taken in anticipation of printing, specifically with respect to flash frames, split shots and dissolves (see Chapter 11).

The maximum length of film that can be printed in one piece is usually about 1100 to 1200' in 16mm (roughly a half hour long); longer films are divided into two or more parts but can often be spliced together after printing (see Chapter 15).

Films Edited in the Original

Films edited in the original without a workprint are usually printed from a single strand (see p. 337). If the film was edited with tape splices, as is often done in super 8, the splices should be remade if they have stretched greatly, since the gap between two pieces of reversal film will show as a flash of white when the print is made. Resplicing with cement splices is preferable. However, some films may be thrown out of sync or seriously disrupted by the frames lost each time a cement splice is made. An alternative is to double splice the film (that is, on both base and emulsion) with a guillotine splicer or with Kodak Presstapes that have been cut on the frame line (see Fig. 11-7). Trimmed tape splices may be less visible on screen than cement splices. Do not double-splice films with mag stripe sound tracks and do not use tape if the original is to be liquid gate printed. Always inform the lab if a film has tape splices.

Films Edited with Workprint

After a film has been edited with a workprint, the camera original must be *conformed*, or *matched*, to the workprint using the latent edge num-

bers that the manufacturer exposes every 20 frames along the edge of the film. Super 8 is made without latent edge numbers. 16mm film sometimes lacks them due to improper manufacturing or printing. If there are no latent edge numbers, you may decide to have inked edge numbers applied identically to the original and workprint to aid in conforming, but this can be risky (see Chapter 12, Edge Code). Workprint without numbers can be matched to the original by eye, but this can be extremely difficult if the location of the shot on the roll of original is not known. Shots with a lot of camera or subject movement are the easiest to eyeball. The original can be measured for cutting by lining up frames with distinctive movement in the synchronizer and rolling both original and workprint to the head and tail of the shot. When editing 16mm film with edge numbers, if a shot is cut shorter than 20 frames and lacks an edge number, make a note of the nearest number and how many frames away it is.

After editing, the workprint is marked with grease pencil to indicate to the person conforming the original how various splices are to be treated:

Indicates that shot 2 should begin black and FADE-IN to normal exposure. A 24-frame fade-in is indicated here.

Indicates that shot 1 should begin with normal exposure and FADE-OUT to black. As marked, shot 2 would begin with normal exposure.

Indicates a DISSOLVE between shots 1 and 2. Note that this is simply a fade-out that overlaps a fade-in.

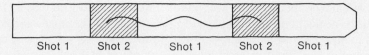

Shot 1 Shot 2 Shot 1 Shot 2 Shot 1

Indicates a DOUBLE EXPOSURE of shots 1 and 2 so that both will be visible simultaneously. This marking is also used for superimposed titles. The beginning and end of shot 2 are cut and spliced into their proper place, indicating the extent of the double exposure. Include enough frames so that there is an edge number in each piece.

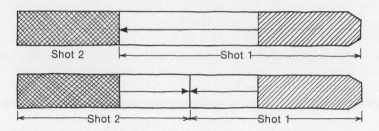

The EXTENDED SCENE marking is used when a piece of workprint has to be replaced with leader because of torn or damaged frames. The arrow indicates to which scene the frames of leader belong.

The UNINTENTIONAL SPLICE mark indicates that a shot has been cut in editing and then put back together, so no cut should be made in the original (normally, the person conforming will plan to cut the original anywhere he finds a splice in the workprint). A careful conformer should check to make sure all splices are intentional regardless of the mark; you can make splices even clearer to the conformer by putting vertical lines down the center of all *intentional* splices. It is a good idea to put vertical lines to mark the extent of fades and dissolves and to write their lengths in numbers on the workprint. Some conformers prefer the markings on the base, others on the emulsion.

Timing Fades and Dissolves

Most labs offer fades and dissolves in the standard lengths of 16, 24, 32, 48, 64 and 96 frames. Check with your lab to see what is available. 48

frames is fairly standard. The first and last quarters of these effects often show little noticeable change (that is, the first 12 frames of a 48-frame fade-in look dark, the last 12 have nearly full exposure) so they seem to go by quicker than the frame count would suggest.

Fades and dissolves are made by the opening and closing of a mechanical shutter in the printing machine, and time must be allotted for its functioning. Call the lab to find the requirements of its particular printers before you finish editing the film. Some printers need a few frames to reset between a fade-in and a fade-out on the same strand, irrespective of which comes first. This would also limit how close together consecutive dissolves can be positioned in A & B rolls (see p. 337). Many printers require a certain minimum number of frames to close the shutter when it is open or to open it when it is closed. Thus, when printing from A & B rolls, some labs will require a minimum separation (often 20 to 30 frames) between a fade-out or dissolve that *precedes* a straight cut. The same separation would be needed between a fade-in or dissolve that *follows* a straight cut (see Fig. 13-3).

Separate from the effects shutter is a *light gate* which controls the color and exposure correction for each shot. This requires a certain minimum length to recue in preparation for the next shot. Thus shots on a single strand of original that require *individual* correction should not be shorter than 5 to 18 frames or more depending on the printer and the printing speed being used. Shorter shots can be accommodated on A & B rolls.

These restrictions may affect your editing decisions or the way in which you prepare the original for printing. If the original is to be printed on a step printing machine rather than a continuous one (see Chapter 14), these limitations do not apply.

Most labs charge a one-time fee for setting up fades and dissolves, which is usually about $2.50 to $5.00 each.

Preparing the Original for Printing

Conforming the original to the workprint must be done with utmost care and precision. The work should be done in a dust-free space, with editing gloves to protect the original from finger smudges. Dirt and scratches must be avoided. Negative stocks are especially vulnerable: Dirt on negative prints white, which is more noticeable than reversal dirt which prints black; negative emulsions are softer than those of reversal and more easily scratched. Cutting errors made during conforming can be disastrous, and badly made splices can cause serious problems if they come apart during printing. Although some filmmakers choose to do this precise, tedious and time-consuming task themselves, others gladly pay

professionals to do it for them. Conformers, who are also called *negative matchers,* may charge $175 to $250 for a 400′ reel of 16mm film. Some charge per cut instead of per foot, which may be cheaper or more costly, depending on how the film is edited.

Some filmmakers lay out the original but let the lab do the final splicing. The filmmaker normally puts *scribe marks* (see Appendix D) at the frames to be spliced. Ask the lab how they want the footage prepared. For further information on conforming your own original see Appendix D.

There are four principle ways of laying out the original for printing. Each has its advantages:

Single Strand

Splicing the conformed original into a single strand (also called *A rolling*) is simple and straightforward. Labs charge less to make prints from a single strand, but there are real disadvantages in this method. First, depending on the printing machine used, the lab may not be able to make the complete color and exposure corrections for each shot that it could if the film were on more than one strand. Second, fades on negative stocks and double exposures, superimposed titles or dissolves on either negative or reversal stocks are normally not possible since these effects require the overlapping of two shots. These effects may be done from a single strand if all or part of the film is optically printed (see Chapter 14).

Perhaps the greatest drawback to printing from a single strand in 16mm and super 8 is that splices, whether made with cement or tape, will show on the screen. Virtually all professionally made films (and many made by amateurs) are printed using a more expensive technique that makes splices invisible.

It is far more common to print from a single strand in 35mm than 16mm since the frame line is wide enough to make splices that do not show on screen and the image does not deteriorate as noticeably when it is duplicated; thus fades and dissolves can be made in an optical printer on a second generation piece of film, which is then spliced into the single strand original. In 16mm, the two generations would compare badly when spliced together.

A & B Rolls

Splices can be made invisible by printing from multiple strands of original. *A & B rolling* (also called *checkerboard printing*) involves dividing the shots from the original onto two rolls and spacing them with black leader. Thus, the first shot would be on the A-roll, with black leader opposite it on the B-roll. The second shot would be spliced onto the B-roll, and leader of the same length would fill the space on the A-roll. In

printing, first the A-roll is run with the print raw stock. The shots on the roll print through, but nothing happens at frames with black leader. Then the B-roll is threaded up with the print stock. The shots on this roll occur and print through only where black leader was on the A-roll. The black leader on the B-roll now protects the shots that were already printed from the A-roll. By using completely opaque black leader, you can be sure that although the print stock must be run twice—once for the A-roll and once for the B-roll—each shot in the film will be printed onto unexposed sections of the print stock.

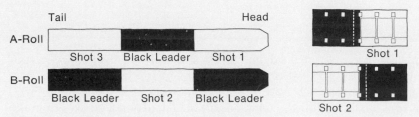

FIG. 13-2. A & B rolling. (left) Three shots laid out on A & B rolls with black leader as spacing. (right) The overlap for the cement splice occurs over the black leader, not over the picture.

This technique leads to invisible splices simply because the overlap needed to make the cement splice occurs *over black leader,* through which no light reaches the print stock. The last frame of shot 1 is clean, and the one quarter of a frame overlap for the splice occurs on the next frame of opaque black leader. Similarly, the first frame of shot 2 is clean, its overlap being on the preceding frame of leader. For this method to work, the emulsion must be scraped off the original film and never from the black leader; otherwise, light could penetrate the splice.

One major advantage of A & B rolling is that two or more images can be exposed on the same section of print stock simply by putting the images opposite each other on the A & B rolls. Double exposures, dissolves and superimposed titles can all be accomplished in this way. Sometimes a third roll, or C-roll, is used for triple exposures, for dissolving from one superimposed title to another, for a supered title placed over a picture dissolve or for beginning a second picture dissolve before the first is completed. Each additional printing roll increases the cost of the print.

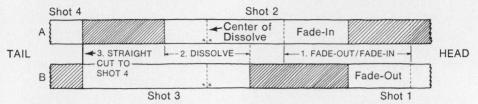

FIG. 13-3. The A & B roll layout for: 1. Fade-out on the B-roll followed by fade-in on the A-roll; 2. Dissolve from A-roll to B-roll; 3. Straight cut from B-roll back to A-roll. The fades indicated in 1 are for reversal film only.

Fade-outs (and fade-ins) with negative stocks are done by splicing a section of clear leader opposite the picture on another roll. Where the picture is supposed to become darker, the light through the clear footage is *increased*. For color negative films, clear camera original is used instead of clear leader because it contains a slightly orange *masking* necessary for proper color reproduction. Some labs request that the section of clear film be somewhat longer than the fade it is covering.

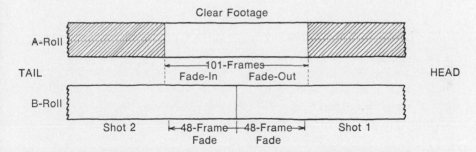

FIG. 13-4. The A & B roll layout for a fade-out at the end of shot 1 followed by a fade-in in shot 2 on negative stocks only. Some labs request that the clear footage be somewhat longer than the fades it is covering.

The other benefit of using A & B rolling is that most labs are equipped to make full color and exposure corrections for each shot. If the length of black leader between two shots on a roll is not sufficient for the printer to readjust for the second shot, additional (C or D) printing rolls may be used. Consult with the lab about minimum spacing of shots and effects.

Zero Cutting

Another technique for making invisible splices is *zero cutting*. In zero cutting, the shots are laid out similarly to those in A & B rolling, but with

at least a four frame overlap at each splice (usually the overlap is much greater). When the printer reaches the end of a shot in one roll, its shutter closes very rapidly. When the printer reaches the same frame on the next roll, the shutter opens. If this is done with a continuous printer, the result is a dissolve of one-frame duration, which may be noticeable on some cuts. On a step printer there should be a normal straight cut. Not all labs are equipped to do zero cutting. Those that are charge about $5 for each zero cut.

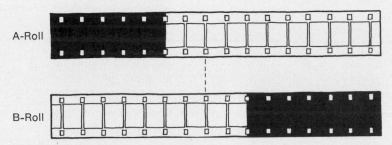

FIG. 13-5. Layout for zero cutting from A-roll to B-roll. The overlap may be far greater than the four frames pictured here.

The main advantage of zero cutting is that shots need not be trimmed to conform to the edited version of the film. Instead, shots can be included in their entirety—the way they came out of the camera—with the printer programmed to print only certain sections. This means several different edited versions can be made of one film. Films that are zero cut in this way often require four or five printing rolls to accommodate all the excess footage. Unlike A & B rolling, opaque black leader need not be used to space the shots on the rolls.

Conforming in Camera by Computer

Another method that, like zero cutting, allows for invisible splices and the possibility of making multiple versions of the film involves using an optical printer. The original is spliced into a single strand, with original rolls either left in their entirety or shots trimmed to nearly their finished length. This is loaded in the projector of the printer, and the print raw stock is put in the printer's camera. The printer is programmed by footage count to print only the desired frames. When the chosen end point of a shot is reached, the print stock is held in place while the original is advanced to the beginning of the next shot. Because the original and the print stock can be moved independently of each other, dissolves, double

exposures and superimposed titles can all be done with this single strand technique. This method, called "conforming in camera" by one lab, requires the use of an optical printer, which is expensive, but it saves the cost and trouble of conforming the original in the traditional way. Often, optical printing is needed for other purposes anyway (for producing high-quality superimposed titles or when making an intermediate from which to print), in which case conforming in camera may be the most economical route.

Printing Leaders

All original material submitted to the lab for printing should have standardized head and tail leaders attached (see Fig. 13-6). All information should be written on the leaders in India ink, never grease pencil. The leaders should be spliced emulsion-to-emulsion and base-to-base with the original. It is recommended that the black leader preceding the first image on the film be replaced with SMPTE head leader, which contains the familiar 8-second countdown (in the case of A&B rolls, the leader is put only on the B-roll). *SMPTE,* or *Society, leader* (see Chapter 12) should be fresh and of the same wind as the original (normally B-wind). This leader is available at all labs. Sound films should have a beep tone applied to the sound track opposite the number 2 (see Chapter 12).

It is simplest to submit sound tracks with the film in *editorial* or *dead sync.* This means that if the sound track and the picture are loaded in a synchronizer with the start marks on their leaders in sync, then the first frames of sound and picture will be in sync as well (as the magnetic track is pictured in Figure 13-6[i]). If a film is submitted along with its optical sound master, it may be lined up in *projection sync* (also called *printer sync*). Projection sync takes into account the fact that the optical sound reader on a 16mm movie projector is located 26 frames (22 frames in super 8 and twenty frames in 35 mm) ahead of the aperture where the picture is projected (see Figure 12-9). If the projection sync mark on the optical sound track is in line with the start mark on the picture, the first frame of sound in 16mm will come 26 frames ahead of the picture (as the optical track is pictured in Figure 13-6[i]).

All picture leaders should contain *only one printer start mark.* Start marks on sound tracks should be clearly labeled for either edit or projection sync. If you submit all materials in edit sync, the lab will put the track into projection sync for you.

Picture Cue Sheets

When the original is submitted to the lab for printing, a *cue sheet,* which indicates the location and length of each effect, should accompany it. The footage counter is normally zeroed at the printer start mark (al-

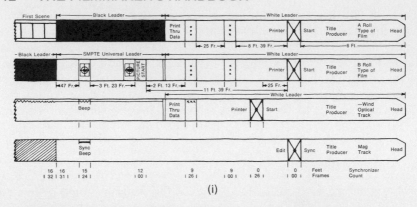

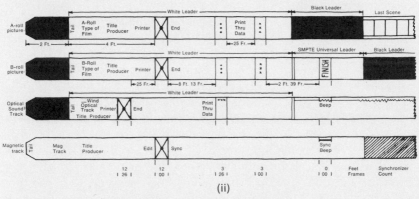

FIG. 13-6. Head (i) and tail (ii) printing leaders for A- and B-picture rolls, optical sound track and corresponding magnetic track. When the optical track is in edit sync, the three *x*'s on the track line up with the three dots on the picture rolls. When it is shifted into projection sync, the *x*'s line up with the three *x*'s on each picture roll. On the magnetic tracks used for mixing *only*, a punched start mark is usually made on the frame opposite Picture Start on the SMPTE leader (with no other start mark).

though some people zero at the "picture start" mark on the SMPTE leader in case the lab changes the head leader to suit their own system). Dissolves are indicated as a fade-in on, say, the A-roll and a fade-out on the B-roll beginning at the same frame. Ask the lab how they want cue sheets prepared.

Preparing Titles

Before a film can be printed, titles and credits must be filmed. The simplest way to make titles is to film letters on a card. Titles can be

written on cardboard or even a blackboard and shot with a tripod-mounted camera. Lights should be placed on both sides of the title at a 45-degree angle from the surface to minimize reflected glare in the direction of the camera. Use a good lens shade or put the lights behind the camera to avoid flare. The title should be illuminated evenly; hold your finger perpendicular to it in the center and in the corners to check that both lights cast equally dark shadows.

A more professional look can be achieved by using pressure-applied lettering, like Letraset or Chartpak. Many typefaces are available in these sets, and, if done carefully, the titles can look as though they were typeset. However, it is surprisingly inexpensive to have a printing house professionally typeset your titles, especially if you cut and lay them out yourself. Avoid typefaces that have very narrow lines or spaces or serifs (the angled lines that extend from and ornament some type styles), since these tend to bleed and fill in if overexposed. Do not photograph the lettering so that its height is less than 1/25 of the total image height, especially if the film will be shown on video. If titles are to be superimposed over other film footage it is essential that they have high contrast, since any exposure from the background on which the titles are written will wash out the picture on which the titles are superimposed. Light lettering should be placed against a very dark, uniform background; dark titles should read against a pure white field, not a piece of mottled, gray cardboard. For non-superimposed titles, dark backgrounds usually work better because they do not show dirt and scratches on the film as readily as a light background.

Titles should be laid out to fit within the film frame. In super 8 and standard 16mm the aspect ratio is 1.33:1, the same proportions as a 4 × 3 rectangle. If there is a chance that the film will be transferred to video tape, all lettering should fit within the *TV safe title area*, which is smaller than the *TV safe action frame* marked in some camera viewfinders (see Fig. 13-7).

Titles should be filmed with a good camera, since steadiness is critical. An incident light meter is best suited to check the exposure for most front-lit titles (use the flat disc diffuser, if possible). It is a good idea to bracket exposures (film half-stop increments above and below in addition to what you think the exposure should be). Always project the filmed titles (usually in workprint) before cutting them into the original to ensure that they are straight, steady and well exposed. When you edit titles into the film, time it so that the titles are visible on screen long enough for you to read them aloud twice at moderate speed.

Most camera film stocks usually do not have sufficient contrast or sharpness for making high quality titles. To obtain good contrast, you can use a fine-grained, high-contrast stock like Plus-X. Even better than this is Kodak's High Contrast Positive 7362 (called Hi Con). Hi Con is

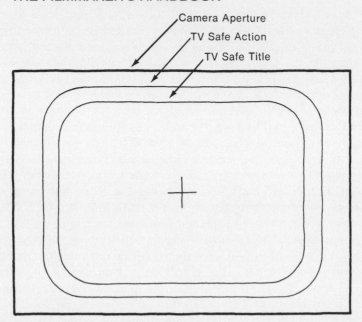

FIG. 13-7. TV safe action and safe title areas. Many camera viewfinders and all projectors crop the outer edges of the full 1.33:1 film frame (here the outermost box). This illustration can be measured for proper proportions when laying out titles.

designed to produce deep blacks and bright whites, with few of the tonalities in between (see Fig. 4-4[iii]). Before you shoot in Hi Con, check with the lab to see at what ASA they rate it. Bracket exposures in one third or one fourth stop increments and, ideally, run an exposure test at the lab on the same day you plan to process the footage. Hi Con can be developed either as reversal or negative; clear lettering on an opaque background can thus be produced either by shooting black letters on a white field or white letters on a black field. There are disadvantages to processing Hi Con titles as negative if the rest of the film is reversal. The frame line on the titles will be white, and if it does not perfectly match the frame line in the rest of the film, the mismatch will be bothersome. It is often easier to shoot titles with the standard color negative film 7291, a stock that some feel is amply sharp and contrasty.

To get really good contrast, titles should be lit from behind. A printing house will set titles on Kodalith or other high-contrast sheet film in order to produce clear lettering on a perfectly opaque background. Opaquing ink is often used to block pinhole imperfections, and an X-acto knife is used to scrape any density out of the letters. When this is illuminated from behind (usually done on an animation camera setup), maximum

contrast between lettering and background is achieved. This technique is especially recommended when you are preparing superimposed titles.

How superimposed titles (or *supers*) are printed is a subject that confuses many people. Supers appear on screen as lettering over a filmed background. For maximum legibility, the lettering is usually white, or a light color, and the background darker. The simplest supers are those that are *burned in*. Titles are shot with Hi Con stock and developed to appear as clear lettering over an opaque background; they are then spliced into the A & B rolls of the original film. In printing, first the A-roll (for example) with the picture is exposed onto the print stock. Then the B-roll with the titles is double exposed onto the same section of print stock. The clear letters *burn through* to produce white titles on reversal prints or black titles on negative-positive prints (remember, a negative turns dark in areas that receive light). The opaque background surrounding the letters protects the picture that was printed from the A-roll.

To produce white supers on a negative-positive print, or black supers on a reversal print, you must withhold *all the light* in the area of the lettering. This may be done by exposing the picture and the titles *simultaneously* on the print stock (not consecutively as done before). Use titles that have opaque lettering on a clear background to mask any light from reaching the print stock where the lettering is (without affecting the light reaching the rest of the picture). One way to visualize this is to imagine the letters casting a shadow on the print stock. This is often done with an optical printer that has a separate head to hold the titles between the projector, which holds the original, and the camera, which holds the print stock. Sometimes *bi-packed* titles are made with the titles in the projector and the original and the print stock sandwiched (bi-packed) in the camera.

35mm film stock is often used for the titles to produce sharper, cleaner lettering. If there is a large number of supered titles (in a subtitled film, for example), it is often cheapest to burn in the titles using the three-step master positive-dupe negative process (see Chapter 14). With this method, clear titles on an opaque background are burned into the dupe negative. This can be done cheaply in a contact printer. It is essentially the same process as making titles on reversal films. Where the titles burn in on the dupe negative, the image will be black after development. When the dupe negative is then contact printed onto the release print, these black letters will hold back the light, producing white supers.

14
Laboratory Processing in Postproduction

After the film is edited, the conformed original is printed, which is done either directly onto release print stock or onto *intermediate* materials from which the release prints will be made. Sharpness is lost and grain increased every time a duplicate is made. A print made directly from the camera original is referred to as a *first generation* print. Copying adds a generation. Thus a print made from a copy of the camera original would be a second generation print, and so on. Optical effects and stock footage are virtually always at least one generation, and often two or more generations, removed from other scenes in the film. The trained eye can usually distinguish scenes in a film of different generations. The film-maker has to decide how many generations are acceptable, and then take into account that more generations may be added later by duplicating; for example, a subtitled print is often an additional generation away from the original. There is a point in the duplication process where contrast increases to an unacceptable level and the graininess and fuzziness of the image increase so much that the image appears to fall apart. The difference is greater in smaller gauges—for example, a super 8 print loses more relative to the original than a 16mm print. In 35mm, a difference of one generation is even less noticeable.

Printing Methods

A printer is essentially a machine that duplicates one piece of film onto another. The camera original and the unexposed printing stock move past an aperture where the intensity and the color of light exposing the stock can be controlled. Prints can be made either by printing in contact with the original on a *contact printer* or by projecting the original onto the print stock through a lens on an *optical printer* (see Figs. 14-1 and 14-2). *Continuous printers* move the original and printing stock at a uniform speed, while *step printers* move the two strips past the aperture one frame

at a time, holding the strips stationary during exposure. Contact prints are almost always made on a continuous printer, and optical effects on a step printer. Dailies are made on a continuous contact printer—the least expensive printing method.

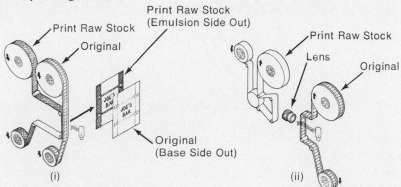

FIG. 14-1. Contact and optical printing. (i) A contact printer: the original is printed in emulsion-to-emulsion contact with the print stock. The inset shows how this changes the wind. Usually the original reads through the base (B-wind), and the contact print reads through the emulsion (A-wind). (ii) The optical printer: a lens is used between the original and print stock. The wind can be preserved or changed on an optical printer.

FIG. 14-2. Simple optical printer. The camera is at left, the projector at right. The control box advances the camera and projector in sync or independently. The lens is mounted on a bellows to allow you to change the magnification or reposition the image. (J-K Camera Engineering)

Liquid (Wet) Gate Printing

Optical printing tends to emphasize dirt, scratches and cinch marks on the camera original. If the original is immersed in or coated with a liquid of the same refractive index as the film when it passes the printer's aperture, base scratches usually will not show, surface emulsion scratches may be minimized and graininess is sometimes lessened. This process—*liquid gate,* or *wet gate, printing*—is particularly useful for making optical effects and printing negative original. The improvement of the print can be dramatic. Liquid gate can also be used for reversal printing and can be adapted to contact printers. Since it entails a lab surcharge, use it only when you are making intermediates rather than release prints.

Printing Exposure and Color Balance

The amount of exposure for each scene, as well as the color balance of color film, must be controlled to correct exposure errors in the original, or to provide another creative control for the filmmaker. The old printer scale divided the increments of exposure into twenty-one steps or *light points.* Each point represents an equal increment in print density. In some of these machines, this scale has been replaced with half-points, but newer machines generally have a scale of zero to forty-four or zero to fifty points.

Color balance is controlled either by inserting colored filters in the path of the printing light *(subtractive printing)* or by dividing the light into three separate filtered sources (red, green and blue) which are modulated by *light gates* and recombined at the printer aperture *(additive printing)* —see Chapter 4. Subtractive printing is an inferior process to additive: It cannot compensate over as wide a range, is less efficient and may result in poorer color reproduction.

When printing, changes in the printer light must be made precisely at the beginning of each shot. In the old method, each scene was notched by removing a thin sliver of film from the edge. This actuated a control mechanism to change the exposure. However, notches weaken the film and they are inconvenient if you change labs or recut at a future date. Other methods of physically cuing the printer include applying metal tabs or spots of metallic paint to the edge of the film. Current methods require no physical marking of the original. Computer tapes, for example, can cue the printing machines by footage count, give a printed read-out of all the scenes with their printing lights and color filtration and avoid any physical alteration of the original.

Labs generally do not like to make timing changes within shots and,

depending on the printing machine, may not be able to do such changes satisfactorily. Those printing machines that can change lights virtually instantaneously may be able to improve a scene, say, that pans from bright sun to heavy shade, by making a timing change mid-scene rather than by using an intermediate compromise light.

When the cut original is sent to the lab to be printed, the *timer,* or *grader,* sets the printer cues for each scene. He may use Cinex strips to determine printer light and color balance, or he may inspect each scene of the original. With reversal film, he may run the film over a light box and, with the aid of a magnifying glass and color compensating filters, will mark the printer light for each scene. For color negative, he most likely will use a video color analyzer, which displays a frame from the scene on a video monitor. The timer adjusts the video image with calibrated knobs until proper exposure and color are achieved, and the information is automatically cued into the printing machine. The timer sometimes uses a *reference picture* (a transparency supplied by the filmmaker or a transparency of a model with standard Caucasian skin—the so-called *China girl*) to aid in color selection. The timer not only chooses the exposure for each scene but also matches scenes within sequences, so that no unnatural color or exposure changes occur.

If you give the timer special instructions, he can *print down* a scene (make it darker) or make it cooler (make it bluer). These instructions usually must be discussed without sitting at the video analyzer. Most labs will not let you fiddle with the knobs since it slows down the operation, but sometimes you can work with the timer at the analyzer long enough to show him what you are after. Often, labs like to time the first print without you being present and then will screen it with you to discuss further changes.

When you talk with the timer, try to understand his view of the film. Since he only looks at representative frames and not the entire picture, his outlook may be different from yours. Timers usually want to even out the exposure of a scene. If there is a large white area in the frame, for example, he will probably want to print it down. You, on the other hand, may be mostly concerned with a face in the frame that would print too dark if the white area was printed down. To prevent such misinterpretations, try to talk to the timer before the print is graded.

The Dry Lab

Dry labs have no processing equipment, only printing equipment. These labs send the exposed printing stock to another lab for processing. They are sometimes able to turn out release prints in volume at lower prices than conventional labs, and some dry labs will allow you access to a video analyzer for timing. If your film needs this kind of attention (for

example, because it has nonstandard color that continually changes) you may want to consider the use of a dry lab. There are disadvantages to their use, however. When a conventional lab does both timing and processing and then makes a processing error, they will redo the work at no extra charge. With a dry lab, you have to work out the various eventualities item by item. Conventional labs make daily test strips to calibrate the analyzer and processing. Inquire at both the dry lab and at the lab that does the processing to see if this is done.

The Optical House

Some of the larger labs have optical printers for making preprint materials like the CRI (see p. 355) and can also do relatively simple optical effects like freeze framing and stretch printing. However, if the optical effects in your film are at all complicated, you may need to use an optical house. Optical work is expensive since it is time-consuming and often has to be redone to get it right. The optical house will not charge you for its own mistakes. If you change your mind about an effect, you will, of course, have to pay extra.

Optical effects printed separately from the rest of the film will be at least one generation removed from other scenes in the film. In 16mm, the loss in quality is less noticeable if the whole sequence goes through the same number of generations. Fades and dissolves are often made optically in 35mm, spliced in mid-shot, and the change in generations passes unnoticed by the general audience.

If you plan to do work at an optical house, get an estimate of costs. Fill out a specification sheet (usually supplied by the optical house). Also, mark the effects you want on your workprint or on leader. The lab should return your original materials, a workprint of the effects and the effects themselves in the desired emulsion position (usually the same wind as the original).

Optical Effects Between Sequences

FADES AND DISSOLVES. To minimize costs and keep the number of generations down in 16mm, fades and dissolves are usually made from A & B rolls when printing the original (see Chapter 13). Fades that are exceptionally long (say over 128 frames), short or close to one another may have to be done on an optical printer. Optically made fades and dissolves are more precise than those that are done on a contact printer from A & B rolls.

WIPES. In wipes, one scene replaces another at a boundary edge moving across the frame. The variety of wipes is endless; some optical houses offer over a hundred varieties. In some wipes one image pushes another off the screen either vertically, horizontally or diagonally. A *flip-over wipe* turns one image over like a book page to reveal the other image on the back side.

Optical Changes in Apparent Camera Speed

FREEZE FRAMING (STOP FRAMING OR STOP ACTION). Freeze framing is one of the most common optical effects. A single frame is repeated, which makes the action appear to have stopped or frozen. The effect can be used at the beginning, middle or end of a shot. The dynamic grain pattern of the original is also frozen, so the grain is static and more apparent, giving the image the appearance of a still photograph with visible grain. If there is no movement in the frame, a sequence of frames may be repeated back and forth to minimize the appearance of grain. Sometimes the head or tail of the shot is frozen—not for the effect, but to increase the length of a shot. Freezes are sometimes used to end films, since they suggest ambiguity or holding a moment in time.

SKIP PRINTING. The apparent speed of the original action is increased by printing, say, every other frame to double the speed or every third frame to triple the speed.

STRETCH PRINTING. The speed of the original action is slowed down by printing every frame twice to halve the speed or every frame three times to slow it down by a factor of three. Stretch printing, unlike skip printing, results in a jerkiness in the action. The image seems to alternate between freezing and moving.

Films shot at 16 fps (the old 16mm silent speed standard) which are to be run at 24 fps (usually to add sound) are stretch printed. To do this, the lab prints every odd frame twice. But, here too, the action is liable to be jerky. Another, more complicated method helps to smooth out the action: odd frames are repeated, but a double exposure is made of the repeat frame with the adjacent even frame. A series of frames 1, 2, 3, 4 . . . would be printed 1, 1 + 2, 2, 3, 3 + 4, 4. . . .

REVERSE ACTION. The scene may be printed with the last frame of the original placed first in the print, showing the movements in the shot in reverse (that is, run backward).

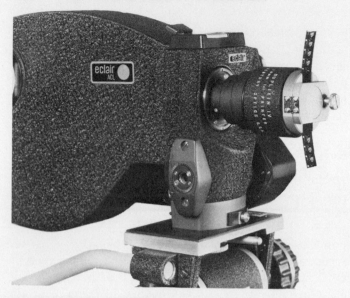

FIG. 14-3. Dupliken IV mounted on an Eclair ACL performs some of the functions of an optical printer like freeze framing, skip printing and stretch printing. (Century Optics)

Optical Effects That Change Composition or Camera Movement

CHANGE OF EMULSION POSITION. As discussed in Chapter 4, contact printing a B-wind original results in an A-wind copy. The A-wind copy could be "flipped" and spliced in base-to-base with the original to provide a mirror image of the original image. With optical printing, the change in emulsion position is optional. Optical printing could be used to make a copy that preserves emulsion position and thus could be spliced into the original without flipping the image.

Labs sometimes use the expression *camera original position* instead of B-wind. If effects will be cut with camera original, request that the effects be printed in camera original position. Footage from different sources may not match emulsion positions. One solution is to reprint optically all the shots that read through the emulsion so that they read through the base (B-wind); then all the shots can be printed together.

CHANGE OF IMAGE SIZE. A portion of the image can be enlarged to change composition, to crop unwanted elements from the picture (for example, a mike boom or dirty aperture) or to enlarge some element. The image can be repositioned to adjust an off-angle horizon line. Sometimes

shaky camera movements can be steadied by optically reprinting the scene. Of course, changing image size increases grain and lowers sharpness.

OPTICAL ZOOM. An area of the frame can be progressively enlarged in successive frames to approximate the effect of a zoom. This will progressively enlarge grain size and decrease sharpness. Optically zooming into a freeze frame exaggerates the effect since the grain pattern of the freeze frame is constant.

Other Image Manipulations

MATTES. Mattes are strips of film with opaque areas that block light from selected portions of the frame. The matte may have a shape like a keyhole or a television screen and be fixed, or it may move to follow some action (traveling matte). The edges of the matte can be hard or, as in a matte simulating binoculars, soft. Use mattes for split screen shots that show two or more scenes simultaneously. If you hide the boundary, a shot can be created where the same actor plays two roles. Traveling mattes can be used to insert filmed backgrounds, usually exteriors, for studio shots that are set up in front of special blue backdrops.

SUPERIMPOSITIONS. An image can be optically superimposed on one or more images. Superimposition may also be made from A & B rolls or during principal photography. Multiple exposure yields the sum of the exposures. For example, a dark tone exposed on a light tone results in a lighter tone. A bright beach scene exposed with a night scene will wash out almost all the dark tones. In general, multiple exposures work better with darker scenes than with lighter scenes.

Whereas in typical multiple exposure the images are consecutively exposed on the print stock, in bi-pack exposure, a kind of superimposition made on an optical printer, light passes through two strips of film simultaneously to expose the print. Here a light tone superimposed on a dark tone yields a dark tone. You can approximate the results of bi-packing, but not multiple exposure, by sandwiching two pieces of film and viewing them on a light box or viewer. Bi-packing film is more expensive than using multiple exposures, but usually works better for lighter scenes.

SUPERIMPOSED TITLES. Titles can be superimposed, or supered, on a scene optically. They can be black, white or in color. Drop shadows, shadow-like outlines around light titles, make the titles stand out on light backgrounds (see Chapter 13 for more on superimposed titles).

Sometimes 16mm optical work is blown up to 35mm and then reduced back to 16mm for superior results, especially when working with supered

titles. If you are printing a section of the original and do not wish to cut the original, it may be less expensive to print *clip-to-clip (section printing);* that is, at a surcharge the lab prints only the footage marked on the original.

Final Printing

Camera stocks are matched to *companion print stocks* to produce an image of proper gamma (see Chapter 4). The gamma is usually higher than you might expect to compensate for the loss of contrast due to stray light in screening rooms and poor quality projection systems. Companion stocks are manufactured with the assumption that the scenes on the original have average contrast. If your overall imagery is flatter than normal, consider a print stock with higher gamma or process the stock to a higher gamma.

Intermediates

After the original is conformed to the workprint, optical effects and titles (other than those to be made in the final printing) are cut in and the leaders are prepared, then the film is sent to the lab for final printing. The rolls of spliced original represent the total effort put into the film at this point; therefore, make it a point to minimize handling. Printing from spliced materials has its dangers, and, even when it is handled carefully, the original will start to show wear after several prints. Negative is more vulnerable to damage than reversal. Some labs do not like to pull more than a few prints from color negative original. If a large number of prints are to be made, standard practice is to duplicate the original onto an *intermediate* to be used for making *release prints* (that is, the distributed prints). Intermediates serve several purposes: they protect the original from handling; they serve as an insurance copy; they allow quantity printing at a lower price; they allow some effects added more efficiently; and duplicates are available for subtitling in different languages. However, if you are only making a few release prints, printing directly from the original avoids the cost of making an intermediate and achieves the highest quality.

BLACK-AND-WHITE NEGATIVE. To control contrast, black-and-white negatives are duplicated by a two-step process. First, the negative is printed onto a *fine-grain master positive,* and then the master positive is printed onto a *duplicate negative.* Ideally, the dupe negative has the same tonal characteristics as the original. As black-and-white processing has

become less common, this has become one of the weakest links in the creation of 16mm release prints with proper contrast.

COLOR NEGATIVE. Color negative original can go through the two-step master positive/dupe negative process described above, but the master positive may be called a *color intermediate master positive* and sometimes an *interpositive*. An alternate method is to make a *color reversal intermediate (CRI)*—a one-step reversal duplicate of the negative that is less expensive and saves one generation. The master-dupe process allows white supered titles without adding generations to the effects (see Chapter 13), and many dupes can be made without handling the original, since the dupes are made from the interpositive. An optically printed CRI also permits white supers to be made without an additional generation. *Color separation negatives* are three separate records of the color original made on panchromatic black-and-white film through red, green and blue filters, respectively. Each strip contains the color information of one of the three color emulsion layers of the original. Although expensive, it uses no color dyes and creates a permanent, nonfading record of the colors.

REVERSAL. A one-step reversal intermediate for reversal original (a *duplicate reversal master*) can be made from black-and-white or color original, but it is more common to make an *internegative*, which is a negative of the reversal original. The internegative now serves the same function as a dupe negative. Making positive prints from a color internegative avoids the difficulty of getting a high-quality silver sound track on reversal prints struck from reversal original (see Chapter 12).

OPTICALLY PRINTED DUPLICATE MATERIALS. Intermediates are often optically printed. Optical printing achieves sharper results than continuous contact printing, and some effects—like freeze framing, supered titles and repositioning the image—can be made while duplicating. With the master-dupe process, generally, only the master is printed optically. Sometimes optical printing increases contrast and apparent graininess as unwanted side effects. Wet gate printing, as discussed above, produces far superior results.

CLEANING THE NEGATIVE. Use extreme care when handling the negative to avoid dirt, scratches and cinch marks. The laboratory should clean the negative before making prints. Dust on the film may become embedded in the emulsion and be nearly impossible to remove. The safest cleaning method is *ultrasonic cleaning*. As the film passes through a solvent bath, high-frequency vibrations remove all but the most firmly embedded dust particles. Both ultrasonic cleaning and wet gate printing may destroy tape splices. Notify the lab if the printing rolls have any tape

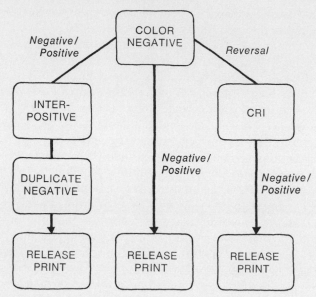

FIG. 14-4. Printing options for color negative original.

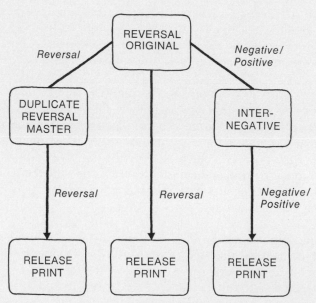

FIG. 14-5. Printing options for reversal original.

splices. Buffing or wet gate printing will often remove base scratches and cinch marks.

The Answer Print

The first print from the conformed original is the *answer print*. It is a timed, color-corrected, trial print that is made before any intermediates or release prints. All the effects made from the A & B rolls (fades, dissolves and superimpositions) are on the print except those that may be made on an intermediate. Typically, the intermediate material is in A-wind emulsion position and the camera original is B-wind: thus the same optical sound track cannot be used for both. If two optical sound negatives are not made, the answer print may be left silent, mag striped or printed with the sound track flipped (a poor solution, see p. 332).

Carefully check the answer print for conforming errors, invisibility of 16mm A & B splices, quality and suitability of effects (at this point it is easy to change the length of a fade) and the accuracy, scene by scene, of the timing and color balance. Not only should scenes have the desired color balance and density, they should also match within sequences. If the print shows dirt from the original, have the printing rolls cleaned before striking the next print. If there are scratches or cinch marks, you may want to do a test to see if wet gate printing will help.

In 16mm, you generally pay for one answer print, and additional corrections are made at a lower "corrected answer print" price. You get to keep all the prints, which can be treated as release prints unless they have serious errors. In 35mm, the lab makes a certain number (sometimes unlimited) of answer prints for a high flat fee until you accept a print, at which time it destroys the unacceptable prints. There are methods, mostly used only in 35mm, that allow for corrections to be tested and made without printing the whole film. One method entails printing a few frames from each scene, and another uses trims from each shot.

If you have supplied the timer with clear instructions for nonstandard scenes, a good timer will make few mistakes. You should, however, always expect some errors. The lab will make an additional answer print at no extra charge only if it is responsible for gross errors.

If the film is to be projected with a xenon or carbon-arc projector (typical in larger halls), order a print balanced for 5400°K—a *xenon print*. If the film is to be projected with tungsten illumination, order a print balanced for 3200°K—a *tungsten print*. Tungsten-balanced prints look slightly blue on a xenon projector, and xenon prints look slightly too warm, or red, on a tungsten projector.

At least one answer print is made before making an intermediate such as a CRI or master positive. The printer-made effects (often supered titles) are then printed onto the single-strand intermediate with each

scene timed and color balanced. A *check print* is made from the intermediate to verify that all went well. The check print costs less than an answer print but more than a release print. Check print prices are often charged for prints made from materials that have not been timed for many years.

EVALUATING THE PRINT. View the answer print (or any other print being evaluated) on a projector you know or under standard conditions. The lab will often have a projection room that meets industry standards for image brightness and color temperature. The projector's light source should be of the color temperature for which the print was balanced; otherwise, it is difficult to evaluate the print's overall color rendering.

After you view the print a few times and check for timing and color errors, compile a list of shots that need correction. It is best to screen the print with the timer at this point. Otherwise, note errors by a footage count from a point on the head leader or put masking tape on the problem scenes, so that the timer knows where to correct the next trial print.

The Release Print

Minor timing errors on a check print or an answer print can usually be corrected when the release print is made. If the errors are serious, the duplicate materials may have to be redone. If the check print is acceptable, then one-light release prints can be made. Labs generally do not charge for timing corrections when they make release prints. However, if you have an intermediate that can be printed with one light, you can easily change labs. Sometimes labs specializing in release prints offer a better price. However, the best quality release prints are generally obtained by staying with the original lab.

There are price breaks for release prints ordered in quantity. At some labs all the prints have to be ordered at once, while at others the price breaks come as you cumulatively reach certain amounts. The catalogue price is usually negotiable when making several prints.

The lab will mount your release prints on reels for a fee. Protective coatings to guard the print against scratches are available. Prints are extremely vulnerable to projector scratches, especially in the smaller gauges. Protective coatings will often extend print life and keep the prints looking better. One of the best coatings, 3M Photogard, must be done at 3M's plant. However, prints with Photogard are difficult to splice with tape, making them unpopular with some projectionists.

RELEASE PRINTS FOR TELEVISION. If you plan on television distribution for your film, carefully control lighting contrast and costuming (see Chapter 9) and consider making a low-contrast print. Low-contrast color stocks have muted, as opposed to saturated, crisp color. With some film-

to-video transfer systems (particularly film chains) prints should ideally be balanced for 5400°K; others accept 5400°K or 3200°K prints equally. TV stations often want prints in double system, or, if composite optical, in B-wind emulsion position. When you edit the film, it helps to mask the image for the TV safe action area.

Blowups and Reduction Printing

Films can be changed from one gauge to another using an optical printer. High-speed continuous optical printers will reduce a 16mm or 35mm film to super 8, or a 35mm film to 16mm. Some allow more than one print to be made at a pass. Generally, reduction prints are one-light prints from an intermediate.

Enlargement, or *blowup*, from one gauge to another, for example, from 16mm to 35mm, is much more difficult since all defects are enlarged along with the image. To achieve high-quality results, only attempt blowups with camera original materials.

Super 8 Blowups

Standard release in both super 8 and 16mm is in an aspect ratio of 1.33:1, so that in moving from super 8 to 16mm there is no need to crop the image. Although there are relatively inexpensive methods of blowing up super 8 to 16mm with a continuous optical printer, custom work demanding scene-to-scene corrections or invisible splicing must be done on the more expensive step printer. You will need to ask the lab how to prepare super 8 for blowup and invisible splices.

The slower speed super 8 films blow up much better. Force processing super 8 invariably reduces quality too much. If you are making more than one print, it is more economical to blow up to an intermediate material— for example, a 16mm internegative. This allows better control of contrast although grain increases and sharpness decreases. If you are making only one print, blowing up to the release print stock is not only cheaper but may achieve better results. Blowups are so costly that, if the shooting ratio is low, it may be less expensive to shoot the film in the larger gauge.

16mm Blowups

If 16mm is to be blown up, use a 16mm viewfinder marked for the 35mm wide-screen aspect ratio (1.85:1 in the U.S.), and compose the image so that an equal amount of top and bottom of the frame can be cropped to fit the wide-screen format. Consider using the super 16 format (see p. 361). More typically, the filmmaker has shot the film in the 1.33:1 aspect ratio, and later he or she has the opportunity for theatrical release

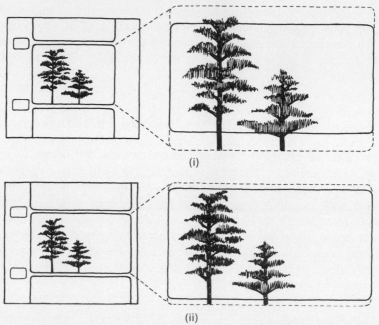

FIG. 14-6. Blowing up to 35mm. (i) When a conventional 16mm frame is blown up to wide-screen 35mm, the image must be severely cropped. (ii) By using the area normally reserved for the optical sound track, super 16 closely approximates the 1.85:1 wide-screen aspect ratio. Very little of the image is lost when the blowup is made.

in 35mm so is faced with the need to crop compositions for the blowup to widescreen. Many optical printers outfitted for blowups allow for *vertical scanning* (see Fig. 14-7). The filmmaker chooses where to crop the image scene-by-scene—from the top, the bottom or both. This allows some flexibility in what is essentially a reframing of the original shot. Some labs can scan within the shot, while others can only make changes between shots. If original compositions are tightly framed or there are many moving camera shots, satisfactorily repositioning the image may prove difficult.

If the original 16mm is reversal, the blowup will be to a 35mm internegative. If the original is negative, the usual practice is to blow up to a CRI to save a generation over the master-dupe negative route.

The graininess of a blowup is critical. Slight overexposure of about one third of a stop of color negative will result in less grain showing in the shadows. On black-and-white negative, on the other hand, this will lead to increase of grain. In either case, underexposure will increase grain. With color negative, when faced with the choice, it is usually better to underexpose a bit rather than to force process, except in the case of some night scenes that can be printed down to yield a good black. In 16mm,

avoid optical effects that add generations. Keep printer rolls shorter than 800′, which blows up to the standard 35mm 2000′ reel.

Super 16

Super 16 provides more picture area than regular 16mm for blowup to wide-screen 35mm. It increases the area for wide-screen blowup by about 40 percent, resulting in increased sharpness and less grain in the blowup. Super 16 is not itself a release format. It extends the 16mm picture area into the area normally occupied by the sound track or by the extra set of perforations on double-perf film. You must therefore use single-perforated film, and the laboratory must be equipped to handle the format. Clearly identify super 16 film so that it receives proper handling.

Some cameras need extensive modifications for super 16mm while others can be converted very easily. The aperture must be widened, the viewfinder properly marked and the lens recentered. Other parts of the camera may need to be modified to prevent scratching. Select lenses that will cover the wider super 16 format. Projection and editing equipment must also be modified.

The super 16 image has an aspect ratio of about 1.66:1, which is a European wide-screen standard. If framing at the top and bottom has not been very tight, the U.S. standard wide-screen projector mask of 1.85:1 will not result in a noticeably cropped image.

For 16mm release, a reduction print can be made from the 35mm blowup or an optical print can be made from the super 16mm original by cropping a portion of the image from the left and right (see Fig. 14-7).

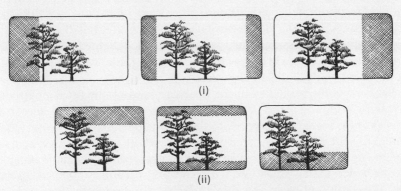

(i)

(ii)

FIG. 14-7. Scanning. When you change aspect ratios, the image must sometimes be cropped. Scanning on an optical printer allows you to crop entirely from one edge or from some combination of each edge. (i) Horizontal scanning reduces the aspect ratio (for example, to show a wide-screen film on television). (ii) Vertical scanning increases the aspect ratio (for example, to blow 16mm up to wide-screen 35mm).

15
Screening the Film and Film–Video Transfer

Screening the Film

Upon the completion of a satisfactory release print, filmmakers usually feel that they have survived all possible surprises of the production process. However, they often fail to take into account the variables introduced by screening facilities, projectionists and audiences which all greatly affect the way the film comes across on screen. Problems are especially acute when films are shown outside of commercial theaters. Filmmakers often need to oversee screenings to make sure that they are handled properly.

The Screening Room

Films should be shown in rooms that are as dark as possible. Exit lights should be positioned or flagged so that their light does not fall on the screen. Stray light on the screen has the same effect as flashing the film stock before processing: the black tones look lighter and the overall contrast is reduced. Theater walls are often a dark color to prevent light from reflecting back onto the screen.

The size of the projected image is determined by the focal length of the projector's lens and the distance from the projector to the screen (the *throw*). For any given projector, the larger the image is projected, the dimmer, shakier and less sharp the image will look. However, a large image—if suitably bright, steady and sharp—will have more impact on the audience than a small one will. The big screen is largely responsible for the greater power that movies have compared to television. It is sometimes recommended that audience seating extend back no further than six times the width of the screen. The image usually looks sharpest if it is surrounded by a black border; dark curtains are often used to frame the picture.

Screens are available in several types, with various surfaces. *Matte*

362

screens are made of white cloth or painted wood. A wall can be used for screening if it is painted with a bright, flat white paint. Matte screens usually give the best color reproduction, and they can be viewed from a sharp angle (for example, from the outermost seats in the front rows.)

Lenticular screens are made of a ribbed fabric that acts like a lens, focusing the reflected light back toward the center of the audience. As a result, the image is brighter than that of a matte screen for viewers sitting near the line from projector to screen and dimmer for those sitting at the sides of the seating area. Some lenticular screens use an aluminum paint surface and may be four times as bright as a matte screen; they can be used in rooms that are not completely dark.

Beaded screens have tiny glass beads embedded in the surface. They are very bright and extremely directional; only a narrow viewing area down the center of the room shows an acceptable image. With these screens, the room must be completely dark. The reflected image is extremely luminous (the whites are very bright and even the dark areas reflect light), but the image may be somewhat less sharp than that produced on a matte surface.

High-gain screens, like Kodak's Ektalite and the ones found with certain large-screen televisions, are concavely curved and rigid; they cannot be rolled up. These screens are extremely directional and bright; the image may be bright enough to view in a daylit room.

Whenever possible, the noise of the projector should be dampened or isolated from the audience. Avoid projectors with built-in speakers. In commercial theaters, a *projection booth* with a double glass window isolates the machinery from the audience. For informal setups, the projector can sometimes be placed in another room or in an open closet to block its noise. Some people build a ventilated housing for the projector, with a window in front and an access door on the side.

Detachable speakers should be separated from the projector and placed near the screen, getting them closer to the audience and reinforcing the sense that the sound is being produced by the action on the screen. In movie theaters, speakers are often placed behind the screen where they project through thousands of perforations in the screen's surface.

"Live" or reverberant rooms may make the sound track echo and seem boomy and unclear. Curtains, furniture, sound-absorbent tiles and the audience itself all help reduce reverberation.

The Projector

Projectors are usually the weak link in the chain of equipment that transfers the image from the world to the screen. Filmmakers frequently spend thousands of dollars for cameras with steady movement and sharp lenses and then project their films on jittery projectors with cheap, low-contrast lenses. In super 8, the projector is often used to record or re-

record the sound track, making it especially important that the machine be of good quality.

All super 8 projectors accommodate single 8 film, and certain models accept regular 8mm film as well. Super 8 projectors sometimes come with zoom lenses that allow the size of the image to be adjusted without moving the projector; these may not be as sharp as fixed focal length lenses. Some super 8 sound projectors are capable of complex manipulation of the sound track (see Chapter 12).

In 16mm, the standard projector lens is about 50mm (2″). Automatic threading on 16mm projectors often does not work as well as the automatic mechanisms typically found in super 8. Avoid these projectors because it can be difficult or, in some cases, impossible to unthread the projector when the film jams.

When you choose a projector, find one that projects a bright, steady image and reproduces sound tracks clearly. Playing a film with a slow music track is often a good test of the projector's reproduction quality. Make sure the projector allows easy access to the film gate for cleaning. The optical sound reader on a 16mm projector needs to be adjusted precisely; this should be checked occasionally by a technician with a test film. Some optical sound readers are set to optimize either A-wind or B-wind release prints, or they may be adjusted in a compromise position. If some films sound better than others on your machine, this may be the reason.

Most home, school and institution projectors use *tungsten* bulbs, and most release prints are color balanced for tungsten projection (although most color reversal *original* stocks for direct projection are balanced for xenon, see below). Old style tungsten bulbs (usually cylindrically shaped) are bulky and run very hot. The newer *tungsten-halogen bulbs* are compact and have most of the bulb's lensing built in. These bulbs run cooler and brighter and consume far less current.

Larger screening facilities usually have projectors with *xenon arc lamps,* and very large houses often use *carbon arcs.* Some film-to-video transfer equipment also uses xenon lamps. Xenon lamps are brighter and bluer in color than tungsten bulbs of comparable wattage. Release prints properly color balanced for xenon projection will look slightly red-orange when shown on a tungsten projector. Tungsten-balanced film will look too blue or "cold" on a xenon arc projector. The tungsten image could be warmed up with a #85 filter (which would bring the 5400°K color temperature of the arc closer to the 3200°K of standard tungsten projectors), but this results in a significant loss of brightness.

Most projectors use a three-bladed shutter (instead of the half-moon-shaped shutter used in cameras, see Fig. 1-1) to reduce the sensation of flicker. This means each frame is flashed on the screen two or three times, with an instant of darkness between each flash. The more rapid the flashes, the more constant the projector's light seems. For film run-

ning at 24 fps, a three-bladed shutter produces seventy-two flashes per second. Some projectors have five-bladed shutters, which help reduce flicker at slower speeds but cut down on the projector's brightness.

Projectors in 16 and 35mm run at 24 fps. Many super 8 projectors run at 24 fps or 18 fps (the latter may be indicated as silent speed). Some 16mm projectors have a silent speed position, but this is normally 16 fps (an old l6mm standard). Contemporary 16mm films without sound are often shot at sound speed. Many projectors will run at slow-motion speeds. This should only be done if the metal screen *heat shield,* which falls between the lamp and the film, is working properly. *Analysis projectors* allow projection at very slow speeds and incremental movement of still frames for examining footage closely.

It is of utmost importance to keep the film path of the projector clean, especially the area of the film gate behind the lens. Dirt and emulsion

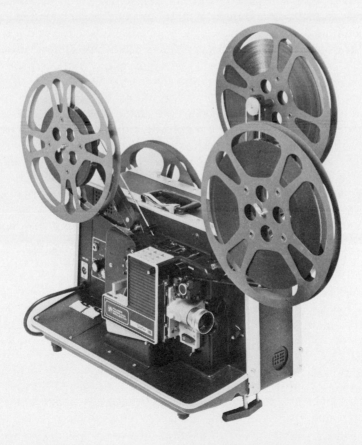

FIG. 15-1. Palmer 16mm Interlock Projector for double system projection. (W.A. Palmer Films, Inc.)

dust regularly accumulate here and can easily scratch the film. Use a cotton swab with alcohol or acetone to clean both sides of the pressure plate and the rim of the aperture. Acetone is a very powerful cleaner and should never be used on plastic or the cemented metal of sound heads. Clean the gate before every film screening. Clean the projector's lens as you would a camera lens. Hairs that lodge in the gate during a screening can often be blown out with a can of compressed air while the film runs.

Whenever possible, focus the picture and adjust the sound before the audience arrives. Focusing can be done with the naked eye, with binoculars or with an assistant at the screen if the throw is great. If you focus the projector on the *grain* and not the image itself, you will be sure to maximize sharpness even if the scene itself was filmed out of focus. As the projector warms up, the focus will drift slightly and will need readjusting.

Most projectors have a tone quality adjustment (bass/treble). Optical sound tracks often sound best with this adjustment set a bit toward the treble. Adjust the level and the tone with someone standing in the middle of the room who can signal when the sound seems clear but not overly scratchy. Projector amplifiers and speakers are of notoriously low quality. Many projectors are equipped with *line output jacks,* which allow you to play the sound through a home stereo or other amplifier for superior sound reproduction.

Double system projectors can play the picture and a separate roll of magnetic film sound track in interlock. These machines are mostly used to screen the workprint with its sound track before a composite print is made. They can also be used to play or record a mag stripe film or, perhaps, to show a film with a sound track that has been translated into a foreign language. Double system projectors in 16mm will usually play films with optical sound tracks. They can be rented in major cities. Double system projection can also be done in a mix studio or preview theater.

The Print

Filmmakers often order prints from the lab mounted on *single-keyed reels,* which have the key-shaped center hole on only one side. This is intended as idiot-proofing to ensure that the film is mounted correctly on the projector. Single-keyed reels can cause inconvenience in the editing room.

You should splice at least 6' of *single-perforated* leader at both the head and the tail of the film. Some people put green leader at the head, red at the tail. Use only single-perf leader to help distinguish the head from tail and to ensure proper threading. Mark head or tail on the leader with your name and the name of the film. If you are splicing on SMPTE head leader, make sure the leader is of the same wind as the film (see Chapter 13). SMPTE allows the projectionist to focus the projector be-

fore the film begins. Unfortunately, many projectionists do not bother to set the focus until the first few images of the film. Films that begin with many short shots or quick camera movements often take longer to focus since the projectionist may need a steady image to focus on. Films that start with black footage are often out of focus when the first image appears, reducing the dramatic effect the filmmaker hoped to achieve. Similarly, sound films that begin silent or with low volume often cause problems in projection.

Films in 16mm that are longer than a half-hour (1200′) are usually printed in at least two sections, and, if the parts are to be spliced together for projection, the sound should be prepared in anticipation of the splice (see The Sound Mix, Chapter 12). Films in distribution are usually mounted on reels of 1600′ or less. A 2400′ reel can accommodate a 66-minute film but may be dangerous due to the strain it places on the film in projection. Projection facilities equipped to handle big reels can show a program of a few hours' length in one piece. In this case, the projectionist will splice the reels together.

Many theaters use two matched projectors and *change over* from one projector to the other at the end of each reel to avoid an interruption for reloading. *Changeover marks* are inscribed in the upper right-hand corner of a few frames to cue the projectionist when to start the next projector. To mark your own film, count backward from the last frame on a reel, and inscribe a small circle in the corner of frames 25 to 28 and 196 to 199. Most labs or projection facilities can give you a mechanical scriber that makes a neat changeover mark.

Prints should be kept clean and free from damage. Broken perforations may be repaired with splicing tape. Preperforated tape can be applied to

FIG. 15-2. Perf-Fix perforation repair system. (The Perf-Fix Co.)

just the edge of the film without obscuring the picture (see Fig. 11-7). Trim it precisely with sharp scissors or a razor blade. A perforation repair device like the Perf-fix or Cine-Bug systems can restore perfs to a film that lacks an entire edge. Usually the beginning of a print takes the most abuse because of misthreading. Ample head leader is thus very important. Filmmakers engaged in quantity distribution often have the lab prepare replacement sections of the first 100′ of a film.

Film—Video Transfer

Film-to-Video Transfer

Video tape is becoming an increasingly important format for distribution of films. Tape cassettes and discs are convenient to ship and to play, and they cost much less than film prints of comparable length. Transfer from film to tape is now a regular component in most movie releases.

The technology of film-to-tape transfer, or *telecine,* equipment has become extremely sophisticated in recent years. *Flying spot* and *CCD scanners* can make transfers from 35mm, 16mm, super 16 and super 8 film projected at speeds from 16 to 30 fps, in single or double system. Some machines are equipped with full liquid gate heads for minimizing the effect of scratches and grain. Unlike conventional video cameras, flying spot and CCD scanners do not suffer from *lag* (an effect where bright objects leave comet tails across dark areas when they move or the camera moves). During the transfer, the image can be manipulated in all the ways available to video tape. Each scene can be corrected for color balance and contrast (both gamma and black level); corrections can be made within scenes as well. Various special effects can be created. A color negative original can be transferred and converted to a positive image in the process; the best quality image can be had by transferring directly from the film original. Six-color machines give individual control over both the additive and subtractive primaries and provide much more versatile adjustment of color timing than three-color machines. Digital pitch shifters can be used to make the movie as recorded on video tape longer or shorter than the original film without any noticable change in the audio.

The flying spot scanner is a particularly advanced and expensive machine. An alternative telecine device is the *film chain,* which is made up of a projector that directly projects the image into a video camera. Most film chains are set up so that no screen is necessary, however, transfers can be made by using a video camera to record the image projected on a typical movie screen. In the U.S., film sound speed is 24 fps and the

standard National Television Systems Committee (NTSC) video signal is recorded at 30 fps. It is thus necessary to use a projector with a five-bladed shutter so that the film frames may be evenly distributed among the video frames; otherwise, the recorded image will have excessive flicker. Magnasync/Moviola makes a machine that has the movement of a flatbed editing table but allows flickerless transfer of 16mm or 35mm film to a video camera, with the film projected at any speed from 2 to 150 or 250 fps (see Fig. 1-13). Both Sony and Goko make telecine devices in super 8. The quality and versatility of a film chain transfer depend on the camera and projector used as well as the auxiliary video processing equipment. Most professional film chains allow scene-to-scene color and contrast correction. Once the film is on tape, myriad effects can be achieved.

Since video tape is a magnetic recording medium, to achieve the best quality, use single or double system magnetic sound for film-to-video transfer whenever possible. The use of optical sound will result in lower quality sound.

Film-to-tape transfers can be made onto any format video tape the transfer house is equipped to handle. Since transfer time is fairly expensive, it is worth making a master tape from which additional copies can be made as the need arises. The master should be made on 1″ tape if your budget allows it. Many transfer facilities can record ten or more cassettes directly from the telecine during the transfer, each tape being a first-generation copy and therefore of better quality (with a 1″ master, this difference is insignificant).

When you show tapes, always set up the monitor or television set carefully by adjusting the color, contrast and brightness controls. You should have *color bars* recorded at the head of each tape for this purpose; a technician can show you how they should look. Always show tapes in a darkened room. If possible, run the sound through an auxiliary amplifier and full-size speakers. Avoid television sets that lack a *DC restoration* or *black clamp circuit*. These sets, usually older or more inexpensive, are recognizable by the way they accentuate high-contrast scenes. Where the original film shows, say, objects on a white table or against the sky, these monitors show detail-less silhouettes. Also, on a monitor without DC restoration, scenes fade out to gray, not black.

When film-to-tape transfer is anticipated, use low-contrast lighting and set design, and compose shots with TV cutoff in mind (see Chapter 9). You may want to consider making a release print on a low-contrast print stock.

Tape-to-Film Transfer

Material on video tape is often transferred to film. Before the advent of video recording, a filmed *kinescope*, or *kine* (rhymes with "skinny"),

was made of live video performances for delayed television broadcast. Kines are still widely used for incorporating taped material into films or sometimes for showing taped material in a theater. Kinescope cameras have special shutters and pull-down mechanisms for converting the 30 fps NTSC video frame rate to 24 fps (film sound speed).

It is possible to film a television screen with a normal film camera, but the image will not be as sharp as that produced with a true kinescope camera. However, this may be necessary if live actors play in a scene that includes a television set. When you use a normal camera you run the risk that a light or dark horizontal band will seem to move through the video picture. This band is variously called a *hum, frame* or *shutter* bar. It occurs when the film exposure time is slightly longer or shorter than one video field (there are two fields to each video frame).

To minimize the shutter bar when you film taped material played on a crystal-controlled video tape player, use a crystal-controlled camera. For best results, use a camera and tape player that can be driven by the same sync source. In the U.S., a camera with a 144° shutter will freeze the shutter bar in position at 24 fps. If the bar is visible in the center of the picture, it may help to stop and start the camera a few times until it moves to the edge, or get a *phase shifter attachment*. Another possibility is to film at 30 fps and then use skip printing to bring the speed down to 24 fps, if necessary. When you film European video material at 25 fps, a 180° shutter should be used.

Methods for tape-to-film transfer that are much more sophisticated than kinescoping now exist. One technique involves projecting the video image onto the film with red, green and blue lasers. Another system uses an electron beam to make separate images of the red, green and blue components of each image on three successive black-and-white film frames. Each group of three black-and-white images is then projected with the proper color filter onto a single frame of color film. These advanced systems are expensive but can produce film images that do not look like they originated on video, as kinescopes often do (the video lines may not be visible at all). Nevertheless, the images produced appear quite different from normal film material, having a "harder" look.

16
Budgets, Fundraising, Copyright and Distribution

The cost and complexity of producing a film make it natural for the filmmaker to seek financial and technical assistance from a number of sources. If a film is to recoup its costs, a great deal of effort must go into getting as wide distribution as possible. In fact, relatively little of the independent filmmaker's time is spent actually making films; instead, much of his or her life is consumed by devising ways to find money and audiences.

Budgets

Because of the high costs of stars, studio overhead, sets and salaries of a Hollywood film, the amount of money spent on film and processing may be less than 10 percent of the film's total budget. For some filmmakers, however, friends may donate time, materials and equipment so that film stock and processing will represent 100 percent of the cash needed to make a movie.

Drawing up a detailed budget allows you to determine your costs and, equally important, shows potential funders what you plan to do and that you understand the process of film production. It often helps to divide the budget chronologically, separating the costs of preproduction (research, scripting, scouting, planning), production (film stock, processing, equipment rental, food and lodging for the crew) and postproduction (editing, music, *finishing costs:* mixing, cutting the negative, making titles and prints). Many projects begin with enough cash in hand to shoot footage that can, in turn, be used to raise money for completing the picture.

Fiction film budgets are sometimes divided into *above-the-line* and *below-the-line costs*. Above-the-line costs are the actors', director's and film producer's salaries and those costs incurred before production begins, like buying a script or the rights to a book. Below-the-line costs include all equipment, materials and other salaries. *Negative costs* of a

371

film are all items prior to the marketing and distribution costs. Distribution costs include advertising, making release prints and booking costs.

Materials, equipment and labor are sometimes donated to a production (or provided at discount), especially for small or nonprofit films. It is important to include these "in-kind" contributions on the budget but indicate that they are not normal cash items. Investors or funding agencies will want to see a budget that includes both types of support, since they are interested in the full value of the production.

There is no standard form for a budget. On page 373 is a proposed budget for a 55-minute documentary film made by two filmmakers who share the responsibilities of camera, sound and editing. The production period lasts approximately 2 months, and no salaries are indicated.

Sundry other budget items for a fiction film or larger documentary include rights to story materials, scriptwriting and/or research; cast; camera, sound and lighting crews; editing assistance; makeup and wardrobe; set costs and location facility fees; catering; payroll taxes; secretarial services; stock footage rights and processing; interlock screenings and office overhead.

Salaries

Outside of union productions, crew salaries must be negotiated on an individual basis. Producers who lack money up front sometimes arrange "deferred salaries," which are paid after the film is finished and begins to generate income; many consider this a euphemism for free labor. Another bargaining technique for getting cheaper labor is to offer lower salaries in exchange for *points*—a percentage of the film producer's eventual income. The problem with this, and all profit sharing deals, is that "income" may be defined as what is left after many expenses have been deducted (see Distribution, below). Without access to the books, the employee (or filmmaker in the case of a distribution deal) is at a great disadvantage.

Renting versus Buying Equipment

The advantages of owning a camera or other equipment include certain tax benefits, familiarity with idiosyncracies of a particular piece of equipment and the avoidance of rental problems, such as unavailability of equipment, defective equipment, out-of-town rental hassles and costly short-term insurance policies.

Renting, however, avoids the problems of yearly overhaul and maintenance, interest payments and yearly insurance premiums. Also, you can choose the most appropriate equipment for a particular shooting situation and not be limited by what you may or may not own.

Filmmakers can often raise the money to buy equipment when they

Proposed Budget for a Documentary

Production Equipment
Arri SR w/acc., 9.5-57mm, 5.9mm $4,200
Nagra IV stereo w/accs., mikes 1,900
Fluid head w/tripod, hi-hat 450
Lights, power belts 900
Subtotal 7,450

Production—Stock and Lab
Raw stock 7291: 54,000' @ $70/400' $ 8,775
¼" sound stock: 90 rolls @ $4.50 405
Processing and workprint @ .24/ft. 12,960
Edge-coding: 108,000' @ .015/ft. 1,620
16mm fullcoat: 64,000' @ $40/1200' 2,130
Sound transfer: 39 hrs. @ $50/hr. 1,950
Subtotal 27,840

Travel and Location
Air fare and baggage $1,500
Apartment/studio rental and car rental 2,900
Per diem @ $25/day x 2 x 60 days 3,000
Subtotal 7,400

Editing
Steenbeck rental 4 plate @ $500/mo. $2,250
 6 plate @ $700/mo. 500
Editing supplies (leader, tape, etc.) 500
Subtotal 3,250

Music
Rights and recording $2,000

Finishing Costs
Negative matching: 5 reels @ $200/reel $1,000
Sound mix: 12 hours @ $200/hr. 2,400
35mm fullcoat rental, 16mm and ¼" dubs 250
Optical track: 5 reels @ $65/reel 325
Titles and optical effects 1,200
Answer print: 2000' @ .59/ft w/effects 1,400
CRI @ .95/ft 1,900
Check print @ .25/ft 500
3 release prints: 2000' @ .14/ft, reels, cans 860
Subtotal 9,835

Miscellaneous
Insurance $3,500
Equipment repair 900
Shipping 600
Telephone 400
Xerox and office supplies 250
Still film and processing 125
Legal and accounting 1,800
Subtotal 7,575

Contingency
10% of budget $6,450
Total $71,800

have been hired to shoot a film over an extended period of time. They can buy the gear and then rent it to the production on which they are working, charging rental house rates. Two or three months of shooting can pay for half the initial cost of a camera.

If you plan to rent, research the rates at a number of rental houses. It is often cheaper to rent from a big company even if it is farther away and transportation costs are added; some houses charge no rental while the equipment is in transit. Longer term rentals are discounted. Typically, the weekly rate is four times the daily rate; the monthly rate, three times the weekly. Some houses allow you to pick up the equipment Thursday afternoon and return it Monday morning for one day's rental charge.

Film Stock Costs

Film should be ordered directly from the manufacturer to avoid retail mark-ups. Buying from the manufacturer ensures that the stock is fresh and that the film is of the same emulsion batch, if you so dictate. Film can be purchased "pre-owned" from clearing houses, but this is done at some risk (see Chapter 4).

When you prepare the budget, you must make an estimate of the shooting ratio. Your experience, personal style and unavoidable mishaps during the production will determine how much stock you need. Ordering enough tape stock to cover one and a half times the film footage allows you to record an ample amount of wild sound. The processing estimate should reflect how much stock will be developed normally and how much will be pushed or flashed, which costs more.

Insurance and Contingency

There are many types of insurance available for film work. *Negative insurance* covers damage to the negative from fire, theft or loss in transit. *Faulty camera, stock and processing insurance* covers loss or damage to film due to defects. These coverages normally do not include "human" errors, like setting the exposure incorrectly. *Camera and equipment insurance* covers loss or damage; usually only the cash value of the equipment at the time it is lost is recoverable. *Extra expense coverage* provides reimbursement for delays in shooting due to damaged or late equipment, sets and the like. *General liability* covers bodily injury and suits arising from accidents on the set. *Errors and omissions policies* cover legal fees and settlements for any suits arising from libel, slander, invasion of privacy and copyright infringement claims. The premiums for these policies are usually determined as some percentage of the film's budget, with specified minimums.

The last entry of most budgets is *contingency costs,* which is usually 5 to 15 percent of the entire budget. This figure is intended to cover the

unexpected: equipment breakdown and delay, reshooting costs, unplanned filming (insurance may cover some of these items). Since films are often planned months or years before they are finished, the contingency allottment may be high to compensate for inflation; some filmmakers figure inflation into each budget line item instead.

The Budget Estimate

Experienced filmmakers sometimes estimate budgets for typical projects on a per-minute basis (for example, $2000/minute) or on a footage basis (for example, 16mm sync-sound, color film shot and synchronized costs about $.45/foot without salaries). Each production entails different costs for salaries and locations. In the mid-1980s, a typical low-budget Hollywood feature cost a few million dollars, independent features cost a few hundred thousand (although some cost much more or much less) and a half-hour documentary, exclusive of salaries, might be made for *at least* $4,000 or $5,000 (a one-hour documentary for public television generally costs more than $100,000). Sometimes a shoe-string fiction film may be cheaper than an unscripted documentary because the action is predictable, entailing lower shooting ratios.

Fundraising

If you initiate your own projects, you will need to raise money for the production. This is often an arduous and lengthy process. The first step is usually to write a proposal and a preliminary budget. Independent filmmakers (those working outside of a studio or large organization) typically bear the costs of researching and writing a proposal themselves, although "seed" money can sometimes be obtained to develop the proposal or script, begin serious fundraising or start preproduction work.

Commercial Funding

Feature films intended for theatrical release are usually financed by studios, film distributors or individuals who invest in exchange for a share of the film's future earnings. Investor funding is a complex topic; laws governing film investment vary from state to state and have changed greatly in recent years. Before 1976, film was an attractive investment because direct profits could be made from successful movies and significant tax sheltering could be provided by unsuccessful ones. Since then, federal tax laws have changed and tax benefits have diminished.

If you plan to solicit investors for your film project, first consult an attorney familiar both with film investment and tax law. You will need a prospectus that details fundraising plans, production costs and the

scheme for returning the backers' money. If only a few backers are needed, perhaps the simplest arrangement is to form a *limited partnership* in which the investors supply capital and the filmmaker retains full legal responsibility for the project.

Industrials are films commissioned by companies or government agencies either for publicity or for such in-house uses as training and sales. Industrial filmmaking can be extremely lucrative, but it is fraught with the problems of working with corporate bureaucracy.

Many fiction and documentary films, especially those by filmmakers with established reputations, are funded wholly or in part by the entities that will distribute the finished product—either film distributing companies or broadcast or cable television companies. *Bankable* movies, like the sequel to a successful film, can be presold to distributors to raise production money. Often distribution rights are divided so that one distributor pays for the right to show the film domestically and another shows it abroad. Producers of less sure-fire films may be unable to sell their film in advance, but will interest a distributor with a rough cut of the film and thus raise money for completion. Television stations may be persuaded by a film proposal to fund all or part of a project, or they may hedge until the film is done before committing themselves to showing it. Ironically, television executives sometimes offer much more money for a movie that is not yet begun—and is therefore a greater risk—than for one that is finished. This may reflect their desire to control and gain credit for the film project. Completed films, especially ones without a strong reputation, often face a buyer's market.

The three major American networks (ABC, NBC, CBS) produce most of their own programming. Various entertainment shows are contracted out or purchased from non-network producers, but the chances of an independent film being shown by a major network are relatively slim. In the world of commercial television, the word "independent" usually refers to producers like Norman Lear who may provide a regular supply of shows like "All in the Family." The networks also have union regulations that may prevent non-union material from being shown.

The Public Broadcasting System (PBS) and its member stations, on the other hand, actively solicit proposals for films by independent producers. The total amount of money available for independent films is extremely limited, but individual projects may be well funded. The programming priority for PBS is to support well-known filmmakers, but opportunities for less-established filmmakers do exist. If significant production costs need to be covered, you should make every effort to sell a film project to television before, and not after, production.

As the cable television industry grows, new possibilities for film funding may develop. Substantial quantities of programming are needed and material never before seen on TV will be shown on cable. Although unusual independent films can be "narrowcast" to a relatively small

audience on cable, major funding will still go to more popular programming. Also, because advertising costs are high, there are advantages to the cable company to buy programming that can be packaged into a series (as opposed to stray individual shows). The filmmaker may want to consult a cable "packager" before approaching a cable company.

In recent years, European television stations, especially in West Germany and Great Britain, have funded many American projects that failed to get support domestically.

While funding is being arranged, temporary cash shortages can often be covered by loans from banks and other sources of credit. Many filmmakers get credit from labs and equipment houses to defer these costs. Credit cards have been used to raise cash quickly for starting or finishing a production. Speedy fundraising may be essential since many films, especially documentaries, cannot survive a delay in starting production.

Getting Grants

Many sources of finance are unavailable to filmmakers whose work lies outside the commercial mainstream since it is unlikely that their work will earn a profit. Since documentary, experimental and short fiction films rarely make back their costs in the short run (or ever, in many cases), these films usually must be subsidized by government or private donations. In the U.S., there are a number of federal, state and private agencies that give film grants.

Some grants are given to filmmakers on the basis of their previous work and are not intended to support any particular project. Others are given for specific projects, and the filmmaker's resume is used to determine if he is capable of completing the task. *Matching grants* are given with the stipulation that the same amount of money be raised first from other sources. Since there is normally a 6- to 8-month lag (or more) between the application deadline and the granting of funds, filmmakers must often plan what they want to work on long in advance. Many filmmakers submit proposals for several projects in the hopes of getting one funded. As one filmmaker said, "It was 3 years between the time I conceived of the film and when I was funded. By then, I wasn't really interested in shooting it."

Below is a list of some major organizations that give film grants. Each should be consulted for submission dates and the specific grants offered in any given year.

The *National Endowment for the Arts* (NEA) (Washington, D.C. 20506) offers grants for films about the arts and for films of artistic merit. There is also a grant for "emerging" film and video artists.

The *National Endowment for the Humanities* (NEH) (Washington, D.C. 20506) has grants for projects on humanities-related topics (as op-

posed to sciences or pure arts). The Youthgrant Program is for applicants under 30 years. They show stronger support for projects that have clear academic uses.

The *American Film Institute* (AFI) (501 Doheny Rd., Beverly Hills, CA 90201) is a graduate-level training school for directors, screenwriters, cinematographers and others. The AFI also administers a group of NEA film grants.

The *Corporation for Public Broadcasting* (CPB) (1111 16th St. NW, Washington, D.C. 20036) is funded by the government to provide funds for public television stations. Recently, there have been CPB grants awarded directly to independents to produce programming for documentary and dramatic series that are broadcast on PBS. Certain public television stations also administer programming grants, such as the *Independent Documentary Fund* at WNET (WNET, 356 W. 58th St., New York, NY 10019).

State arts councils support artists and their works. Check with your state or local government for available grants.

There are many private foundations and corporations that support filmmakers, and public and private agencies that do not specialize in arts grants but may support a specific project. The Foundation Center has a network of 90 libraries and clearing houses that list granting agencies and a tally of projects funded in the past. They publish a directory listing the 3000 largest grant-giving agencies in the country (write to 888 Seventh Ave., New York, NY 10019). State arts councils often have similar lists.

When you write a grant proposal, keep in mind that it will be read by panelists who are sifting through hundreds of applications; they will need to understand what you want to do as quickly as possible. Simple, direct and clear prose is important. Since you are usually asked to summarize your proposal in a paragraph or two, you will need to have a clear and succinct idea of your film.

It's helpful to find out what kinds of projects the granting agency has funded in the past and, if possible, how the review panel is selected. Each proposal should be tailored to the guidelines of the individual agency and the project should be represented in a way that is consistent with the agency's interests. If you can, it is often to your advantage to meet with the agency's staff so that your name, person and project are known to them prior to the meeting of the review panel. Although the staff usually does not pass judgment on proposals, it can help in various ways.

Beginning filmmakers are usually at a disadvantage in competing for grants because past work is often counted heavily. Frequently, well-known figures are brought in as consultants to lend credibility to a project; some grants, like those from NEH, require that experts be involved as advisors. Most agencies are particularly responsive to projects that are financed elsewhere and need only a relatively small amount to complete the funding. Remember to include donated labor, materials or

equipment, so indicted, in the budget; these in-kind contributions often cannot be used to match funds given in a matching grant.

You are often asked to submit a sample film when applying for grants. A tight, well-made ten-minute film is usually much better than a long, slowly developing feature. In fact, many panels request a ten-minute excerpt. A video tape copy can often be submitted instead of the film, which is especially valuable for films still in progress. Many filmmakers, however, feel that tapes have much less impact than projected films.

NONPROFIT STATUS. Some grants are only available to nonprofit organizations or indirectly to filmmakers working under the aegis of one. Such arrangements do not prevent a funded film from turning a profit. However, the filmmaker must often establish that his primary goal is to make a film of social, educational or artistic merit, not just one that is profit oriented.

Commercial filmmakers often create for-profit corporations solely to produce one film. In doing this, most legal responsibility rests on the corporate entity and is not the burden of one individual. Nonprofit corporations are more difficult to establish. It is usually more expedient for a filmmaker to affiliate himself with a nonprofit "conduit" through which to apply for funding. Many organizations will perform this service: film foundations, universities, church groups. Typically, the supporting group will take a percentage of the monies raised as overhead, but this may be waived.

One great advantage of certain types of nonprofit status is that individuals or corporations that support a film may be able to deduct their contribution from their income taxes. This factor can be a powerful incentive for wealthy contributors.

Contributions

Goods and services for a film production can often be obtained (legally) without the exchange of money. Food, air travel, props and labor may be offered by persons or companies in exchange for a tax deduction, a credit in the film or the chance to see a film in production.

A company may support a locally made film to build good community relations or, in a larger project, simply for the advertising. An airline may offer free tickets to a worthy project if a shot of one of their planes is included in the film. (Airlines often supply free stock footage of planes in flight, saving you the cost of getting it from a stock footage library.)

Production assistants will often work for free (although it is frequently the case that you get what you pay for).

By putting a notice in the newspaper, you can get acting extras for crowd scenes for free. It's a good idea to offer the extras something in exchange for their presence (for example, food or entertainment).

Copyrights and Releases

Copyrights

Finished films are copyrighted so that no one may legally duplicate or use material from the film without permission. To get a copyright, you must certify that the material in the film is original to you or that you have clearance to use anything covered by someone else's copyright. Copyright coverage includes dialogue, sound track, music and film footage. Neither the title of a film nor the ideas or concepts contained in it are protected. The broad ideas for plots, characters and settings cannot be owned, but verbatim excerpts of dialogue can be. Copyright laws were significantly revised for films made after 1978 and many people are only aware of the older statutes.

If your film is entirely original—that is, it contains no material protected by someone else's copyright—you can reserve copyright by placing, so as to be clearly visible in the film, the sign © (with or without the word "copyright"), along with the year of first publication and the name of the copyright holder (for example, © 1986 Joe Schmoe). In addition, you must submit a copy of the "best edition" of the work to the Library of Congress Copyright Office for archiving within 3 months of publication. The date of publication is defined as the first time the film is offered for distribution to the general public, whether by sale, rental or loan. Merely showing the film without offering it for distribution is not considered publication. The terms of best edition and the duration of its deposit in the archive may be negotiable if you apply for *special relief*. For a small fee you can also *register* the film, which provides certain additional protections in the event of copyright litigation. Write to the Library of Congress (Washington, D.C., 20559) for complete details.

Previously published music and the performances of it are subject to copyright protection. If you plan to use a cut from your favorite record, you must get permission from both the song's publisher and the record company. The publisher can be identified by first noting whether BMI or ASCAP is listed with the song on the record or the jacket. Broadcast Music, Inc. and the American Society of Composers, Authors and Publishers have offices in New York, Los Angeles and other cities and list the publishers of their songs. You must then negotiate with the record company and publisher for the rights to use the music in your film, which are called *synchronization rights*. Use of recorded performances can be especially costly; it is often cheaper to buy only the publisher's clearance and then hire your own musicians. Music from the public domain (for example most classical music) requires no publisher's clearance, but the

recorded performance may be protected. Music purchased from a commercial music library comes with copyright clearance: you can pay a *needle drop fee* for one-time continuous play or pay more for *unlimited use*.

Failure to get proper clearances leaves the filmmaker vulnerable to law suits. Distributors, television broadcasters and some film festivals may not accept such a film. Some filmmakers figure that the chance of litigation is low and choose to run the risk rather than to pay for clearance. Not-cleared films shown only in nonprofit or educational contexts requesting no money for viewing are less frequently the target of legal action. Under the *fair use laws,* you may be able to use short excerpts of copyrighted material without permission.

Releases

People appearing in films customarily sign *releases* in which they give permission for the filmmaker to use their picture, sound or likeness in the film. The purpose of the release is to establish that the person is aware that he is being filmed and that he permits footage of himself to be shown publically. This helps protect the filmmaker in a law suit if the subject claims he has been taken advantage of or has had his privacy invaded.

There is a fairly standard release form (below) that the film subject

Sample Release Form

For consideration received, I give permission without restrictions to _____ Productions, their successors and assignees to use my name, likeness, pictures and/or voice in connection with the motion picture tentatively titled _____ for broadcast, direct exhibition and any subsidiary purposes whatsoever in perpetuity.

The foregoing consent is granted with the understanding that you have the sole discretion to cut and edit the film and/or voice recording of my appearance and interviews as you see fit for incorporation in the program and I specifically waive any rights of privacy or publicity or any other rights I may have with respect to such use of my name, likeness, pictures and/or voice.

Signed_____ Date _____
Address_____
Signature of Parent or Guardian (for minors)_____

Witness [not needed in some states]_____Date_____

signs, which is normally accompanied by a token $1 cash payment, although some contend that this *consideration received* must be greater. Frederick Wiseman, the documentary filmmaker and attorney, has said that he simply tape records himself explaining to the subjects the nature of the film and its possible distribution, along with their verbal consent to be filmed.

Experts are divided on the value of releases, especially for documentary film. If a subject can establish that he has been libeled by the filmmaker's presentation of him, a signed release probably will not stand in his way of suing successfully. In a privacy infringement case, on the other hand, the mere presence of a camera crew may be sufficient grounds to establish that the subject was aware that what he said or did would be made public.

Releases are vital if the film footage will be used commercially to promote some product or company (in this case, the release should state that the subject waives his "right of publicity"). There are certain circumstances in which no releases are needed. If you are filming the public goings-on at some newsworthy event, for example, you have the same right as news photographers to film without permission (not, however, for product endorsement). If you surreptitiously shoot someone's intimate sidewalk conversation, however, you may go beyond the limit of the public's right to know. Court precedents in both libel and privacy law are complex and forever shifting; when in doubt, it is simplest to ask permission before filming or at least to ask those with objections to leave the area.

Distribution

Distribution refers to the various tasks required to get a finished film shown to its eventual audience. Distribution involves packaging, advertising, scheduling, shipping and negotiating with theater managers, television executives, school teachers, film festival committees and anyone else who might screen the film. Traditionally, distribution has been handled by companies set up to take care of this business. Filmmakers are increasingly performing this task themselves to retain more control and a larger share of the film's income.

Commercial Distributors

The filmmaker's relationship to his distributor is much like an author's is to his publisher. In both cases, a creative work is delivered to an organization that must arrange to have it copied, packaged, promoted and distributed to the consuming public. Usually, the filmmaker or author

receives an advance payment before the work actually generates any income, although this advance is often small relative to the time and cost of producing the work. In addition, he receives a royalty, which is a percentage of the money the work makes; the distributor or publisher retains all royalties until the advance is repaid. Unless special arrangements are made, the filmmaker or author usually has little say over how much or in what way the work is promoted or distributed.

This arrangement is essentially equitable, but you should be sure that you understand the specific terms of the contract. For example, the filmmaker's royalty is usually not based on the total money earned by the film *(box office returns)* or even on what is left after the theater owner skims his share *(total film rentals)*. Usually, the film distributor first deducts advertising and print expenses, and *then* the producer's royalty is calculated as a percentage of this *distributor's net* figure. For a typical educational film, the filmmaker may see as little as 15 percent of the film rentals earned by his movie.

Be aware that, if a commercial distributor feels a certain film is not profitable, he may decide not to promote it. Instead, he may simply list it in a catalogue, which, if large, offers the film little exposure to potential users. Under the terms of some distribution contracts, the filmmaker has no recourse for a period of years.

In addition to issues inherent in the contract, the filmmaker must try to monitor what the distributor is doing. Finding out how the film is being promoted and whether the correct royalties are being paid on film rentals and sales can be very difficult.

There are, however, some good reasons to sign with a commercial distributor. The job of distribution is costly and time-consuming; many filmmakers feel unprepared and uninterested in taking it on. If a distributor thinks there is money to be made on a film, he will invest in release prints and advertising and will exploit the inroads he has established in various markets. Distributors keep mailing lists of people who have rented similar films in the past, and they have a sales force familiar with key personnel in school systems, libraries and theaters. When you sign with a distributor, you do give up a large percentage of your film's future earnings, but you are spared the investment—which can easily run into thousands—necessary to generate income in the first place.

When you are choosing a distributor, shop around for one who will commit himself to promoting your film. Small companies usually have less money for advances but may pay more attention to the films they carry. Find out what costs, if any, you will bear. Read the contract carefully to determine which rights you are reserving and which you are assigning to the distributor. The distributor will usually want theatrical or educational *(audiovisual)* distribution rights, but you may be able to retain other markets (like broadcast or cable television or foreign distribution) for yourself or to sell to another distributor. Make sure there is a

contract clause that reverts all rights to you should the distributor fail to do his job.

Alternative Distributors

Between the extremes of running your own distribution business (self-distribution) and signing with a commercial distributor is the possibility of working with a distribution cooperative, which allows the filmmaker to share some of the chores and costs while retaining independence.

The older co–ops, like the Filmmakers Cooperative in New York City and the Canyon Cinema Cooperative in Sausalito, function somewhat like film shipping houses. They will carry a film along with many others in their catalogue, and will ship the film out in response to rental requests. These co–ops will accept any film, and, unlike commercial distributors, they do not require exclusive privileges which would prevent you from sending out the film yourself or from using other distributors. Their fee is relatively low (about 25 percent of film rentals). They do not, however, promote or invest in a film's distribution; that job is left to the filmmaker.

There are many newer cooperatives whose organization ranges from communal groups sharing resources, publicity and labor to more commercial ventures that have the profile of regular distribution companies but place more financial and promotional responsibility with the filmmakers. Cooperatives exist in many cities. Since a cooperative's success is, in varying degrees, dependent on the success of the individual members, some of the most prosperous groups, like New Day Films, have stayed small and highly selective.

Self-Distribution

Despite all the effort and cost involved, self-distribution does have its rewards. The filmmaker's control over promotion ensures that the film will be represented in a way satisfactory to him, and that potential users will be made aware of his film, which is often not the case with commercial distributors. Also, the small-time filmmaker has a much better chance of actually seeing profit from a movie if he distributes it himself. As one distribution specialist put it, "Take your film to a distributor. If he wants it, you know it's profitable so don't give it to him, distribute it yourself."

Self-distribution can be a full-time job, especially in the first few months of the film's release. The distribution campaign requires an initial outlay for prints, publicity, business forms, shipping and costs such as film festival entrance fees. There is the continuing overhead for cleaning and inspecting prints, replacing damaged footage, telephone and promotional mailings. Those self-distributors who have turned a profit have done so by streamlining the mechanical aspects of scheduling, shipping prints and organizing billings. Certain costs, like advertising, do not in-

crease much for two films instead of one, so it can be cheaper to work with someone who is distributing a similar film. This approach is especially effective when two short films can be promoted as a single program.

You will need a promotional brochure for mailing that includes a description of the film and any reviews, endorsements or awards the film has won. You should also have a poster made that can be distributed for individual screenings. Films used in schools are often accompanied by study guides. Whether or not you have a distributor, to get attention for your film, you should consider the following.

FILM FESTIVALS. There are hundreds of festivals in the world. Many of them highlight specific types of films—features, documentaries, films on mental health. Most festivals require that films be submitted within a year or two of the film's completion, so do not delay in sending the film out. Entering your film in a festival may cost you shipping and entrance fees and often ties up a print for a few months. Festival awards or a showing at an exclusive event can be a boost to your film, as can the reviews that festival screenings often generate. Attending festivals where your film is showing is a good way of making contacts in the film world, and increases the chances that the film showing will be well-attended and the film reviewed. Some festivals will pay a rental fee or the filmmaker's expenses. You must usually negotiate these payments. *The Independent,* published by the Association of Independent Video & Filmmakers (AIVF, 625 Broadway, 9th Floor, New York, NY 10012) includes reviews of recent festivals, indicating how they treat films and filmmakers.

Many museums and universities have screening series that often include personal appearances by the filmmaker. Even more than festivals, professional conferences that are relevant to the subject matter of your film (such as a psychologists' convention for a film on family problems) can provide direct exposure to people who might buy or rent your film, and may include a reference in professional journals. (See the Bibliography for publications with lists of festivals and screening series.)

REVIEWS. Most newspapers will only review a film if it is playing locally for a number of days. Nationally distributed journals will review a film if they think it is important and likely to be widely distributed eventually. Do not be afraid to invite a reviewer to a screening; support from recognized writers can promote distribution greatly. The Educational Film Library Association (EFLA—43 West 61st St., New York, NY 10023), publishes a list of journals that review nontheatrical films.

DIRECT MAILINGS. EFLA also publishes a list of the largest libraries and school systems that regularly purchase films. There are many organizations that buy and rent films on specific topics (such as black studies, performing arts, child education). You can purchase computerized mail-

ing lists that are broken down into groups that have used films on topics relevant to your film. Cine Information's Film Users' Network (419 Park Ave. South, New York, NY 10016) sells lists on about 100 topics, which can be printed on precut mailing labels if you choose. Consult the yellow pages for many other mailing list companies. It is often possible to buy subscription lists from professional journals.

ADVERTISING. Ads in trade journals can be useful. Consider EFLA's list of film journals and publications of groups related to your film's topic.

SCREENINGS. Filmmakers often arrange their own screenings. Many films tie-in easily to the concerns of various special-interest groups. Successful self-distributors have been aided by groups that promote them in exchange for a charity opening-night gala. Sometimes a theater is rented outright for an evening or week, which is called *four-walling*. A more typical contract involves some promotion on the part of the *exhibitor* (theater owner). A percentage of the advertising and promotion costs are usually assigned to the exhibitor and a percentage to the film's distributor (you). There is often a sliding royalty scale to divide the "box." Generally, the scale moves in the filmmaker's favor after the exhibitor has earned back his "nut," or basic costs of keeping the theater open.

Museum and school screenings can earn significant income. To obtain information on putting together a tour, consult the Film and Video Makers' Travel Sheet (see Bibliography).

To distribute yourself, you will need several prints on hand for rentals, sales and *previews* (screenings by potential buyers prior to purchase). Most labs offer quantity discounts for release prints. Scratch-resist treatment is costly but can extend the life of a print in distribution. Many films are distributed on video cassette, which lowers the initial outlay for prints, but leaves the filmmaker extremely vulnerable to pirating by renters with video recording equipment.

The time required for shipping, cleaning, inspecting and repairing prints (and billing those responsible for damage) can be overwhelming. Many self-distributors employ a film shipping house (like Transit Media, P.O. Box 315, Franklin Lakes, NJ 07417) to do these tasks. The charge is about $10 to *turn a print around* (inspect it, clean it, ship it and bill the renter). Because of the costs involved in renting to audiovisual markets, it is usually more profitable to sell rather than to rent prints of short educational subjects.

Appendix A

A Comparison of Running Times and Formats of 8mm, Super 8, 16mm, and 35mm Motion Picture Films

Running Times and Film Lengths for Common Projection Speeds

FILM FORMAT	8 mm (80 Frames per Foot)				Super 8 (72 Frames per Foot)				16 mm (40 Frames per Foot)				35 mm (16 Frames per Foot)	
PROJECTION SPEED IN FRAMES PER SECOND	18		24		18		24		18		24		24	
RUNNING TIME AND FILM LENGTH	Feet	Frames	Feet	Frames	Feet	Frames	Feet	Frames	Feet	Frames	Feet	Frames	Feet	Frames
Seconds 1	0	18	0	24	0	18	0	24	0	18	0	24	1	8
2	0	36	0	48	0	36	0	48	0	36	1	8	3	0
3	0	54	0	72	0	54	1	0	1	14	1	32	4	8
4	0	72	1	16	1	0	1	24	1	32	2	16	6	0
5	1	10	1	40	1	18	1	48	2	10	3	0	7	8
6	1	28	1	64	1	36	2	0	2	28	3	24	9	0
7	1	46	2	8	1	54	2	24	3	6	4	8	10	8
8	1	64	2	32	2	0	2	48	3	24	4	32	12	0
9	2	2	2	56	2	18	3	0	4	2	5	16	13	8
10	2	20	3	0	2	36	3	24	4	20	6	0	15	0
20	4	40	6	0	5	0	6	48	9	0	12	0	30	0
30	6	60	9	0	7	36	10	0	13	20	18	0	45	0
40	9	0	12	0	10	0	13	24	18	0	24	0	60	0
50	11	20	15	0	12	36	16	48	22	20	30	0	75	0
Minutes 1	13	40	18	0	15	0	20	0	27	0	36	0	90	0
2	27	0	36	0	30	0	40	0	54	0	72	0	180	0
3	40	40	54	0	45	0	60	0	81	0	108	0	270	0
4	54	0	72	0	60	0	80	0	108	0	144	0	360	0
5	67	40	90	0	75	0	100	0	135	0	180	0	450	0
6	81	0	108	0	90	0	120	0	162	0	216	0	540	0
7	94	40	126	0	105	0	140	0	189	0	252	0	630	0
8	108	0	144	0	120	0	160	0	216	0	288	0	720	0
9	121	40	162	0	135	0	180	0	243	0	324	0	810	0
10	135	0	180	0	150	0	200	0	270	0	360	0	900	0

Typical Running Times of Films

FILM FORMAT	8 mm				Super 8				16 mm				35 mm	
PROJECTION SPEED IN FRAMES PER SECOND	18		24		18		24		18		24		24	
INCHES PER SECOND	2.7		3.6		3.0		4.0		5.4		7.2		18.0	
FILM LENGTH AND SCREEN TIME	Min	Sec	Min	Sec	Min	Sec	Min	Sec	Min	Sec	Min	Sec	Min	Sec
Feet 50	3	42	2	47	3	20	2	30	1	51	1	23	0	33
100	7	24	5	33	6	40	5	0	3	42	2	47	1	7
150	11	7	8	20	10	0	7	30	5	33	4	10	1	40
200	14	49	11	7	13	20	10	0	7	24	5	33	2	13
220	—	—	—	—	14	40	11	0	—	—	—	—	—	—
300	22	13	16	40	20	0	15	0	11	7	8	20	3	20
400	29	38	22	13	26	40	20	0	14	49	11	7	4	27
500	37	2	27	47	33	20	25	0	18	31	13	53	5	33
600	44	27	33	20	40	0	30	0	22	13	16	40	6	40
700	51	51	38	53	46	40	35	0	25	56	19	27	7	47
800	59	16	44	27	53	20	40	0	29	38	22	13	8	53
900	66	40	50	0	60	0	45	0	33	20	25	0	10	0
1000	74	4	55	33	66	40	50	0	37	2	27	47	11	7
1100	81	29	61	7	73	20	55	0	40	44	30	33	12	13
1200	88	53	66	40	80	0	60	0	44	27	33	20	13	20
1600	—	—	—	—	106	40	80	0	59	16	44	27	—	—

Number of Frames Separation Between Sound and Picture

	8 mm	Super 8	16 mm	35 mm
Magnetic Track	56	18	28	28
Optical Track	—	22	26	20

Figures in the table are for reel-to-reel projection in which the sound precedes the picture. The speed of 25 frames per second is used for 16 mm TV films, and increasingly for other 16 mm sound films, in 50 Hz countries.

Reprinted by permission of Eastman Kodak.

Appendix B
A Technique for Synchronizing the Rushes

1. Load the workprint and the mag film in the synchronizer or editing machine. They are usually loaded on the left so that the forward direction is from left to right. For this discussion, we will assume the material is set up in this way.

2. Use the slate or other point of reference as a guide for putting the sound and picture for the first shot in sync with each other (see Accuracy, Slates and Lip Syncing, Chapter 12). This requires shifting the position of the rolls with respect to each other.

3. Once the first shot is in sync, move the workprint and the mag film backward (to the left) to the *head* (beginning) of the picture roll. On the right-hand side of the synchronizer cut off any excess laboratory leader on the picture (although if it contains the lab order number for the roll, you may want to leave some of it), and trim the sound roll at the same spot. Splice on about 6′ of plain, single-perforated leader on both rolls. Any time you splice leader or fill onto the sound, make sure it is positioned with the base toward the sound head.

 Continue moving backward onto the leader about a foot or so, and mark a *start* or *head sync* mark with a Sharpie at the same frame on both rolls (see Fig. 12-3). At the head of the leaders write your name, the name of the film, the camera roll number and either "head pix" or "head track" on the picture and sound, respectively.

4. Move the picture and sound forward to the end of the first shot. The end can usually be located by the flash frames—overexposed frames that occur when the camera stops between shots. Mark both sound and picture with the number 1 at the same frame.

5. Go forward and sync up the second shot. You will again need to shift the sound and picture relative to each other to accomplish this.

6. After the second shot is in sync, roll the sound and picture backward together to the number 1 you just marked on the picture. Mark a *second* 1 on the sound at the same frame. Search through the sound roll by hand to find the first 1 you marked on it.

7a. You will usually find the first 1 toward the head of the roll (to the right), which occurs whenever there is more sound than picture (normally the recorder runs longer than the camera). Move both rolls slightly to the right, and cut the sound from the left-hand edge of one of the frames marked 1 to the left-hand edge of the other (for consistency's sake, always cut on the left-hand edge of a marked frame). Splice the sound roll back together, and hang the wild sound you have just removed on a bin or spool it up on a separate roll.

7b. If you find the original 1 toward the *tail* (end) of the roll (to the left), this indicates that there is not enough sound to cover the picture (perhaps because the recorder started late on the second shot). Cut a piece of leader that is the same length as the distance from the left-hand edge of one 1 to the left-hand edge of the other. Often you can use the editing machine or synchronizer to measure the leader quickly. Splice the leader at the appropriate frame marked 1; this will depend on whether the first or the second shot has insufficient sound. When you have finished, both the first and second shots should be in sync; realign them if necessary.

8. Now go forward to the end of the second shot, and mark it with a 2 on the same frame of both sound and picture.

9. Return to step 5; this time you will be syncing up the third shot, and so on.

10. At the tail of the picture roll, cut the sound at the same spot and splice tail leaders on both rolls, marked as before but with tail sync marks and "tail pix" and "tail track" written on the leaders.

This method is fast and leaves a string of wild sound of which each piece is marked according to the shot from which it was removed, which helps in identifying it later. If you decide to leave any wild sound in the sync rolls, you can do so simply by splicing the same length of leader into the picture at the corresponding spot.

Appendix C
Cement Splicing

The types of cement splicers are varied, ranging from large foot-operated models to small portable units. Splicers used for acetate base films use cement to fuse together the overlapping ends of two pieces of film. (For polyester-base films, large, expensive splicers fuse the pieces of film together, generally without the aid of film cement.) Follow the instructions for the particular type of splicer you have and get someone to show you how it works. Before you attempt to splice important material, practice with scrap film until you are proficient. While practicing, test your splices by yanking on them. The film should snap before a well-made splice comes apart. Twisting will make most splices come apart, but will give you a way to compare the comparative strength of test splices.

Hot splicers have a heating element to speed the drying of the film cement, and are faster to use. Since the heating element takes a fair amount of time to warm up, hot splicers are often left plugged in during the whole working day (or, in busy editing rooms, they may never be turned off). However, some editors feel splices made with the heating element on do not last as long, weakening within a year. These editors often use hot splicers because of the quality of their construction but use them with the heating element turned off.

The film cement contains a solvent that dissolves film base, and, when dry, will weld together two properly prepared pieces of film. It is important to use a high-quality *fresh* cement. When exposed to air, this solvent evaporates, and the film cement becomes gummy and will no longer make a good splice. To keep the cement fresh: keep a small working supply of cement in a small well-capped glass bottle, and discard the contents every couple of hours. Store the bulk supply (which generally need be no more than a pint bottle) separately.

Keep the splicer clean of emulsion, properly adjusted and the scraper sharp. Acetone will dissolve both emulsion and film cement. You can use it to clean both the splicer and the small bottle that holds the film cement.

To splice: Place the film in the splicer, emulsion side up. Use the scraper to remove *completely* the emulsion and binder from the section

of film to be overlapped (see Figs. A and B). Make sure the scraped area is clean and dry before applying the film cement. On some splicers you must moisten the emulsion with water or saliva before scraping, and on others you can dry-scrape. You must also remove magnetic striping in the area to be spliced, either by scraping or by dissolving it with film cement and wiping it away. When scraping emulsion you must be careful not to scrape too deep and gouge the exposed base (see illustration E).

Any wax or dirt on the base of the overlapping piece of film (that is, the film to be spliced to the area where the emulsion has been scraped) may interfere with a good weld. To remove any foreign material, wipe with an alcohol-moistened cloth or apply a small amount of film cement and immediately wipe it off with a soft cloth. Some editors also lightly scrape the base on the overlapping piece of film. Again, be careful not to scrape too deeply.

Apply the cement to the area where the emulsion has been scraped in a thin, even layer. *Immediately* press the base of the overlapping section onto the scraped, cement-coated area. Open the splicer, and wipe off any excess cement. Rub the splice firmly with a soft cloth to give added assurance of a good splice. Check that the splice is transparent; hazy areas or bubbles are signs of a poor splice.

A properly made splice can be removed from the splicer after ten to thirty seconds (depending on the type of film cement). A hot splicer cuts the time down to five to ten seconds. Though the film can be projected immediately, the splice cures and becomes stronger over time (two or more hours).

Causes of poor splices include: emulsion or binder not completely removed; excessive scraping weakening the base, causing the film to break; too great a delay in joining the sections of film after applying cement; too much cement, making a messy splice and also possibly causing the film to buckle in the projector gate; too little cement, making the weld too weak; wax or oil not removed from the base of the overlapping film; old or unsuitable film cement.

FIGURE A—If a small section of motion picture film were to be magnified to great size, we should see that the film is made up of more than one layer. In the above illustration the thickness of the various layers is exaggerated.

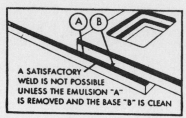

FIGURE B—It is impossible to cement the base side of one piece of film to the emulsion of another. The emulsion and binder must first be completely removed so that the two film base surfaces can come in direct contact with each other.

FIGURE C—A good motion picture film splice is actually a weld. When a perfect splice is made, one side of the film base is dissolved into the base of the other film. With most splicing apparatus this requires from 10 to 20 seconds.

FIGURE D—If any emulsion or binder remains on the base in the area where the splice is to be made, a good weld will not result and the splice may not hold.

FIGURE E—Scratching or gouging the prepared film base near the emulsion edge should be avoided. Such scratches (A) weaken the weld and may cause the film to break at this point. Fine abrasive scratches are not serious.

Figures A–E reprinted by permission of Eastman Kodak Co.

Appendix D
Conforming the Original

See Chapter 13 before reading this section. When you have finished cutting and marking the workprint, you are ready to conform the original. The following discussion assumes that the film is loaded on the editing bench on the left side so that forward movement is from left to right.

The work space should be clean and dust-free. Handle the original only with white editing gloves, which are available at most labs. The cement splicer should be properly aligned and used only with *fresh* cement (see Appendix C for more on cement splicing). Never mark the original with a grease pencil; only use India ink or scribe marks (see below). Any black leader used should be fresh and *completely opaque*. The cans in which the original is stored should be marked with the latent edge numbers so that any shot can be located by edge number. It is extremely helpful to have two pairs of rewinds. One pair can be used for searching for shots, while the other is used for splicing and, with the aid of a synchronizer, for matching workprint with the original.

Some conformers work by first logging the edge numbers of each shot in the workprint and then culling *all* the shots from a given roll of original at one time. This cuts down on the handling of the original since each roll does not need to be rewound every time a shot is taken from it. The shots are then put aside (see below) and assembled in proper order when all the shots have been cut. Other conformers work by culling each shot from the original in the order it appears in the workprint. This involves more handling of the original rolls but may reduce confusion. Most conformers find it simpler to cut all the shots out of the original and then cement splice them rather than trying to do both tasks at the same time.

Place the edited workprint in the front gang of the synchronizer, and wind down to the first shot you want to conform until you find the first latent edge number. Lock the shot in place by turning down the lever on the front of the synchronizer. Locate the corresponding shot in the original by its latent edge number, and place it in the second gang of the synchronizer in precise frame-to-frame alignment with the workprint.

Unlock the synchronizer and run the two pieces of film back to the head of the shot in the workprint. Mark the frame where the original is to be spliced with *scribe marks*—two small scratches made *outside the picture area* on either side of the sprocket hole where the splice is to be made. Roll both pieces of film to the right slightly until the scribe marks are to the right of the synchronizer. Cut the original with scissors at least a half frame beyond the frame you just marked (which is to the right on most editing setups). This half frame is needed to make the cement splice. Now wind down the workprint and original to the tail of the first workprint shot, and scribe the original at the last sprocket hole of the shot. Roll the footage slightly to the left of the synchronizer, and again cut the original at least a half frame longer than the workprint shot.

Some conformers wind up each shot separately (either on a core or around itself), and wrap the last few winds in a piece of paper that identifies the shot by its latent edge number. Sometimes white leader is attached with a very small piece of tape to the head and tail of each shot to protect it. The other widely practiced technique is to tape the shots in a continuous strand on a reel. This is only feasible if the shots have been culled in the order they appear on the workprint. Many people feel this is a poor practice since tape can damage the original and the gum may be hard to remove. Only low-tack masking tape should be used on the original.

When cutting any shots to be used in a dissolve (which is only possible with A & B rolls), do not forget to cut at the *end* of the dissolve mark on the workprint; that is, the shot should be cut one-half the length of the dissolve longer than where the splice occurs in the workprint (the splice is at the center of the dissolve). On the original, sometimes a small x is marked on either side of the sprocket hole at the center of the dissolve (see Fig. 13-3). This should be done outside the picture area on both the A- and the B-rolls, as this helps in aligning the rolls later.

When you are preparing A & B rolls, it is advisable to have a synchronizer with at least three gangs. Begin by preparing the printing leaders as described in Chapter 13. Line up the printer start marks in the synchronizer. The SMPTE leader is usually spliced on the head of the B-roll immediately following the white printing leader. Black leader is spliced opposite it on the A-roll and trimmed to the same length (run both strands in the synchronizer to measure where to cut). The first shot of the cut original film is then placed on the A-roll, with black leader spliced on the B-roll opposite it, and so on.

Remember that fades are laid out differently for reversal films than they are for negative films, while dissolves are laid out the same for each (see Chapter 13).

It is imperative that the emulsion of the black leader never be scraped during splicing as this will defeat the purpose of checkerboard printing—

invisible splices. Only scrape the original film on the overlap you left when trimming each shot. The workprint should be run in the third gang of the synchronizer to ensure proper cutting of shots and effects on the A & B rolls. After the rolls are spliced, they should again be checked against the workprint for cutting errors.

Appendix E
Depth of Field Tables

This appendix contains two tables. The first is in feet and inches, the second is in the metric system.

To use these tables: (1) Find the lens aperture you are using (expressed as a T-stop) in the Lens Aperture column at upper left. Read across that row to the right until you locate the lens focal length at which you are filming. This is the column in which the depth of field is indicated. (2) Find the point at which the lens is focused in the Point of Focus column on the left side of the chart. Read across that row to the right until you come to the column you located in (1). These figures indicate the near and far limits of the depth of field as measured from the focal plane. For example (using the Ft. and In. table), at T8, a 100mm fixed focal length lens focused at 10 feet, provides a depth of field from 9-0 to 11-4 (that is, 9 feet to 11 feet, 4 inches).

This method is used for a $\frac{1}{500}$ inch circle of confusion. For $\frac{1}{1000}$ inch circle of confusion (often used in 16mm work, see Chapter 3), read depth of field two columns to the right.

See Chapter 3 for limitations on depth of field tables.

Depth of field is a geometrical calculation, and the f-stop, a geometrical measurement, should be used for depth of field estimations. These charts were calculated with f-stops but are expressed in terms of T-stops, allowing $\frac{1}{3}$ stop for the difference. For most lenses, using the T-stop with these charts will be fairly accurate. If your lens is not marked in T-stops, using the f-stop will give a slightly stingy figure for depth of field.

Depth of Field Tables: Ft. & In.
Nearest and Furthest Point of Acceptable Focus

Lens Aperature (T-stop)	Lens Focal Lengths in Relation to Lens Aperture (mm)										
	For 1/500in. circle of confusion use tables as printed.										
	For 1/1000in. circle of confusion transpose focal lengths two columns to right.										
T2				21	25	30	35	42	50	60	70
2·8			21	25	30	35	42	50	60	70	84
4		21	25	30	35	42	50	60	70	84	100
5·6	21	25	30	35	42	50	60	70	84	100	120
8	25	30	35	42	50	60	70	84	100	120	140
11	30	35	42	50	60	70	84	100	120	140	170
16	35	42	50	60	70	84	100	120	140	170	200
22	42	50	60	70	84	100	120	140	170	200	240

Point of Focus Measured from Focal Plane (Feet)

Fixed Focal Length Lenses and Most 16mm Type Zoom Lenses

Point of Focus (Feet)												
3-0	Near	1-11½	2-2½	2-4¾	2-6½	2-8	2-9	2-9¾	2-10½	2-11	2-11¼	2-11½
	Far	6-7¼	4-8¼	3-11¾	3-7¾	3-5½	3-3½	3-2½	3-1¾	3-1¼	3-0¼	3-0½
3-6	N	2-2½	2-5¼	2-8¼	2-10¾	3-0½	3-2	3-3	3-3¾	3-4½	3-5	3-5¼
	F	9-3¼	6-0¾	5-0¾	4-5¼	4-1¾	3-11	3-9½	3-8½	3-7½	3-7	3-6¾
4-0	N	2-4	2-8½	2-11¾	3-2¾	3-4¾	3-6¾	3-8	3-9¼	3-10	3-10¾	3-11
	F	15-5	7-9¾	6-2½	5-3½	4-10½	4-6¾	4-4¾	4-3¼	4-2¼	4-1¼	4-1
4-6	N	2-6	2-11¼	3-2¼	3-6½	3-9	3-11¼	4-1	4-2½	4-3½	4-4½	4-4¾
	F	25-2	10-1	7-6¼	6-2¾	5-7¾	5-2¾	5-0	4-10	4-8¾	4-7¾	4-7¼
5-0	N	2-7½	3-1½	3-5¾	3-10	4-1	4-4	4-6	4-7¾	4-8¾	4-10	4-10½
	F	75-0	13-1	9-1	7-3	6-5½	5-11½	5-7½	5-5¼	5-3½	5-2¼	5-1½
6-0	N	2-10½	3-5¾	3-11	4-4½	4-8¾	5-0½	5-3½	5-5¾	5-7½	5-9	5-9¾
	F	Inf	23-10	13-2	9-7¼	8-3	7-5	6-11½	6-7½	6-5¼	6-3½	6-2½
8-0	N	3-3	4-0½	4-8	5-4	5-10½	6-4½	6-9¼	7-1	7-4	7-6½	7-8
	F	Inf	Inf	30-2	16-2	12-8	10-9	9-10	9-2¼	8-9	8-6¼	8-4½
10-0	N	3-6¼	4-5¾	5-3	6-1¾	6-10¼	7-6¾	8-1½	8-7¼	9-0	9-3½	9-5¾
	F	Inf	inf	inf	27-6	18-7	14-9	13-0	11-11	11-4	10-10	10.7
15-0	N	3-11¾	5-3	6-4	7-8½	8-10¼	10-1	11-1½	12-0	12-11	13-5	13-10
	F	Inf	Inf	Inf	Inf	50-0	29-6	23-1	19-11	18-2	17-0	16-5
25-0	N	4-5	6-0¾	7-7	9-7¾	11-7	13-9	15-9	17-9	19-3	20-10	21-11
	F	Inf	Inf	Inf	Inf	Inf	Inf	61-0	42-7	36-9	31-4	29-3
50-0	N	4-10	6-10	8-11	11-11	15-0	19-0	23-0	27-4	32.0	35-7	38-9
	F	Inf	inf	Inf	inf	inf	Inf	Inf	Inf	200-0	100-0	70-0
Inf	N	5-4	7-11	10-9	15-7	21-3	30-3	42-3	60-3	80-0	120-0	170-0

35mm Type Zoom Lenses

Point of Focus (Feet)												
5-0	N	3-2	3-7	3-10	4-1½	4-3¾	4-6	4-7½	4-8¾	4-9½	4-10¼	4-10¾
	F	19-9	9-9	7-8	6-6½	6-0¼	5-7¾	5-5½	5-5¾	5-2¾	5-1¾	5-1¼
6-0	N	3-6	4-0	4-4	4-9	5-0	5-3	5-5¼	5-7	5-8¼	5-9½	5-10
	F	177-0	16-2	10-11	8-7	7-8	7-0½	6-8¾	6-5¾	6-4	6-2¾	6-2
8-0	N	3-11	4-7	5-2	5-9	6-2	6-8	7-0	7-3	7-5¼	7-7¼	7-8½
	F	Inf	94-0	23-0	14-1	11-8	10-2	9-10	8-11½	8-8	8-5½	8-4
10-0	N	4-3	5-1	5-9	6-7	7-3	7-11	8-4	8-10	9-1¼	9-4½	9-6¼
	F	Inf	Inf	70-0	23-1	16-11	13-10	12-7	11-8	11-1	10-9	10-6
15-0	N	4-9	5-11	6-11	8-3	9-4	10-7	11-5	12-4	13-0	13-6	13-11
	F	Inf	Inf	Inf	154-0	43-3	26-11	22-2	19-4	17-10	16-10	16-4
20-0	N	5-1	6-5	7-8	9-5	10-11	12-8	14-0	15-5	16-5	17-5	18-0
	F	Inf	inf	Inf	Inf	195-0	51-0	35-11	28-10	25-8	23-6	22-6
50-0	N	5-8	7-7	9-7	12-6	15-8	19-10	23-6	28-3	31-2	36-0	38-10
	F	Inf	Inf	Inf	Inf	Inf	Inf	Inf	260-0	120-0	82-6	70-3
Inf	N	6-2	8-8	11-5	16-4	22-0	31-9	43-0	61-7	85-6	125-0	170-0

Depth of Field Tables—Metric
Nearest and Furthest Point of Acceptable Focus

Lens Aperture (T-stop)	Lens Focal Lengths in Relation to Lens Aperture (mm)										

For 0·05mm circle of confusion use tables as printed.
For 0·025mm circle of confusion transpose focal lengths two columns to right.

T-stop											
T2				21	25	30	35	42	50	60	70
2·8			21	25	30	35	42	50	60	70	84
4		21	25	30	35	42	50	60	70	84	100
5·6	21	25	30	35	42	50	60	70	84	100	120
8	25	30	35	42	50	60	70	84	100	120	140
11	30	35	42	50	60	70	84	100	120	140	170
16	35	42	50	60	70	84	100	120	140	170	200
22	42	50	60	70	84	100	120	140	170	200	241

Point of Focus Measured from Focal Plane (Meters)

Fixed Focal Length Lenses and Most 16mm Type Zoom Lenses

Meters												
1·0	Near	0·6	0·72	0·78	0·84	0·88	0·91	0·93	0·95	0·96	0·97	0·98
	Far	2·5	1·65	1·40	1·25	1·17	1·11	1·08	1·05	1·04	1·03	1·02
1·2	N	0·72	0·82	0·89	0·97	1·02	1·07	1·10	1·13	1·15	1·17	1·18
	F	4·41	2·30	1·84	1·58	1·45	1·37	1·31	1·28	1·26	1·24	1·23
1·3	N	0·75	0·86	0·95	1·03	1·09	1·15	1·19	1·22	1·25	1·26	1·27
	F	5·37	2·72	2·1	1·76	1·61	1·5	1·44	1·39	1·36	1·34	1·33
1·5	N	0·82	0·94	1·05	1·15	1·23	1·3	1·35	1·39	1·42	1·44	1·46
	F	18·7	3·82	2·69	2·16	1·93	1·78	1·69	1·63	1·59	1·56	1·54
1·7	N	0·87	1·02	1·14	1·27	1·36	1·45	1·51	1·56	1·59	1·63	1·65
	F	Inf	5·54	3·43	2·60	2·27	2·07	1·95	1·86	1·83	1·77	1·75
2·0	N	0·94	1·11	1·26	1·42	1·54	1·66	1·74	1·81	1·8	1·91	1·93
	F	Inf	11·2	4·98	3·4	2·86	2·53	2·35	2·23	2·15	2·10	2·07
2·5	N	1·03	1·25	1·44	1·66	1·82	1·98	2·11	2·21	2·29	2·35	2·39
	F	Inf	Inf	10·2	5·20	4·02	3·40	3·08	2·88	2·75	2·67	2·62
3·0	N	1·07	1·36	1·59	1·86	2·07	2·28	2·24	2·59	2·71	2·79	2·85
	F	Inf	Inf	33·4	8·03	5·51	4·41	3·89	3·57	3·37	3·25	3·17
5·0	N	1·24	1·65	2·0	2·45	2·84	3·26	3·62	3·94	4·22	4·43	4·58
	F	Inf	Inf	Inf	Inf	21·6	10·8	8·12	6·85	6·15	5·75	5·51
8·0	N	1·36	1·87	2·35	3·0	3·6	4·3	4·95	5·59	6·15	6·61	6·95
	F	Inf	Inf	Inf	Inf	Inf	60·0	21·0	14·1	11·5	10·1	9·42
17·0	N	1·147	2·1	2·71	3·62	4·54	5·73	6·95	8·28	9·56	10·7	11·7
	F	Inf	Inf	Inf	Inf	Inf	Inf	Inf	82·0	35·1	25·0	21·0
Inf	N	1·62	2·42	3·29	4·74	6·48	9·22	12·9	18·4	26·0	37·1	52·0

35mm Type Zoom Lenses

Meters												
1·5	N	0·97	1·08	1·16	1·24	1·3	1·35	1·39	1·42	1·44	1·46	1·47
	F	5·55	2·86	2·27	1·95	1·8	1·69	1·63	1·59	1·56	1·54	1·53
1·7	N	1·03	1·16	1·26	1·36	1·44	1·51	1·55	1·6	1·62	1·64	1·66
	F	13·0	3·94	2·86	2·35	2·11	1·96	1·88	1·82	1·79	1·76	1·74
2·0	N	1·1	1·27	1·39	1·53	1·63	1·73	1·79	1·85	1·89	1·92	1·94
	F	Inf	6·87	4·05	3·04	2·64	2·4	2·27	2·18	2·13	2·09	2·06
3·0	N	1·28	1·53	1·74	1·98	2·18	2·38	2·52	2·64	2·73	2·81	2·86
	F	Inf	Inf	18·9	6·97	5·03	4·12	3·75	3·48	3·33	3·22	3·16
5·0	N	1·47	1·84	2·18	2·61	2·99	3·41	3·72	4·03	4·26	4·46	4·59
	F	Inf	Inf	Inf	Inf	18·3	9·79	7·78	6·64	6·07	5·69	5·49
10·0	N	1·66	2·17	2·68	3·4	4·14	5·05	5·79	6·64	7·32	7·99	8·44
	F	Inf	Inf	Inf	Inf	Inf	Inf	40·4	20·8	15·9	13·4	12·29
20·0	N	1·77	2·38	3·03	4·02	5·12	6·64	8·03	9·8	11·4	13·2	14·51
	F	Inf	Inf	Inf	Inf	Inf	Inf	Inf	Inf	85·2	41·64	32·33
Inf	N	1·89	2·63	3·49	4·99	6·7	9·69	13·1	18·8	26·0	38·0	52·0

Appendix F
Hyperfocal Distance Tables

If the lens is focused at the hyperfocal distance, everything from half that distance to infinity should be in acceptably good focus. See Chapter 3 for limitations on the use of hyperfocal distance and depth of field tables.

To use these tables: (1) Find the lens aperture you are using (expressed as an *f*-stop) in the column at left. Read across that row to the right until you locate the lens focal length at which you are filming (you will find this either in the upper or lower chart). This is the column in which the hyperfocal distance is indicated. (2) Find the circle of confusion you are using on the lower left side of the charts. Read across that row to the right until you come to the column you located in (1). This is the hyperfocal distance for the focal length/aperture combination you are using.

A circle of confusion of 1/1000″ (0.001) is often used for 16mm work (see Chapter 3).

Hyperfocal Distance

f-stop	Lens focal lengths (mm)						
1					9	11	12.5
1.4				9	11	12.5	15
2			9	11	12.5	15	17.5
2.8		9	11	12.5	15	17.5	21
4	9	11	12.5	15	17.5	21	25
5.6	11	12.5	15	17.5	21	25	30
8	12.5	15	17.5	21	25	30	35
11	15	17.5	21	25	30	35	42
16	17.5	21	25	30	35	42	50
22	21	25	30	35	42	50	60

Circles of confusion	Hyperfocal distances						
0.001in	2ft 6½in	3ft 7in	5ft 3in	7ft 3 in	10ft 6in	14ft 9in	20ft 6in
0.002in	1ft 3in	1ft 9½in	2ft 7in	3ft 7½in	5ft 3in	7ft 4in	10ft 6in
0.025mm	0.8m	1.1m	1.6m	2.2m	3.2m	4.5m	6.3m
0.05mm	0.4m	0.56m	0.8m	1.1m	1.6m	2.2m	3.2m

f-stop	Lens focal lengths (mm)						
1	15	17.5	21	25	30	35	42
1.4	17.5	21	25	30	35	42	50
2	21	25	30	35	42	50	60
2.8	25	30	35	42	50	60	70
4	30	35	42	50	60	70	84
5.6	35	42	50	60	70	84	100
8	42	50	60	70	84	100	120
11	50	60	70	84	100	120	140
16	60	70	84	100	120	140	170
22	70	84	100	120	140	170	200

Circles of confusion	Hyperfocal distances						
0.001in	29ft 6in	41ft	59ft	82ft	118ft	164ft	236ft
0.002in	14ft 9in	20ft 6in	29ft 6in	41ft	59ft	82ft	118ft
0.025mm	9m	12.5m	18m	25m	36m	50m	72m
0.05mm	4.5m	6.3m	9m	12.5m	18m	25m	36m

Bibliography

General

Baddeley, W. Hugh. *The Technique of Documentary Film Production*, 4th ed. New York: Hastings House, 1975. An overall view of traditional documentary production.

Brodsky, Bob and Treadway, Toni. *Super 8 in the Video Age*. (63 Dimick St., Somerville, MA 02143). 1983. Using super 8 to best advantage. Details video transfer techniques.

Goodell, Gregory. *Independent Feature Film Production*. New York: St Martin's Press, 1982. Manual on independent feature film production. Especially good on unions, casting agencies, budgeting and distribution.

Happe, L. Bernard. *Basic Motion Picture Technology*. New York: Hastings House, 1978. An excellent survey of film technology.

Lipton, Lenny. *Independent Filmmaking*. San Francisco: Simon & Schuster, 1983. An overall technical view of film production, stressing experimental film techniques.

Malkiewicz, Kris J. *Cinematography*. New York: Van Nostrand Reinhold Co., 1973. Covers most technical aspects of motion picture production. Well-written and well-illustrated.

Mayer, Michael F. *The Film Industries: Practical Business/Legal Problems in Production, Distribution and Exhibition*. New York: Hastings House, 1978.

Roberts, Kenneth H., and Sharples, Win, Jr. *A Primer for Film-Making*. Indianapolis: Bobs-Merrill, 1978. A well-illustrated overview of film production. Particularly strong on editing techniques and equipment.

Production

Academy of Motion Picture Arts and Sciences. *Academy Players Directory* (8949 Wilshire Blvd., Beverley Hills, CA 90211). Photographs of actors and actresses with agent listings. Regularly updated.

Association of Motion Picture and Television Producers. *Guide to Location Information* (8480 Beverley Blvd., Los Angeles, CA 90048). Regularly updated.

Brook's Standard Rate Book. Union rates and rules.

Clark, Frank P. *Special Effects in Motion Pictures*. New York: Society of Motion Picture and Television Engineers, 1966.

Directors Guild of America. *Directors Guild of America Directory* (7950 West Sunset Blvd., Los Angeles, CA 90056). Lists members of the Directors Guild. Regularly updated.

Fielding, Raymond. *The Technique of Special Effects Cinematography*. New York: Hastings House, 1972.

The Hollywood Production Manual (1322 North Cole Avenue, Hollywood, CA 90028). Contains guild and union rules and rates. Lists production facilities in the Los Angeles area.

Kehoe, Vincent J. R. *The Technique of Film and Television Make-Up for Color and Black & White*. New York: Hastings House.

Motion Picture, TV and Theatre Directory (Motion Picture Enterprises, Tarrytown, NY 10591). Useful lists by category of suppliers of production and postproduction services and equipment. Published semi-annually.

Writers Guild, *Writers Guild Directory* (8955 Beverley Blvd., Los Angeles, CA 90048). Lists members of the Writers Guild and their agents. Regularly updated.

Camera, Lens, and Lighting

American Cinematographer (P.O. Box 2230, Hollywood, CA 90028). A monthly magazine devoted to camera techniques. Although it has a strong bias toward large crew production, there are numerous articles on low-budget films.

Carlson, Verne, and Carlson, Sylvia. *Professional Cameraman's Handbook*. New York: Amphoto, 1981. Fully outlines standard industry practice for the camera crew and describes in detail all the professional 16mm and 35mm cameras.

Clarke, Charles G., ed. *American Cinematographer Manual*. Hollywood: American Society of Cinematographers, 1980. Camera threading diagrams and many useful charts. A standard manual, referred to as "the bible."

Clarke, Charles G. *Professional Cinematography*. Hollywood: American Society of Cinematographers, 1968. A Hollywood director of photography discusses his craft. Special emphasis on studio lighting.

Cox, Arthur. *Photographic Optics*. London: Focal Press, 1973. A standard text, with many practical examples. Theoretical but not highly technical.

Millerson, Gerald. *Lighting for Television and Motion Pictures*. New York: Hastings House, 1972. Thorough grounding in lighting theory. Less useful for practical setups.

Ray, Sidney. *The Lens in Action*. New York: Hastings House, 1979. Combines concise theoretical explanation with practical applications. Clear drawings.

Ritsko, Alan J. *Lighting for Location Motion Pictures*. New York: Van Nostrand Reinhold, 1979. Comprehensive discussion of lighting in cramped locations and large industrial settings.

Samuelson, David W. *Motion Picture Camera and Lighting Equipment*. New York: Hastings House, 1977. Gives brief descriptions of many camera and lighting techniques accompanied by clear drawings.

Samuelson, David W. *Motion Picture Camera Techniques*. New York: Hastings House, 1978. Many techniques and hints while "on the set."

Sound

Clifford, Martin. *Microphones—How They Work & How to Use Them.* Blue Ridge Summit, PA: Tab Books, 1977. Easy to read. Many specifics on recording music.

Frater, Charles B. *Sound Recording for Motion Pictures.* New York: A. S. Barnes, 1979. Detailed information for the working recordist. Location sound techniques.

Nisbet, Alec. *The Use of Microphones,* 2nd ed. Woburn, MA: Focal Press, 1983.

Nisbet, Alec. *The Technique of the Sound Studio,* 4th ed. Woburn, MA: Focal Press, 1979.

Runstein, Robert. *Modern Recording Techniques.* Indianapolis: Sams, Howard W. & Co., 1974. Thorough. Specializes in concerns of studio music recording.

Tremaine, Howard M. *The Audio Cyclopedia.* Indianapolis: Sams, Howard W. & Co., 1982. Comprehensive discussion of all aspects of sound recording and reproduction. A technical source.

Film and Exposure

Campbell, Russell. *Photographic Theory for the Motion Picture Cameraman.* New York: A. S. Barnes Co., 1970.

Dunn, Jack F., and Wakefield, George L. *Exposure Manual,* 3rd ed. Hertfordshire, England: Fountain Press, 1974. A thorough discussion of characteristic curves, exposure and exposure problems.

Eastman Kodak Company. *The Book of Film Care.* Rochester, NY: Eastman Kodak Co., 1982. Covers storage preservation, maintenance, rejuvenation and projection of movie film.

Eastman Kodak Company. *Eastman Professional Motion Picture Films.* Rochester, NY: Eastman Kodak Co., 1982. Technical description of Eastman Kodak professional films and explanations of film data sheets.

Fuji Photo Film Co. *Fuji Film Photo Handbook: Photographic Properties of Fuji Motion Picture Films.* New York: Fuji Photo Film.

Editing and Laboratory

Association of Cinema and Video Laboratories. *Handbook: Recommended Procedures for Motion Picture and Video Laboratory Services.* Bethesda: The ACVL (P.O. Box 34932), 1982. Leader preparation and lab services.

Burder, John. *The Technique of Editing 16mm Films.* New York: Hastings House, 1968.

Crittenden, Roger. *Film Editing.* London: Thames and Hudson, 1981. An excellent practical and theoretical discussion of editing.

Happe, L. Bernard. *Your Film & The Lab,* 2nd ed. Woburn, MA: Focal Press, 1983. A clear, well-illustrated manual on lab technology and preparing material for lab work.

Reisz, Karel, and Miller, Gavin. *The Technique of Film Editing,* 2nd ed. Woburn, MA: Focal Press, 1968. A classic text, though a bit pedestrian.

Distribution

Film and Video Makers Travel Sheet. (Section of Film & Video, Museum of Art, Carnegie Institute, 4400 Forbes Avenue, Pittsburgh, PA 15213.) Lists at no charge to the filmmaker new releases of independent films and traveling filmmaker's schedules.

Gadney, Alan E. *Gadney's Guide to 1800 International Contests*. Festival Publications (Box 10180, Glendale, CA 91209).

Reichert, Julia. *Doing It Yourself: A Handbook on Independent Film Distribution*. New York: The Association of Independent Video and Filmmakers, Inc., 1977. An excellent short manual. Lists some festivals.

Trojan, Judith, and Covert, Nadine. *16mm Distribution*. New York: Educational Film Library Assn. Thorough and informative. Lists film festivals.

Index

Figures are indicated by italics.

407